The ART of PHOTOGRAPHY
1839–1989

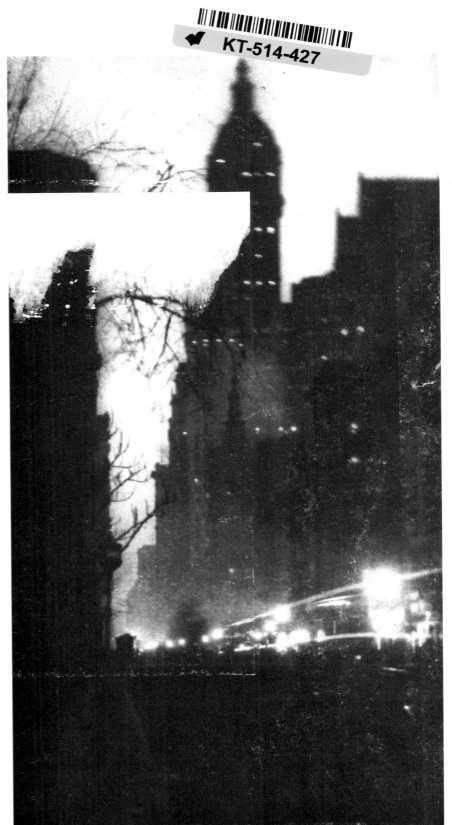

Museum of Fine Arts, Houston
11 February–30 April 1989

Australian National Gallery, Canberra
17 June–27 August 1989

Royal Academy of Arts, London
23 September–23 December 1989

KT-514-427

south essex college
FURTHER & HIGHER EDUCATION
SOUTHEND

30130504262859

Published on the occasion of the exhibition
THE ART OF PHOTOGRAPHY 1839–1989

Museum of Fine Arts, Houston
Australian National Gallery, Canberra
Royal Academy of Arts, London

The ART of PHOTOGRAPHY

1839–1989

Catalogue edited by
MIKE WEAVER

Photographs selected by
DANIEL WOLF
with Mike Weaver and Norman Rosenthal

Museum of Fine Arts, Houston
Australian National Gallery, Canberra
Royal Academy of Arts, London

Catalogue published in association with

Yale University Press, New Haven and London

Exhibition Selectors

DANIEL WOLF
with
MIKE WEAVER
NORMAN ROSENTHAL

with the assistance of
MARK HAWORTH-BOOTH
DAVID MELLOR
CHRIS TITTERINGTON

Catalogue

Editor
MIKE WEAVER

Assistant Editor
ANNE HAMMOND

Co-ordinator
MARYANNE STEVENS

BASILDON COLLEGE LIBRARY

© The Royal Academy of Arts, 1989
All rights reserved. This book may not be reproduced in whole or in part, in any form (beyond that copying permitted by Sections 107 and 108 of the U.S. Copyright Law and except by reviewers for the public press), without written permission from the publishers.

House editor: Gillian Malpass
Photographic sequencing by Daniel Wolf
Typeset in Monophoto Bembo by
Tameside Filmsetting Ltd, Ashton-under-Lyne
Printed in Italy by
Amilcare Pizzi S.p.A., Milan

Library of Congress Cataloging-in-Publication Data

The art of photography, 1839–1989.

Bibliography: p.
1. Photography, Artistic—Exhibitions. I. Weaver, Mike. II. Royal Academy of Arts (Great Britain)
TR646.G72L66192 1989
779'074 88–28032
ISBN 0-300-04457-7 (cloth)
ISBN 0-300-04456-9 (pbk)

FRONTISPIECE: Alvin Langdon Coburn, *Singer Building, New York*, 1909–10 (cat. 172)
COVER ILLUSTRATION: Man Ray, *Portrait of a tearful Woman*, 1936 (cat. 245)

Contents

FOREWORD

Few people would challenge the statement that photography has revolutionised the visual arts over the past one hundred and fifty years. Indeed, its impact has been the subject of considerable discussion and debate since the initial lodging of the patent simultaneously in 1839 by Fox Talbot in Britain and by Daguerre in France. Greeted by some as the perfect solution to the artist's quest for the accurate recording of incidental details in nature—the mechanical sketchbook—it was also seen as the harbinger of death to painting as an art form, or as a new visual means of communication governed by its own techniques and capable of creating images that were works of art in their own right. While fully cognisant of the first two responses to photography, it is the third which this exhibition seeks to celebrate.

The pioneers of photography were mostly English and French; its appeal soon spread, however, to the other countries of Europe and to the continent of North America. This exhibition does not attempt to be all-inclusive. Rather, by choosing a limited number of both European and American photographers, each represented by a significant corpus of his or her work, we would hope to demonstrate the specific contribution of these artists to the iconographic and technical developments that have rendered the medium an art form in its own right. Thus the exhibition moves from the innovations of its pioneer through to the revolutions in technique explored by Steichen and the radical dialogues with abstraction conducted by Lissitzky, Moholy-Nagy and Man Ray. The more recent chapters in the story range from photography's capacity to carry the bitter truths of war and everyday life, the fragile glitter of the world of fashion and the creation of innovatory ways of seeing through the appropriation of photographic techniques and images by contemporary painters.

This exhibition has been an exciting collaborative enterprise, initially between the Royal Academy of Arts and the Museum of Fine Arts in Houston. The decision of the Australian National Gallery to become a partner in the show has added an important dimension to the project, permitting this major review of the art of photography to be seen in three continents. The genesis of the idea for the exhibition came from Daniel Wolf and Weston Naef, curator of the Photography Collection at the Getty Museum, California. The selection has been undertaken by Daniel Wolf, Dr Mike Weaver, of Oxford University, and Norman Rosenthal, of the Royal Academy, in consultation with Anne Tucker, of The Museum of Fine Arts Houston, and with the assistance for specific sections of Mark Haworth-Booth, Dr David Mellor and Chris Titterington. Anne Tucker's staff at the Museum of Fine Arts, Houston, has co-ordinated the requests for the loans. It is to Mike Weaver, ably assisted by Anne Hammond, that we also owe the major task of planning and editing the catalogue. This incorporates important contributions by leading scholars of the history of photography both in Britain and in the United States of America. Many lenders, both public and private have been most generous in their support of the show. Such generosity has ensured the construction of a show which we believe will come as a major revelation to the visitors to our three institutions, causing them to reflect upon the remarkable history of this most inventive of artistic media.

Roger de Grey, President, The Royal Academy of Arts, London.
Peter Marzio, Director, Museum of Fine Arts, Houston.
James Mollison, Director, Australian National Gallery, Canberra.

LENDERS TO THE EXHIBITION

H.M. The Queen

Corporate collections and Galleries

Exchange National Bank, Chicago (Herb Kahn, Curator)
FORBES Magazine Collection, New York (Robert Forbes)
Gilman Paper Company Collection, New York (Pierre Apraxine, Curator, and Lee Marks)
Hallmark Photographic Collection, Kansas City, Missouri (Keith Davis, Curator)
Edwynn Houk Gallery, Chicago
Robert Koch Gallery, San Francisco
Massachusetts General Hospital, Boston, courtesy of Fogg Art Museum, Harvard University (Davis Pratt, Curator)
Metro Pictures, New York
Pace/MacGill Gallery (Peter MacGill)
Joseph E. Seagram and Sons, Inc., New York (Carla Caccamise Ashe, Curator)

Public Institutions

Albright-Knox Gallery, Buffalo, New York (Douglas Schultz, Director)
Amon Carter Museum, Fort Worth, Texas (Tom Southall, Curator, and Marnie Sandweiss)
Art Institute of Chicago (David Travis, Curator)
Australian National Gallery, Canberra
Bibliothèque des Arts Décoratifs, Paris (Josainne Sartre, Conservateur)
Canadian Centre for Architecture, Montreal (Phyllis Lambert, Director, Richard Pare, Curator, and Laurie Gross)
Canadian Museum of Contemporary Photography, Ottawa (Martha Langford, Director, and Sue Lagasi, Registrar)
Center for Creative Photography, University of Arizona, Tucson (James Enyeart, Director, and Terrence Pitts, Curator)
Cleveland Museum of Art (Tom Hinson, Curator)
Detroit Institute of Arts (Ellen Sharp, Curator)

Edinburgh City Libraries, Scotland (Margaret Sharp, Director)
J. Paul Getty Museum, Santa Monica, California (Weston Naef, Curator, Louise Stovall, and Joan Gallant Dooley)
High Museum of Art, Atlanta, Georgia (Susan Krane, Curator)
International Center of Photography, New York (Cornell Capa, Director, and Miles Barth, Curator)
International Museum of Photography at George Eastman House, Rochester, New York (Robert A. Sobieszek, Director, and David Wooters)
Metropolitan Museum of Art, New York (Maria Morris Hambourg, Curator)
Musée d'Orsay, Paris (Françoise Heilbrun, Conservateur)
Museum of Fine Arts, Boston (Clifford Ackley, Curator)
Museum of Fine Arts, Houston
Museum of Modern Art, New York (John Szarkowski, Director, and Susan Kismaric, Curator)
National Gallery of Art, Washington, DC (Sarah Greenough, Curator)
National Gallery of Canada, Ottawa (James Borcoman, Curator)
National Portrait Gallery, Washington, DC (Will Stapp, Curator)
Philadelphia Museum of Art (Martha Chahroudi, Curator)
The Art Museum, Princeton University, New Jersey (Peter C. Bunnell)
Royal Photographic Society, Bath (Pam Roberts, Curator)
San Francisco Museum of Modern Art (Sandra Phillips, Curator)
Science Museum, London (John Ward, Curator)
Scottish National Portrait Gallery, Edinburgh (Duncan Thomas, Keeper)
Harry Ransom Humanities Research Center, University of Texas, Austin (Roy Flukinger, Curator)
University Research Library, University of California, Los Angeles (David Zeidberg, Department Head)

Victoria and Albert Museum, London (Mark Haworth-Booth, Curator, and Chris Titterington, Assistant Curator)

Private Lenders

Timothy Baum, New York
Gilberte Brassaï, France
Sonja Bullaty and Angelo Lomeo, New York
George T. Butler, New York
Mary Cooper, England
Liza Cowan and Sharon Mumby, New York
Leonard J. Halpern, New York
Yasuo Hattori, Japan
Robert Herskowitz, England
Anne and William S. Hokin
Mrs Jean Horblitt, Connecticut
Ros Jacobs, New York
Jedermann Collection, N.A.
Diane Keaton, New York
Joe Kelly, New York
G. E. Kidder Smith, New York
Hans P. Kraus, Jr., New York
Harriette and Noel Levine, New York
Menil Collection, Texas
Jean Pigozzi, New York
Pritzker Collection, Illinois
Jacques Rauber, Switzerland
Rubel Collection, California
Richard Sandor, Illinois
Emily and Jerry Spiegel, New York
Robert Shapazian, California
Erich Sommer, England
Roger Thérond, France
Newby Toms, New York
Marjorie and Leonard Vernon, California
Thomas Walther, New York
Stephen White, California
Michael G. Wilson, England
Takouhy and Don Wise, New York

and the photographers who kindly lent their work and those lenders who wish to remain anonymous

Acknowledgements

The following staff at the Museum of Fine Arts, Houston were essential to the successful organisation of the exhibition:

Peter C. Marzio, Director
Margaret Skidmore, Development Director
Celeste Marie Adams, Associate Director, Special Projects
Karen Bremer, Curatorial Administrator
Anne Wilkes Tucker, Gus and Lyndall Wortham Curator
Mathilda Cochran, Secretary, Photography Department
Maggie Olvey, Curatorial Assistant for Works-on-Paper
Patricia Clark-Faenger, Secretary

Charles J. Carroll, Registrar
Sara K. Garcia, Assistant Registrar

Gregory Woodard, Design
Lorri Lewis, Graphics

Beth B. Schneider, Education Director
Karen Luik, Educator for Exhibition Programs

Anne Lewis, Public Relations
Hannah Baker, Public Relations

The following staff at the Royal Academy of Arts have contributed to the organisation of the exhibition and the production of the catalogue:

Piers Rodgers, Secretary
MaryAnne Stevens, Librarian and Head of Education
Annette Bradshaw, Deputy Exhibitions Secretary
Julie Summers, Exhibitions Assistant
Susan Thompson, Exhibitions Assistant

In addition, the organisers and contributors to the catalogue would wish to thank the following people for their advice and assistance:

Clifford Ackley
Pierre Apraxine
Miles Barth
Richard Benson
Bob Beroman
Cornell Capa
Eleanor Caponigro
Patricia Carrol
Martha Chahroudi
Roy Flukinger
Lee Friedlander
Peter Galassi
Frank Gohlke
Sarah Greenough
Margaret Harker
Françoise Heilbrun
Ed Houk
André Jammes
Diane Keaton
Josef Koudelka
Phyllis Lambert
Maria Morris
Weston Naef
Richard Pare
Sandra Phillips
Jill Quasha
Tina Rahr
Pamela Roberts
Sally Robinson
Aaron and Jessica Rose
Ingrid Sischy
Robert Sobieszek
Erich Sommer
John Szarkowski
Sean Thackrey
David Travis
John Walsh
Thomas Walther

Special thanks to John Froats, assistant to Daniel Wolf.

PHOTOGRAPHIC ACKNOWLEDGEMENTS

Reproduction photographs are courtesy of the lender except:

Jean-Loup Charmet (73, 81)

Philip DeBay (1, 4, 6, 7, 9, 10, 54, 55, 57, 60, 61, 85, 87, 88, 89, 104, 105, 110, 111, 134, 155, 156, 157, 178, 180, 181, 182, 425, 426, 427, 428)

Fotoatelier B. & M. Dermond (8)

Jean Dubout (20, 23, 45, 46, 47, 49, 50, 72, 74, 75, 76, 79, 140, 268, 269, 294)

Ron Gordon (33, 217, 282, 283, 284, 285, 287, 288, 289, 290, 291, 292, 293)

Paul Hester, Houston (461)

Scott Hyde (2, 3, 5, 25, 26, 28, 29, 30, 31, 32, 34, 43, 66, 68, 69, 71, 86, 92, 93, 94, 108, 113, 115, 116, 118, 131, 133, 135, 136, 139, 141, 142, 150, 151, 152, 153, 154, 163, 164, 165, 166, 169, 175, 176, 177, 179, 185, 186, 187, 188, 189, 197, 220, 234, 236, 238, 239, 243, 244, 245, 247, 256, 264, 312, 314, 315, 316, 326, 332, 333, 334, 335, 336, 337, 342, 343, 358, 409, 410, 411, 412, 418, 419, 420, 421, 422, 423, 424, 438, 439, 440, 441, 444, 445)

Magnum Photos, Inc. (272, 273, 274, 275, 276, 277, 278, 279, 280, 281)

Moon Photography (126, 127, 128, 174, 214, 259, 260, 261, 262, 286)

Museum of Contemporary Photography, Chicago (258)

Museum of Fine Arts, Houston (144, 198)

Museum of Modern Art, New York (359, 360, 361, 362, 363, 364, 365)

Otto E. Nelson (442, 443)

Portland Photographics (429, 430, 431)

Nathan Rabin (246)

Adam Reich (78, 122, 212, 221, 313, 321, 323, 338, 339, 340, 341, 345, 351, 366, 367, 369, 370, 371, 372, 457, 458)

Juergen Wilde (213, 219, 227, 230, 240, 248, 249, 250I, 251, 252, 253, 254, 263, 317, 318, 319, 437)

Simon Yuen (11, 12, 13, 14, 15, 16, 35, 36, 37, 39, 40, 42, 62, 90, 100, 109, 132)

The following copyrights apply:

Copyright Robert Adams (336, 367, 368, 369, 370, 371, 372)

Copyright © Estate of Diane Arbus (329)

Copyright © Estate of Diane Arbus 1972 (328, 330, 331)

Copyright David Bailey courtesy Camera Eye Ltd (446, 447, 448)

Copyright Henri Cartier-Bresson/Magnum, Inc. (272, 273, 274, 275, 276, 277, 278, 279, 280, 281)

Copyright Robert Frank courtesy Pace/MacGill Gallery (320, 321, 322, 323, 324, 325, 326, 327)

Copyright Lee Friedlander (332, 333, 334, 335, 336, 337)

Copyright Susan Meiselas/Magnum, Inc. (429, 430, 431)

Copyright Irving Penn/Condé Nast Inc. (441, 442, 443, 444, 445)

Copyright Joel Sternfeld courtesy Pace/MacGill Gallery (338, 339, 340, 341)

Copyright © Aperture Foundation, Inc, Paul Strand Archive (183, 184, 185, 186, 187, 188, 189, 190, 191, 192, 193, 194, 195, 196)

All other photographs are copyright of the artist

Daniel Wolf

INTRODUCTION

This exhibition is about the art of photography and about those photographers who share with great artists working in all media the need to create and communicate. We wish to show that photography, since its invention one hundred and fifty years ago, has developed its own rich tradition through the work of artists who are possessed of a particularly gifted vision and who are masters of their craft. To this end we have chosen those individual artists who we feel have significantly contributed to what has now become a highly complex tradition. This has inevitably involved painful choices of inclusion and exclusion, but, by showing each artist in appropriate depth, the innovative power and force of his or her work is more clearly demonstrated.

The framework for the exhibition is based on three important ways of considering photography as an art: photography made consciously in the tradition of painting; photography made principally as a means of record and description; and, finally, photography made as art derived from the unique qualities and inherent possibilities of the medium. These modes are not all-inclusive nor are their boundaries rigid, since the work of most of the photographers we are considering contains elements of all three modes. However, these distinctions are as important today as they were in the early days of the art, as seen, for example, in the observations on photography made in 1857 by Lady Elizabeth Eastlake, art critic and wife of the painter Sir Charles Eastlake, Director of the National Gallery in London and President of the Royal Academy of Arts: 'What are [a photograph's] representations, but facts which are neither the province of art nor of description but of that new form of communication between man and man—neither letter, message nor picture—which now happily fills the void between them.' While Lady Eastlake defined photography as 'a new form of communication', excluding from it both the provinces of art and of description, we include all three categories within our own definition.

The 'province of art' defines a mode in which photographers share with painters certain visual characteristics such as detail, form, contrast, imagery, pose, costume, surface, composition and manipulation. This can be illustrated by a photograph, *Beech Trees*, (pl. 6) by William Henry Fox Talbot who, between 1833 and 1840, and independently of Daguerre, invented a form of photography that used a negative, thus becoming the basis of photography as we know it today. In this work Talbot composed an image from a sun-drenched landscape that deliberately emphasised the painterly and atmospheric qualities of the light and shadows on the leaves. A decade later, in the 1850s, the French master Gustave Le Gray composed seascapes to look like small-scale paintings (pls 87, 89). In the 1860s and 1870s Julia Margaret Cameron made portraits that borrowed poses and costumes from allegorical paintings, and an international movement in the early part of the twentieth century known as Pictorialism emulated the look of Impressionist paintings by emphasising the quality and beauty of the print itself and its subtleties of colour, contrast, reflection and surface. Modernism, too, has had its influence on photography at least twice during the twentieth century, first with Dada, Surrealism and Constructivism in the 1920s and 1930s, and again in more recent years when photography has become more intertwined with painting and sculpture and has played an essential role in the

realisation of the work of many artists, representative examples of which are shown in the last section of the exhibition.

Our second mode is the 'province of description'. The emphasis here is on subject matter. Functioning more as a window than as a picture, these photographs convey a specificity of time, place, character and event; detail is presented primarily as information, not as form. Again, using a photograph by Talbot as an example, *Articles of China* (pl. 3), we are presented with a visual inventory which seems not to have been set up by the photographer, but records a collector's display. At about the same time that Talbot was making salted-paper prints from paper negatives, a process that gives soft definition to detail, other photographers chose to make daguerreotypes, a unique positive on a polished surface of silver over a copper plate, which gave an extraordinarily high resolution of detail. Daguerreotypists photographed historical, political and scientific events at home, and also travelled to near and distant lands to photograph people, architecture and landscape. Travel photography continued throughout the 1860s, 1870s and 1880s, employing the albumen process. This required making a negative before making a print, but because the emulsion on the negative was a smooth layer on a glass plate, rather than impregnated into the fibres of the paper negative, resolution of detail was also extraordinary. In the twentieth century this mode continued in Europe and in the United States, but the concern shifted to the culture at home. Also, the camera came increasingly to be hand held, which gave the artist greater flexibility. The work that resulted is more personal than earlier documentary styles. Photojournalism is another aspect of this mode. Covering war and scenes of conflict, photographers have inevitably created work that itself transcends its function of recording. These works have had a tremendous effect on the way in which our culture shapes its perceptions and conscience. Similarly, the great fashion photographers transcend advertising and have the power to influence and modify our social habits and identities.

In the third mode, Lady Eastlake's 'new form of communication', photographs are meant to look neither like paintings nor like documents. The medium has inherent technical possibilities that give it its own visual language. Given photography's ability to depict real space and atmospheric light so convincingly, this mode allows the photographer to be an instant observer of reality, and to select and to compose those moments that are in themselves the visual poems, or metaphors, the expressions of a new language. It is this power of individual artistic vision and recognition that gives photographers the ability to elevate and transform images of reality into images of aesthetic contemplation.

A Talbot photograph in this third mode is *Street Scene, Paris* (pl. 16). At first sight, the stone buildings and the light appear to be depicted with documentary clarity. However, the off-centre placement of the main building, creating a tense composition, seems to have been determined by the artist's own interpretations of the scene rather than by the scene itself. In the large image that results from Talbot's many visual decisions, the buildings appear like theatrical backdrops, yet the passageway between them is realistic and deep: a lamppost divides a blurred horse from another more precisely drawn one. These and other effects create a city that is both real and unreal, a city that seems to exist essentially in the imagination of the artist.

Although this mode is present in the works of many nineteenth-century photographers, it does not manifest itself as a clear or distinct style or movement. However, particular artists such as Carleton Watkins, working in a topographical tradition, and Roger Fenton and Gustave Le Gray, whose work was influenced by their training as painters in Paris, began to explore new territory unlike that of painting and that of literal documentation. The horizon of that which is purely photographic emerges—a new visual language capable of expressing one's self and

one's emotions. But it is not until the late work of Alfred Stieglitz and Edward Weston that this mode is consciously applied. Stieglitz called his cloud studies *Equivalents*, which signified an image equivalent to a feeling. In the 1950s a generation of photographers, some of whom, like Minor White, were influenced by Stieglitz, used this language which 'fills the void between letter, message and picture' to express an inner vision of the world.

As photography celebrates its one hundred-and-fiftieth anniversary, it would seem safe to presume that these three modes will continue to flourish. Documentation remains a powerful form of expression, while some photographs are referred to as art works. And photography as an art form in its own right will continue to serve the artist's need to work with light.

CHRONOLOGY

1839 Invention of the daguerreotype on silver-coated copper announced by Arago to Académie des Sciences, Paris; Talbot presents photogenic drawings on paper at Royal Society, London; Bayard exhibits direct paper positives.

1840 Petzval lens constructed by Voigtländer, reducing exposure time by 90 per cent.

1841 Calotype negative on paper introduced by Talbot; Hunt, *A Popular Treatise on the Art of Photography*.

1843 Series of calotype portraits begun by Hill and Adamson for painting to commemorate foundation of the Free Church of Scotland.

1844 Talbot, *The Pencil of Nature*, part 1, illustrated with original photographs.

1847 Photographic Club founded in London; negative on albumenised glass developed by Niépce de Saint-Victor.

1851 Invention of Frederick Scott Archer's wet collodion on glass process; Le Gray invents waxed-paper negative; Société Héliographique founded in Paris; first issue of *La Lumière* (Paris); Great Exhibition, London, exhibits photographs; Mission Héliographique established to record France's ancient monuments.

1852 Exhibition at the Society of Arts, London, of 779 photographs.

1853 Photographic Society of London founded; first issue of the *Journal of the Photographic Society*.

1854 Société Française de Photographie founded.

1857 Rejlander shows *The Two Ways of Life* at Manchester Art Treasures Exhibition (a composite photograph from multiple negatives).

1860 Frith, *Egypt, Sinai, and Jerusalem*.

1861 Maxwell demonstrates principles of three-colour photography.

1864 First issue of *Photografische Korrespondenz* (Vienna); invention of Woodburytype; Swan receives patent for carbon process.

1866 *Gardner's Photographic Sketch Book of the* [American Civil] *War*.

1867 Watkins, *Yosemite*; O'Sullivan, U.S. Geological Survey of the 40th Parallel.

1869 Robinson, *Pictorial Effect in Photography*, conceptualises art photography.

1871 Development of gelatine-silver bromide by Maddox makes dry plates possible.

1873 Platinotype process patented by Willis; Thomson, *Illustrations of China and its People*.

1875 Cameron, *Idylls of the King and other Poems*, illustrated with albumen prints.

1879 Klíč invents photogravure process.

1881 Gelatine-silver chloride paper introduced by Eder and Pizzighelli.

1884 Eastman produces flexible negative film; first issue of the British *Amateur Photographer*.

1885 Half-tone (cross-line screen) invented by F. E. Ives for reproduction.

1886 Emerson and Goodall, *Life and Landscape on the Norfolk Broads*, illustrated with platinum prints by Valentine of Dundee.

1890 Hurter and Driffield publish researches on sensitometry.

1891 Interference process of colour photography developed by Lippmann; first telephoto lenses.

1892 Linked Ring, an association of photographers to promote the medium as an art form, founded in London.

1893	First issue of *American Amateur Photographer*; 'The Photographic Salon' exhibition, Dudley Gallery, London.
1897	First issue of *Camera Notes*, edited by Stieglitz.
1898	Stieglitz, *Picturesque Bits of New York and Other Studies*; Atget begins to photograph Paris and its environs.
1900	'The New School of American Photography' exhibition, Royal Photographic Society, London (1901, in Paris).
1903	First issue of *Camera Work*, edited by Stieglitz to 1917.
1905	'291' gallery opened by Stieglitz; 'Art in Photography', *Studio* (London), important summer issue on art photography.
1906	Invention of off-set lithography.
1907	Autochrome colour process introduced by Lumière brothers.
1908	'Colour Photography', *Studio* (London) illustrated with half-tones from autochromes.
1909	Coburn, *London*, a Symbolist view of the city.
1910	'International Exhibition of Pictorial Photography', Albright Art Gallery, Buffalo.
1914	De Meyer, *Sur le Prélude à l'Après-midi d'un Faune* illustrating the Ballets Russes; Clarence White School opens in New York.
1916	'291' exhibits photographs by Paul Strand; *Twenty-Five Great Houses of France* (T. A. Cook) illustrated by F. H. Evans.
1919	Three-colour Carbro process developed by H. F. Farmer.
1921	First issue of *Camera* (Lucerne).
1923	Steichen appointed Condé Nast's chief photographer for *Vogue* and *Vanity Fair*.
1925	Leica marketed; Moholy-Nagy, *Malerei, Fotografie, Film*.
1928	First issue of *Vu* (Paris); Rolleiflex introduced.
1929	Sander, *Antlitz der Zeit*; Stieglitz opens 'An American Place' gallery; 'Film und Foto' exhibition, Deutscher Werkbund, Stuttgart.
1932	The f64 group, to promote 'straight' photography, founded by Van Dyke, Adams, Cunningham, Weston and others in San Francisco.
1933	Brassaï, *Paris de Nuit*.
1934	First issue of *Lilliput* (London).
1935	Stryker's Farm Security Administration project begins to document rural effects of the depression in U.S.
1936	First issue of *Life*; Photo League, New York, founded; Kodachrome colour transparency film introduced.
1937	'Photography 1839–1937' exhibition, Museum of Modern Art (MOMA), New York, curated by Beaumont Newhall; Moholy-Nagy establishes New Bauhaus at Chicago Institute of Design.
1938	First issues of *Picture Post* (London) and *Match* (Paris); Walker Evans, *American Photographs*.
1940	Strand, *Photographs of Mexico*.
1941	Agee and Evans, *Let Us Now Praise Famous Men*.
1942	Kodacolor negative film introduced.
1944	Eugene Smith joins *Life* magazine.
1945	Lécuyer, *Histoire de la Photographie*; Weegee, *Naked City*.
1947	Magnum Agency founded; Polaroid Land camera and film invented.
1948	Adams publishes his Zone System for tonal control through exposure and development, and his *Portfolio 1*.
1949	Newhall, *The History of Photography from 1839 to the Present Day*; International Museum of Photography established at George Eastman House, Rochester, N.Y.
1950	Weston, *My Camera on Point Lobos*.

1951	Brandt, *Literary Britain*; Lieberman, *The Art and Technique of Color Photography*; Steinert, *Subjektive Fotografie*.
1952	Cartier-Bresson, *Images à la sauvette* (*The Decisive Moment*); first issue of *Aperture* (New York).
1955	'Family of Man' exhibition, MOMA, New York; Gernsheim, *The History of Photography*.
1958	Frank, *Les Américains*.
1960	Penn, *Moments Preserved*.
1964	Introduction of Cibachrome positive colour prints from transparencies.
1966	International Center of Photography established, New York.
1967	Friends of Photography, a programme of exhibitions, publications, and workshops, founded by Adams, Beaumont and Nancy Newhall and others in Carmel; Antonioni's *Blow-Up* portrays the photographer as hero; 'New Documents' (Arbus, Friedlander, Winogrand), exhibition, MOMA, New York.
1969	Minor White, *Mirrors, Messages, Manifestations*; first issue of *Creative Camera* (London).
1970	Rencontres Internationales de la Photographie, an annual summer festival of photography with workshops, founded in Arles, France.
1971	Opening of Photographers' Gallery, London, Witkin Gallery, New York, and gallery at the Bibliothèque Nationale, Paris; Strand retrospective exhibition at Philadelphia Museum of Art.
1975	'New Topographics' exhibition, George Eastman House, Rochester, New York, on the despoiled landscape; Center for Creative Photography established at University of Arizona, Tucson.
1977	Side Gallery, Newcastle-upon-Tyne, opens to public and revives the British documentary tradition.
1979	'Three Perspectives on Photography' exhibition (fine art, socialist and feminist), Hayward Gallery, London.
1983	National Museum of Photography, Film and Television, Bradford, opens.
1984	'The Golden Age of British Photography' exhibition, Victoria & Albert Museum, London.
1987	'Photography and Art: Interactions since 1946', exhibition, Los Angeles County Museum of Art.
1989	One hundred and fifty years of photography celebrated.

Mike Weaver

Prologue: The Picture as Photograph

My dearest Miss Mitford, do you know anything about that wonderful invention of the day, called the Daguerreotype?—that is, have you seen any portraits produced by means of it? Think of a man sitting down in the sun and leaving his facsimile in all its full completion of outline and shadow, steadfast on a plate, at the end of a minute and half! The Mesmeric disembodiment of spirits strikes one as a degree less marvellous. And several of these wonderful portraits . . . like engravings—only exquisite and delicate beyond the work of the engraver—have I seen lately—longing to have such a memorial of every Being dear to me in the world. It is not merely the likeness which is precious in such cases—but the association, and the sense of nearness involved in the thing . . . the fact of the *very shadow of the person* lying there fixed for ever! It is the very sanctification of portraits I think—and it is not at all monstrous in me to say what my brothers cry out against so vehemently . . . that I would rather have such a memorial of one I dearly loved, than the noblest Artist's work ever produced.

Elizabeth Barrett Browning[1]

There is nothing inherent in any medium that guarantees its value as art. The relation between fact and symbol, expression and idea, by which we detect the presence of art in an object, is not in the gift of any particular medium but is the result of an artist's negotiation with the actual world according to certain principles. Just as sculptors at the beginning of this century debated the merits of carving against those of modelling, so camera artists debated those of straight against manipulated photography. These dual approaches have been with us since the beginning of photography and run throughout its history. They can be described as the difference between a direct and a more circuitous approach to reality. We can set direct Daguerre against circuitous Talbot, Mayall against Cameron, Abney against Davison, in the European tradition, as some would set primitive O'Sullivan against sophisticated Muybridge, Watkins against Ansel Adams, Walker Evans against Stieglitz, in the American. The straight versus manipulated division is still with us today in the conflict between the personal style of the contemporary British documentarists and those who construct a picture by appropriating or imitating the images of other artists.

Naturally, both sides claim to have realism on their side. Photography, too, has known its Gabos and Kandinskys, who claimed concrete status for their obviously abstract art. This allowed Moholy-Nagy to demote photography's most obvious property—its objective aspect—to merely one of eight varieties of photographic expression (p. 231). The Modernist photographers claimed that *optical* consciousness, raised to new levels of perception by the photogram (itself a more direct apprehension of actuality than the lens could achieve), was more real than *plastic* consciousness, which moulded reality in the rhetorical way of painting. This was but a new example of the carving (straight) versus modelling (manipulated) debate. However, Berthold Brecht drew the line at such reflexive preoccupations with photography.[2] For him the recorded document was absolutely essential: we were past the stage of endlessly demonstrating what photographic technique could do in the name of media-consciousness. In his conversations with Brassaï in 1939, Picasso said that the objective aspect of things, as well as the narrative side, was the province

1 *Elizabeth Barrett to Miss Mitford*, ed. B. Miller, London and New Haven 1954, 208-9.
2 Berthold Brecht, *Schriften zur Literatur und Kunst*, Frankfurt 1967, II, 74.

of photography rather than of painting. For Moholy-Nagy the goal of the medium was the discovery of its unique properties, whereas for Brecht and Picasso the documentary aspect of photography had still not lost its allure, its mesmeric power.

The subtle emanations from an object in a photograph are incomparable with anything in painting. Photography shares with film this exclusive and peculiar property—'the sense of nearness involved in the thing'. One day someone may discover a method of detecting in film emulsions an identifiable imprint—a genetic fingerprint, so to say—of the thing represented in the image. Out of focus, over-exposed, badly composed or not, the object and the image are felt instinctively to be identical as well as indexical. This has nothing to do with the pictorial aspect of the image but with a sense of real presence in the photograph. It is the source of the uncanny sensations Bertha experiences in Talbot's poem 'The Magic Mirror' (p. 16). Insofar as the photograph includes a core of being with its code of representation, photography is as much an occult science as an art. This has long been photography's bugbear ('too real'), as well as its saving grace ('so immediate'). Although historical, the photograph is always contemporary in that it incorporates within its emulsified surface this sensation of the actual. This wizardry in photography makes it akin to natural magic.

If in this sense the photograph is identical with actuality it is, of course, also a rhetorical construction of the photographer. This is why connoisseurs of the medium may treat it as an art object. Every photograph has a pictorial aspect: it confines itself to a traditional picture-frame; it stops time and movement short; and it alters our normal perception of scale, tone and colour. In certain periods of the history of photography the straight photograph may be preferred to the manipulated picture, but even the straight photograph is only *relatively* direct. Every artist using the picture-frame puts an opaque screen of rhetorical devices between him and his more or less transparent window on the world. In this sense, there never was a truly realistic mode of photography, although for the sake of polemic—an important ingredient in the evolution of any art—the carvers of photography, the realists, have claimed a closer relation to nature than the modellers, the idealists. The Postmodernist movement of today has placed the modellers in the ascendant—at least, for the moment.

The artists in this exhibition are distinguished from many other photographers because their treatment of reality is, as a body of work, often sufficiently coherent and consistent to identify it as the work of a particular person. It is by this that we recognise them as artists. But in photography criticism this is only a first step. To understand fully the extent of their achievement we have to take into account their relation to the various estates of photography: *fine art*, *advertising*, *amateur photography* and *journalism*. The specially adapted rhetorics of these separate orders of photography have determined to a large degree the nature of their different imagery, and their differing methods of handling and presenting it. What pleases the curator of the photography department of the museum may be of no use to the picture editor of a newspaper or fashion magazine. The four estates exercise effective control over their respective styles in relation to market values: the spiritual lords of the museum are no less demanding than the commercial and industrial controllers of the consumer, and the temporal masters of media. But it is hard to know sometimes, in past photography, whether Fenton's still lifes were fine art or advertising photographs, whether de Meyer's society portraits were not fashion plates, and whether Cartier-Bresson's Modernist compositions were ever journalistic in origin. In present photography, as the museum culture becomes ever more commercial (no longer the mere preserver but the active creator of culture), the relations between these once separate orders of photography become increasingly interdependent. Now all roads lead to the museum, just as in the mid-nineteenth century, in a period

Fig. 1 H. F. Talbot, *The Pencil of Nature*, part I (London 1844).

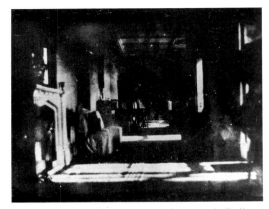

Fig. 2 H. F. Talbot, *Interior of the South Gallery, Lacock Abbey*, c.1839–40. London, Science Museum.

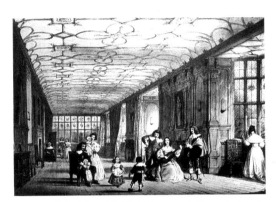

Fig. 3 'Haddon Hall', lithograph from J. Nash, *The Mansions of England in the Olden Time* (London 1839), pl. 23.

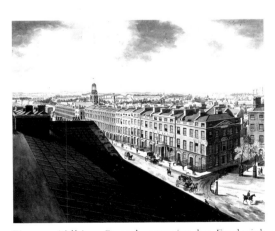

Fig. 4 'Albion Street', aquatint by Frederick Birnie, from G. Barker, *Panorama of London* (1792). Yale Center for British Art.

of intense imperial rivalry, they led to the industrial palace of the nations: the Great Exhibition (1851), the Exposition Universelle (1855), and the International Exhibition (1862). Photography was the product of an age that also produced the railway and the telegraph, an age of new systems of communication. It was to serve a commercial, bourgeois society, and it could be patented.

Invented by Niépce and Talbot with the printing trade in mind, photography (the very word coined by analogy with *lithography*) came at the end of a long search for an autographic process. The photochemical negative was thought of as a step on the way to photomechanical processes such as photogravure and the half-tone engraving in the same way, perhaps, that Paul Sandby hoped the watercolour might be successfully reproduced in aquatint. Talbot's *The Pencil of Nature* (1844–46) (fig. 1) takes its place in the history of the illustrated book, along with Hassell's *Aqua Pictura* (1818) and Hullmandel's *The Art of Drawing on Stone* (1824), the one difference being that Talbot's positives from negatives were produced photochemically rather than mechanically. When Talbot watched the South Gallery at Lacock (fig. 2) 'draw itself' by photography, he realised at once that such a medium would save the extraordinary labour of a John Nash, whose *Mansions of England in the Olden Time* (1839) was reproduced in lithography (fig. 3). He did not think of his invention as revolutionising taste so much as making it possible for him to share with Nash the taste for earlier English architectural styles, and to advance antiquarian and picturesque interests. Like Sandby, who had tried to control aquatint, and Hullmandel, who wanted to regulate the use of lithography, Talbot, an amateur embarrassed by potential commercial success, felt he owed it to himself (as well as to his ambitious mother) to patent his invention, and to pursue photoglyphic engraving, as he called it. The most famous photographers in Britain up to the First World War—Fenton, Cameron, Emerson, George Davison, James Craig Annan and Coburn—were all firmly committed to photomechanical reproduction, and Stieglitz's great magazine, *Camera Work* (1903-17), continued their graphic approach to photography in America.

By enforcing his patent Talbot created an unexpected effect. Far from slowing down the development of the aesthetic uses of photography in Britain, it created an élite interest in the medium analogous to that in watercolour drawing. Artists such as Hill in Scotland and Calvert Jones in Wales, who usually made wash drawings, availed themselves freely of the new medium, with Talbot's permission. Hill, who had used lithography for his *Sketches of Scenery in Perthshire* (1821), therefore came to photography on the basis of prior knowledge of art. By comparison, the French gift of the daguerreotype to the whole world (except England, the imperial rival, of course) created a popular cult of actuality without much regard for anything except commerce. A peculiar paradox of the invention of photography is that Daguerre, an artist, developed Niépce's swiftly obsolescent process on metal, whereas Talbot, a scientist, gave us a durable and flexible medium employing traditional materials. It tends to support the truism that artists are sometimes seduced by new technology whereas scientists often retain a respect for older media.

Just as graphic illustration profited over the centuries from various kinds of drawing devices such as the camera obscura, the camera lucida and the Claude glass, so photography learned from illustration how to contain its image within a frame. As graphic arts they shared a common evolution of visual knowledge. It was not an especially photographic vision that produced the strong diagonals and blocked foregrounds of Barker's *Panorama of London* (1792), but a camera vision combined with a high elevation (fig. 4). A hundred years later, this view of the city with its blocking elements and elevated vantage-point had been culturally validated by *japonisme*, with its anti-recessive devices and axonometric viewpoints. It was Hiroshige, Whistler and Caillebotte who authorised Coburn's photographs of

London and New York (1909-10) from rooftops and pinnacles (pls 172,175), not some special characteristic of photography. The rhetoric of the photographic image has never been anything different from that of any other contemporary graphic art, with the one proviso that subject-matter has never been quite abandoned by photography as it has by other visual arts. In camera art the photograph has never entirely left the picture.

But artists realised from the beginning that photography's labour-saving capacity for recording infinite detail told against its ability to represent abstract thought. An excess of minute particulars militated against a general statement. To lift fact from the accidental to the essential was as much the concern of Hill, who drew his principles from Sir Henry Raeburn, as of Robinson, who learnt from J.D. Harding, Cameron, who learnt from Watts, Emerson, who learnt from Millet and Whistler, and Coburn, who learnt from Arthur Wesley Dow. Breadth-of-effect, tonalism and other kinds of elimination of detail were aesthetic aspects of an ideological attitude founded on the belief that mastery of art (as of politics) required from the individual an ability to generalise rather than get bogged down in unwelcome detail. *Selected* detail was the key, as P. G. Hamerton pointed out (p. 101).

Talbot, far from regretting the absence of colour in photography, saw an advantage in monochrome: 'if we could but fix the outline of it [external reality], the lights and shadows, divested of all *colour*, such a result could not fail to be most interesting.'[3] Colour, like excessive detail, was felt to be a disadvantage in art because it never failed to suggest the indiscriminate vulgarity of actual life. Linearists were seen as intellectual seekers-after-abstract-truth, whereas colourists were flashy entertainers purveying, to an over-stimulated mob, nature in the raw. The English origins of this attitude are to be found in the words of the first President of the Royal Academy of Arts: 'A firm and determined outline is one of the characteristics of the great style in painting.'[4] Yet, despite Talbot's first descriptions of his process (photogenic *drawing*, the *pencil* of nature), photography (like nature) really has no outline. It is essentially a tonal process, more like aquatint than engraving and more like photogravure than etching. But in any case, colour photography like painting is pigment-based, sensitive to light only according to the modern colourman's abstract code. As such it is a perfectly legitimate part of the pictorial means of photography, no closer to nature than any other aspect of the medium.

When Man Ray, a conceptualist, wrote that the painter often felt that a black-and-white reproduction of his work was better than his original painting,[5] he was merely privileging design over colour in the time-honoured manner, and when Walker Evans, a realist, criticised chiaroscuro in photography as painterly,[6] his motive was an attack upon the tonalism of the Photo-Secessionists, Stieglitz, Steichen, Coburn and Kühn. In 1892 Stieglitz had envied the British the tone of their pictures:

> Those exquisite atmospheric effects which we admire in the English pictures are rarely, if ever, seen in the pictures of an American. This is a very serious deficiency, inasmuch as here is the dividing line between a *photograph* and a *picture*.[7]

For the sake of argument and discussion, the line between photograph and picture may be said to divide as follows:

PHOTOGRAPH		PICTURE	
optical	straight	plastic	manipulated
concrete	detail	abstract	breadth
carved	outline	modelled	tone
hard	tactile	soft	intangible

An emphasis on the photograph may result in a vitalised classicism rejecting a certain

3 William Henry Fox Talbot, Appendix A in G. Tissandier, *A History and Handbook of Photography*, ed. J. Thomson, London 1878, 355

4 Sir Joshua Reynolds, *Discourses on Art*, ed. R.R. Wark, New Haven and London 1975, 52.

5 Man Ray, 'Photography is Not Art,' *View* (October 1943).

6 Walker Evans, 'Photography', in *Quality in the Arts*, ed. L. Kronenberger, New York 1969, 202.

7 *Alfred Stieglitz: Photographs and Writings*, ed. S. Greenough, Washington, D.C. 1983, 182.

decadent romanticism of the picture–the later work of Stieglitz, Strand and Weston set against their earlier work. But the best artists in photography have always carved photographs and modelled pictures at the same time, even when the images were made, as it were, on the move: the French title of Cartier-Bresson's *The Decisive Moment* (1952) was *Images à la sauvette*, 'on the run' conveying a plebeian pleasure taken in a patrician mastery of the moment.

The special attraction of art made by means of photography is that it combines the visual rhetoric of the picture with the actuality of the photograph. The goal of the picture as photograph is to achieve detail and breadth in equal proportions. In this endeavour the art of photography will be seen by future generations to have faithfully pursued the quest for actual beauty in pictorial form and served the great mimetic tradition in Western art, at a time when philosophical self-doubt had called everything into question and made cowards of us all.

1

Beaumont Newhall
THE PENCIL OF NATURE

Ever since the Renaissance, artists and craftsmen had used the simple box camera–then called the camera obscura–as an aid to drawing. They traced the image formed by the lens on the ground glass of the camera. In the early years of the nineteenth century this skill of hand was replaced by what was picturesquely called 'the pencil of nature': the capturing of the camera's image by photochemical means.

The first system to be announced was the daguerreotype, the invention of Louis-Jacques-Mandé Daguerre, a well-known French painter. On seeing daguerreotypes for the first time the art critic of the Paris newspaper *La Gazette de France* wrote, on 6 January 1839:

> This discovery seems like a prodigy. M. Daguerre has discovered a method to fix the images which are represented at the back of a camera so that these images are not the temporary reflection of objects, but their fixed and durable impress, which may be removed from the presence of those objects like a picture or an engraving.[1]

On the following day the learned members of the French Academy of Sciences heard the noted physicist François Arago describe the process in a general way. Daguerre had shown Arago and two other members of the Academy several of his pictures of Paris, like the *Notre Dame from the Pont des Tournelles* that is in this exhibition (pl. 17). Arago said that the pictures could be studied with a magnifying glass without losing sharpness.

Daguerre's process seemed so important to Arago that he felt it indispensable for the government to recompense Daguerre for his expenses and time. 'France', he said, 'should nobly give the process to all the world.' At his urging a bill to award lifelong pensions to Daguerre and Isidore Niépce, Daguerre's late partner's son, was presented to parliament. Both the Chamber of Deputies and the Chamber of Peers voted favourably, and on 19 August, at a joint meeting of the Academy of Sciences and the Academy of Fine Arts, Daguerre's secret process was divulged to an enthusiastic audience that filled the Palace of the Institute.

To make a daguerreotype a highly polished sheet of silver-plated copper was placed silver side down over a box containing particles of iodine, the fumes of which formed light-sensitive silver iodide on the plate. After exposure in a camera the plate was developed by placing it over mercury heated to 140° Fahrenheit. The mercury formed a whitish amalgam where light had been received. The plate was then bathed in a strong solution of salt or sodium hyposulphite to remove the iodine, after which it was thoroughly washed in hot water.

At first the exposures ranged from a few minutes upwards to an hour; moving objects could not be recorded. But soon the light-sensitivity of the plate was increased by recoating the iodised surface with bromine or chlorine. Lenses of larger aperture were introduced which produced images twenty-two times more brilliant than Daguerre's. Portraits and landscapes with windblown foliage now became possible.

Architecture was also a common subject. The diplomat Baron Jean-Baptiste-Louis Gros made many plates of famous antique buildings on his travels (pls 23, 24). John Jabez Edwin Mayall, who went to London from Philadelphia, made superb

1 Translated in the *Literary Gazette* (13 January 1839), 28.

daguerreotypes on 'mammoth plates' (14 × 11 in.) of the Crystal Palace at the time of the 1851 Great Exhibition of the Works of Industry of All Nations (pl. 22).

Daguerreotypes were extremely popular in America. Every city had several portrait galleries; there were eighty-three in New York alone by 1853. The finest American daguerreotype portraits were taken in Boston by Albert Sands Southworth and Josiah Johnson Hawes. They were both students of François Gouraud who represented himself as an agent of Daguerre. He had brought from Paris daguerreotype cameras and processing equipment for sale and gave demonstrations. The portraits taken by the firm, such as the striking *Daniel Webster* (pl. 33), have an intensity and impact that is remarkable. As Southworth wrote:

> What is to be done is obliged to be done quickly. The whole character of the sitter is to be read at first sight; the whole likeness, as it shall appear when finished, is to be seen at first, in each and all its details, and in their unity and combinations It is required of and should be the aim of the artist-photographer to produce in the likeness the best possible character and finest expression of which that particular face or figure could ever have been capable.[2]

When the English scientist William Henry Fox Talbot read the announcement of Daguerre's photographic process he was astounded, for he had invented a similar process. He later recollected that he was

> placed in a very unusual dilemma (scarcely to be paralleled in the annals of science) for I was threatened with the loss of all my labour, in case M. Daguerre's process proved to be identical with mine, and in case he published it at Paris before I had time to do so in London.[3]

The idea of photography came to Talbot in 1833 while he was vacationing on Lake Como in Italy. He tried to make sketches of the scenery, but without success. He then thought of using a camera

> to throw the image of the objects on a piece of paper in its focus–fairy pictures, creations of a moment and destined as rapidly to fade away. It was during these thoughts that the idea occurred to me–how charming it would be if it were possible to cause these natural images to imprint themselves durably and remain fixed upon the paper![4]

On his return to England Talbot began to experiment. He made paper light-sensitive by bathing it first in a solution of common salt (sodium chloride) and then, after it had dried, in a solution of silver nitrate. These chemicals reacted to form silver chloride in the fibres of the paper. He then placed leaves (pl. 1), a piece of lace (pl. 2), or other flat objects on the paper, which slowly turned dark when exposed to sunlight except under what was laid upon it. He then washed the paper in a strong solution of salt, which rendered it relatively insensitive to further light action. In August 1835 he used this 'photogenic drawing paper,' as he called it, in a camera to record a lattice window in his house in Lacock. He carefully mounted it on a card with a note: 'When first made the squares of glass, about 200 in number, could be counted with the help of a lens.'[5]

Talbot showed examples of his photogenic drawings at the Royal Institution in London on 25 January 1839 and described the process in full detail at the Royal Society six days later. In 1841 he improved his process radically by discovering that exposures could be greatly reduced by development. Previously he had exposed his sensitised paper until a visible image appeared. Now he found that with a much shorter exposure an invisible or latent image could be developed with a solution of gallic acid and silver nitrate. This principle of the development of the latent image is basic to all current photographic processes and is Talbot's greatest contribution to

2 *British Journal of Photography* (8 December 1871), 538.

3 *Literary Gazette* (13 April 1839), 286.

4 H. F. Talbot, *The Pencil of Nature*, London 1844-46, n.p.

5 Illustrated in Beaumont Newhall, *Latent Image*, Albuquerque 1983, pl. 4.

photographic science. This new process Talbot called the calotype, and he patented it.

Between 1844 and 1846 Talbot produced *The Pencil of Nature*, a handsome volume of twenty-four original calotypes and an account of 'some of the early beginnings of a new art before the period which we trust is approaching of its being brought to maturity by the aid of British talent.' The photographs were chosen to represent the scope of the calotype process, and each plate was accompanied by Talbot's succinct observations. His comment on Plate x, *The Haystack*, (pl. 8) seems particularly fitting:

> One advantage of the discovery of the Photographic Art will be, that it will enable us to introduce into our pictures a multitude of minute details which add to the truths and reality of the representation, but which no artist would take the trouble to copy faithfully from nature.

With Plate vi, *The Open Door* (pl. 10) he writes:

> We have sufficient authority in the Dutch school of art, for taking as subjects of representation scenes of daily and familiar occurence. A painter's eye will often be arrested where ordinary people see nothing remarkable. A casual gleam of sunshine, or a shadow thrown across his path, a time-withered oak, or a moss-covered stone may awaken a train of thoughts and feelings, and picturesque imaginings.

In the daguerreotypes and calotypes of the pioneers lie the origins of two trends in later photography–the objective, highly detailed records of the world and the subjective, imaginative interpretations of the familiar, or even the commonplace. Both techniques became obsolescent with the invention in 1851 of the collodion process of sensitising and processing glass negatives.

HENRY FOX TALBOT

from 'The Magic Mirror' (1830)

Twice fifteen years had roll'd in peace away–
Now old, and nigh to death, the Wizard lay.
With his last breath he summon'd to his side
Bertha, his only child, his joy, his pride.
Daughter! he said, this castle's stern command
Must soon be trusted to thy feeble hand:
I may not tell thee Who its builders were!
Not of this Earth . . . then O my child beware,
And heed a father's dying counsel well!
In days of yore I framed a charmed Spell,
Which like a shield o'er this enchanted ground,
Sheds its protecting influence around.
Not that by this alone I caused to rise
The mighty Fabric that around thee lies,
(Far other secrets raised its banner'd wall,)
But in this Talisman they center all!
'Tis like the Clasp of a mysterious Chain,
Which if thou rendest . . . all the links are vain.

Behold yon Mirror . . . veil'd! . . . In Secrecy
What it concealeth, seek not Thou to see.
Tempt not the Spirits of the viewless Deep,
Long would'st thou rue it and thy folly weep!
Raise not the veil . . . a thousand forms of Death
And overwhelming Ruin lurk beneath!
But if thou dost . . . 'twere easier in that hour
To chain the wild winds, than arrest Their pow'r!

Thine are these tow'rs, and all this fair domain
Of wide-spread forest and of fertile plain:
Rule as thou wilt–but let my words prevail,
And never, never lift that dreadful Veil!

His voice grew faint, and ere the morrow's sun
His eyes were dim–his earthly race was run.

A month–but surely Chronicles must err–
O! could not Prudence watch a single year?
One thoughtless month o'er Bertha's head had flown
Since that fair heritage she call'd her own–
Already Pleasure drooped her languid wing,
The weary hours Amusement ceased to bring,
For ah! her days in Folly's wild career
She past, nor cared she Wisdom's voice to hear.

Extract from H. F. Talbot, *Legendary Tales in Verse and Prose*, London 1830.

Fill'd was her castle with the gay and proud,
And flatt'rers came, a mercenary crowd:
In song and dance, in feast and wassail high,
The hours were spent, and idle revelry.

It chanced one time that she remain'd alone,
For over was the feast . . . the guests were gone;
It was the bright and sunny month of May,
The hours seem'd long . . . she wearied of the day.
She traversed every hall, then went again,
For Pleasure seeking . . . seeking it in vain . . .
When through the Chamber dim she chanced to pass,
Where that dark curtain veil'd the Fatal Glass.

A sudden wish arose . . . she long'd to see . . .
But fear'd her father's words of mystery.
She stopp'd . . . drew nearer to behold the veil . . .
Touch'd it . . . then felt again her courage fail!
Three times she paused . . . but ah! the veil was thin,
A glorious Light was streaming from within!
It seems so lovely! Need I fear? she cried,
And with rash hand she flung its folds aside!

⁓⁓⁓

What show'd the Mirror? In an azure sky
The Sun was shining, calm and brilliantly,
And on as sweet a Vale he pour'd his beam
As ever smiled in youthful poet's dream:
With murmur soft, a hundred mazy rills
In silver tracks meander'd down the hills
And fed a crystal Lake, whose gentle shore
Was grassy bank with dark woods shadow'd o'er.

Far in the midst a lovely Isle there lay,
Where thousand birds of Indian plumage gay
Flutter'd like sparkling gems from tree to tree,
And caroll'd wild, with Nature's minstrelsy.

A Temple's fair proportion graced the Isle,
The rippling waters that around it smile
Reflect its columns in their sportive play
And glitter in the sun's unclouded ray.

And prints of tiny footsteps on the sand
Betray'd the gambols of some fairy band
Who now were flown, but scatter'd all around
Lay many a rosy chaplet on the ground,
And baskets heap'd with blushing fruits, and flow'rs
Fragrant as those which bloom'd in Eden's bow'rs,
And golden harps and timbrels cast away
Spread on the sward in rich confusion lay,
As if that light and airy company
Had shrunk in terror from a Mortal's eye!

In rapture o'er the mirror Bertha hung,
And pleased her fancy stray'd those scenes among;

But, as she gazed, a dimness seem'd to steal
O'er the bright glass, and slowly to conceal
The distant hills: then rolling up the vale
Shrouded it o'er with Vapours wan and pale.
The Lake, the Mountains, fade in mist away,
And lurid Darkness overspreads the day.

Too late repenting, Bertha tried once more
The Mirror's faded brightness to restore:
Alas! alas! it baffles all her skill,
The vapour on the glass falls thicker still.
To chase away the noxious dew she strives . . .
An instant, see! the shadowy scene revives . . .
But ah! how changed a picture doth it show
Of desolation, misery, and woe!

Dark frown'd the Sky, all leafless were the woods,
The brooks were swollen into raging Floods–
The gloomy lake, its beauty now no more,
Rolled long and angry billows to the shore–
Voices, not human, rose upon the blast . . .
Forms, not of Earth, across the Darkness past . . .
Fly! cried a whisper to her startled ear,
O haste and fly! the Storm of Death is near!
There shone a dazzling flash . . . with Echoes dread
The distant Thunder roar'd . . . and Bertha fled.

1 Talbot *Leaf of a Plant* c. 1839

2 Talbot *Lace* c. 1845

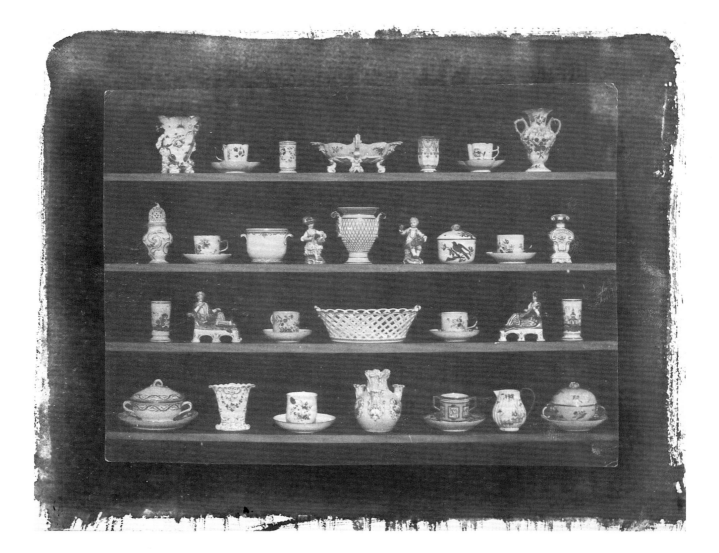

3 Talbot *Articles of China* 1844

4 Talbot *Honeysuckle* 1 June 1840

5 Talbot *A Bush of Hydrangea in flower* mid-1840s

6 Talbot *Beech Trees, Lacock Abbey* c. 1844

7 Talbot *Trees and Reflections* 1843

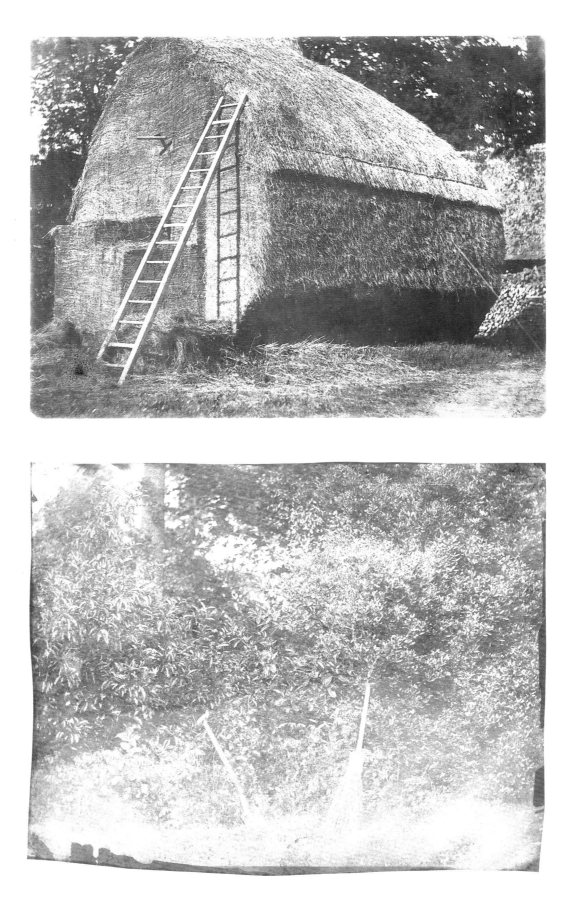

8 Talbot *The Haystack* 1844

9 Talbot *Broom and Spade* c. 1842

10 Talbot *The Open Door* 1 March 1843

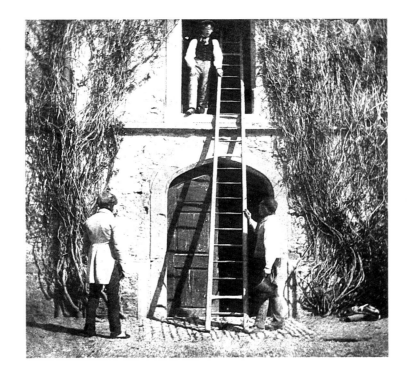

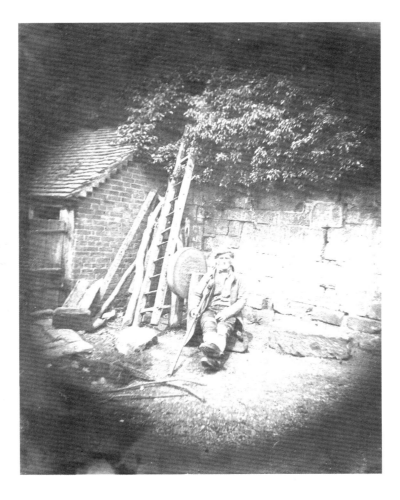

11 Talbot *The Ladder* 1844

12 Talbot *Man with a Crutch* 1844

13 Talbot *The Chess Players* c. 1845

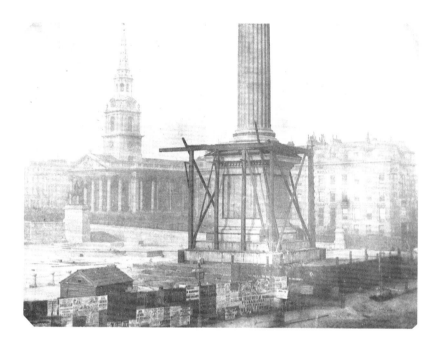

14 Talbot *Trafalgar Square: Nelson's Column under construction* 1843

15 Talbot *Ships in the Harbour at Rouen* 16 May 1843

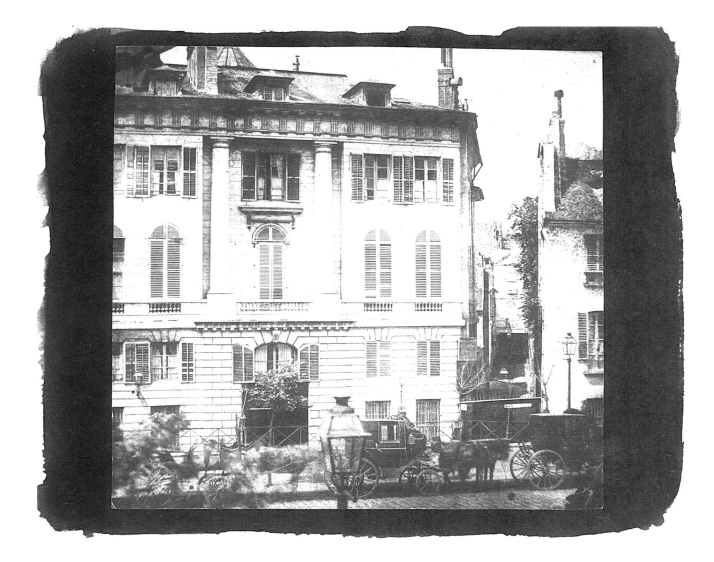

16 Talbot *Street Scene, Paris* 1843

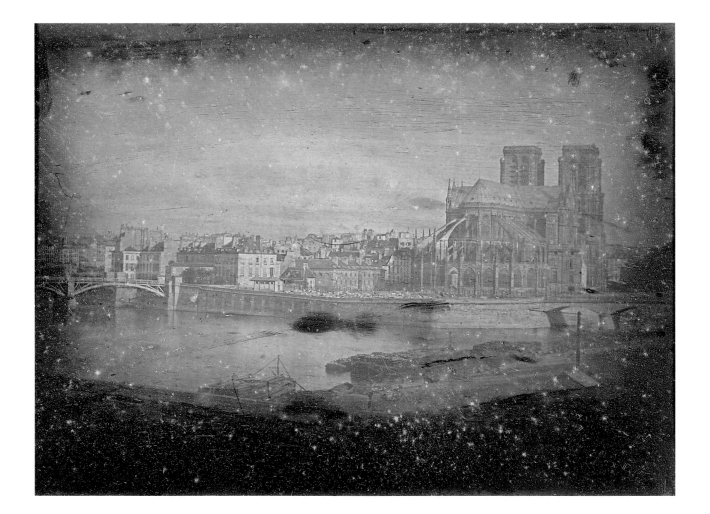

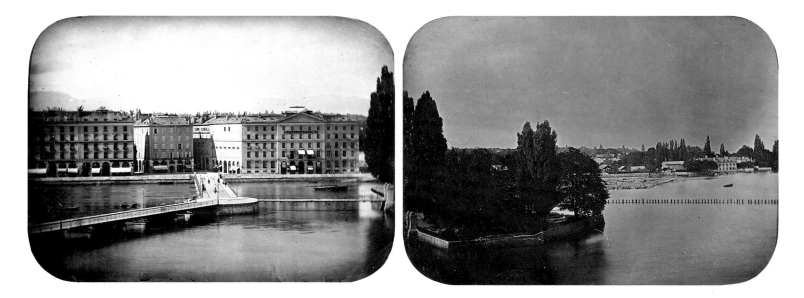

17　Daguerre　*Notre-Dame from the Pont des Tournelles*　1838–39

18 (bottom left and right)　Eynard-Lullin　*Panorama of Geneva*　c. 1850

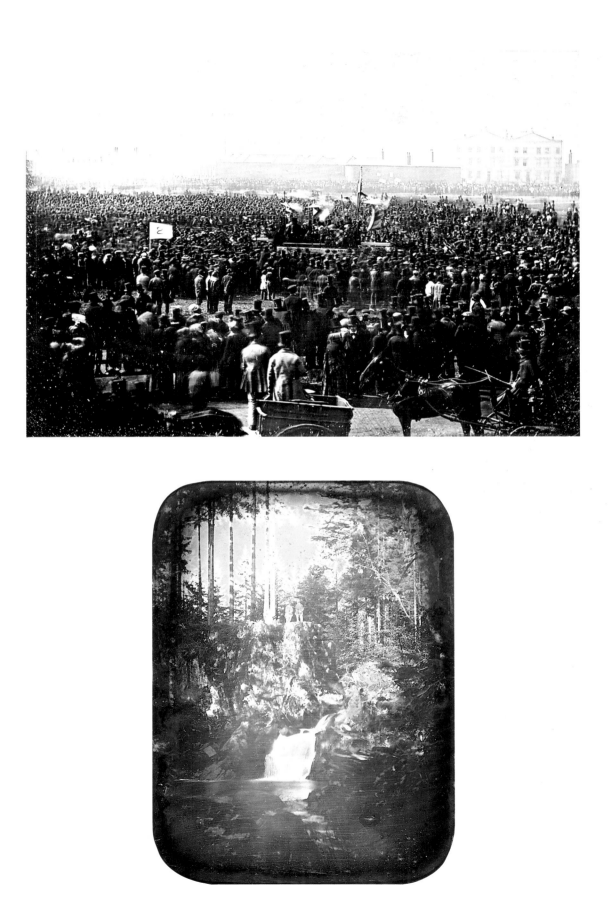

19 Kilburn *The Great Chartist Meeting on Kennington Common* 10 April 1848

20 Gilbert *Landscape with Waterfall* 1843–45

21 Clausel *Untitled* c. 1855

22 Mayall *The Crystal Palace, Hyde Park* 1850

23 Gros *Athens, the Acropolis* May 1850

24 Gros *Monument of Lysicrates, Athens* 1850

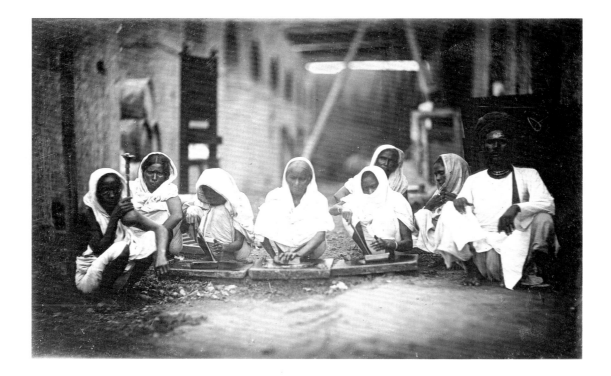

25 Unknown Photographer *Indian Women grinding Paints* [n.d.]

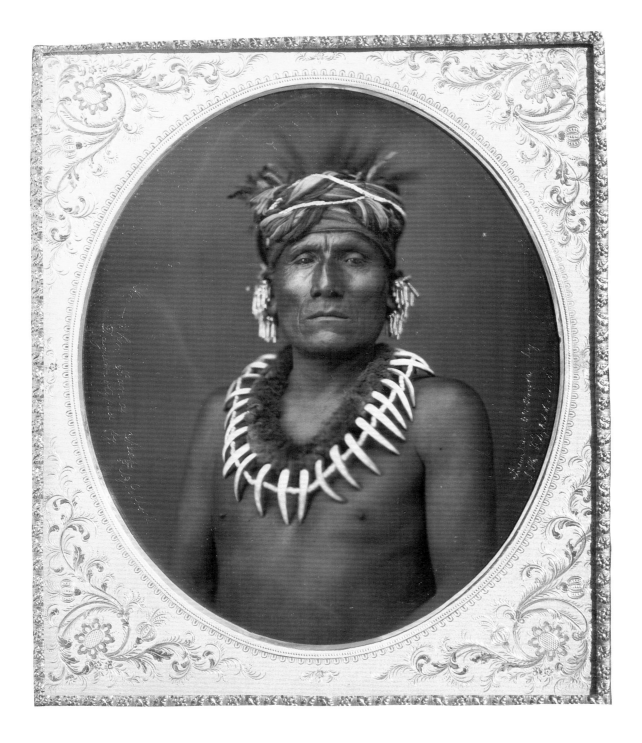

26 Fitzgibbon *Kno-Shr, Kansas Chief* 1853

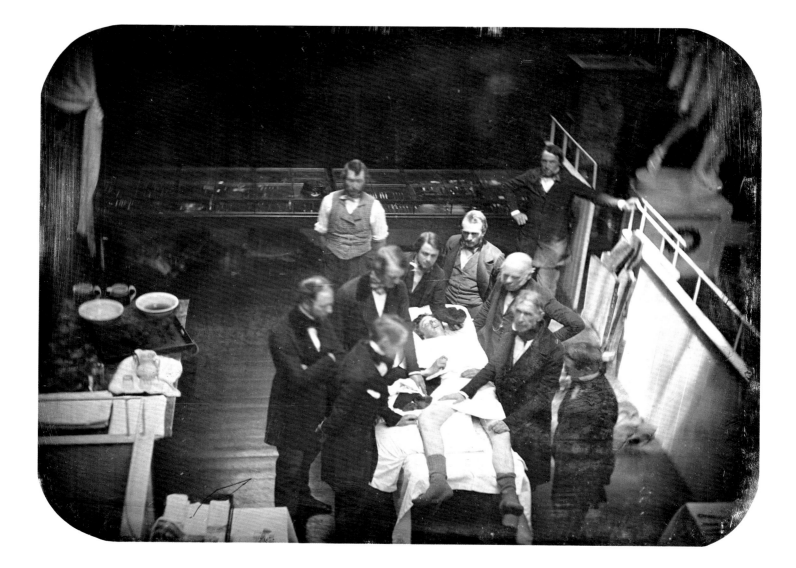

27 Southworth and Hawes *Operation under Ether* c. 1852

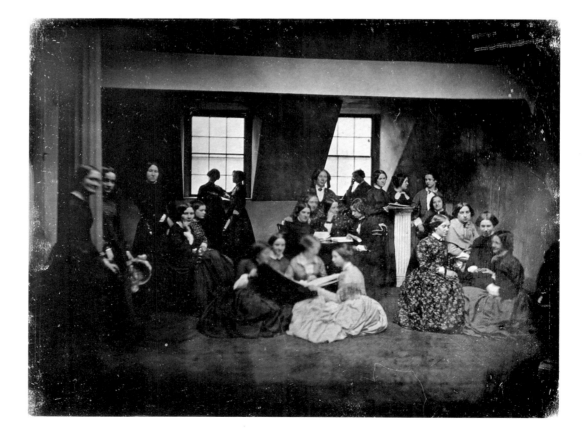

28 Southworth and Hawes *Classroom in Emerson School for Girls* 1850s

29 Southworth and Hawes *Women in the Southworth and Hawes Studio* c. 1854

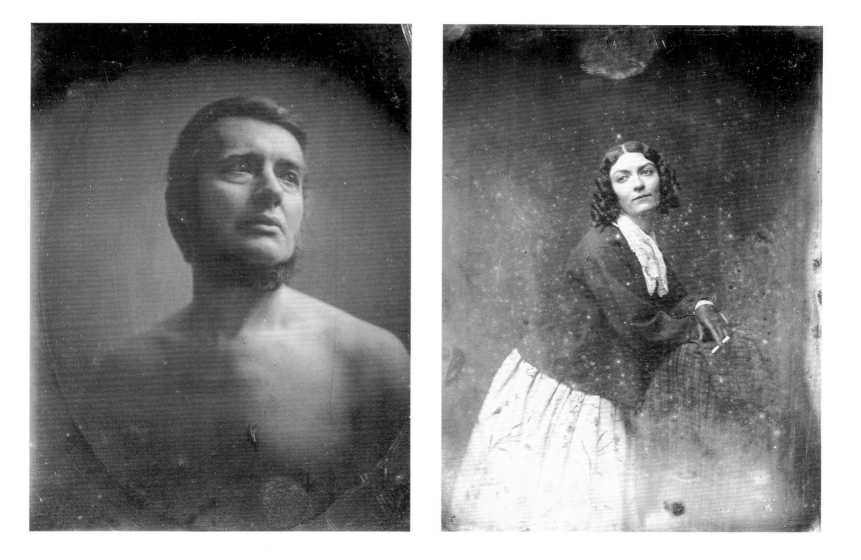

31 Southworth *Self-portrait* c. 1848

32 Southworth and Hawes *Lola Montez* 1851

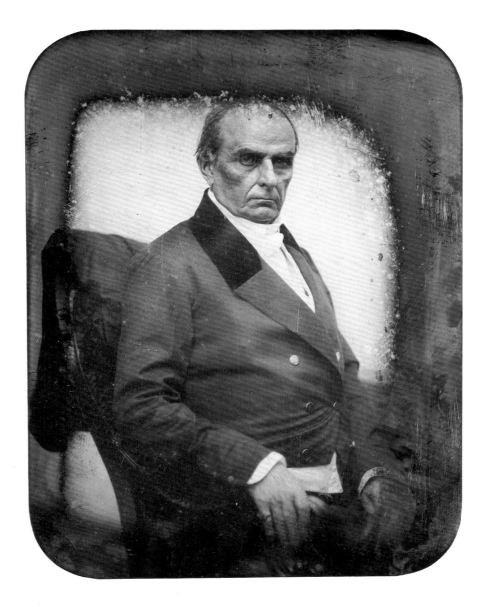

33 Southworth and Hawes *Daniel Webster* c. 1851

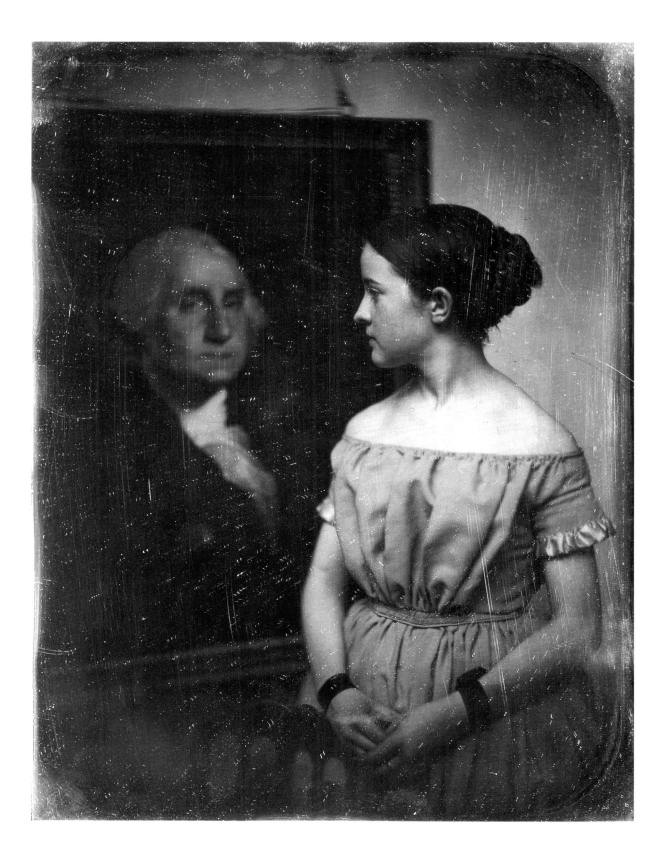

34 Southworth and Hawes *Unidentified Girl with Gilbert Stuart Portrait of George Washington* 1850s

Will Stapp

THE NINETEENTH-CENTURY PORTRAIT

The drive to perfect the early photographic systems concentrated on adapting them to portraiture by reducing exposure times to comfortably endurable levels, resulting in the discovery of chemical modifications to the original processes that significantly increased their effective sensitivity to light, and in the adoption of lens systems that maximised the amount of light transmitted to the photo-sensitive materials in the camera. For the daguerreotype these advances were rapid and dramatic. By the end of 1839, less than five months after the first complete publication of Daguerre's process, experimenters in the United States and France had shortened the exposure times required to make an acceptable daguerreotype from fifteen or more minutes in bright sunlight to less than sixty seconds. By the spring of 1840 the modified daguerreotype process had been sufficiently refined in the United States to enable the consistent making of accurate, vital likenesses, and by May of that year the first two commercial photographic portrait studios in the world had opened in New York and Philadelphia. The successful transformation of Daguerre's invention from a novel and imperfect technology into a practical, commercially exploitable pictorial medium had been accomplished within less than a year of its introduction to the world. Comparable improvements to Talbot's system did not become available until 1841, when the calotype process was published.

Because it reached technological maturity before Talbot's process, but also because of its superior clarity, its incomparable rendition of detail and long tonal scale, and—perhaps above all—the unique quality of the seemingly tactile, physical presence evoked by its image, the daguerreotype dominated European and American commercial portrait photography into the mid-1850s. Conventions of pose and expression were quickly standardised, and accuracy of delineation combined with perfect technique became the major aesthetic criteria for the daguerreotypist. Except for Southworth and Hawes of Boston, the great daguerrian portraitists are remembered primarily for whom they photographed, rather than how they photographed.

The first photographers to produce a major body of artistically significant portraits were David Octavius Hill and Robert Adamson, who worked as partners in Edinburgh between 1843 and 1847. Their collaboration, unquestionably one of the most inspired and creative associations in the entire history of the medium, began when Hill, a painter and the Secretary of the Royal Scottish Academy, conceived a monumental historical painting to commemorate the founding in 1843 of the Free Church of Scotland. To ensure accurate likenesses of the participants in his painting, Hill decided to base their portraits on photographs specifically commissioned for that purpose. He hired Adamson, who had just opened a studio in Edinburgh, to take the portraits, which he (Hill) posed.

Hill and Adamson worked exclusively with the calotype process, and their images consistently exploit the inherent visual characteristics of that medium to maximum artistic effect. Calotypes typically lack fine detail and are contrasty: the paper negative/positive paper print combination imparts a texture to the image that diffuses it, merges intermediate tones and mutes resolution. Hill and Adamson photographed in brilliant sunlight to minimise exposure times, which only

emphasised the contrast, but they consciously organised their compositions so that the enhanced chiaroscuro articulates the image and imparts a dynamic rhythm that gives it vital force.

With a few exceptions, their portraits are not the dispassionate, essentially descriptive presentations that characterised the conventional nineteenth-century studio portrait, but rather, frozen glimpses of a seemingly transitory, ordinary moment. Nor were they especially concerned with revealing psychological truth. Rather, Hill and Adamson's work reveals a seminal conceptual understanding of photography as a vehicle for pictorial expression that is manifested in the total integration of image and medium.

Nadar (Gaspard Félix Tournachon) was a flamboyant, gregarious personality who lived in Bohemian circles and was an intimate of France's leading artists, writers and intellectuals. They all became subjects for his camera, and he characterised each one with a directness and penetration that remains exceptional in photography. His style was straightforward and unpretentious: his subjects posed in a typical, non-specific studio setting, where diffused light from the overhead skylight defined and modelled their features. His sitters are often obviously aware of the camera and acknowledge its presence through pose or gaze, yet the images seem remarkably natural and unpretentious. Many of his subjects were, indeed, his friends and acquaintances, which undoubtedly contributed to the intimacy of the likenesses, but Nadar also had the rare intuitive ability—which he had already demonstrated as a caricaturist—to analyse a personality rapidly and to summarise it accurately in a single telling image.

Julia Margaret Cameron took up photography in middle age with an ardour that was almost compulsive. From the very beginning she considered herself an artist who made photographs, rather than a photographer. Within a year of being given her first camera, she was showing her work in major exhibitions, and she continued to exhibit actively in Britain and on the Continent for as long as she took photographs. She deliberately renounced the accepted technical standards of photography as incompatible with her aesthetic aims; as a consequence, her work was often condemned by conventional photographers and critics who saw her rejection of sharp focus and accurate delineation as a lack of ability rather than a deliberate artistic decision. It was, however, Cameron's consistent emphasis on pictorial effect over descriptive content and the indisputable aesthetic impact of her images that soon made her one of the most influential photographers of the nineteenth century.

Cameron's oeuvre includes religious compositions and allegories, sentimental scenes of secular life, illustrations to Tennyson's *Idylls of the King* and images inspired by popular literature, but her major contribution lies, unquestionably, in portraiture. Cameron's most usual subjects were her family, friends and acquaintances—who included many of the most illustrious names in British arts and letters. Many of them she seems to have compelled to pose for her by sheer force of will. She was an exceptionally demanding portraitist and sitting for her was physically and emotionally arduous. Thomas Carlyle (pl. 63), who knew Cameron well, described his one sitting for her as 'an inferno' and refused ever to be photographed by her again. Ironically, the images made on that occasion are among her finest portraits: the tight compositions, the dramatic contrasts of light and shade, the haunted, introspective expression of the sitter and the subtle blurring of the image because of minor movements all combine to impart an emotional intensity to the photographs that decisively transcends their literal, descriptive content. Except for Cameron's photographs of the aged Sir John Herschel (pl. 62), few portraits in the history of photography have comparable impact.

Although she conceived many images primarily as likenesses, her portrayal of her subjects was always sympathetic and idealising. She often selected her sitters because they conformed to her concept of some ideal type—the Madonna, the patriarch,

Mary Magdalene—and her images were carefully posed (and often titled) to evoke that ideal. At their worst Cameron's images are maudlin, but at their best they transcend the factual identity of sitter and the historical occasion of the photograph to work purely as beautiful pictures.

A Scotsman who had obviously mastered photography in Great Britain before he went to the United States in 1856 and worked for Mathew Brady, Alexander Gardner provides a tangible link between British and American photographic traditions. From 1856 until he retired from photography around 1872, Gardner photographed largely within the conventions of the American studio tradition. Indeed, until he left Brady and opened his own studio in Washington, D.C. in 1863, it is impossible to distinguish Gardner's images unless they have been otherwise identified. It is tempting (and sometimes logical) to associate certain Brady studio images with him because of some intangible, compelling, extra quality to the image, in combination with the location of the sitting (i.e., Washington between 1858 and 1861, when Gardner managed the Brady studio there), but those associations cannot be verified. One nonetheless senses that Gardner elevated the style of Brady simply because of the influences he had absorbed in Scotland.

The influence of British photography on Gardner's work was real, and though it is subtle rather than obvious, it can be detected in his portrait work and particularly in his great photographs of Abraham Lincoln. American portrait photography was intentionally detached in its representations of the sitter. Its primary function was to be descriptive, and although the representation of positive moral character was considered to be an integral element of the portrait, it was achieved symbolically through upright stance and impassive expression. Gardner photographed Lincoln during his presidency more than any other single photographer. These images of Lincoln, who was an exceptionally photogenic man and certainly understood the popular appeal of the photograph, are unquestionably the most intimate and revealing likenesses of the man ever taken. Gardner achieved this through poses that are natural rather than constrained, dignified rather than aggrandising, sympathetic rather than emotionally detached. There was clearly a relationship between the two men that allowed this presentation, and it resulted in a small body of portraits of a major historical figure that is exceptional in its lack of façade and in its direct emotional impact.

One of American photography's greatest portraits is the last photograph Alexander Gardner made of Abraham Lincoln (pl. 65): the camera is close so that the head alone almost fills the frame, the lens is focussed on the plane of the eyes, and the depth of field is so shallow that the viewer's eyes are drawn into Lincoln's and held there. In its relentless description of the exhausted president, it is a wholly American photograph; in its pictorial devices, it evokes Hill and Adamson. It represents the synthesis of technique and vision that Gardner embodied and that places his work in the balance between the purely pictorial and the purely descriptive.

Julia Margaret Cameron

from 'Annals of My Glass House' (1874)

'Miss Lydia Louisa Summerhouse Donkins informs Mrs. Cameron that she wishes to sit to her for her photograph. Miss Lydia Louisa Summerhouse Donkins is a carriage person, and therefore, could assure Mrs. Cameron that she would arrive with her dress uncrumpled.

'Should Miss Lydia Louisa Summerhouse Donkins be satisfied with her picture, Miss Lydia Louisa Summerhouse Donkins has a friend who is *also* a Carriage person who would *also* wish to have her likness taken.'

I answered Miss Lydia Louisa Summerhouse Donkins that Mrs. Cameron, not being a professional photographer, regretted she was not able to 'take her likeness,' but that had Mrs. Cameron been able to do so she would have very much preferred having her dress crumpled.

A little art teaching seemed a kindness, but I have more than once regretted that I could not produce the likeness of this individual with her letter affixed thereto.

This was when I was at L. H. H. [Little Holland House], to which place I had moved my camera for the sake of taking the great Carlyle.

When I have had such men before my camera my whole soul has endeavoured to do its duty towards them in recording faithfully the greatness of the inner as well as the features of the outer man.

The photograph thus taken has been almost the embodiment of a prayer. Most devoutly was this feeling present to me when I photographed my illustrious and revered as well as beloved friend, Sir John Herschel. He was to me as a Teacher and High Priest. From my earliest girlhood I had loved and honoured him, and it was after a friendship of 31 years' duration that the high task of giving his portrait to the nation was allotted to me. He had corresponded with me when the art was in its first infancy in the days of Talbot-type and autotype. I was then residing in Calcutta, and scientific discoveries sent to that then benighted land were water to the parched lips of the starved, to say nothing of the blessing of friendship so faithfully evinced.

When I returned to England the friendship was naturally renewed. I had already been made godmother to one of his daughters, and he consented to become godfather to my youngest son. A memorable day it was when my infant's three sponsors stood before the font, not acting by proxy, but all moved by real affection to me and to my husband to come in person, and surely Poetry, Philosophy and Beauty were never more fitly represented than when Sir John Herschel, Henry Taylor and my own sister, Virginia Summers, were encircled round the little font of the Mortlake Church.

When I began to photograph I sent my first triumphs to this revered friend, and his hurrahs for my success I here give. The date is September 25th, 1866:

'My Dear Mrs. Cameron,

'This last batch of your photographs is indeed wonderful in two distinct lines of perfection. That head of the "Mountain Nymph, Sweet Liberty" (a little farouche and egarée, by the way, as if first let loose and half afraid that it was too good), is

Extract from *Photographic Journal* 11 (July 1927).

really a most astonishing piece of high relief. She is absolutely alive and thrusting out her head from the paper into the air. This is your own special style. The other of "Summer Days" is in the other manner—quite different, but very beautiful, and the grouping perfect. Proserpine is awful. If ever she was "herself the fairest flower" her "cropping" by "Gloomy Dis" has thrown the deep shadows of Hades into not only the colour, but the whole cast and expression of her features. Christabel is a little too indistinct to my mind, but a fine head. The large profile is admirable, and altogether you seem resolved to out-do yourself on every fresh effort.'

This was encouragement eno' for me to feel myself held worthy to take this noble head of my great Master myself, but three years I had to wait patiently and longingly before the opportunity could offer.

Meanwhile I took another immortal head, that of Alfred Tennyson, and the result was that profile portrait which he himself designates as the 'Dirty Monk.' It is a fit representation of Isaiah or of Jeremiah, and Henry Taylor said the picture was as fine as Alfred Tennyson's finest poem. The Laureate has since said of it that he likes it better than any photograph that has been taken of him *except* one by Mayall; that '*except*' speaks for itself. The comparison seems too comical. It is rather like comparing one of Madame Tussaud's waxwork heads to one of Woolner's ideal heroic busts. At this same time Mr. Watts gave me such encouragement that I felt as if I had wings to fly with.

35 Hill and Adamson *Disruption Group: Rev. Dr John Bruce, Rev. John Sym, Rev. Dr David Walsh* c. 1843

36 Hill and Adamson *Masons working on a carved Griffin for the Scott Monument* c. 1844

37 Hill and Adamson *Sergeant of the 42nd Gordon Highlanders reading the Orders of the Day* April 1846

38 Hill and Adamson *Gordon Highlanders at Edinburgh Castle* 1845–46

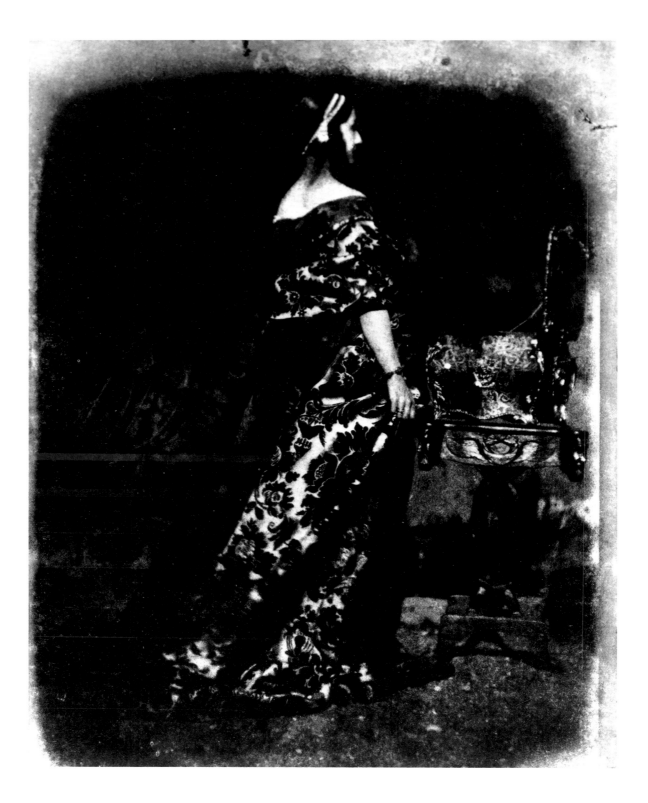

39 Hill and Adamson *Glynn, an Actress and Reader* c. 1845

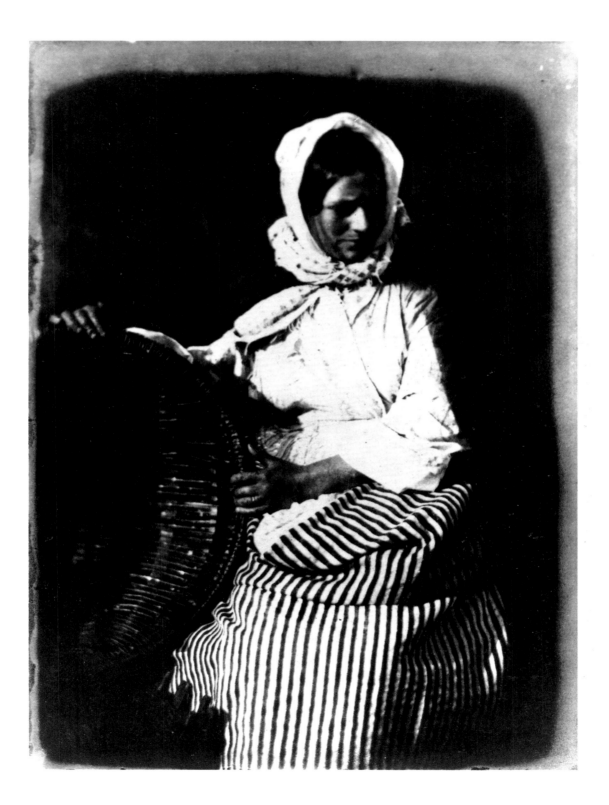

40 Hill and Adamson *Mrs Elizabeth Johnstone, Newhaven* c. 1846

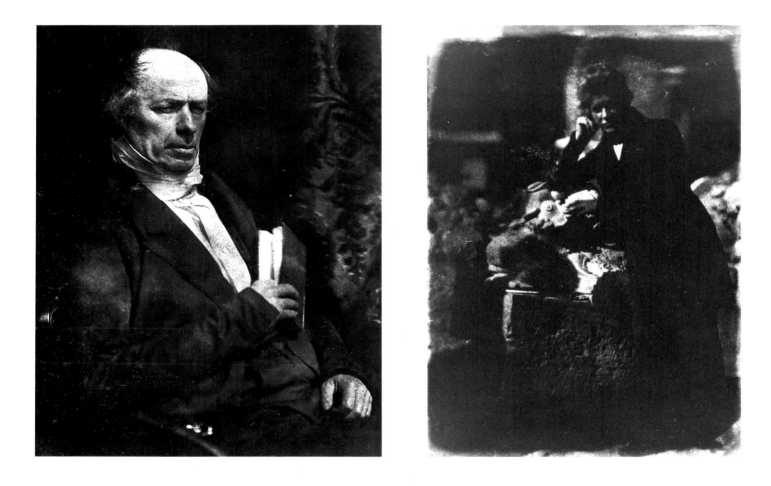

41 Hill and Adamson *The Reverend Thomas Henshaw Jones* 1843

42 Hill and Adamson *George Meikle Kemp* c. 1843

43 Hill and Adamson *Hugh Miller* 1843–47

44 Nadar *Pierre Petroz* 1855–65

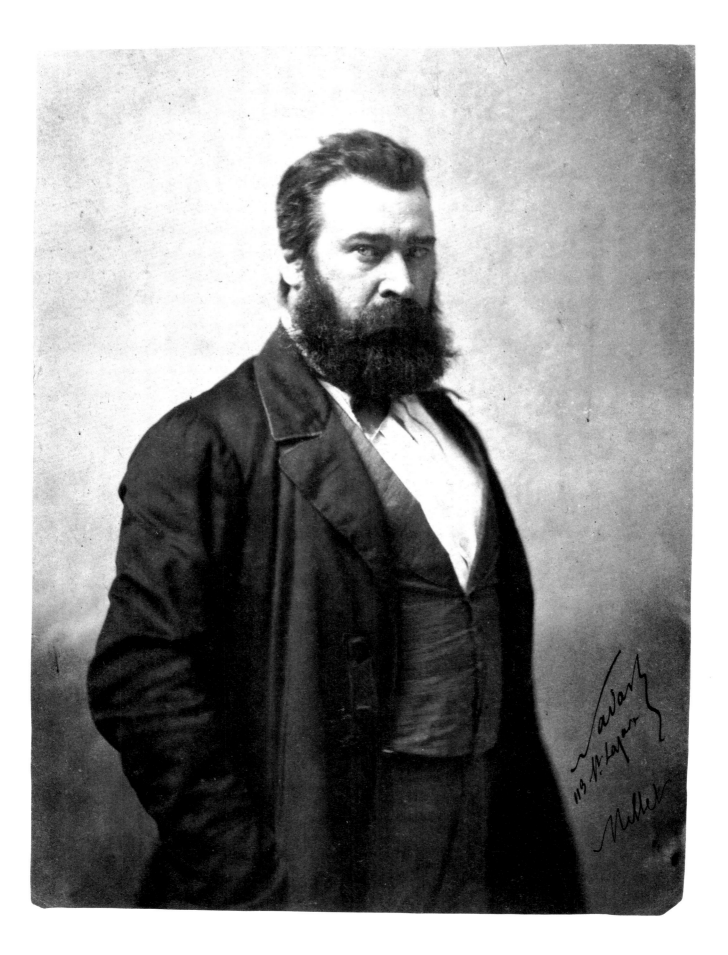

45 Nadar *Jean-François Millet* 1855–65

46 Nadar *Théophile Gautier* 1855–65

47 Nadar *Gustave Doré* 1855–65

48 Nadar *Mère Eulalia Jamet* 1860

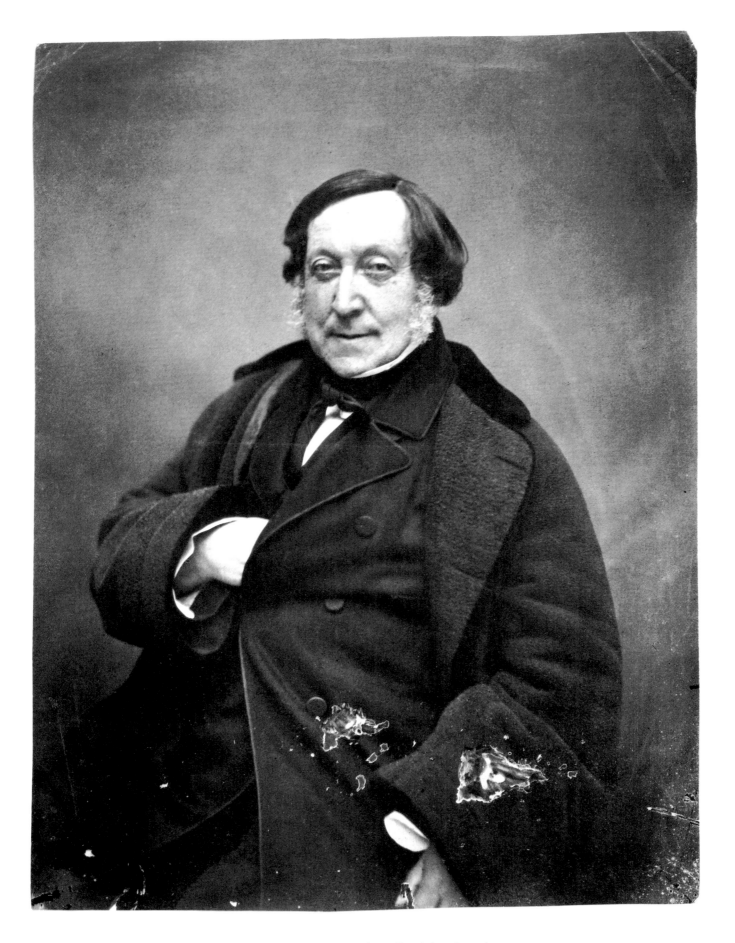

49 Nadar *Gioacchino Rossini* 1855–65

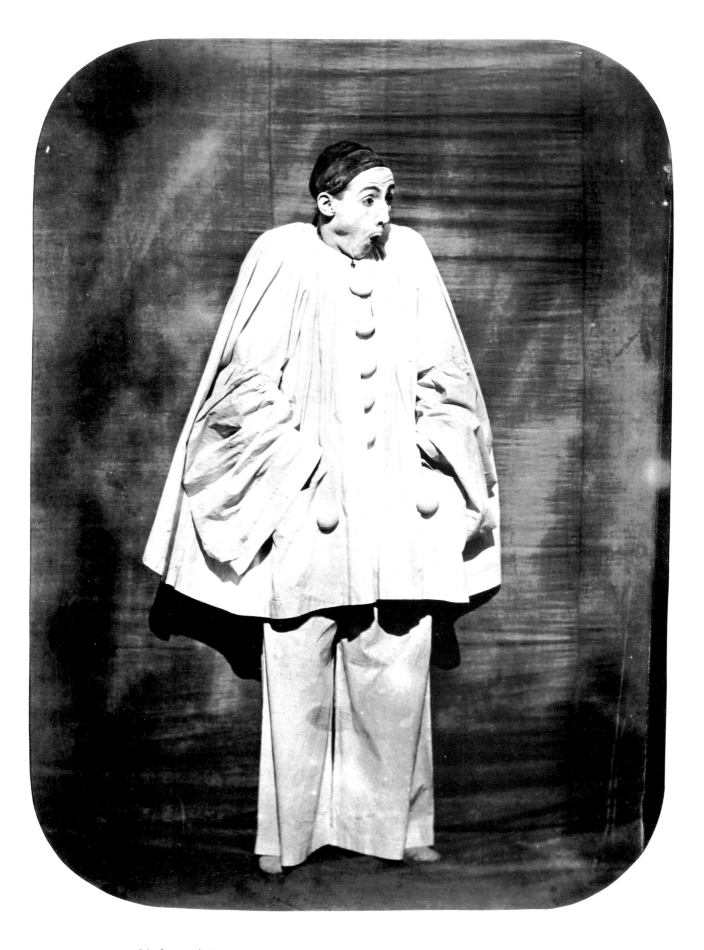

50 Nadar and Tournachon *The Mime, Debureau, expressive Figure* 1854–55

51 Nadar *The Son of Auguste Lefranc* c. 1855–65

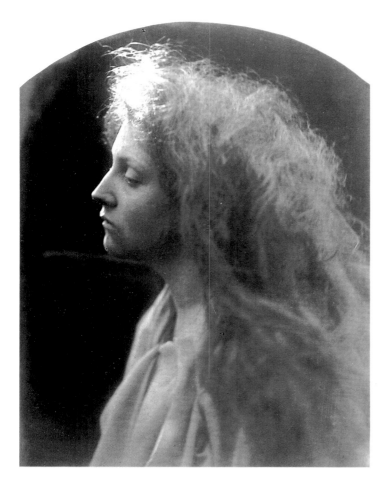

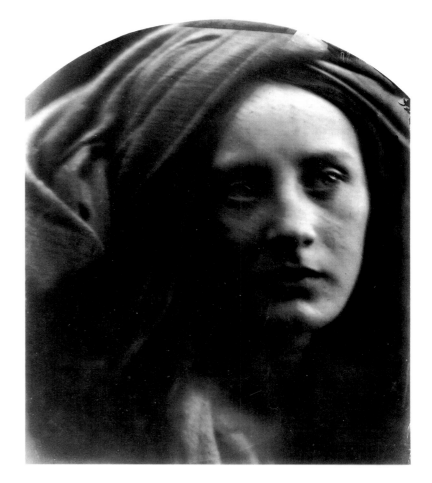

52 Cameron *The Angel at the Tomb* 1870

53 Cameron *A Light Study* c. 1866

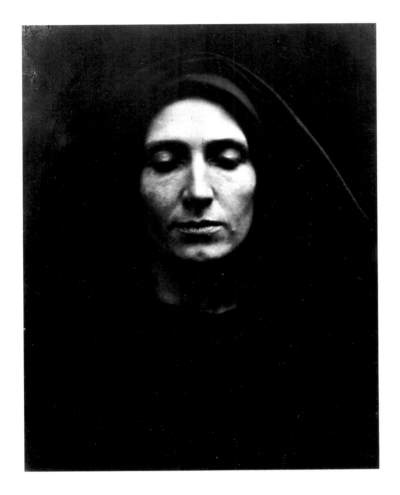 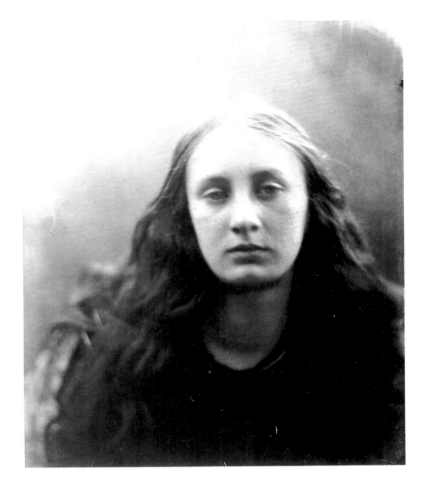

54 Cameron *Untitled* c. 1867–69

55 Cameron *Christabel* c. 1867

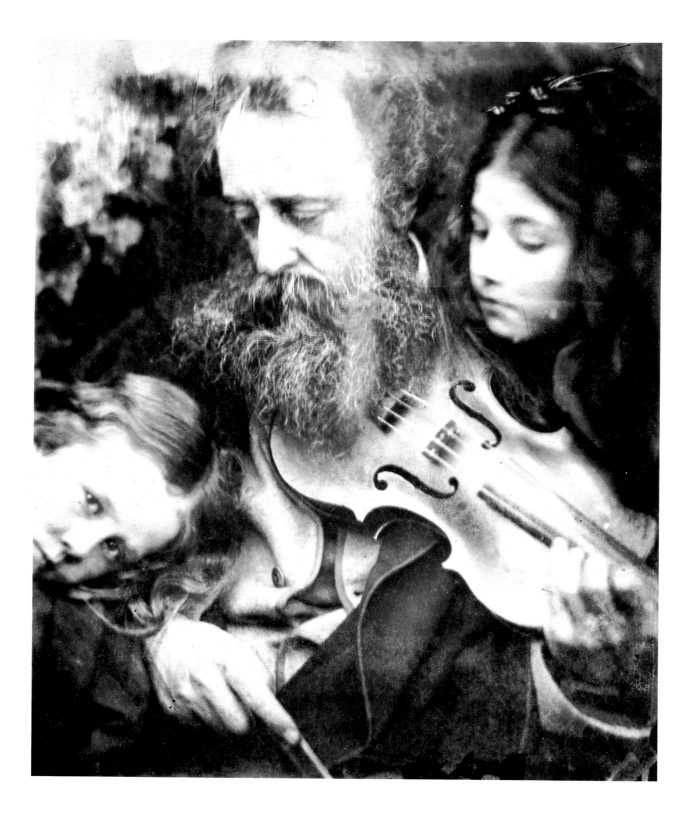

56 Cameron *The Whisper of the Muse* April 1865

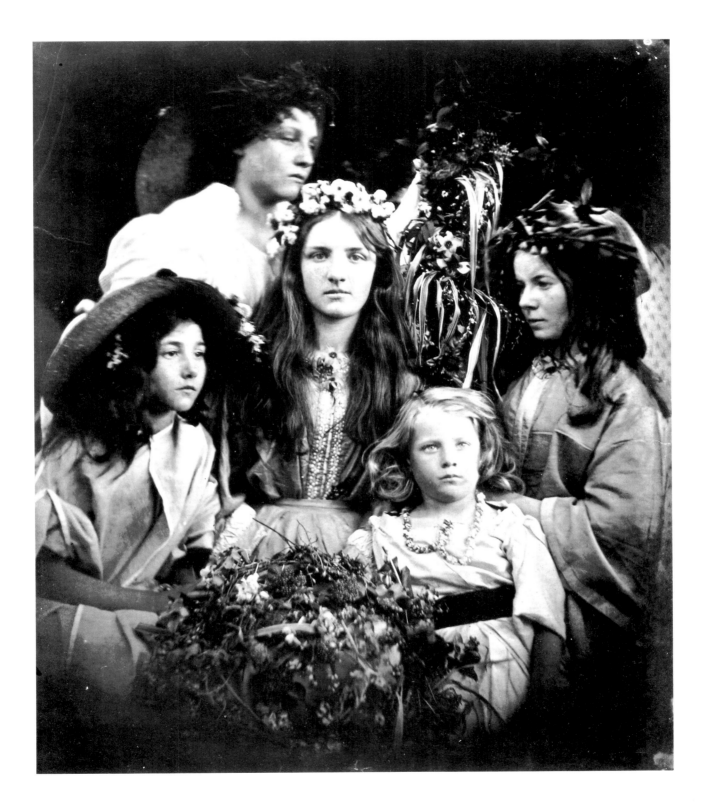

57 Cameron *May Day* 1875

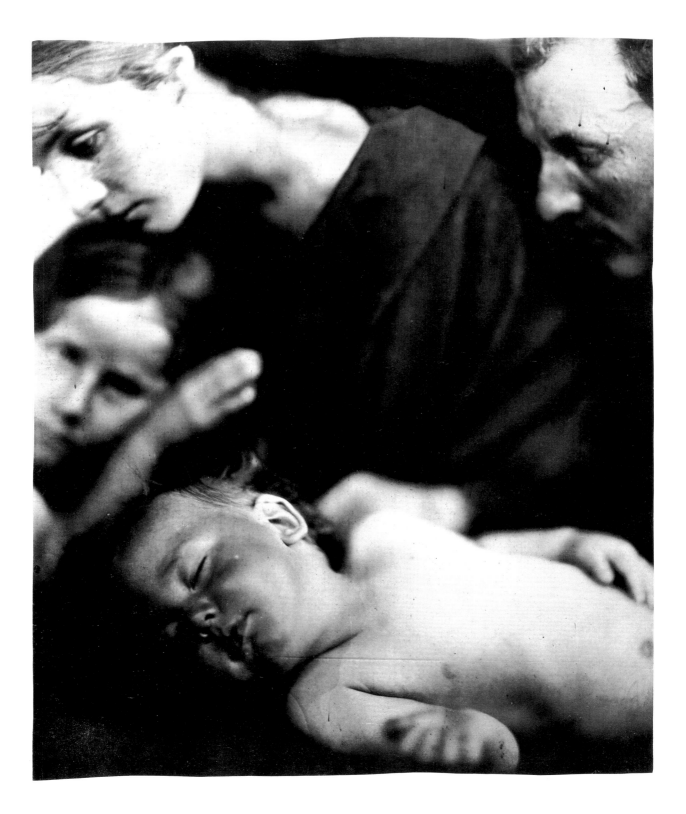

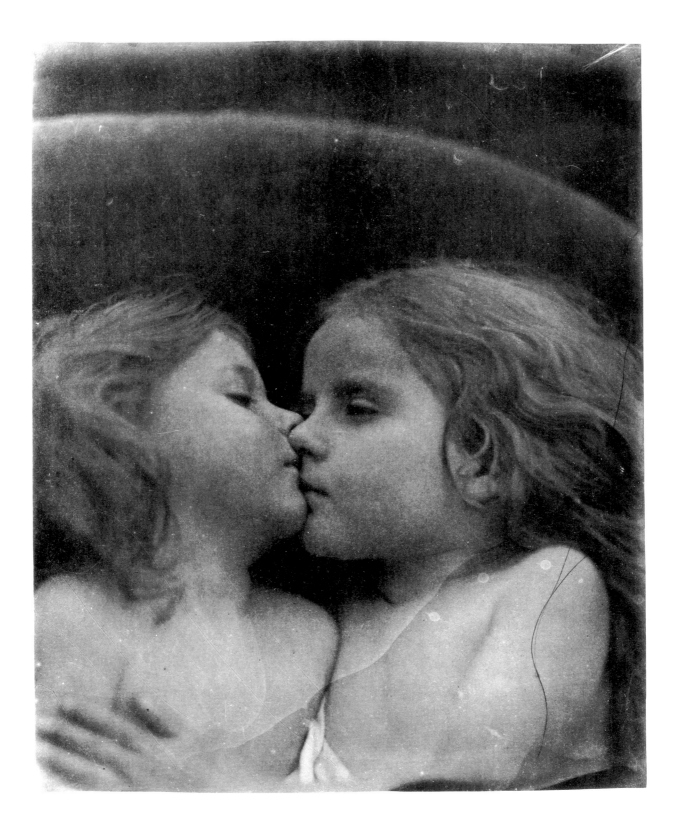

59 Cameron *The Double Star* April 1864

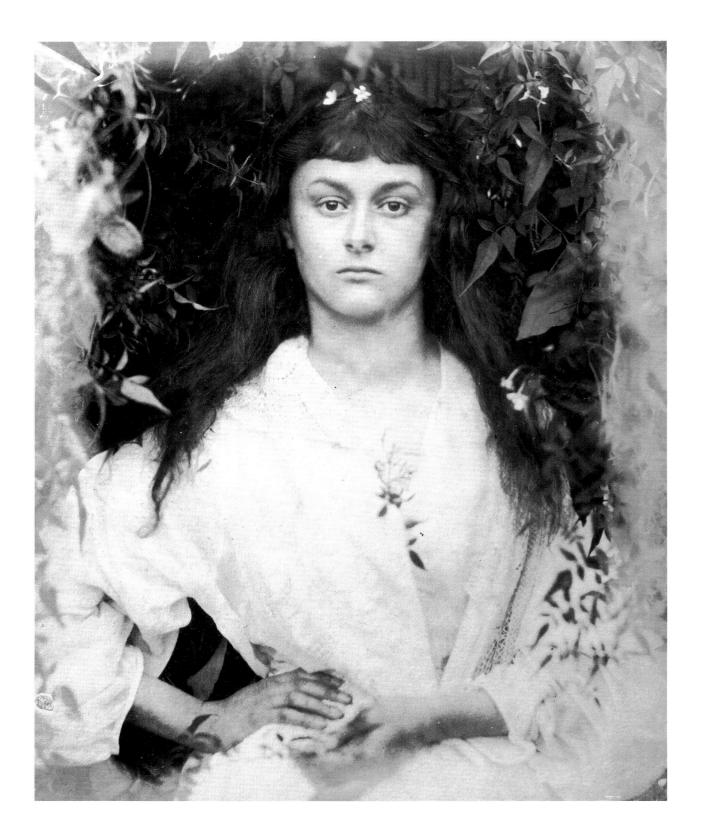

60 Cameron *Pomona* September–October 1872

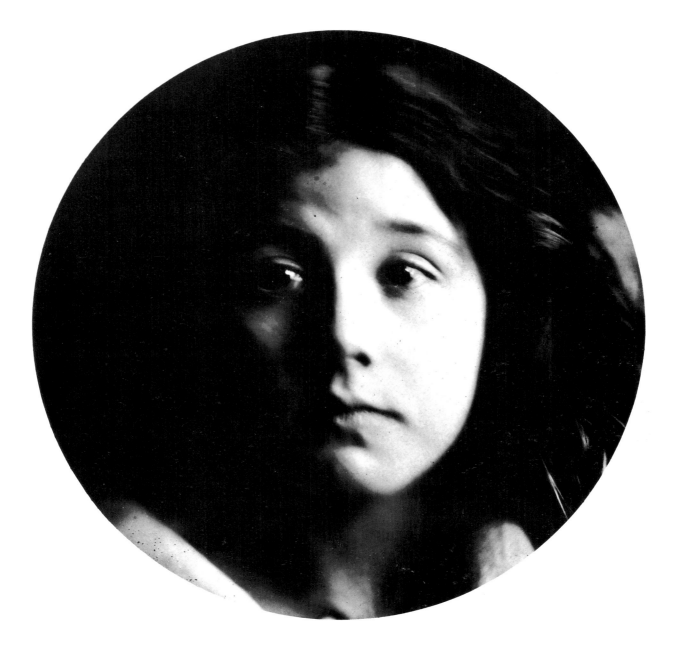

61 Cameron *Child's Head* 1866

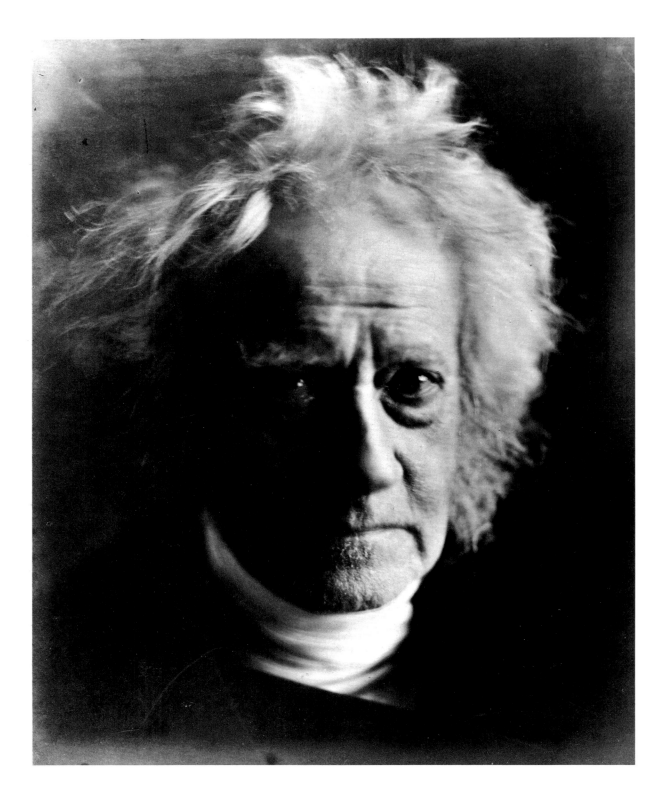

62 Cameron *Sir J. F. W. Herschel* April 1867

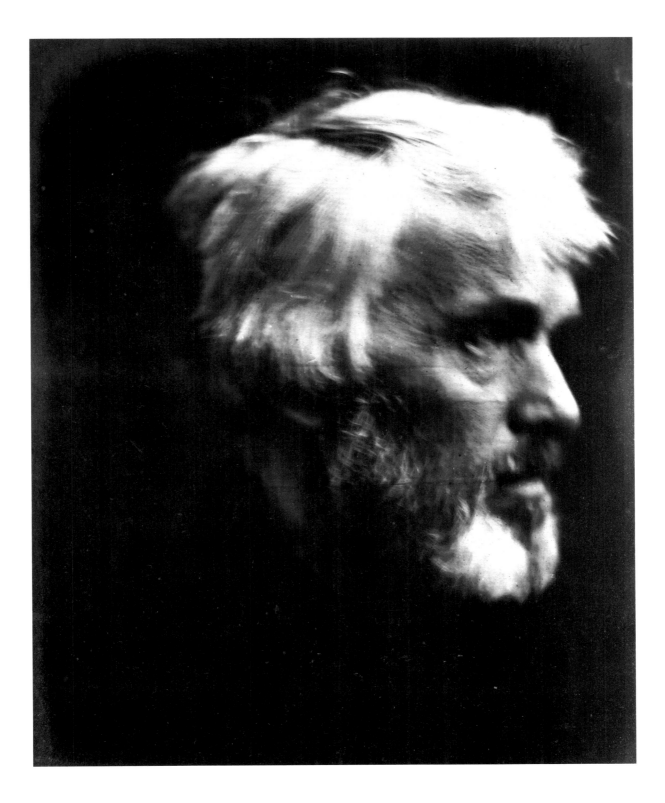

63 Cameron *Thomas Carlyle* 1867

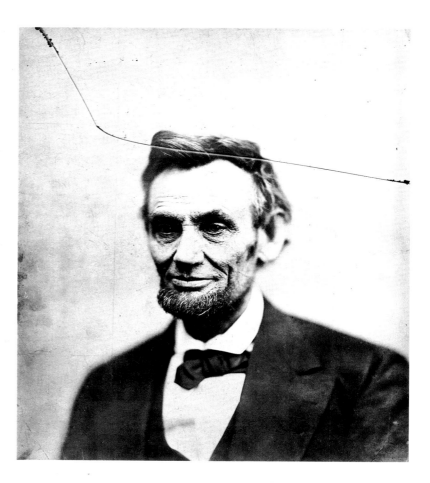

64 Gardner *Abraham Lincoln and his Son Thomas (Tad)* 1865

65 Gardner *Abraham Lincoln* 10 April 1865

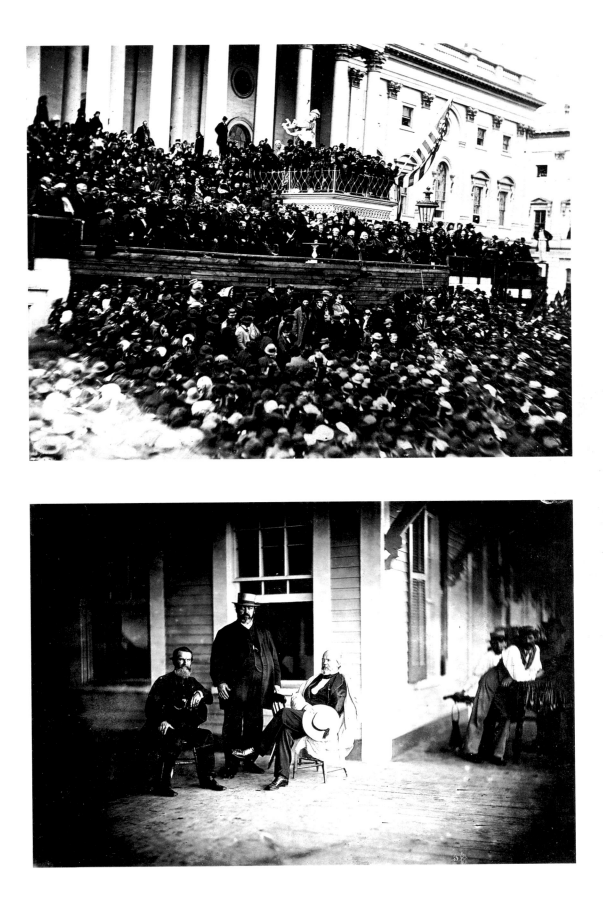

66 Gardner *Lincoln reading his Second Inaugural Address* 1865

67 Gardner *Railroad Commissioners at the State Line, Kansas* 1867

Ben Lifson

EARLY FRENCH MASTERS

In the early 1840s, photography was practised ambitiously by only a few men in a small number of widely scattered places: Talbot at Lacock Abbey; D. O. Hill and Robert Adamson in Edinburgh; Hippolyte Bayard in Paris; Mathew Brady in New York, for example. And although Talbot went to Edinburgh and to Paris, and Bayard to England, these men knew of each others' work mostly through letters, and whatever photographs went from country to country with artists, collectors, scientists and other interested people. Most of the books about photography during this time were unillustrated technical manuals.

Things changed dramatically in Paris in the 1850s. Suddenly, here was a city crowded with strong and talented photographers: more great photographers worked in Paris in the 1850s than in any other artistic capital at any other time in the century. No group of nineteenth-century photographers was so much charged with the ideas and ambitions of a sophisticated artistic and intellectual milieu as was that of mid-century Paris. Also, for the first time, photography was given a sustained self-consciousness in the form of regularly appearing, graceful and rigorous criticism, especially in the weekly journal *La Lumière* (1851–60). Also for the first time, many photographers were supported not only by what was essentially journeyman work (studio portraiture and the like), but by intellectually and aesthetically ambitious public and private commissions, by book publication, by print sales and by exhibitions.

These men were intensely aware of photography's infancy, achievements and potential. Many belonged to photographic societies which met regularly and whose journals reported upon photography outside France. Some worked on the same commissions or for the same publishers; others had studios in the same parts of town, sometimes on the same streets or even in the same buildings; still others photographed the same sitters, or posed for each others' pictures. Their technical innovations, shared freely, were advanced, their common knowledge of painting (some had studied painting with the same masters) was at once well grounded in history and up-to-date, and their aesthetic aims were far-reaching: they knew first hand and sometimes on a daily basis the shape and direction of photography at any given moment.

We should like to know more of what was said about photography in the art world of Paris during the late 1840s, for it was there that these men came together: Charles Nègre (b. 1820) up from the south and an established painter by the age of twenty-three; Gustave Le Gray (b. 1820) from just outside Paris, an exhibiting painter at twenty-eight; the Parisian Charles Marville (b. 1816), a successful lithographer and illustrator by the early 1840s; the Parisian architect Louis-Auguste Bisson (b. 1814), who turned to photography with his younger brother Auguste-Rosalie (b. 1826), an heraldic painter, like their father; the wealthy and titled Henry Le Secq (b. 1818), also a Parisian, who, immediately upon succeeding as a painter in the late 1840s, learned photography from the younger and poorer Le Gray; and Edouard-Denis Baldus (b. 1815), who became a photographer in his late thirties, shortly after his reputation as a painter had been made. They were all photographers

by 1851, as were the chemist Henri-Victor Régnault (b. 1811), head of the state pottery works at Sèvres, outside Paris, and his colleague Louis Robert (b. 1810), who directed the painting and gilding workshops at Sèvres by 1848. And although he is represented in the portrait section of this exhibition, we must name here the Parisian lithographer Nadar (b. 1820), whose flamboyant caricatures and personal life made him vivid in Paris's bohemian world by the time he was in his mid-twenties, and whose photographs were central to this photographic effort of the 1850s.

The precise factors that led so many successful men to turn to photography are still matters for speculation. But it is clear that their work, together with the criticism in *La Lumière*—especially the interpretive essays of its editor Ernst Lacan and the theoretical essays of the novelist Francis Wey who would, for example, tell painters that photography could teach them how to see and what to paint—can be understood as a vanguard aesthetic campaign conducted in the world capital of the avant-garde. It was successful in many ways.

The technical control of these men over negatives and printing papers after 1849 dramatically increased photography's flexibility in respect of the handling of tonality and of surfaces, the transparency of the print, and the illusions of texture and of detail in the image. By the early 1850s their command of photography's tonal range was such that some photographers—Le Gray, Nègre—could explore the effects of light and darkness as boldly as some Romantic and realist painters and writers did from the 1820s into the 1850s.[1] Their mastery of light and of line was such that others—Baldus, the brothers Bisson—could bring to a more classical style of drawing unprecedented extremes of brightness, precision, solidity, relief and detailing.

By the late 1850s advanced painters thought it neither remarkable nor unorthodox to make and use photographs as they used their own sketchbooks—nor indeed to use all of photography as they used all of painting, that is, as a dictionary of imagery, forms and visual effects. Considered by itself, photography was seen in fact to be somewhat like the sketch, which the avant-garde valued for its immediacy, lyricism, abruptness, indeterminancy and fragmentation. As early as 1839 Francis Wey had seen in photography a 'radical criticism of schools of draftsmen founded on the dry rigor of contours', and had understood the photographic image as a mixture of 'the impression of reality with the fantasy of dreams . . .'. He also thought photography's 'sobriety' gave its imagery 'monumentality'[2]—a quality less of the sketch than that of a heightened realism.

By the mid-1850s French photography had made strong and original contributions to landscape, still life, the genre scene and the nude. And by 1859, when Gustave Le Gray photographed Napoleon III's visit to the army's annual summer exercises at Chalons-sur-Marne, it was clear that there could be history photographs as well as history paintings. In general, these photographers, like the painter Gustave Courbet at the same time, depicted many subjects of contemporary life with a stillness and a visual solemnity and even majesty that had been reserved for historical and religious motifs. Like realist painters and writers in the 1850s, they taught the present to see itself in historical terms.

At the same time, in photographs of mediaeval churches, some in disrepair and even ruins, elements such as scaffolding, graffiti, the later architecture of neighbouring buildings and contempoary details seen in the surroundings generally, and even aspects of light and weather, bring the Gothic past into the modern present. So for landscape. Consider Marville's wood, for example. Because a fashionable young man poses fashionably beneath an old tree, an ancient forest becomes a modern place (pl. 74).

At this time all of Europe was interested in the Middle Ages, and photographers everywhere made pictures of mediaeval architecture. But in 1851 Baldus, Le Gray, Le Secq and Nègre were commissioned to document France's mediaeval architecture

1 Eugenia Parry Janis, *The Flowering of Early French Photography*, exhibition catalogue, J. Paul Getty Museum, Malibu, California 1987, n.p.
2 André Jammes and Eugenia Parry Janis, *The Art of French Calotype*, Princeton, N.J. 1983, 4.

in a systematic and encyclopedic way by the Commission des Monuments Historiques, which was interested in its preservation and renovation.

There were several other large comissions during the 1850s, many occasioned by social change. The Ministry of the Interior, for example, hired Marville to photograph old areas of Paris that were to be torn down for the sake of an urban renewal project designed to serve political ends. It also commissioned Baldus in 1856, 1857 and 1858 to document the building of the new Louvre and the flooding of the Rhône. The railroad magnate Baron James de Rothschild hired Baldus to document both the works of engineering—bridges and stations—brought into being during the 1850s by his new railway lines, and the impressive natural scenery made more accessible by these new routes.

To the photographers involved, such essentially documentary commissions became occasions for the development of individual styles and for the mastery of subject-matter. So with Charles Aubry and Adolphe Braun, whose still lifes began as studies of flowers for fabric designers. Photography, then, like literature and painting, responding to a changing world and to changing ideas of legitimate artistic purposes, mastered, one by one, themes, motifs and fields of artistic endeavour created specifically by modern life.

There are, in addition, pictures like Régnault's rooftops at Sèvres (pl. 72), or Le Secq's bright and leaning trees above a stream (pl. 73), pictures that find harsh angularity and jarring contrasts of light and dark within otherwise traditionally picturesque material. In such pictures (and there were many in the 1850s), as in Charles Baudelaire's prose poems about Paris or in Gustave Flaubert's descriptions of antiquity, the modern element is not the subject but the artist's handling of it.

It makes sense, then, to understand these men as being, on the one hand, at the forefront of their medium and, on the other, absolutely representative of the efforts and conflicts that animated their larger artistic milieu. Like the Romantics, they were preoccupied by history, by turbulent expression. But they came to Romanticism late, and with newer temperaments, interested in the life of cities, in irony, iciness and modernity, as were the late Romantic poet Baudelaire and the realists Courbet and Flaubert. Their work is bold and frontal. It is also an enthusiastic expression of prowess—of delight in the sheer capaciousness that hard-won technical achievements had given to the medium. However, these bravura works are not merely displays of virtuosity or of the medium's strength. These men seem to have been possessed of an extraordinary desire for visual experience and for a world-view based upon what can be understood through sight. Again, we should like to know what led them to think that it could be satisfied by turning from painting to the young and relatively untried medium of photography.

ROGER FENTON

from 'Photography in France' (1852)

Presuming that many of the facts here stated are well known to many of our photographers, I will mention, first of all, that there is a photographic society in Paris, having a fixed place of meeting, and a regular organ of publicity.

Its head quarters are, at present, in a part of the house of its president, the Col. de Montfort. An entire suite of apartments, consisting of 4 or 5 rooms, at the top of the house, of course, and opening on to an extensive terrace, with an excellent light, is devoted to the purposes of the society. One room is entirely occupied, walls, drawers, and cupboards, with choice specimens of the art, mostly in metal; another is fitted up as a laboratory, one corner of which is an enclosure surrounded with yellow curtains, to exclude the light. In fact there is every requisite facility, both for receiving the amateurs in a suitable *locale*, and for their trying, experimentally, any new development of the science.

The society includes in its ranks many of the most distinguished of the French artists, who, as a body, have been much more quick than our own in appreciating the great advantages which this science presents to the careful and conscientious interpreter of nature, and the complete extinguisher it puts upon the artist who seeks success by tricky effects of colour, and oppositions of light and shade.

In the lower part of the same house, a laboratory shop has been opened by Mr. Puech, exclusively for the manufacture and sale of photographic chemicals.

The proceedings of the Society are regularly reported in a weekly journal under the title of *La Lumière*, the bureau of which was also, until lately, in the house if not under the direction of M. de Montfort. It has, however, recently been established upon an independent footing, though still connected with the Society. In the office of the journal is an album of specimens illustrating the progress of the art since its first application to the production of paper pictures. Containing, not only a collection of artistic proofs, but also results of the various experiments by which advances in the science have from time to time been made, this album forms an invaluable record of the history of photography.

In this, as in every other pursuit, the most complete results are obtained by the division of labour. It demands study of one kind to obtain a clear and brilliant negative impression. To produce from that negative a positive picture of any shade of colour that may be desired, and of depth and richness of tone, requires a separate experience, and considerable length of practice.

It is often found by the photographer that all the time which he can give to his favorite pursuit, is insufficient to do all that he wishes in the acquisition of satisfactory negatives. When he is so fortunate as to produce one which will, as the phrase goes, print well, he is more solicitous to repeat his success in the reproduction of some new object than to proceed immediately to the multiplication of the positive copies of his pictures, a result which he knows can be attained at any time.

This want is provided for in Paris, by the establishment in the rue St. Nicolas d'Antin, No. 72, of a photographic printing establishment, the director of which devotes his time to the study of the positive photograph.

For a small charge, the positive pictures are here printed off, and fixed, so as to present any colour, or gradation of colour and tone that may be previously decided

Extract from *The Chemist* III, 29 (February 1852).

upon by the owner of the negative. When it is remembered how, in the process of fixing, the colour of the picture is never actually stationary: and how, to produce a certain colour, it is often necessary to remove the picture, at different stages of its progress, from one bath of hyposulphite to another, it will at once be seen of what advantage it must be, that a process demanding such watchfulness and discriminating observation should be made a separate and special department of the science. Why, in fact, should not the reproduction of these positive photographs be as distinct an occupation from the making of the negative type, as is the engraving of a steel plate, from the taking impressions of it upon paper. . . .

So much for the machinery of the study of photography in France. There are yet other advantages which they possess on that side of the water;—such as the absence of any patent interfering with the enterprise of individuals, and the liberal encouragement given by the late government, to the eminent in photographic skill. I was shown, in October last, by M. Le Gray, the author of the wax process, and M. Mestral, an ingenious amateur, several hundred negatives, made by them for the government, during a tour in the provinces, from which they had just returned. The subjects were mostly such as were equally interesting to the antiquarian and the lover of the picturesque.

I may mention here, that the wax process by which these pictures were produced seems to have superseded in practical employment all the other kinds of prepared paper.

At present, excited by the accounts from England, they are all occupied with experiments on collodion. In company with M. de Montfort, I made essays with collodion prepared by M. Puech. Neither these nor subsequent ones made with collodion brought from England, were very promising. Some collodion transmitted to me subsequently by M. Puech, of his preparation, presents great tenacity and adhesiveness and but a very small amount of sensitiveness, as compared with that sold by Messrs. Archer, Horne, & Co., Knight, and other English chemists.

Into the question, however, of the comparative utility of different processes, I do not wish to enter at present; I have merely stated what measures are adopted in France to advance photographic knowledge by combination, emulation, and publicity; and what assistance is rendered by the government. From our rulers, it is not our practice to seek or hope for any assistance in such matters; but surely it is something strange that in the organisation of the voluntary system of mutual assistance, we should have to receive lessons from Frenchmen.

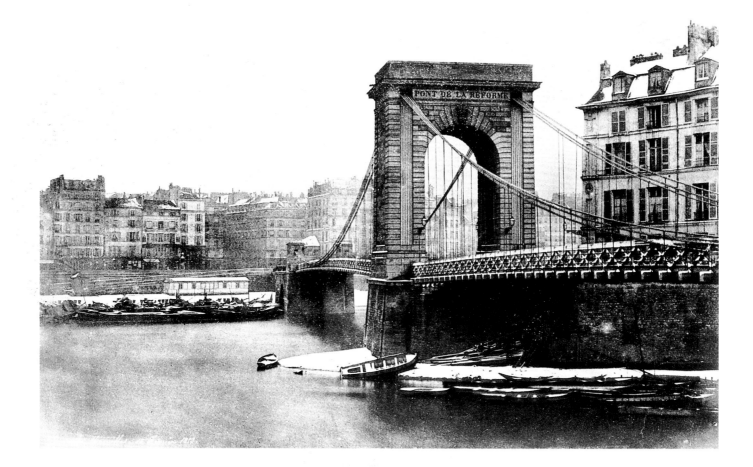

68 Marville *Vue du Pont de la Réforme ou Pont Louis Philippe, Paris* 18 February 1853

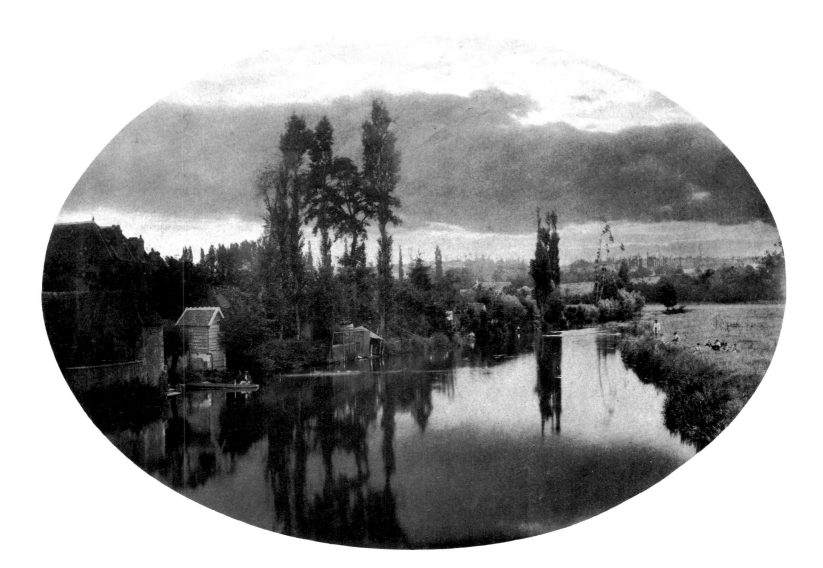

69 Silvy *River Scene, France* 1858

70 Baldus *The Enghien Watermill* c. 1855

71 Régnault *Sèvres, the Seine at Meudon* c. 1853

72 Régnault *The Manufactory at Sèvres, East Entrance* c. 1852

73　Le Secq　*Forest Stream*　c. 1850–55

74 Marville *Young Man reclining beneath a Horse-chestnut Tree* 1853

75 Nègre *Chartres Cathedral: Part of the Porch of the North Transept* c. 1851

76 Nègre *Montmajour: The Abbey's Postern* 1852

77 Baldus *Pavillon Richelieu* c. 1860

78 Bisson *Portal of St Ursinus at Bourges* 1863

79 Robert *Versailles, Fountain of the Pyramid of Girardon* 1853

81 Le Secq *Water Jug, engraved Glass and Pears on a Plate* c. 1862

82 Braun *Still life with Game* 1865 83 Robert *Still life with Statuette and Vases* 1855

84 Aubry *A Study of Leaves* 1864

Mike Weaver

LE GRAY–FENTON–WATKINS

The connoisseur's approach to landscape and marine photography emphasises very often the sheer technical difficulties—Fenton's photographs of Kiev were made in freezing temperatures, Le Gray's clouds required a second negative, Watkins's equipment weighed terribly heavily when carried over mountains. Technical grace under climatic pressure scores high in the discussions of the early period of photography; art is confused with labour. Such mundane approaches omit any discussion of the imagery of these early masters. If photography history often consists of a prosaic account of certain pictorial experiences in the photographer's life, the photography critic's duty is to embody some sense of the poetic aspect of those same events now before us in the form of prints.

The aesthetic aspect of the print strikes us easily enough, but the symbolic aspect requires some further understanding of the artist's language of expression. One commentator on Roger Fenton's *The Valley of the Shadow of Death* (pl. 99) referred to 'its terrible suggestions, not merely awakened in the memory but actually brought materially before the eyes, by the photographic reproduction of the cannonballs lying like the strewed moraines of a melted glacier through the bottom of the valley'.[1] The actual locality was already called the Valley of Death before the charge of the Light Brigade took place, but the public had immediately endowed it with Christian significance: the valley of the *shadow* made it a type of Christian sacrifice in a Moslem world. The additional reference to an implacable geological fate (glacial moraine) was perfectly compatible in 1855 with Christian tragedy. In the seventeenth century Thomas Burnet's *Sacred History of the Earth* had tried to fathom God's plan for the universe from the earth's geology, and John Ruskin continued the tradition of attempting to reconcile revealed with natural religion in the nineteenth century. Biblically typical and geologically actual, the world was beautiful and horrible at the same time. This state was blamed upon the Flood, which had resulted from man's Fall.

In the eighteenth and nineteenth centuries, ideas of beauty and sublimity, familiarity and fear continued to reflect this Christian ambiguity: injured as they are by time, ruins remind us not only of once-fine buildings but of a broken covenant. But Fenton's steps leading to an open door (pl. 107) tend in the direction of a world restored by Christ's intercession. Carleton Watkins found such temples in nature—in the panorama of Yosemite (pl. 112). This sense of the historical and analogical is based on the belief that the creation is both physical and theological. Ruskin wrote that the air, water and rocks constituted a language of visual motifs or types which should be closely read if the sanctifying influences of the deity were to be properly recognised.[2] The face of nature had been stamped with a great set of types which transformed it in men's minds from mere scenery into a moral landscape. Readily discoverable in Fenton, Watkins and Gustave Le Gray, these motifs can be interpreted in both a positive and negative light:

The Trees:	Sacrifice/Redemption
The Rock:	Vengeance/Foundation
The Waterfall:	Deluge/Forgiveness

1 *Journal of the Photographic Society of London* II, 34 (21 September 1855), 221.
2 *The Works of John Ruskin*, ed. E. T. Cook and A. Wedderburn, London 1904, XI, 41.

The Sanctuary:	Ruin/Salvation
The Cloud:	Divine Wrath/Ministry

Sir Joshua Reynolds recommended as an artistic procedure the displacement of such motifs from Renaissance and Baroque art to new contexts consonant with the taste of his age. Photography, like painting, also kept pace with this substitution of motifs and changes in the style of presenting them. Thus, Fenton's bridge (pl. 102), Le Gray's jetty and lighthouse (pl. 85), like Watkins's Half-Dome, the sacred mountain of Yosemite (pl. 112a), are all types of the Sanctuary. How they are depicted, whether in the good or bad sense, is a matter of aesthetic response in the treatment of the scene: Le Gray's uprooted column in Egypt (pl. 96) and the exposed roots of the beech tree (pl. 92) portend ultimate destruction, just as the new shoots around another tree, together with the somewhat incongruous lamppost—a lighthouse for the forest–suggest salvation (pl. 91). Watkins's tranquil cascade (pl. 113) combines elements of trees, rocks and water in a way that Courbet and Le Gray[3] would have recognised, although their work is imbued with tragic feelings of death and entombment rather than those of baptism and resurrection. Watkins was never as profound as either Eadweard Muybridge or Ansel Adams in dealing with the natural scene, but in *Cathedral Spires* (pl. 116) he perceived in true Ruskinian fashion the connection between the vital and the typical: the trees, fallen and upstanding, are as much spires as the rocks.

Watkins is less consistently expressive than Fenton in his use of the motifs. His buckeye tree (pl. 120) gives the shack beneath it shade and protection of the most rudimentary kind, whereas Fenton's *View in the Slopes, Windsor* (pl. 103) is a highly wrought expression of the relationship between the camera and the Crown. It employs a symbolism of elevation in which the castle is glimpsed directly through a tree-clearing, and approached indirectly via a pathway across a bridge and up the slopes: the great tree mediating these different approaches stands for the monarchy. Thus, there is often a political aspect to the depiction of the natural scene. What does the arrangement of nature mean, when it is applied to society, but the placing of certain parts of it in positions *over* others? The 'natural' scene implies a political heaven in which some things (and persons) are subordinated to others. *The Harbour at Balaklava* (pl. 98) transforms a three-masted naval ship into a mobile sanctuary, and subordinates to it a shed on shore: wherever the Royal Navy drops anchor, the monarch (*fidei defensor*) rules. Fenton was, in effect, Queen Victoria's photographer laureate. Equally, there is a political dimension to Le Gray's sacrifice of photographic clarity for impressionist effect. The overwhelming impression left by his pictures of army manoeuvres (pls 93, 94) is of military presence in an empty land distinguished only by a rampart: here, breadth of effect is placed at the service of a political goal.

Le Gray's great seascapes are Cloud and Sanctuary pictures: cloud/breakwater; cloud/lighthouse; cloud/ship(s); cloud/light on the sea. In each case, the cloths of heaven relate in various splendid ways to sea or rocky shore. Such lighting effects were already common in the work of J. M. W. Turner and—note P. G. Hamerton's comparison (p. 100)—of William Holman Hunt. Hunt's *Fairlight Downs: Sunlight on the Sea* (fig. 5) points up the relation of sea to land: someone has thrown a stick for the dog to catch but the attention of the sheep suggests an ambiguous relation between dog-play and sheep-worrying. The sea on this particular day is calm, but five thousand lives lost at sea in the mid-1850s offered proof of its other moods. Le Gray's marines evoke similar feelings. Consider the effect of clouds upon our feelings in Byron's *The Prisoner of Chillon*:

> Lone—as the corse within its shroud,
> Lone—as a solitary cloud,
> A single cloud on a sunny day,

3 See André Jammes and Eugenia Parry Janis, *The Art of French Calotype*, Princeton, N.J. 1983, pls XIII, XXV.

> While all the rest of heaven is clear,
> A frown upon the atmosphere,
> That hath no business to appear
> When skies are blue, and earth is gay.

The close observation of clouds began only at the end of the eighteenth century. The Meteorological Society was founded in London in 1823, but Lamarck's earlier classification of clouds into 'sheets', 'flocks', 'sweeps' and 'heaps' still relied on metaphor, and Luke Howard noted that fine-weather clouds are beautiful, and those connected with rain mostly ugly. The recognition of profound ideas beneath a superficial imitation of nature remains the basis of our conception of what is beautiful in nature even today.

PHILIP GILBERT HAMERTON

from 'The Relation between Photography and Painting' (1860)

Nature's power of light is like a great organ with all its vast range of octaves. The photograph's power of light is in comparison, something like a voice, but a voice of extremely limited compass.

How is the voice to follow the organ in an exercise on the scales?

The voice will sing its own notes in the places where they occur, but must ignore all the rest.

This is exactly the way the photograph imitates Nature. And when Nature plays only in the middle of her scale, photography would follow her with much accuracy if it were not for that fact about the excited film being insensitive to yellow rays.

Now, what is painting?

It is an intellectual and emotional interpretation of Nature, by means of carefully balanced and cunningly subdivided hues. Its powers of *imitation* are extremely limited. However, the eye of the painter, instead of being insensible to everything that is yellow, is as sensitive to gold and orange as to blue, so that in this respect he may do truer work. And in his way of interpreting Nature's light, he has opportunities of compromise and compensation which the unthinking photograph cannot have. So he gets more truths . . .

I have at hand a portfolio of good photographs by professional photographers, and a portfolio of photographs, not so good, done by myself. These will afford ample materials for our investigation

I have an oval photograph of sea by M. Colliau, with a boat in the middle distance. The time of exposure must have been very brief, for the forms of the waves are quite firm and clear, yet there is nothing black but the hull of the boat. If there had been anything solid in the foreground—as, for instance, a pier—it would have come in silhouette, and spoiled the photograph.

I have another oval of rough sea, by the same manipulator. It includes a fine cumulus cloud, and is altogether wonderful. Where it fails as a study is in the absence of distinction between *foam* and *reflection*. The negative has evidently been exposed long enough for the *foam* to act upon it; so that it is as bright as the glitter, and there is no separating them. A little more exposure, and the middle tints would have blackened the negative all over the surface of the water in the interstices between the spots of foam and glitter. Once this done [*sic*], the picture would have been destroyed altogether; for the sea would have been one black blank in the negative, and one white blank in the positive.

And now, if we want to know the relation between these marine photographs and a good picture of the sea, it is easy to ascertain it. We have only to compare one of the best specimens of marine photography we can find, with one of the best pictures of sea hitherto produced by our realist school.

I will take for this purpose one of Gustave le Gray's marine photographs, and Holman Hunt's exquisite little picture entitled 'Fairlight Downs: Sunlight on the Sea'.

In the photograph the blaze of light upon the sea is given with perfect fidelity; but in order to get this, and the light on the edges of the clouds, all else has been sacrificed:

Extract from P. G. Hamerton, *Thoughts About Art*, London 1873.

Fig. 5 W. Holman Hunt, *Fairlight Downs: Sunlight on the Sea*, oil on canvas, 1852–58. Private collection.

the shaded sides of the clouds, in nature of a dazzling grey, brighter than white paper, are positively black in the photograph, and the pale splendour of the sun-lit sea—except where it *flashes* light—is heavy and impenetrable darkness. Towards the sides of the photograph, the distinction between sea and sky is wholly lost in one uniform shade of dark brown, extending from top to bottom, without any indication of a horizon; so that, if you were to cut a strip an inch and a half broad from each side of the photograph, no one on looking at the strip would at all suspect that it represented either sea or sky, or anything else in nature. The crowning falsity is, however, the sun itself, which is *darker* than the surrounding clouds, being simply a grey wafer on a white ground. . . .

At Mr. Gambart's Winter Exhibition in the year 1858, the reader may have seen a wonderful little picture by Holman Hunt, entitled 'Fairlight Downs: Sunlight on the Sea'. The sunlight itself in its broad white glare on the water under the sun, and its gradual scattering into glitter to the right hand and to the left; in its long lines in the distance, divided by the shadows of the clouds; in its restless flashing on the crests of the little waves far away,—is as true and truer than the photograph: but here all comparison ends, because there is no longer in the photograph anything to be compared with the picture. Where the photograph is simply dark brown, the picture is full of the most delicate gradations, and the sweetest play of hue. Where the glitter is not, we have still the sunlit beauty of the fair sea, which is indeed better and more precious even than the glitter itself, just as the fairness of a beautiful woman is better than the glitter of her diamonds. And there is a hot haze in the blinding distance miles away, and there is a sultriness in the accumulated clouds which shall light up that sea at night with another and more terrible splendour. And then there is the green of the rich land, and the purple of the fallow, and nearer is a mingled glow of scarlet flowers and green leaves, and staring sheep, and a dog, and the shepherd's staff. And all these other facts Hunt could get into his picture because painting is a great intellectual art; an art of compensation, and compromise, and contrast; an art capable of moderation, and subject to mastery. And all these other facts Gustave le Gray could *not* get into his photograph, because photography is not a fine art, but an art science; narrow in range, emphatic in assertion, telling one truth for ten falsehoods, but telling always distinctly the one truth that it is able to perceive.

On comparing photographs with good topographical pen-drawings of the same objects, I find a result very different from anything that many persons would expect. I find the *sum* of detail, in subjects including both distant and near objects, to be much greater in the drawing than in the photograph. Thus, Bisson's Chillon, a magnificent photograph, gives the castle in true detail, but loses the near foliage in black, and the mountain detail in pale brown, like the sky. A good topographical drawing would have given the castle less exquisitely, but we should have had the nearer foliage thoroughly drawn, and the mountain forms defined. I have before me a good positive of the Lac de Gaube, evidently printed from a waxed-paper negative, and therefore a remarkable degree of detail is not to be expected; still few people not accustomed to analyse photographs would be prepared, in a photograph of clear weather, such as this one evidently is, to find such a large space of sheer vacancy as the mountain slope on the left. A topographical drawing might be done in a week which would contain ten times as many facts as this photograph.

Having taken a waxed-paper negative of Craiganunie, and since drawn and painted the same subject in various ways, I find that with five or six hours' labour I can get a memorandum containing much more detail than the photograph. The details in the drawing are not so accurately or delicately done; but they are quite accurate enough for artistic purposes, and there are *more of them* than in the photograph.

The collodion process would have afforded more abundant detail; but, to an artist,

this additional detail is often of little consequence, being not *the* detail he wants. For the best photograph of any extensive scene never gives more than *partial* detail, however perfect as far as it goes. The artist, too, gives selected detail, that which seems to him the most needful and vitally expressive: and here, ten to one, if he is a good artist, he and the photograph will not be of the same opinion.

It is, therefore, quite impossible to produce good pictures by copying photographs. And this is the reason why Mr. Ruskin, in answer to a malicious accusation against the pre-Raphaelites that they 'copied photographs,' challenged the accusers to produce a pre-Raphaelite picture themselves, or anything like one, by that process. The challenge was perfectly safe, and has never been responded to.

85 Le Gray *Breakwater at Sète* c.1855

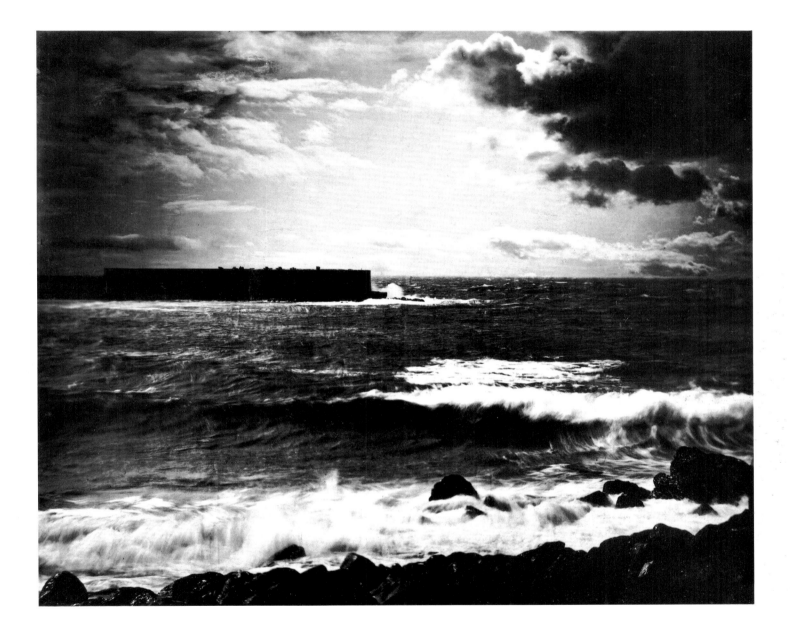

86 Le Gray *The Great Wave, Sète* 1856–59

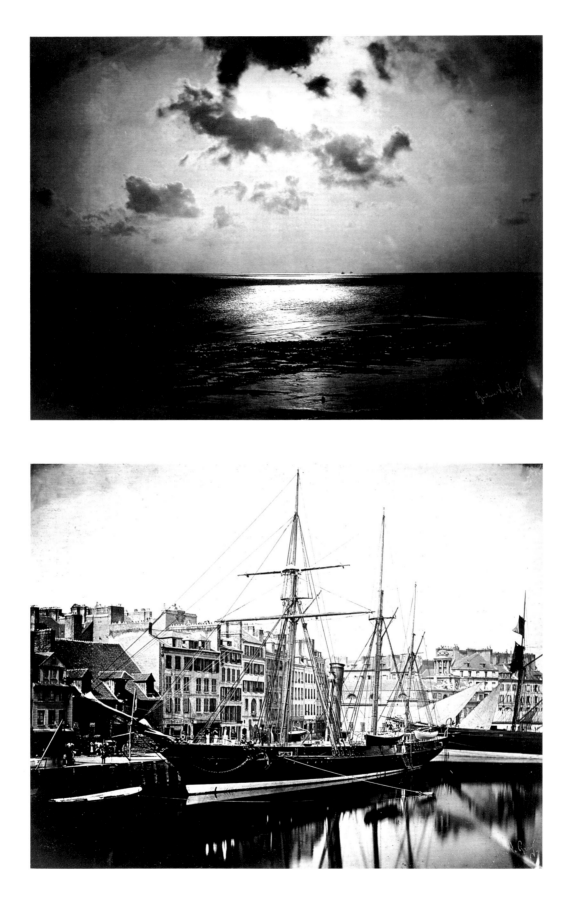

87 Le Gray *An Effect of the Sun, Normandy* 1856–59

88 Le Gray *The Imperial Yacht, 'La Reine Hortense', Le Havre* 1856

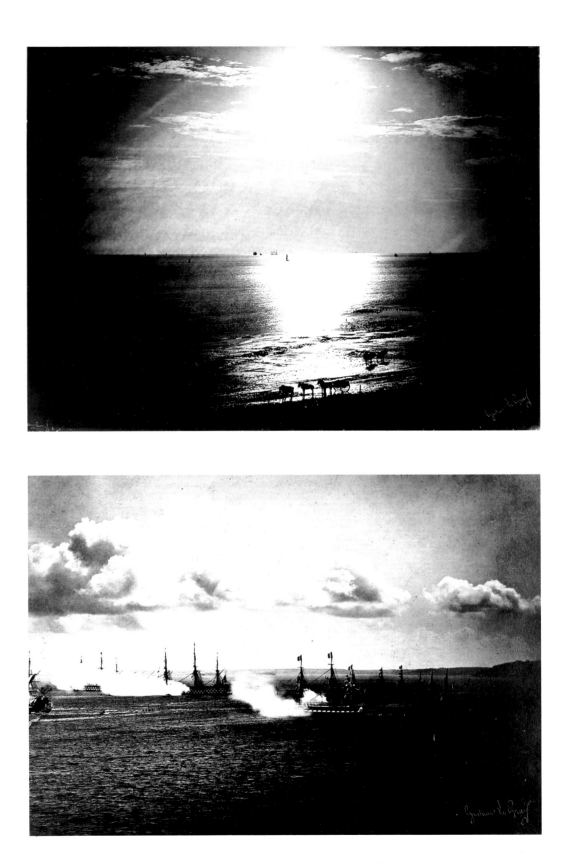

89 Le Gray *The Sun at its Zenith, Normandy* c. 1860

90 Le Gray *Arrival of the Body of Admiral Bruat and Flagship 'Montebello' at Toulon* 2–3 December 1855

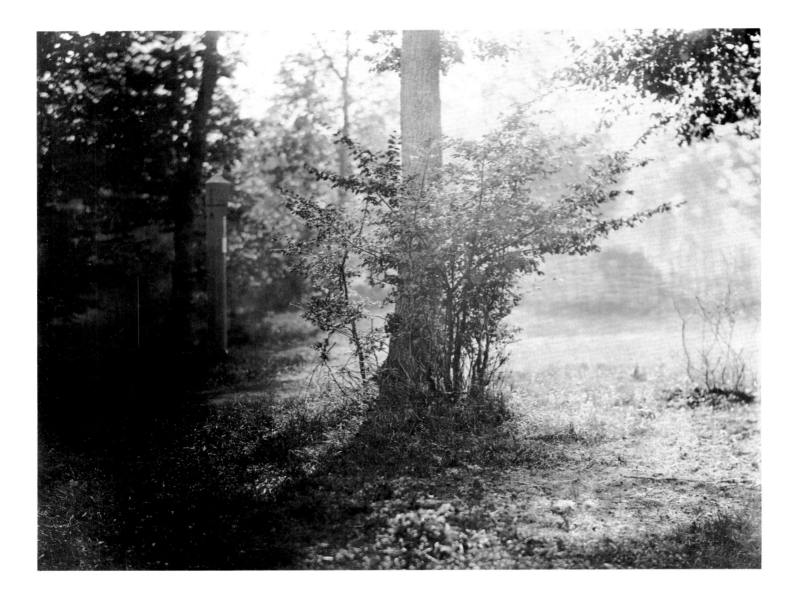

91 Le Gray *Tree Study in the Forest of Fontainbleau* 1856

92 Le Gray *Beech Tree in the Forest of Fontainbleau* before 1858

93 Le Gray *Cavalry Manoeuvres, Camp de Châlons* 1857

94 Le Gray *Cavalry Manoeuvres, Camp de Châlons* 1857

95 Le Gray *Pavillon Molien, Louvre, Paris* c. 1857–59

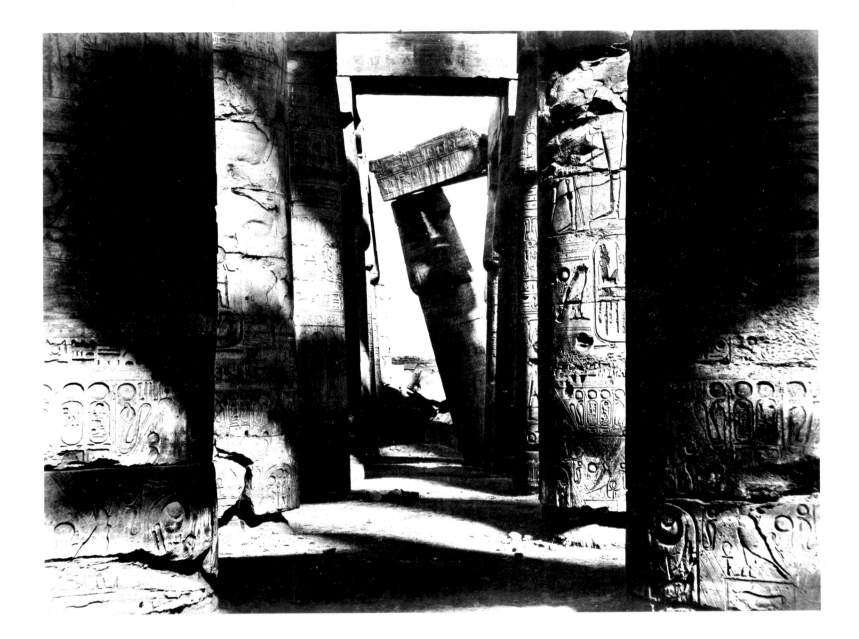

96 Le Gray *Karnak: Pillars of the Great Hall* c. 1859

97 Fenton *External Walls of the Kremlin, Moscow* September 1852

98 Fenton *The Harbour of Balaklava, the Cattle Pier* 1855

99 Fenton *The Valley of the Shadow of Death* 1855

100 Fenton *Cloud Study* 1859

101 Fenton *The Long Walk, Windsor* 1860

102 Fenton *Pont y Garth near Capel Curig* 1858

103 Fenton *View in the Slopes, Windsor* 1860

104 Fenton *Harewood House from across the Lake* 1860

105 Fenton *The Keeper's Rest, Ribbleside* 1858

106 Fenton *Vista, Furness Abbey* 1860

107 Fenton *Lichfield Cathedral: Portal of the South Transept* 1858

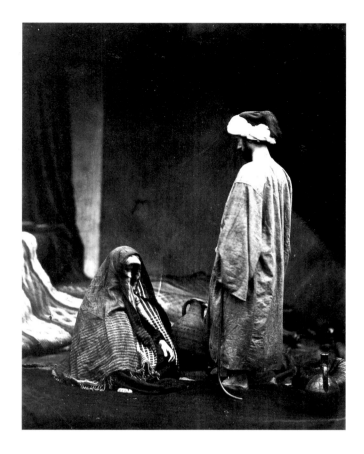

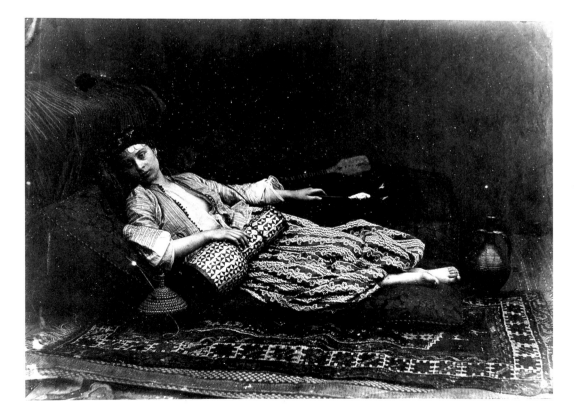

108 Fenton *Untitled* 1858

109 Fenton *Odalisque* 1858

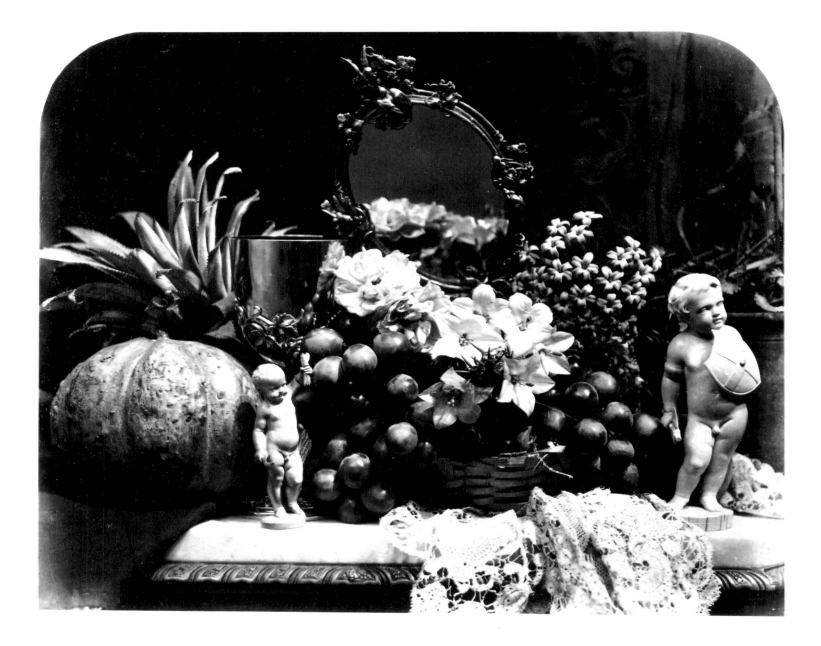

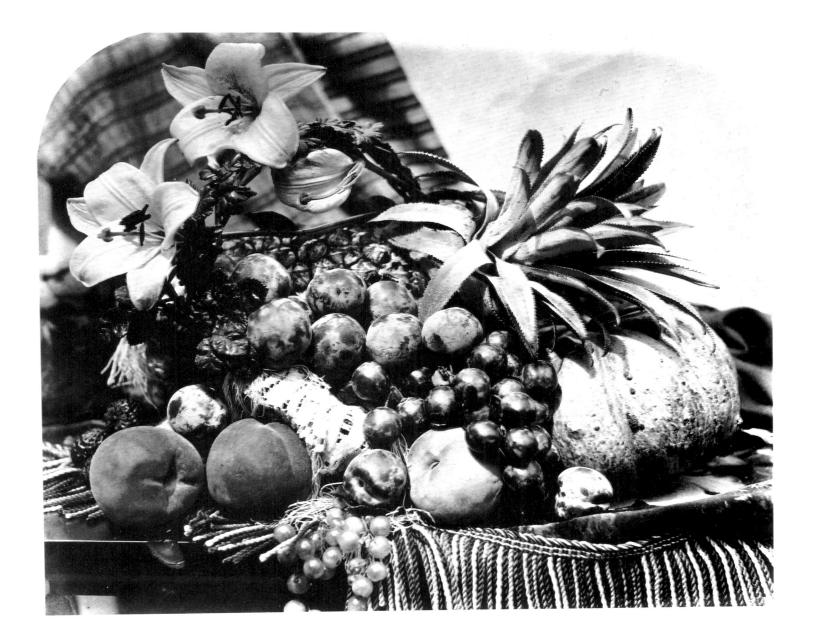

111 Fenton *Still life* 1860

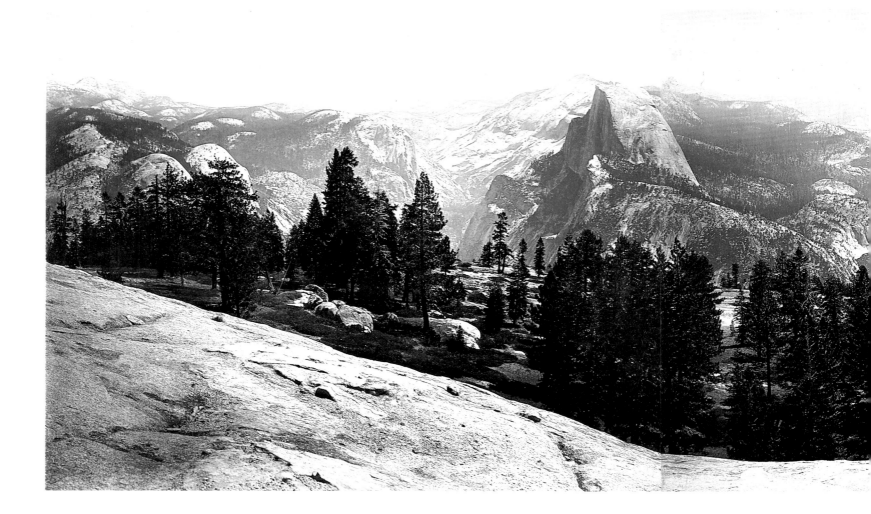

(a) *The Domes*

112 Watkins *Panorama of Yosemite Valley from Sentinel Dome* 1866

(b) *The Lyall Group and Nevada Fall* (c) *The Merced Group*

113 Watkins *Untitled* c. 1872

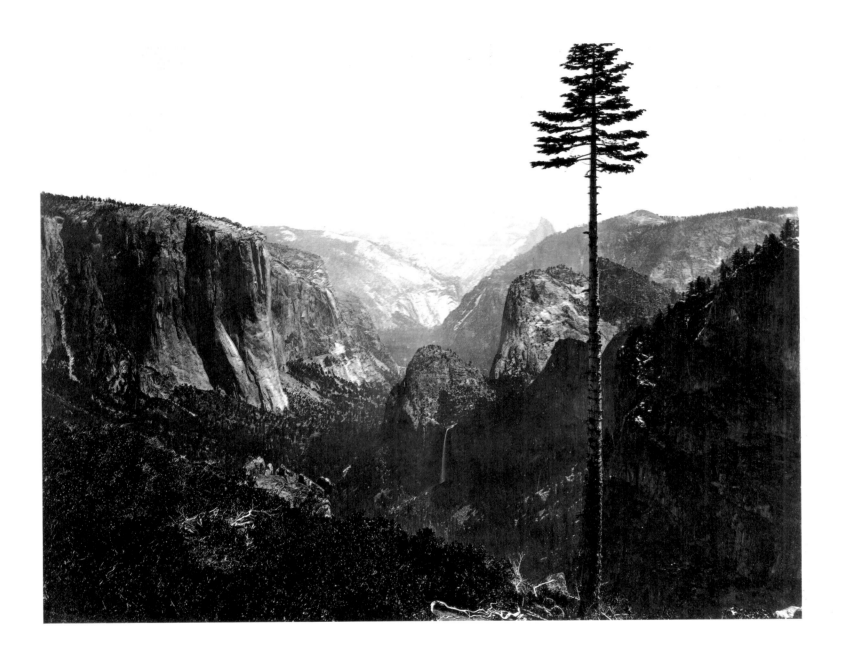

114 Watkins *Yosemite Valley from the 'Best General View'* c. 1866

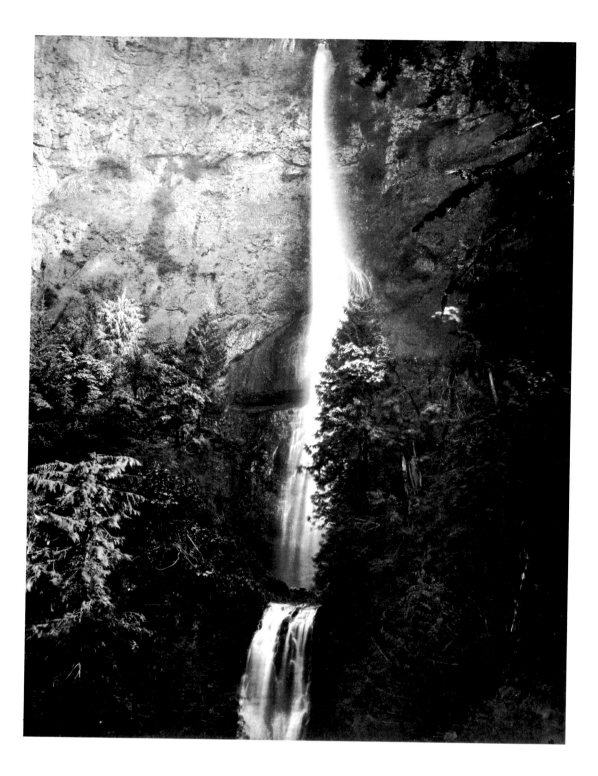

115 Watkins *Multnomah Falls Cascade, Columbia River* 1880

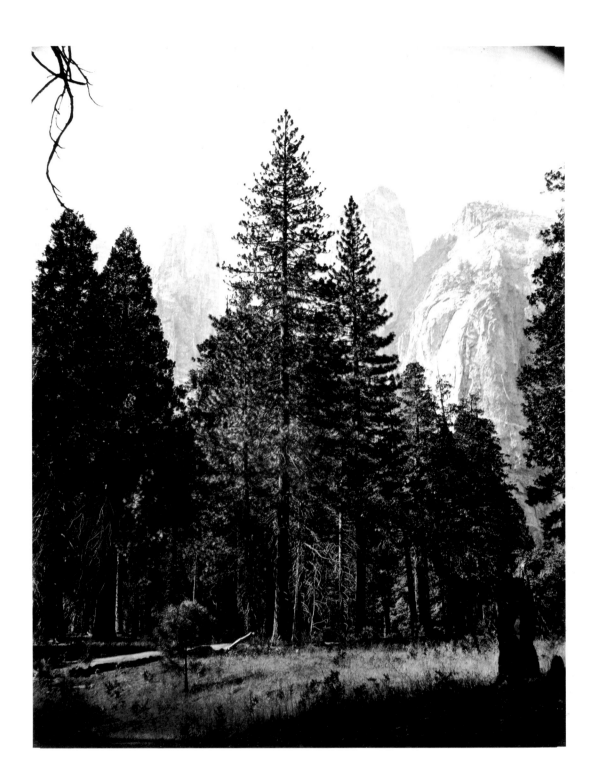

116 Watkins *Cathedral Spires, Yosemite* 1861

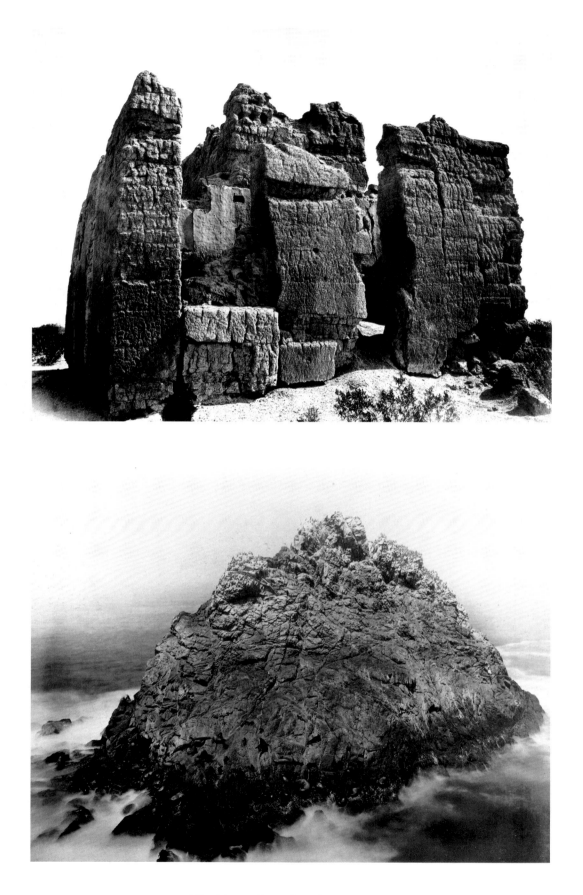

117 Watkins *Casa Grande, Arizona* 1880

118 Watkins *Sugar Loaf Islands, Farallons* c. 1868–69

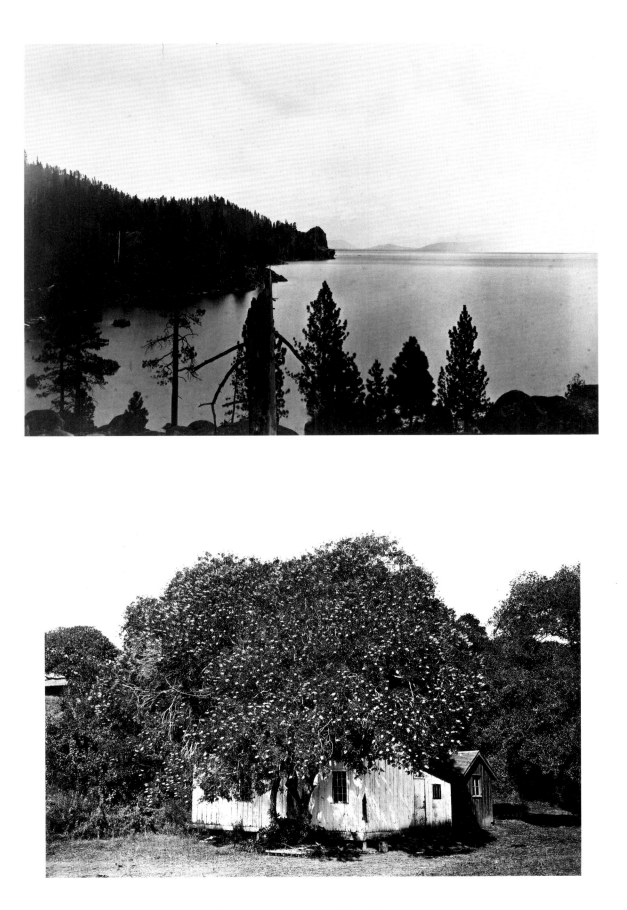

119 Watkins *A Storm on Lake Tahoe* c. 1880–85

120 Watkins *Buckeye Tree, California* c. 1870

121 Watkins *The Wreck of the Viscata* 1868

122 Watkins *Cape Horn near Celilo, Oregon* 1867

5

Robert A. Sobieszek

TRAVEL

It may be a rash attempt to endeavour to separate into its different elements, the magic power exercised upon our minds by the physical world, since the character of the landscape, and of every imposing scene in nature, depends so materially upon the mutual relation of the ideas and sentiments simultaneously excited in the mind of the observer.

Alexander von Humboldt, 1848[1]

Fig. 6 T. Maurisset, *La Daguérreotypomanie*, lithograph, December(?) 1839. International Museum of Photography at George Eastman House.

In his New Year's print for 1840, the French lithographer Théodore Maurisset celebrated the public's intoxication with photography just a few months after it was introduced to the world (fig. 6). In a riotous panorama, Baudelaire's 'idolatrous mob' converges upon the centre of photographic activity and is divided into those who are wild about daguerreotypes and those who adore them. Here, indeed, is the poet's 'squalid society' rushing, 'Narcissus to a man, to gaze at its trivial image on a scrap of metal.'[2]

For Baudelaire, photography's true duty was to be the humble servant of science and art. 'Let it', he wrote in 1859, 'hasten to enrich the tourist's album and restore to his eye the precision which his memory may lack.'[3] In his print of twenty years earlier, Maurisset had clearly anticipated photography's inordinate rôle in the service of travel and topographic studies. A balloon floats in the sky with a giant camera in place of a basket. A steamship is being loaded with a line of cameras. A man struggles to hitch his daguerrian waggon to a brace of horses. In the distance a locomotive pulls an entire train of oversized cameras. In the left foreground a roughly dressed man strides forward with a 'portable travel camera'.

Some months before this lithograph appeared, the French optician Noël-Marie-Paymal Lerebours equipped a team of operators with full daguerrian outfits and sent them off to record the principal sites and monuments of the world. The plates they brought back included not only scenes from Western Europe, but from the Near East and North Africa, Moscow and even Niagara Falls, seen from the Canadian side. From over 1,200 daguerreotypes, more than one hundred were subsequently transformed into engravings and aquatints and published between 1841 and 1844 as *Excursions Daguerriennes*. While not actual photographs, these prints were still based on camera images—and like photographs they miniaturised the world, satisfied a Western appetite for documentation and assisted in the period's attempts to classify everything that existed.

To amass information, to observe, and to catalogue every salient distinction in nature and art were central to this time of empiricism, naturalism and positivism, from the French social *physiognomies* to Darwin's *Notebooks*. So, too, were travel and the immediate experience of exotic sites fundamental to nineteenth-century poetics, from Wordsworth to Maeterlinck. In 1853 the journalist and photographer Maxime Du Camp wrote: 'the spirit of modern writers is essentially that of the traveller'.[4] Only now, in addition to pen and paint brush, the traveller had a uniquely modern advantage for fuelling this spirit–the portable camera, by which the sights and marvels of the material world could be captured with unparalleled facticity.

The object of travel was to experience and thereby to unite the twin desires of

1 Alexander von Humboldt, *Cosmos*, London 1848, I, 5. Cited in Estelle Jussim and Elizabeth Lindquist-Cock, *Landscape as Photograph*, New Haven and London 1985, 41.
2 Charles Baudelaire. 'The Salon of 1859', in *Art in Paris, 1845–1862: Salons and Other Exhibitions*, trans. and ed. Jonathan Mayne, London 1965, 152–3.
3 *Ibid.*, 154.
4 Maxime Du Camp, 'A Théophile Gautier', *Le Nil* (1853), in *Un Voyageur en Egypte vers 1850: 'Le Nil' de Maxime Du Camp*, ed. Michel Dewachter and Daniel Oster, Paris 1987, 69.

Fig. 7 Francis Frith, *Hypaethral Temple (Kiosk of Trajan) at Philae*, 1858. International Museum of Photography at George Eastman House.

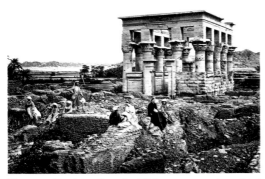

Fig. 8 F. M. Good, *Philae, near view* [sic] *Hypaethral Temple*, c.1870–75. International Museum of Photography at George Eastman House.

romantic (spiritual) adventure and realistic (scientific) observation into a single action whose ultimate aim was the collection of information that validated our world, our pasts and ourselves. It did not matter whether it was a sylvan glen in Windsor or a storm-tossed seacoast along the Mediterranean, the ruins of El Karnak in Luxor or Casa Grande in Arizona, an island pagoda near Foochow or a railbed along the Columbia River. The camera made collecting this information easier, more complete and seemingly more truthful and 'factual' than ever before. The British photographer William Lake Price wrote in 1858:

> In a multiplicity of ways, Photography has already added and will increasingly tend to contribute, to the knowledge and happiness of mankind: by its means the aspect of our globe, from the tropics to the poles,—its inhabitants, . . . its cities, the outline of its mountains, are made familiar to us.[5]

The critical terms in this passage are 'knowledge' and 'made familiar to us', for linked with knowledge and familiarity was the unspoken assumption of superiority and otherness. Discussing the photography of ancient monuments in 1851, the French critic Francis Wey claimed that such surveys would 'prove our superiority, our supremacy . . . by associating heliography with these peaceful conquests [*conquêtes pacifiques*]'.[6] Through its means, the world was conquered visually by photographers from the West.

Far from being neutral and objective, nineteenth-century photography of landscape and topographic subjects is fraught with hidden agendas and biases. For the artist the most mundane field in the Ile de France carried with it an appreciation of contemporary agrarian reform and urban growth, while the most spectacular rock formations and operatic mountainscapes of the American West were charged with a variety of sub-texts ranging from Ruskinian pantheism to the latest controversial theories of evolution. Even the simplest photograph of a tree could amount to an emblem of history, social status or political persuasion.[7] For those who commissioned these photographs (architects, publishers, railroad companies, governments, etc.) there were a complementary set of meanings. Foreign lands were carefully documented by the French and British photographers, as earlier they had been by draughtsmen, 'to produce more complete information than was common in Europe of the commercial resources of a country'.[8] The latest bridge or lighthouse testified to a nation's modernisation and technological progress. The mountainous landscapes of the American territories were photographed first to help survey potential routes for railway lines and later to entice tourists westward.

The success of organised tourism (Thomas Cook and others) soon began to make travelling to exotic locales more convenient and accessible. When Francis Frith photographed the Hypæthral Temple (Kiosk of Trajan) at Philæ (fig. 7) in 1858, he portrayed the edifice in noble isolation, the only modern intrusion being the photographer's darkroom tent in the small boat at the bottom. When the British photographer Frank M. Good interpreted the same monument in the early 1870s (fig. 8), the landscape was littered with European tourists, who in twenty years' time would be carrying snapshot cameras and wishing to verify their own presence there, instead of witnessing what was in front of them, and often beyond their imaginations.

Despite the contextual issues that conditioned both the making and the meaning of prints, landscape and topographic photography from about 1850 to about 1880 remains one of the supreme artistic achievements of the century. The first decade of photography was still a period of experimentation and development, and while many fine images were created during the 1840s, none has that degree of transparency combined with a lustre of authenticity that characterises those prints made after the early 1850s. In part this has to do with the nature of self-masking

5 William Lake Price, *A Manual of Photographic Manipulation, Treating of the Practice of the Art; and its Various Applications to Nature*, 2nd edn., London 1858, 1–2.
6 Francis Wey, 'Un voyage héliographique à faire', *La Lumière*, 1, 7 (23 March 1851), 26.
7 Cf. Grace Seiberling with Carolyn Bloore. *Amateurs, Photography, and the Mid-Victorian Imagination*, Chicago 1986, 57–9.
8 Anon., *Travels in Upper and Lower Egypt, by C. S. Sonnini and by Vivant Denon, During the Campaigns of Bonaparte, in that Country*, Glasgow 1822, 221.

albumen prints generated from perfectly clear glass-plate negatives. In part, it has also to do with the specific colour sensitivity of collodion emulsions in which a painterly contrast was imparted to the prints' richly tonal balance. After the mid–1880s 'more accurate' isochromatic emulsions furnished a greyer and far less dramatic look to the print.

Nineteenth-century landscape and topographic photographers documented their world with an almost naïve sincerity bordering on reverence. Altogether, their photographs are an extensive travel album in which we cannot help but share in the photographers' impulse to see the world not as it necessarily was, but as it appeared as if through meditation. Describing Maxime Du Camp's Egyptian photographs in 1851, Wey wrote:

> To penetrate this album is to travel; its truth overwhelms you, astonishes you, excites you in so many ways that soon you forget the print; objects are assimilated by the imagination, and you are caught in a dream as if you were following a caravan. What is this but the country itself? A vision, a silent picture, an inert image of the past.[9]

In 1985 the American artist Thomas Joshua Cooper (who happens to use a camera) recounted his experiences with certain landscapes:

> These landscape places simply exist; quietly. It is in their quiet that they first become notable, like the first pages of an old album, acknowledged immediately (but why?) and linger to establish a ritualised time in which acquaintance may occur. Memory unfolds at times like these, and in places, like album pages, expectation occurs.[10]

The critic at the dawn of photography saw the landscape through the photograph while the artist of today sees the landscape as a photograph. Both, however, have grasped what nineteenth-century photographers intuited in front of these scenes of nature and history: with images like these, travel becomes the province of mind and memory.

9 Francis Wey, 'Voyages héliographiques. Album d'Egypte de M. Maxime Du Camp' *La Lumière*, I, 32 (14 September 1851), 127.
10 Thomas Joshua Cooper, *Between Dark and Dark*, Edinburgh 1985, n.p.

FRANCIS FRITH

from 'The Art of Photography' (1859)

Next to the truthfulness of photography, its most striking peculiarities are its somewhat mechanical character, and the rapidity with which its results are produced. These characteristics constitute the chief elements of the extent and popularity of the practice of photography, just as its truthfulness is the greatest charm of its results. It was perfectly natural and inevitable that when this art began to excite universal attention, the whole body of skilled draughtsmen looked upon it with jealousy and distrust. It is inevitable that many artists must continue to dislike or to despise it. We can even imagine that some who hailed it as a beautiful thing, and who even made a partial and timid use of it, have harboured it as they would a tame snake; giving it a good switching now and then, lest it should grow rampant, and bite. It is evident that some classes of artists had substantial cause to dread it. It has already almost entirely superseded the craft of the miniature painter, and is upon the point of touching, with an irresistible hand, several other branches of skilled Art.

But, quite apart from 'interested motives', there was, and there continues to be, a reasonable jealousy, not so much of the Art itself, or of its capabilities, as of its pretensions, and the *spirit of its practice*. We do not participate in these fears, because we are convinced of two things with reference to this subject. Firstly, that to practice the Art *with distinction*, which will very shortly be, if it be not now, the only kind of practice which will command notice, requires a much greater acquaintance with the principles of Art than would seem to be applicable to 'a merely mechanical science'. And, secondly, we are convinced that no extravagant 'pretensions' can long be maintained in the public mind. Photography does not even now profess to be either 'high Art,' or in any way a substitute for it. We shall endeavour to define clearly, at a future time, both what in our opinion it *has* done, and what it may yet hope to accomplish; and we shall not hesitate also to exhibit what we consider it has *not* done, and what, in our humble opinion, it can never, in the nature of things, hope to do.

The class of persons, now a very large one, who practise photography, is undoubtedly a very different class from the old regime of 'artists.' It certainly includes a vast number who know nothing, and, if we judge by their *crimes*, care less for the principles, we will not say of Art, but of common sense and decency. But even these, its practice, how degrading soever to an '*artist*,' may insensibly benefit. Whatever Art may, in the opinion of some, suffer from photography, that large class of the public, who are sunk so far *below Art*, will unquestionably reap from it a more than compensating advantage. We do not believe in its power to deter any youth, to whom nature has given an artist's eye and heart, from a proper cultivation of those tastes and talents from which he is gifted. Your most accomplished artist, if he will stoop to the task, will ever be your best photographer, and your skillful 'manipulator,' if he be possessed likewise of a grain of sense or perception, will never rest until he has acquainted himself with the rules which are applied to Art in its higher walks; and he will then make it his constant and most anxious study how he can apply these rules to his own pursuit. And this—although no easy matter, and a thing not to be perfected in a day—he will find to be a study which will admit of the most varied and satisfactory application.

The rapidity of production of which the merely mechanical process of

Extract from *The Art Journal* v (1859).

photographic picture-making is capable, may easily become a source of great mischief. The student should bear in mind that what he is to aim at is not the production of a large number of 'good' pictures, but, if possible, of ONE which shall satisfy all the requirements of his judgment and taste. That one, when produced, will be, we need not say, of infinitely greater value to his feelings and reputation than a 'lanefull' of merely 'good' pictures. Think of the careful thought and labour which are expended over every successful piece of canvas, and the months of patient work which are requisite to perfect a first-class steel plate! And then turn to the gentleman who describes a machine which he has contrived for taking six dozen pictures a day! Every one of them—this is the distressing part of the business—every one of them capable of throwing off as many impressions as the steel plate! We shudder to think of the thousands of vile 'negatives' boxed up at this moment in holes and corners, any one of which may, on a sunny day, hatch a brood of hateful 'positives'.

We feel it to be a solemn duty to remind photographers of the responsibilities which they incur by harbouring these dangerous reproductive productions; and we beg of them—for their own sakes, and for that of society—to lose no time in washing off, or otherwise destroying, by far the greater part of their 'negative' possessions.

123 Beato *Tycoons' Halting Place on the Tocaido Hasa* 1868

124 Beato *Giving Prayer to Buddha* c. 1865

125 Beato *Samurai with raised Sword* c. 1860

126 Thomson *Prince Kung* c. 1871–72

127 Thomson *The Altar of Heaven* c. 1870–71

128 Thomson *A Pagoda Island in the Mouth of the Min River* c. 1870–71

129 Frith *Fallen Colossus, Ramasseum, Thebes* 1858

130 Frith *Pyramids from the Southwest, Giza* 1858

131 Murray *Panorama of Agra* 1859

132 Murray *The Taj Mahal* c. 1856

133 Bourne *Group of Todas* c. 1868

134 Bourne *Lepcha Man* 1868

135 Stillman *Western Portico of the Parthenon, from above* 1870

136 Stillman *Western Portico of the Parthenon* 1870 137 MacPherson *The Arco dei Pantani at the Entrance of the Forum of Augustus, with the Temple of Mars Ultor, Rome* before 1863

138 Charnay *Façade, Governor's Palace, Uxmal* 1860

139 MacPherson *Grotto at Tivoli* c. 1860 140 Charnay *Tree of Santa-Maria del Tule,*
Mexico c. 1858

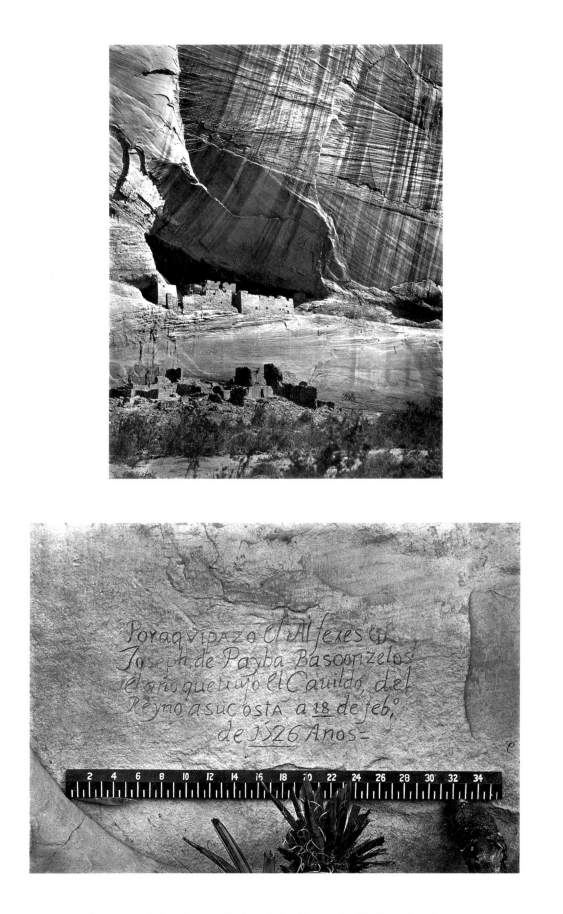

141 O'Sullivan *The Ancient Ruins of the Cañon de Chelle, New Mexico* 1873

142 O'Sullivan *Inscription Rock, New Mexico* 1873

143 O'Sullivan *Desert Sand Hills near Sink of Carson, Nevada* 1867

144 Jackson *Cañon of the Rio Las Animas, Colorado* after 1880

145 Jackson *Grand Canyon of the Colorado* 1883

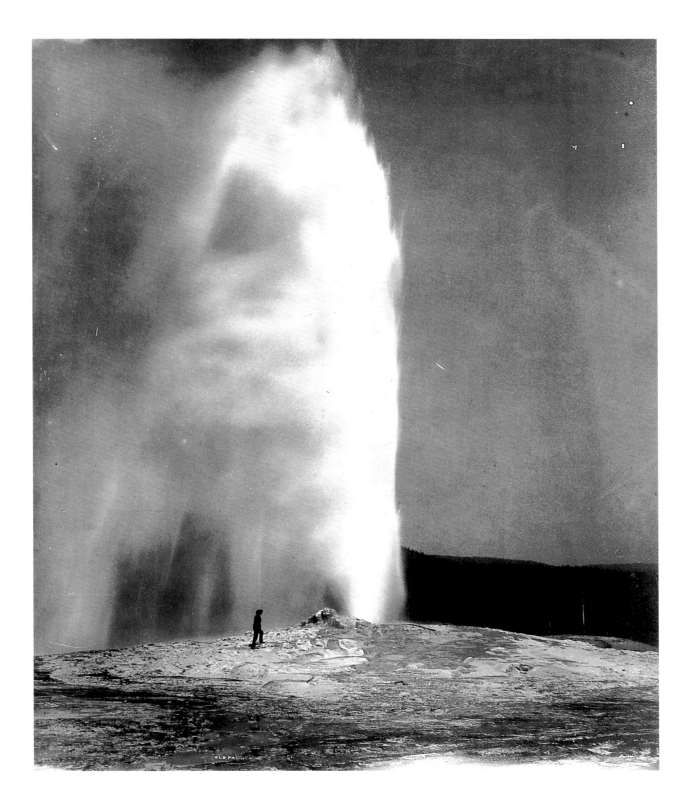

146 Jackson *Old Faithful* 1870

6

Peter C. Bunnell

PICTORIAL EFFECT

Late in the nineteenth century there evolved a well-organised and highly self-conscious movement in photography which had as its basis an artistic style known as Pictorialism. As a distinctive structure of events and actions the movement lasted from the early 1890s to the end of the Great War. It was an international alignment of photography with the objective of establishing for it an essential place within the contemporary media of personal expression.

The origin of the Pictorialist style may be found in Henry Peach Robinson's *Pictorial Effect in Photography* (1869). This book, one of the few early treatises on photography to focus on the aesthetics of picture-making, provided the serious amateur with a guide to the beautiful in art based on respected principles dating from the Renaissance to Ruskin. Crucial in Robinson's formulation was his commitment to the study of past art as a way of enhancing the photographer's sensitivity in ordering the observable world. Robinson recognised that the photographer of the later nineteenth century was going to be neither a trained artist nor an educated gentleman of the sort who had earlier practised photography in the context of watercolour painting or sketching: thus his call for a clear set of methods and principles to guide in the stylistic formulation of the newer art.

One of the issues that plagued photography throughout the nineteenth century was its seemingly unalterable connection to a 'machine'—the camera—and to a scientific technology which, it was believed, prevented the photograph from being accepted into the realm of art. It is understandable, then, that beginning in the last decade of the century, characteristics of photography and photographic practice that might be termed precisionist, or scientifically determined, were progressively de-emphasised in favour of the creation of a work that frequently bore little resemblance to one of the sort commonly derived from a straightforward camera negative. In making this adjustment these Pictorialists were bringing themselves more in line with expression in other visual arts, notably the graphic arts, where the physical and tonal beauty of the printed object itself was all important. The manipulative processes of photography such as the gum bichromate, oil pigment, gelatine carbon, glycerine-developed platinum and hand-printed photogravure became some of the favoured choices in articulating the Pictorialist aesthetic. Another was the platinum process which, while less obviously synthetic and manipulative, nonetheless beautifully rendered the soft and eloquently subtle tonal values of Pictorialist works. Thus, such photographs seem to look like works in other media, and those qualities that would readily point to their photo-optical origin—exactitude, clarity and recessional perspective—were suppressed in favour of light and touch.

In making their pictures express more forcefully the concepts of art as demonstrated in related techniques, photographers were attempting to associate their works both with certain accepted pictures, and with accepted aesthetic traditions. Not only in matters of composition and surface did the photographers seek to be inspired by the other arts, they undertook also to interpret various contemporary iconographic sources and motifs, whether from literature or history, or from the Symbolist canon. More and more photographers turned from the depiction of the world around them to the portrayal of personal sentiments and

Fig. 9 Clarence White, *The Ring Toss*, 1900. International Museum of Photography at George Eastman House.

Fig. 10 Edward Steichen, *Self-portrait with brush and palette, Paris*, photogravure, from *Camera Work* (April 1903). International Museum of Photography at George Eastman House.

emotions. They focussed their cameras on intimate spaces and close-up details, including the still life or arranged subject, and a lack of real depth in the pictorial space became a characteristic of works where the photographer sought to draw attention to the difference between the traditional, three-dimensional optical rendering and the newer, flattened space created within the work itself. The goal was to define a space that was in the picture and not a mirror reflection of the reality of the world. It was to be seen and felt as the imagined space of an idea. In this the articulation of the print as object was essential in the effort to direct attention to the emotional core of the work. Matting and framing became progressively more elaborate and decorative, and in most instances titles were given to the images.

One of the most outspoken proponents of the need for rigorous self-discipline and a harmonious blending of science and art was Peter Henry Emerson, an Englishman, who published the second major book to consider the Pictorialist aesthetic, *Naturalistic Photography* (1889). Another important concept put forth by Emerson and others who stood behind the cause, such as the American leader of the Photo-Secession, Alfred Stieglitz, was that of intentional creation. Thus, everything from choice of theme to composition, to design of the format, to choice of the lens and to materials used to print the final image were all decisions that had to be made out of knowledge and out of the determination to make visible the expressive aim of the artist.

The demonstration of the beautifully rendered, more naturalistic photographic method may be seen in the work of Emerson, Clarence H. White and Frederick H. Evans–all masters of the platinum print process. White's *The Ring Toss* (fig. 9), for instance, is an absorbing and sophisticated picture in its articulation of the pictorial space that transforms a simple, indoor setting into a figuration of dynamic visual rhythm. That it is a posed and constructed picture, influenced by White's knowledge of Japanese prints and by works of the American painter, William Merritt Chase, does not take away from the buoyant effect of this intimate, idyllic picture. It is a work that shows more than just the innocent childhood game that bonds these graceful young women to each other; it is about a ritual of ordinary life that symbolises their time and place.

In dramatic contrast, Edward Steichen, through sheer physical and emotional virtuosity, reveals a much more expansive and romantic sensibility than White's. Only through the use of the highly manipulative processes such as gum bichromate, oil pigment and other combinations could Steichen's vitality be expressed. Also, by linking himself to the gravity of one of the greatest artists of his time, Rodin, in such pictures as *Rodin, 'Le Penseur'* (pl. 163) or *Balzac, the Open Sky, 11 p.m.* (pl. 166), Steichen revealed his youthful attempt to obtain for himself and for photography a rightful place in the artistic hierarchy, if only by appropriation. His *Self-portrait with brush and palette, Paris* (fig. 10) is a *tour de force* of process and projection, and it is in the same spirit as his images of Rodin. Loosely based on a portrait by Titian, Steichen renders himself as painter, a narcissist unafraid to mark his sympathies with the traditional arts but also proud, even eager now, to reveal his talents in a work of almost terrifyingly aggressive Pictorial photography.

Heinrich Kühn was a leading European Pictorialist. Between 1897 and 1904 Kühn, together with Hugo Henneberg and Hans Watzek, was a member of an important, but shortlived Austrian photography group called the Trifolium. The three were known internationally for their skill with the gum-bichromate process which they had adopted and modified for their use after encountering it in the work of the Frenchman Robert Demachy in 1895. All three were active early on in the Vienna Camera Club, and they also showed with secessionist groups in Munich and Vienna. Kühn was deeply interested in the qualities of natural light, as rendered in a special way through the use of soft-focus lenses.

The tactics of the Pictorialist movement may be seen as partially political, a revolution of sorts linked to the various secessionist movements then current in the arts in Europe generally. But most fundamentally, Pictorial photographers had qualitative goals: a desire to position the medium in such a way so as to mark clearly the creative potential of photographically derived imagery, and to garner respect for their serious artistic aspirations. Underlying the notion of a movement was the sense that organised group activity was essential if success was to be achieved in exposing a common ideology.

SADAKICHI HARTMANN

from 'On the Possibility of New Laws
of Composition' (1910)

In photography, pictorial expression has become infinitely vast and varied, popular, vulgar, common and yet unforeseen; it is crowded with lawlessness, imperfection and failure, but at the same time offers a singular richness in startling individual observation and sentiments of many kinds. In ordinary record-photography, the difficulty of summarising expression confronts us. The painter composes by an effort of imagination. The photographer interprets by spontaneity of judgement. He practices *composition by the eye*. And this very lack of facility of changing and augmenting the original composition drives the photographer into experiments.

Referring to the average kind of photographic delineation, we perceive how composition may exist without certain elements which are usually associated with it. A haphazard snapshot at a stretch of woodland, without any attention to harmony, can only accidentally result in a good composition. The main thoroughfare of a large city at night, near the amusement center, with its bewildering illumination of electrical signs, must produce something to which the accepted laws of composition can be applied only with difficulty. Scenes of traffic, or crowds in a street, in a public building, or on the seashore, dock and canal, bridge and tunnel, steam engine and trolley, will throw up new problems. At present the amateur has reached merely the primitive stage.

The most ignorant person will attempt a view or a portrait group out-of-doors. Even children will strive for accidental results. The amateur has not yet acquired calligraphic expression. Like the sign painter who takes care to see that his lettering is sufficiently plain to be understood at one glance, the amateur only cares to make statements of fact. As we examine amateur photographs as they are sent in to the editorial offices of photographic magazines, we now and then will experience a novel impression. We do not remember of ever having seen it done just that way, and yet the objects are well represented and the general effect is a pleasing one. I have seen trees taken in moonlight that were absolutely without composition and yet not entirely devoid of some crude kind of pictorialism. It was produced by the light effect. Such a picture cannot be simply put aside by the remark that we hear so frequently, 'That is a bad composition.' It may be poor art but it is physically interesting.

Climatic and sociological conditions and the normal appreciation of the appearance of contemporary life will lead the camera workers unconsciously to the most advantageous and characteristic way of seeing things. The innovations which will become traditional will be transmitted again and again, until some pictorialist will become the means of imposing the authority of the most practical manner upon his successors. In this way all night photographers, good or bad, will help to discover and invent a scheme or method that will be suitable for the subject and consequently become universally applicable. And so it will be with every branch of pictorialism, may it be in the domain of foreground study, of moonlight photography, of animal or flower delineation, of portraiture, figure arrangement, or the nude.

The most important factors in these discoveries will be those qualities that are most characteristic of photography as a medium of expression. The facility of producing detail and the differentiation of textures, the depth and solid appearance of dark

south essex college

FURTHER & HIGHER EDUCATION
SOUTHEND CAMPUS

Extract from *Camera Work* 30 (April 1910).

planes, the ease with which forms can be lost in shadows, the production of lines solely by tonal gradations, and the beautiful suggestion of shimmering light—all these qualities must be accepted as the fundamental elements of any new development. Photographic representation, no doubt, will become addicted more and more to space composition, to the balancing of different tonal planes and the reciprocal relation of spaces. This may be an advantage from the point of physical optics. Beauty is chiefly concerned with the muscular sweep of the eye in cognizing adjacent points. It is generally conceded that the impression is more gratifying if these points are limited to a few. Every spot requires a readjustment of the visual organs, as we can only observe a very small space at a time. Too many spots, as may occur in modern compositions, no doubt will prove wearisome and fatiguing; but if the spotting is skillfully handled, it after all will represent the fundamental principle of esthetic perception, and the sense of sight will adjust itself gradually to the necessity of rapid changes.

Also the relationship of lines, so confused and intricate in scenes like a railroad station or a machine shop, factory, derrick or skeleton structure of a building, will need special consideration. The variety and the irregularity of such lines, in which the straight and angular line will predominate, may be compared to the unresolved discords, unrelated harmonies, little wriggling runs, and all the external characteristics of the modern French composers. Debussy mastered these apparently incongruous elements sufficiently well to construct novel combinations of sound that, after all, are pleasing to the ear.

If new laws are really to be discovered, an acquaintance with the various styles is prejudicial rather than advantageous, since the necessary impartiality of ideas is almost impossible, inasmuch as the influence of study and the knowledge of preexistent methods must inevitably, although perhaps undesignedly, influence new creations and ideas. All natural objects have some sort of *purpose*. And the photographer should strive primarily for the expression of the *purpose*. Each object (like the free verse of Whitman) should make its own composition. Its forms and structures, lines and planes should determine its position in the particular space allotted to the picture. More than ever must the artist be gifted with a happy appreciation of beautiful proportions, which often are sufficient to bestow a noble expression on a pictorial representation.

147 Robinson *Bringing Home the May* 1862

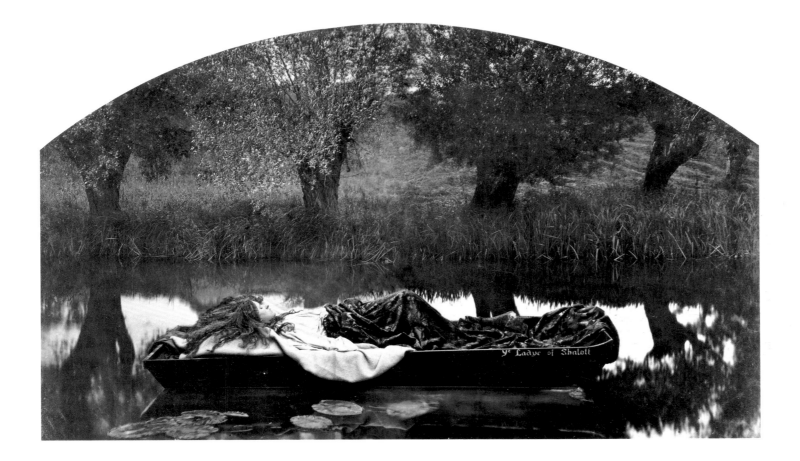

148 Robinson *The Lady of Shalott* 1860–61

149　Emerson　*In Marsh Land*　c. 1885

151 Emerson and Goodall *Coming Home from the Marshes* 1886

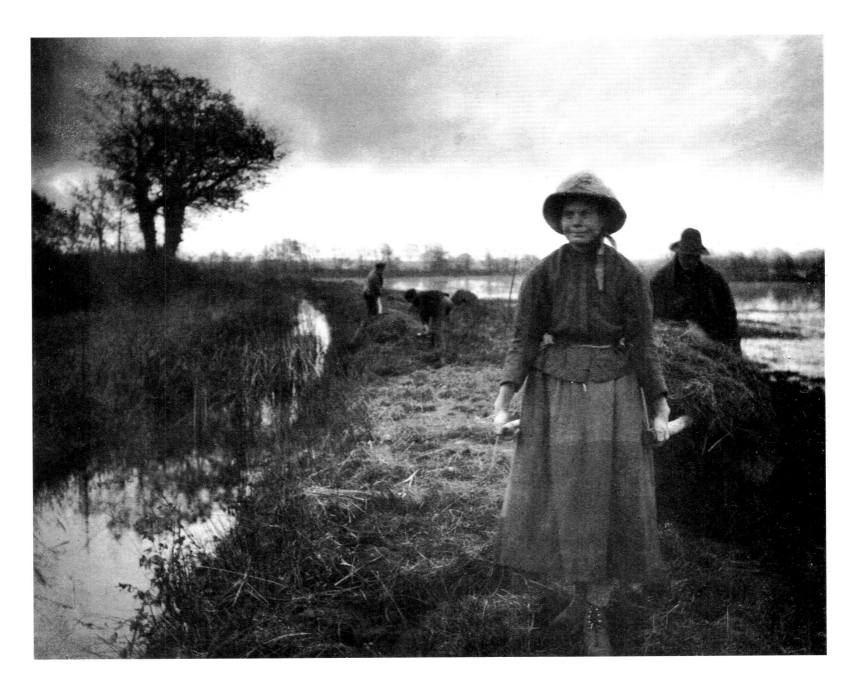

152 Emerson and Goodall *Poling the Marsh Hay* 1886

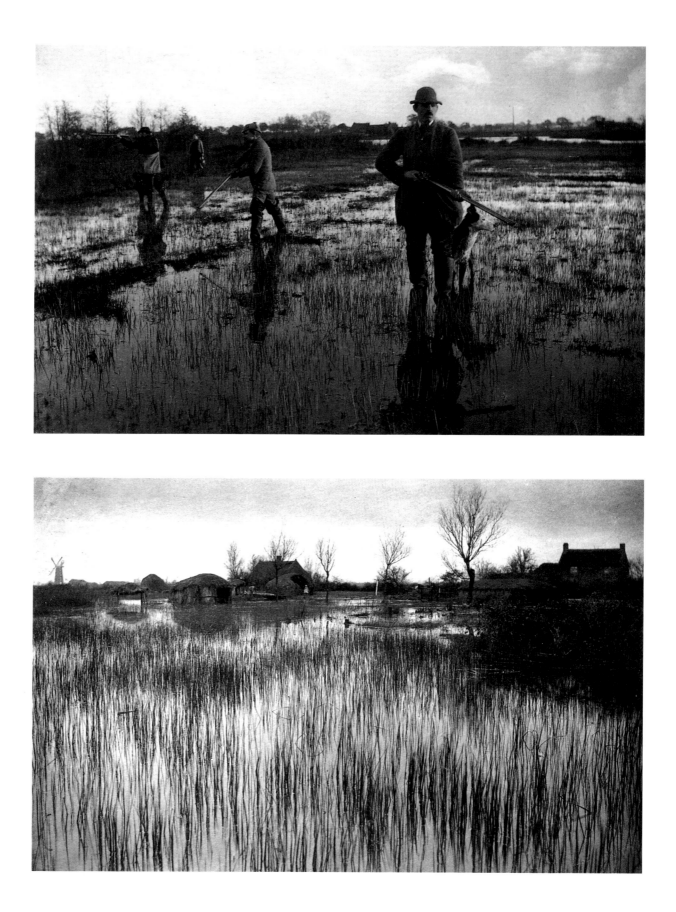

153 Emerson and Goodall *Snipe Shooting* 1886

154 Emerson *A Rushy Shore* 1886

155 Emerson *The Snow Garden* 1895

156 Emerson *The Fetters of Winter* 1895

157 Frederick H. Evans *Kelmscott Manor: Through a Window in the Tapestry Room* 1896

158 Frederick H. Evans *Kelmscott Manor: Attics* 1896

159 Frederick H. Evans *Untitled* c. 1906–9

160 Frederick H. Evans *'A Sea of Steps', Wells Cathedral: Stairs to the Chapter House and Bridge to Vicar's Close* 1903

161 Frederick H. Evans *In Redland Woods, Surrey* 1894

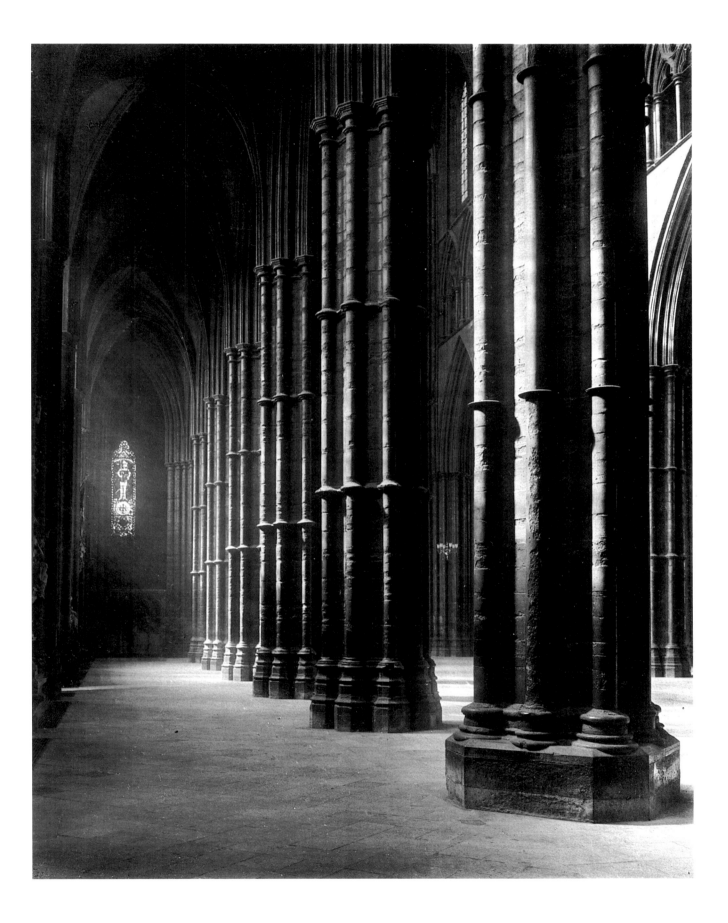

162 Frederick H. Evans *Westminster Abbey, South Nave Aisle* c. 1911

163 Steichen *Rodin, 'Le Penseur', Paris* 1902

164 Steichen *J. P. Morgan* 1904

165 Steichen *After the Grand Prix, Paris* 1907

166 Steichen *Balzac, the Open Sky, 11 p.m.* 1908

167 Steichen *Nocturne: Orangerie Staircase, Versailles* 1907

168 Steichen *Trees, Long Island* 1905

169 Steichen *The Big White Cloud, Lake George* 1903

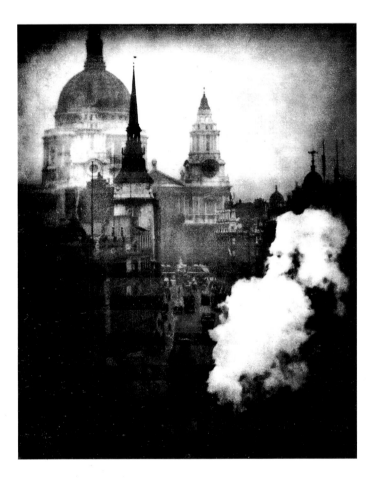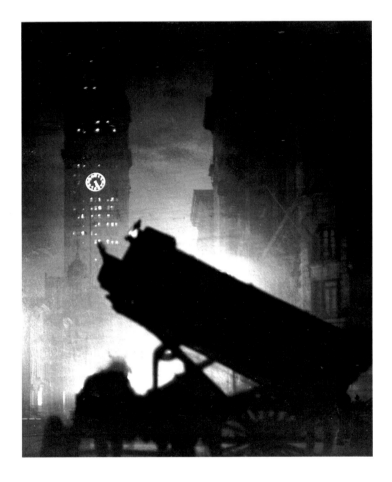

170 Coburn *St Paul's from Ludgate Circus* 1905

171 Coburn *The Coal Cart* 1911–12

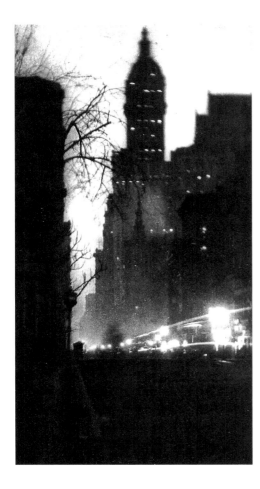

172　Coburn　*Singer Building, New York*　1909–10

173　Coburn　*Trinity Church*　1912

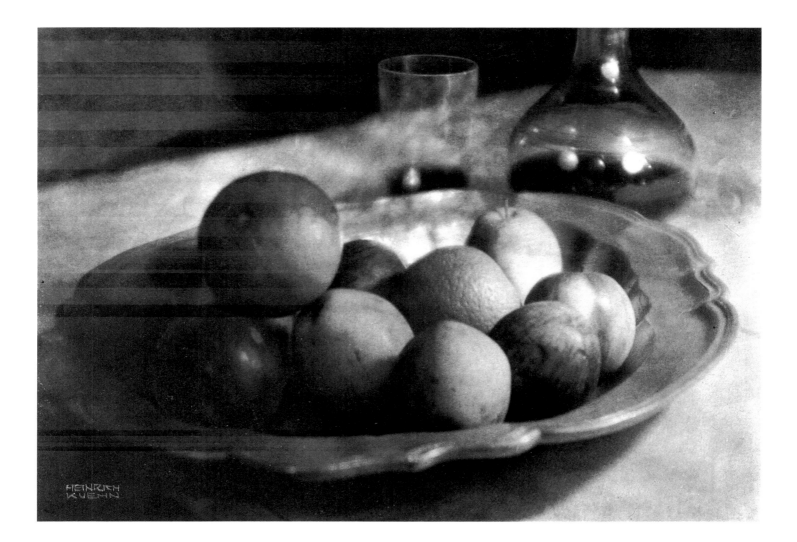

174 Kühn *Untitled* c. 1909–12

175 Kühn *Flowers in a Bowl* c. 1909–12

176 Kühn *Lotte and Edeltrude* c. 1908

177 Kühn *Lotte and Edeltrude* c. 1908

178 Clarence White *The Fountain* 1906

179 Clarence White *The Orchard* 1902

180 Clarence White *The Faun* 1907

181 Clarence White *The Mirror* 1912

182 Clarence White *Still life* 1907

Mike Weaver
'An American Place'

Fig. 11 Edward Weston, *D. H. Lawrence, Mexico*, 1924. © 1981 Arizona Board Regents, Center for Creative Photography, University of Arizona.

1 *The Autobiography of William Carlos Williams*, New York 1951, 236.

2 See *The Letters of D. H. Lawrence*, ed. W. Roberts et al, Cambridge 1987, IV, 499, 543 for replies to Stieglitz; and the Strand Papers, Center for Creative Photography, University of Arizona, Tucson, for replies to Strand.

3 See M. Green, *The Von Richthofen Sisters: The Triumphant and Tragic Modes of Love*, New York 1974.

Between 1929 and 1946 Alfred Stieglitz ran a gallery on the seventeenth floor of 509 Madison Avenue, New York. William Carlos Williams said that Stieglitz had his book *In the American Grain* (1925) in mind when he named it 'An American Place'.[1] Williams's book, a series of essays about the ways in which various explorers and pioneers had tried to make contact with the American earth, had been inspired by D. H. Lawrence's *Studies in Classic American Literature* (1923). Herbert J. Seligmann, whom Paul Strand introduced to Stieglitz in 1917 at the time of the cultural renaissance heralded by *Seven Arts* magazine, wrote one of the first critical books on Lawrence. Both Stieglitz and Strand corresponded with Lawrence in the 1920s,[2] and Edward Weston made his photographic portrait (fig. 11). Lawrence's sense of the spirit of place, and of man's need to understand the sacredness of living things, had a profound influence on members of the Stieglitz circle, who believed that the ability to make art depended primarily on the vitality of the artist himself.

Stieglitz probably developed his obsession with the vital quality of nature out of his association with the Vienna and Munich Secession movements to which Lawrence had access via his wife Frieda von Richthofen.[3] The American link with the erotic movement in Europe was embodied in the person of Mabel Dodge Luhan, first in New York and then in Taos, New Mexico. The love and passion that were synonymous with sexual freedom and intensity of physical experience among the vitalists was, in Stieglitz's opinion, and probably Strand's and Weston's too, essential to full creative expression. The work had to come into being, stand up and salute the mind first through the body. Straight photography as practised by these artists after 1920 had nothing to do with Modernism in the formalist sense. To be straight meant to respond directly, erectly, correctly in a physical rather than spiritual sense.

This vitalist stance turned Stieglitz away from his *japoniste* Impressionism, diverted Strand from his false start with machine Modernism and emancipated Weston from a decayed Pictorialism. Stieglitz's *The Terminal* (pl. 197) may convince us of the driver's total commitment to the tram horses and their labours, but it still draws upon tonalist effects of bad weather in the British manner of Emerson and James Craig Annan. Strand's *Wall Street* (pl. 183) is an expressionistic exercise in which people hasten, unconscious of their fate, past great, blind window shapes. Stieglitz's *The Steerage* (pl. 199), which resulted from an interest shared with the painter Arthur Wesley Dow in Japanese or axonometric composition, was made a touch more significant by one woman having her back turned in the manner of Ter Borch and by the boy in the straw hat looking into the women's quarters in the impudent manner of youth. At these stages of their careers the photographers were as much concerned with the opacity of Modern art as with the transparency of the photographic medium. After 1920 they would prefer the viewer not to be conscious of any medium at all. They never lost their feeling for composition, but the vitalist belief that the most powerful response to nature was to be located somewhere between the literal and the metaphorical became the foundation of their aesthetic.

Stieglitz's portrait of Georgia O'Keeffe (pl. 205) has been turned through ninety degrees to transform the needle and thimble from an emblem of the domesticated woman (like the distaff) into an image of male and female antagonistic co-operation,

or interpenetration. By moving the hands away from the natural horizontal position to an awkward vertical one, they no longer appear to belong wholly to the same person. A sinewed lower hand, aggressively thimbled, snakes towards a flower-like hand with curving, foliate fingers, which both create an opening and push a needle into puckered fabric. The rhythm of the parts represents a whole, complex relationship.

Weston's hand-and-breast image (pl. 219) is tilted about forty-five degrees to make of an arm and leg two thighs, in relation to a breast rendered pudendal by shape and context. Our perception of the object is confused intentionally. Weston wanted us to retain in our minds the transparent or vital quality of the object rather than to allow our thoughts to be polarised by metaphor: he knew that the life of his picture, as opposed to the life of the object, depended entirely upon the shift back and forth between a sense of physical contact and perceptual contact, of animate and inanimate touch. The influence of T. A. Cook's *The Curves of Life* (1914) on Edward Steichen's sunflower and shell photographs was morphological in a scientific sense, but on Weston's shells and peppers, metamorphic in an artistic sense.[4] Yet the nautilus shell, the halved artichoke and the pepper (pl. 220) never lose touch with reality, no matter how strange they seem, no matter how perversely beautiful their vital growth.

When Strand described Stieglitz as a great engineer of the soul,[5] he was using Stalin's description of the artist to invoke not social revolution but psychological radicalism of the Lawrentian kind. If, by 1932, Strand was a socialist, he never abandoned the vitalist analogy: it became an essential part of his iconography of labour. His portrait of the New England farmer's wife (pl. 192) shows to her right a flat board studded with nails. Mrs Thompson's eyes, clasp, breasts and hands are notated abstractly, as it were, by the nails in the board—a trope of the most minimal kind of the loving grace of this aproned, working woman.

The family at Luzzara (pl. 193) combines and recombines the seated and standing figures of Strand's most important single work, *Photographs of Mexico* (1940), to transcend reportage and arrive at complete portrayal. Mrs Thompson's board is here replaced by the mother's sons standing and seated in the doorway as a single living tree. But this standing-seated motif results on the right in a bicycle wheel being substituted for a seated figure. In De Sica's film *Bicycle Thieves* (1948) this symbol refers culturally to mobility for employment,[6] but is presented here as the attribute of its owner, whose hat, neckerchief and waistcoat separate him from his brothers: his insouciant toes and casual air suggest a certain psychological distance in his relation both to them and to his mother. The son in profile standing near his mother is sufficiently abstracted from our view to suggest an effigy of the absent father, while the son seated on the doorstep, at the centre of the picture, is the only one to confront us directly: feet firmly planted, his arms are folded in a gesture protective of a working household particularised by bars of soap above the lintel. This is a Neo-realist conversation piece of the very highest order.

The relation between opaque idea and transparent detail is embodied in Strand's portrait of Stieglitz (fig. 12), in which one spectacle lens relates to the shiny knot-hole on the gnarled trunk, and the other lens, to the eccentric blur of light in the black window of the house: Strand's mentor combines in himself the organic life of a tree with the abstract design of a building. It is an abstract-concrete portrait of Stieglitz in which the sense of tangibility—hairs sprouting from his ears like some Pan-figure—so essential to the vitalist approach is more physical than spiritual. This was the fundamental idea behind 'An American Place'. Although Stieglitz showed his own and Strand's work there in February and April 1932, he never showed Weston's. But there can be no doubt that Weston was associated in his own mind as well as in Stieglitz's with such a place so necessary to a culture without benefit of milieu.

Fig. 12 Paul Strand, *Alfred Stieglitz, Lake George, New York*, 1929. Copyright © 1971, Aperture Foundation, Inc., Paul Strand Archive.

4 For more on this, see Mike Weaver, 'Curves of Art', in *EW: Centennial Essays in Honor of Edward Weston*, ed. P. C. Bunnell and D. Featherstone, Carmel 1986, 80–91.

5 P. Strand, 'Alfred Stieglitz 1864–1946', *New Masses* (6 August 1946), 7.

6 The script of *Bicycle Thieves* was by Cesare Zavattini, who wrote also the text for Strand's Italian book, *Un Paese*, Turin 1955.

EDWARD WESTON

from 'America and Photography' (1929)

Photography in America is in a sadly anaemic condition,—only a few strong figures outstanding. Generally speaking, the stage has been held by dextrous technicians who depart as far as possible from photographic quality: or on the other hand by those who think photography an easy way to release and expose their excess personal emotions or aspirations. They could not do so with such an honest, direct, uncompromising medium without resorting to tricks,—diffusion of focus, manipulation of prints, or worse, recording of calculated expressions and postures.

Hundreds of tired businessmen or tradesmen, and idle women, play with photography as a holiday hobby,—then offer their results as 'art!'

Opposing this facile approach is a photography free from technical tricks and incoherent emotionalism. The finished print is previsioned on the ground glass while focussing, the final result felt at that moment,—in all its values and related forms: the shutter's release fixes forever these values and forms,—developing [,] printing becomes only a careful carrying on of the original idea.

Those who feel nothing, or not completely at the *time of exposure*, relying upon subsequent manipulation to reach an unpremeditated end, are predestined to failure.

Nothing can be transmitted to another, unless an original problem has been felt, conceived and solved: not a trivial problem of clever decoration or the personal ego, but the recording of the very quintessence and interdependence of all life.

Vincent Van Gogh wrote: 'A feeling for things in themselves is much more important than a sense of the pictorial.'

Photographers take note!

With a medium capable of revealing more than the eye sees, 'things in themselves' could be recorded, clearly, powerfully: but instead these 'pictorial' photographers resort to impressionistic blur.

Impressionism is scepticism; it puts what one casually notices above what one positively knows.

Not to interpret in terms of personal fancy, transitory and superficial moods, but present with utmost exactness,—this is the way in photography,—and it is not an easy way. Vision, sensitive reaction, the knowing of life, all are requisite in those who would direct through the lens forms from out of nature,—maybe only a fragment, but indicating or symbolising life rhythms.

I have written of photography as 'direct, honest, uncompromising,'–and so it is when used in its purity, if the worker himself is equally sincere and understanding in selection and presentation. Then it has a power and vitality which moves and holds the spectator. There can be no lie in such photography. No human hand of possible frailty has in the recording lessened its pristine beauty, nor misrepresented its meaning, destroying significance.

A once well known photographer stated as an argument for controlled or manipulated prints that photography needed the vitalising influence of the hand. Then why photograph at all! The artist of brush and palette has a trained hand with which to better execute and express all things in a better way. Photography has, as already indicated, intrinsic value and use, apart from any other medium.

I have allowed the word 'art' to enter in? In this day of ever changing values it is

Manuscript © 1981, Arizona Board of Regents, Center for Creative Photography.

immaterial whether or not photography can be labelled art. It is of our day,—we understand, respond to and need photography as a vital contemporary expression.

But for the sake of argument,—the difference between good and bad art in any medium or of any age lies in the creative mind rather than in skill of hands. The way of seeing is what counts and that is conditioned by the artist's attitude, not by his skill as craftsman. Given a big enough artist and he will make of himself a consummate craftsman to better express his thoughts.

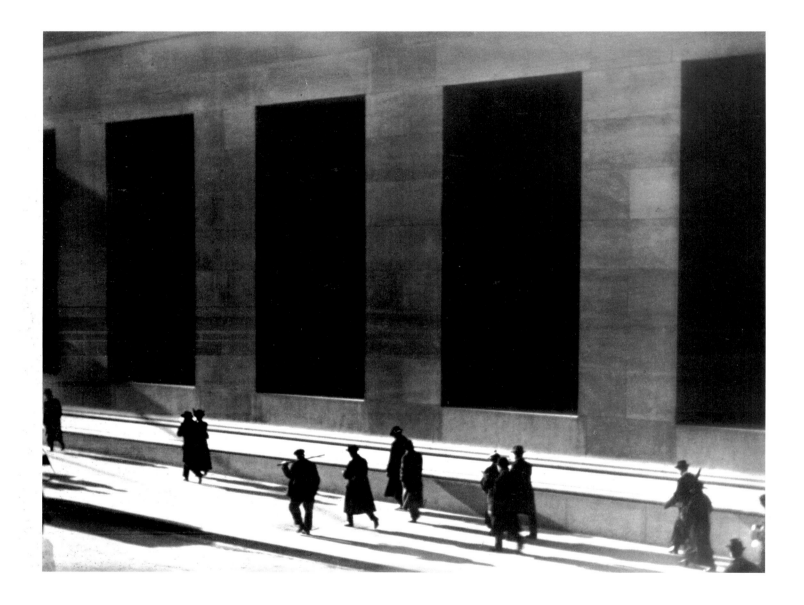

183 Strand *Wall Street, New York* 1915

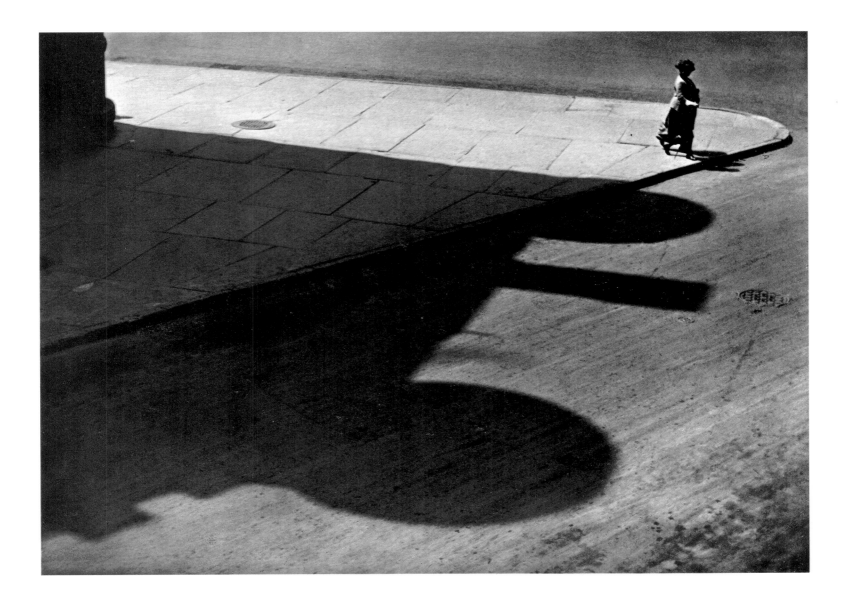

184 Strand *People, Streets of New York, 83rd and West End Avenue* 1915

185 Strand *Shadows, Twin Lakes, Connecticut* 1916

186 Strand *Abstraction, Bowls, Twin Lakes, Connecticut . 1916*

187 Strand *Wire Wheel, New York* 1918

188 Strand *Man, Five Points Square, New York* 1916

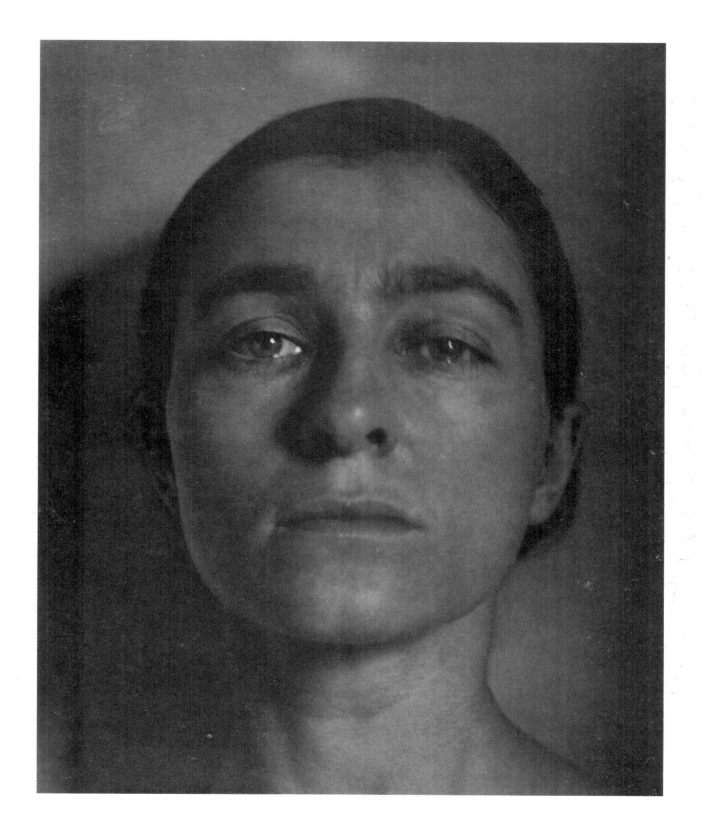

189 Strand *Rebecca, New York* c. 1922

190　Strand　*Church on the Hill, Vermont*　1946　　　　191　Strand　*Bell Rope, Massachusetts*　1945

192 Strand *Susan Thompson, Cape Split, Maine* 1945

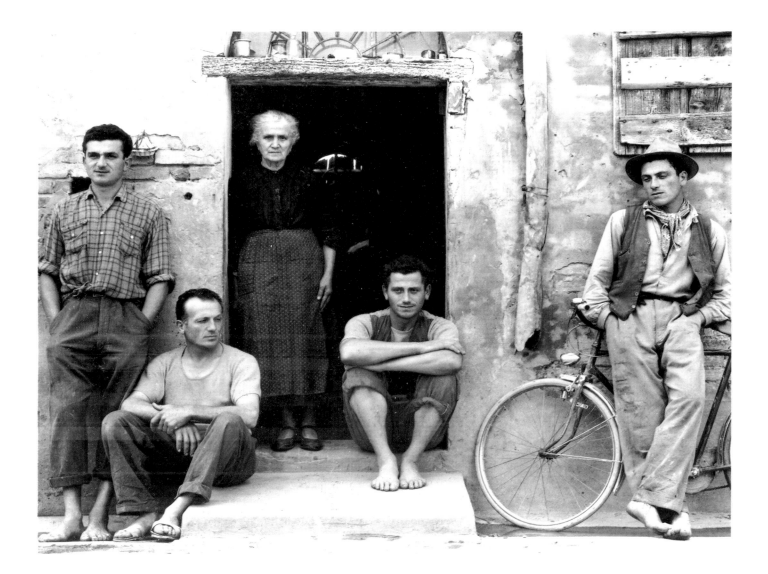

193 Strand *The Family, Luzzara, Italy* 1953

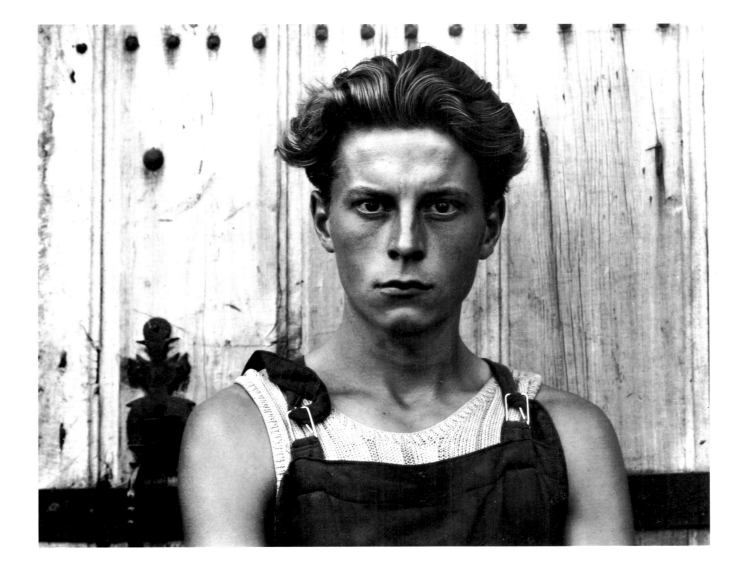

194 Strand *Young Boy, Gondeville, Charente, France* 1951

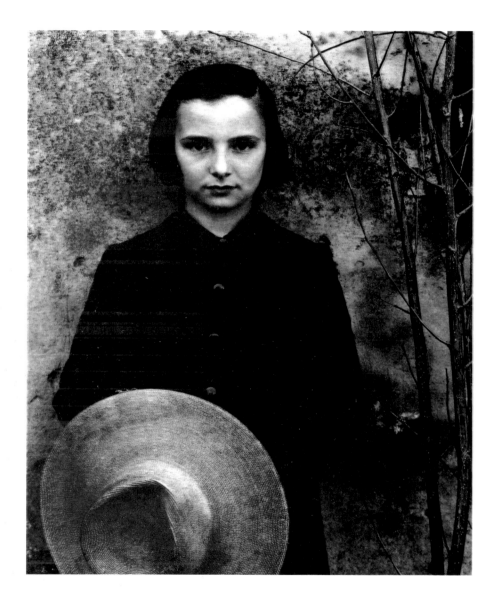

195 Strand *Tailor's Apprentice, Luzzara, Italy* 1953

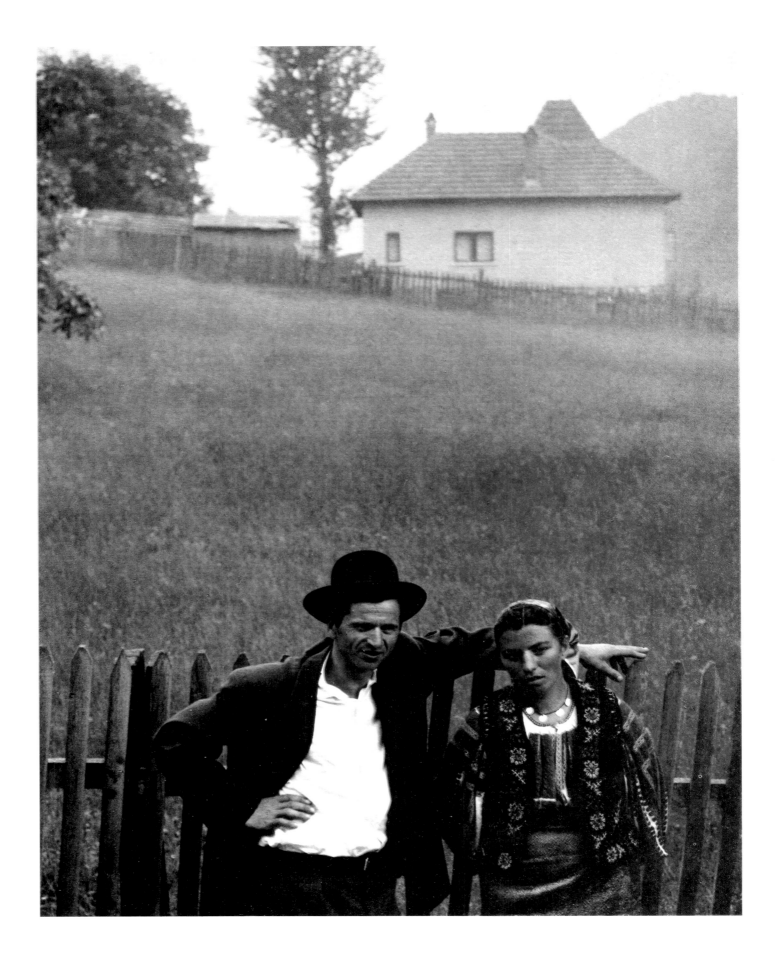

196 Strand *Couple at Rucar, Rumania* 1967

197 Stieglitz *The Terminal* 1893

198 Stieglitz *The Hand of Man* 1902

200 Stieglitz *Out of the Window, '291', New York* 1915

201 Stieglitz *From the Back Window, '291', New York* 1915

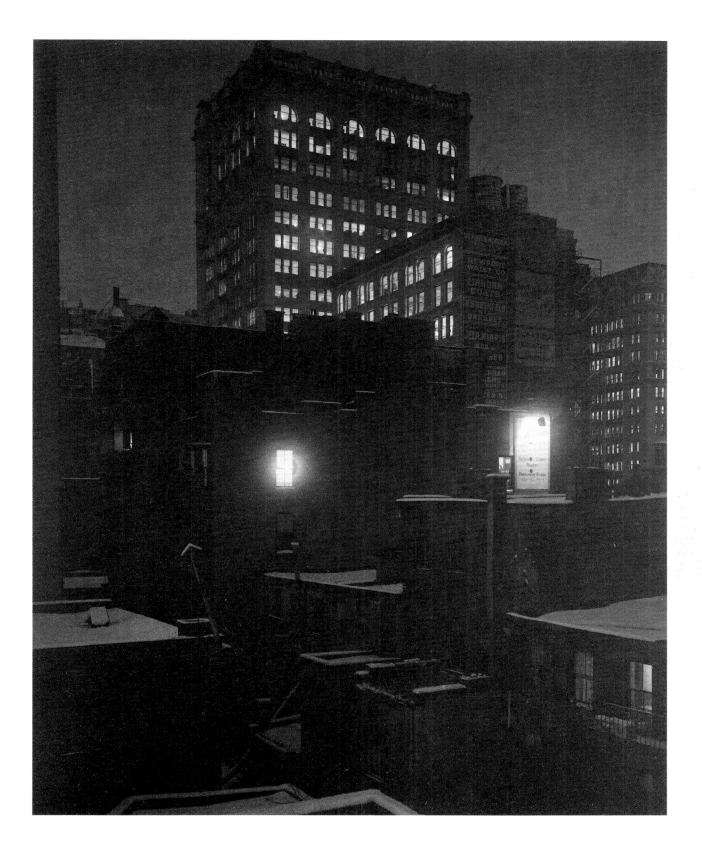

202 Stieglitz *From the Back Window, '291', New York* 1915

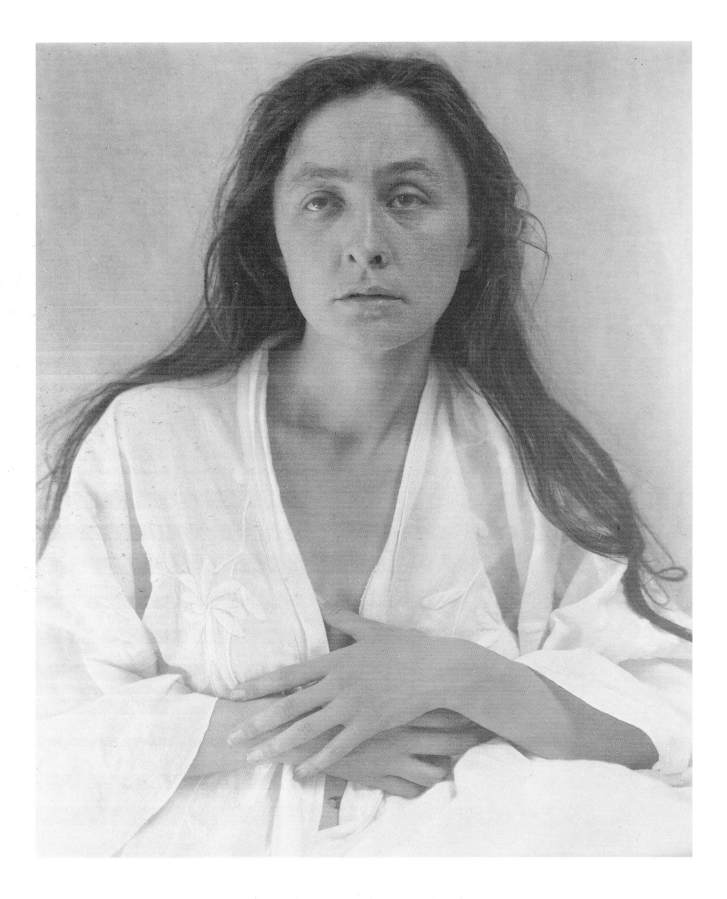

203 Stieglitz *Georgia O'Keeffe: A Portrait* 1918

204 Stieglitz *Georgia O'Keeffe: A Portrait—Neck* 1921

205 Stieglitz *Hands with Thimble* 1920

206 Stieglitz *Music: A Sequence of Ten Cloud Photographs, No. VIII* 1922

207 Stieglitz *Equivalent* 1924–26

208 Stieglitz *House with Grape Leaves* 1934

209 Stieglitz *Grapes and Vine* 1933

210 Stieglitz *From the Shelton, looking west* 1935–36

211 Stieglitz *From the Shelton, looking west* 1933–35

212 Weston *Armco Steel, Ohio* 1922

213 Weston *Attic* 1921

214 Weston *Untitled* 1919

215 Weston *Cloud, Mexico* 1926

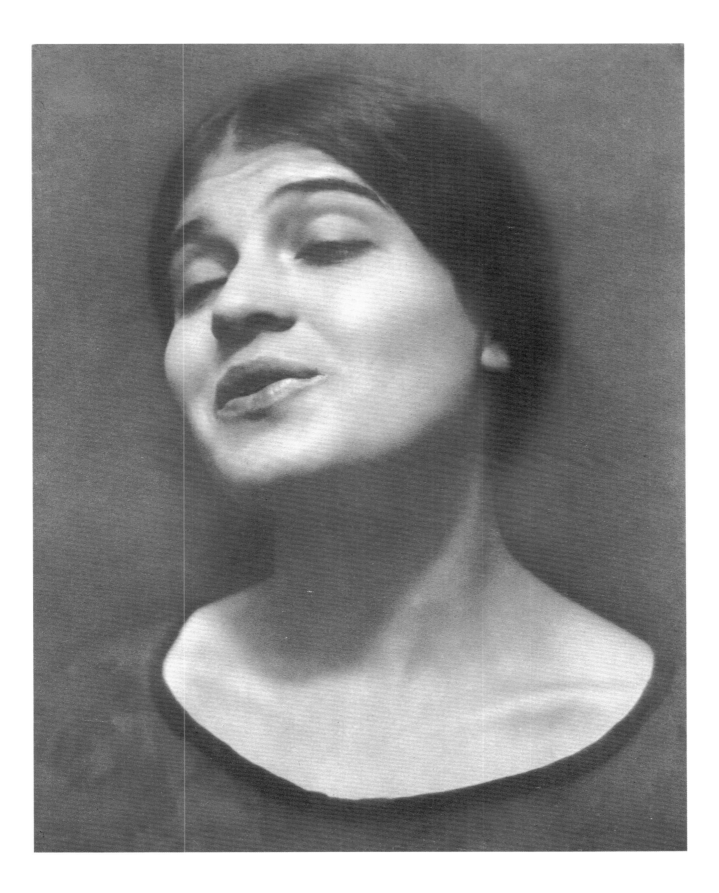

216 Weston *Tina Modotti* 1924

217 Weston *Of Neil* 1925

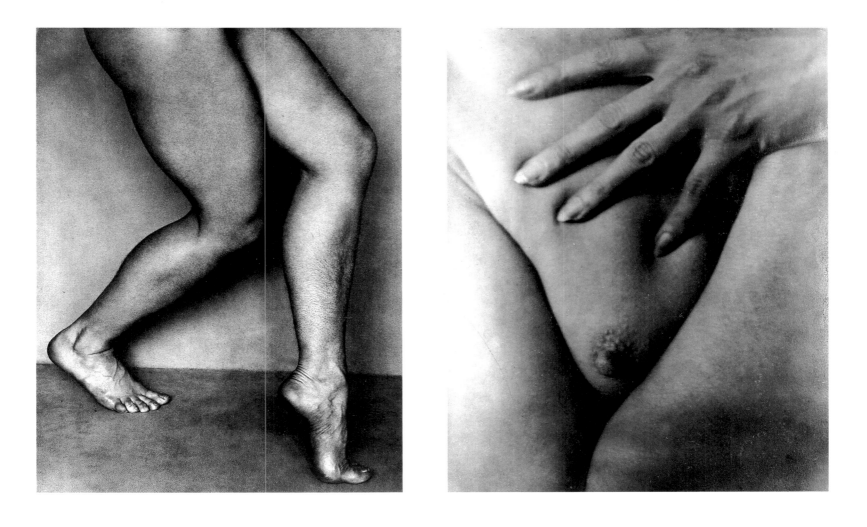

218 Weston *Legs* 1927

219 Weston *Hand on Breast* c. 1923

221 Weston *Dunes, Oceano (The Black Dune)* 1936

222 Weston *Tide Pool, Point Lobos* 1940

223 Weston *Point Lobos* 1946

8

Robert Shapazian

THE MODERN MOVEMENT

Around 1910, photographers imbued with the Modernist spirit saw in a sudden and intense way what few had seen before: that in photographic imagery the world seemed at once solid and intangible, present yet ephemeral. This paradoxical fusion of the concrete and the intangible seemed also to offer them a complex visual field in which they, like Modernist artists everywhere, could both evoke the enigmatic nature of presence and question the reality of permanence. This fresh understanding of an intangible element in photography was the common starting point for many new approaches, approaches that were political, aesthetic, psychological or perceptual, depending on the photographer.

Consider this statement by Tristan Tzara, written in 1922:

> The photographer has invented a new method; he presents to space an image that goes beyond it; and the air, with its clenched hands, and its advantage of surmounting all, captures it and keeps it in its breast.[1]

And this by El Lissitzky, written in 1925:

> We are now producing work which in its overall effect is essentially intangible. For we do not consider a work monumental in the sense that it may last for a year, a century, or a millenium, but rather on the basis of continual expansion of human performance.[2]

Tzara is describing the phantom appeararance of Man Ray's Rayographs which profoundly influenced the course of Surrealist photography. These are camera-less photograms made by placing objects on photographic paper and then allowing light to shine upon them. Rayographs thus distil photography to a trace of fugitive reality, made by light and shade. But Tzara might well have been describing Man Ray's camera pictures too.

In contrast, Lissitzky speaks for Constructivism, a programme directed towards conceptualising, then achieving, a new society. Constructivism affirms man's belief in his power to change his vision and his material world; its stance engendered the photographic work of Rodchenko, of Moholy-Nagy and of a great tide of Modernist photography that emerged in Germany in the mid-1920s.

Two early examples of avant-garde photography in this section are based on this new sense of photography's connection to the intangible. For a few years beginning in 1911, the Futurist Anton Giulio Bragaglia made photographs, of human bodies in motion. The true subject of these photographs, however, is not movement, but the location of pure energy and the shape of motion's underlying dynamic, which the Futurists believed to be the essential property of reality. For Bragaglia, the blur fixed upon the image was the mark of this unfixed and disembodied energy and dynamism (fig. 13).

Similarly, one of Marcel Duchamp's first photographic experiments, made in 1914, shows a piece of spotted gauze blowing in the wind (fig. 14). The shape of the gauze, as fixed by the image, registers forever the path of the otherwise unseen and ephemeral wind. From this image Duchamp then charted the position of three

1 From the Preface to *Champs Délicieux*, Paris 1922; an album of twelve Rayographs by Man Ray published in an edition of forty signed and numbered examples.
2 From 'A. and Pangeometry', in *Europa Almanach*, Potsdam 1925. Reprinted in *Russia: An Architecture for World Revolution*, trans. Eric Dluhosch, Cambridge, Mass. 1970, 149.

Fig. 13 Anton Giulio Bragaglia, *Photodynamic*, 1911.

Fig. 14 Marcel Duchamp, *Piston de courant d'air*, 1914.

elements (called 'draught pistons') in his now famous three-dimensional construction of 1915–23, *The Bride Stripped Bare by her Bachelors Even (The Large Glass)*. But since it is not only the wind's path but the photographic image that was thus translated into the sculptural work, the print, which is conventionally thought of as an artistic *end*, is here perceived to be only an intermediary and fugitive *means*, a step in the wind's passage toward its final transformation and resting place in *Large Glass*.

In 1918, Man Ray, influenced by Duchamp, created the photograph *Woman* (pl. 239), in which banal and enigmatic objects—clothes-pins, some sort of metal discs—are brought together with a title that refers to human gender and corporeality. Like a shadow of a woman, Man Ray's odd assemblage stands for everything evoked by the word 'woman'. Indeed, both the assemblage and its title are equally signs for the concept, woman. It is this concept, then, hovering like a phantom above assemblage, image and title alike, that is the picture's intangible element.

Dust Breeding (pl. 241)—a photograph of Duchamp's *Large Glass*—also depends upon this sort of accrued meaning. Because Duchamp wanted to infuse the *Large Glass* with ingredients not usual to art-making he let dust settle for months on the work and intended then to trap the accumulated debris under varnish within an area of it called 'The Sieves'. In this way time, air and gravity would become embodied in the work—like a 'pigment' embedded in painting, according to Duchamp. One evening he and Man Ray decided to photograph the dusty surface. They set up the camera, opened the lens in low light, and went out to dinner.[3] In the hour that followed, the image drifted through the lens onto the photographic plate, just as the dust had settled upon the *Large Glass*, or as light passes into the eye to form in the mind a visual image of the external world. The camera eye, left alone, watched, like a living organ, the passage of light and dust through time; the 'click' of photographic time passed for a while into the slowness of real time, only to snap back into photography's stasis in the finished print. But when we understand the event and the idea behind this photograph we perceive the print as an image, like a motion-picture image, of slowly moving time, of the natural history of light and dust; only here, movement and pace belong to the realms of thought and conceptualisation.

Pictures like this, whose effects exceed what visual imagery alone can express and properly reside in the mind's eye, are like visual fields of abstract space in which conceptual play is as important as visible fact or as pictorial structure. El Lissitzky's *The Constructor* (pl. 263) is such a picture. The fragmented objects it represents appear to float like disembodied elements within a field, or like notations in a mathematical equation, itself a sign of abstract thought. Its subject is an abstraction too, for although this is a photographic self-portrait it is hardly a description of a specific man; rather, it is a projection of a new and ideal type of artist seen with the tools of his new mode of artistic production: compass, graph papers, stencilled letters—not brush and easel. The camera is conspicuously absent too, for Lissitzky rejects also the rôle of the traditional photographer. For him the camera eye is not the equal of the new and powerful eye of the artist-constructor that rivets our attention in this picture; nor can traditional photography describe the field of layered and partially transparent objects that have surrendered their materiality to Constructivism's vision.

Rodchenko also wanted photography to change the eye, the mind and the material world of the common man. Rodchenko disavowed art for art's sake, which he called 'useless' art, and wanted his photographs, which documented the physical power and substance of men and materials, to serve social reconstruction after the 1917 revolution. Indeed, the faces and bodies pushed up against the picture plane, the torque of twisted buildings and crowded streets, and the uniform darkness and sombre tone of the photographs convey sobriety, unification and power in mass. The monolithic quality of these pictures provided an image of substance to a people that

3 Man Ray, *Self Portrait*, Boston, Mass. 1963, 91.

recognised that the material betterment predicted by the ideology of the new regime was a long way off.

In comparison, the Constructivist pictures of Moholy-Nagy appear delicate, meticulous and more conventionally aesthetic. Moreover, his photographs do not investigate ideas of trace and presence as do Man Ray's Rayographs, which inspired them. The forms, light and angles in Moholy's camera-less photographs are not effects of chance but of engineering. Moholy's love of engineering is a Constructivist, not a Surrealist trait. But his Photoplastiks (photographs of collages made up of photographic imagery and drawing) do show Surrealism's influence. For these not only bring their clearly factual photographic imagery into an ambiguous space directly reminiscent of the void-like ground common to both the photograms and the Rayographs; like Surrealism, they use imagery that is psychologically charged. Unlike the more rigorous Duchamp, Man Ray and Lissitzky, Moholy is eclectic in his anti-realism. This is true also of his theoretical writings, which postulate a utopian synthesis of all kinds of media and technologies.

Unlike his ideological, theoretical and visionary contemporaries, Kertész celebrated intimacy, personal emotion, and the charm of man's environment. In his work the city of Paris is transformed into a place of repose, like the accommodating décor of the rooms that are so often his settings. Compliance governs the dissolving bodies of the nudes in the series *Distortions* (pl. 258), just as it does the drooping of a tulip (pl. 257) or of the heavy eyelids of a young woman (pl. 250). Photography is not used here to argue the problematic nature of presence. Ultimately, Kertész's photographs are lyrical responses to a present that is charged with passivity and reverie. They herald a new attitude towards tangibility: the availability and acceptance of things as they are, just as they appear in the world—and in the photograph.

László Moholy-Nagy

from 'A New Instrument of Vision' (1932)

THE EIGHT VARIETIES OF PHOTOGRAPHIC VISION

1. Abstract seeing by means of direct records of forms produced by light: the photogram which captures the most delicate gradations of light values, both chiaroscuro and coloured.

2. Exact seeing by means of the normal fixation of the appearance of things: reportage.

3. Rapid seeing by means of the fixation of movements in the shortest possible time: snapshots.

4. Slow seeing by means of the fixation of movements spread over a period of time: *e.g.*, the luminous tracks made by the headlights of motor cars passing along a road at night: prolonged time exposures.

5. Intensified seeing by means of:
 a) micro-photography;
 b) filter-photography, which, by variation of the chemical composition of the sensitised surface, permits photographic potentialities to be augmented in various ways—ranging from the revelation of far-distant landscapes veiled in haze or fog to exposures in complete darkness: infra-red photography.

6. Penetrative seeing by means of X-rays: radiography.

7. Simultaneous seeing by means of transparent superimposition: the future process of automatic photomontage.

8. Distorted seeing: optical jokes that can be automatically produced by:
 a) exposure through a lens fitted with prisms, and the device of reflecting mirrors; or
 b) mechanical and chemical manipulation of the negative after exposure. . . .

All interpretations of photography have hitherto been influenced by the aesthetic-philosophic concepts that circumscribed painting. These were for long held to be equally applicable to photographic practice. Up to now, photography has remained in rather rigid dependence on the traditional forms of painting; and like painting it has passed through the successive stages of all the various 'isms'; though in no sense to its advantage. Fundamentally new discoveries cannot for long be confined to the mentality and practice of bygone periods with impunity. When that happens all productive activity is arrested. This was plainly evinced in photography, which has yielded no results of any value except in those fields where, as in scientific work, it has been employed without artistic ambitions. Here alone did it prove the pioneer of an original development, or of one peculiar to itself.

Extract from *Telehor* 1, 2 (1936).

224 Rodchenko *Pioneer* 1930

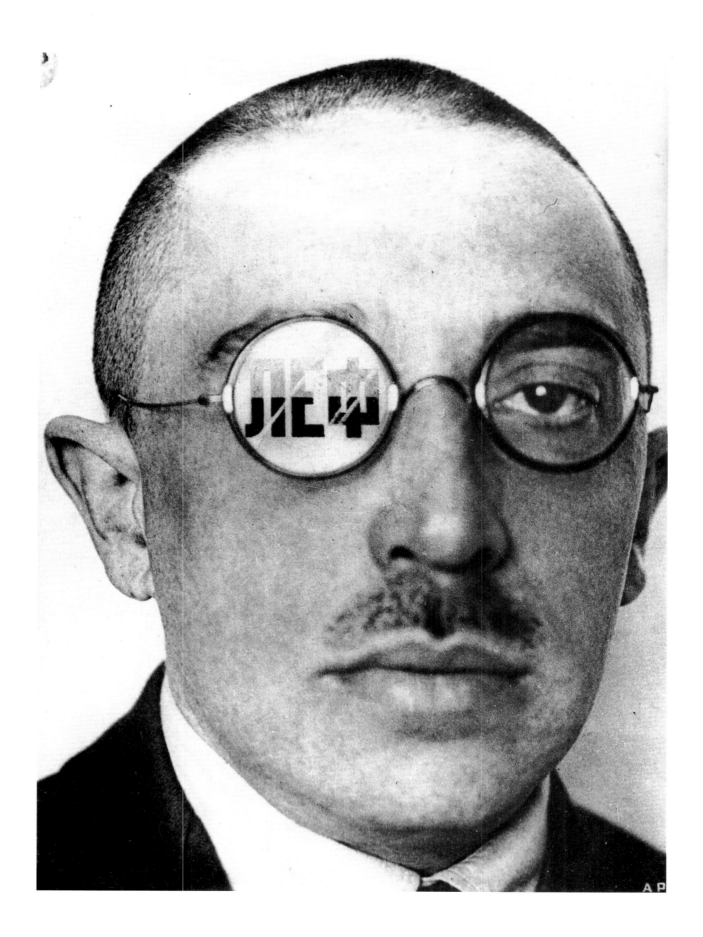

225 Rodchenko *The Critic Osip Brik* 1924

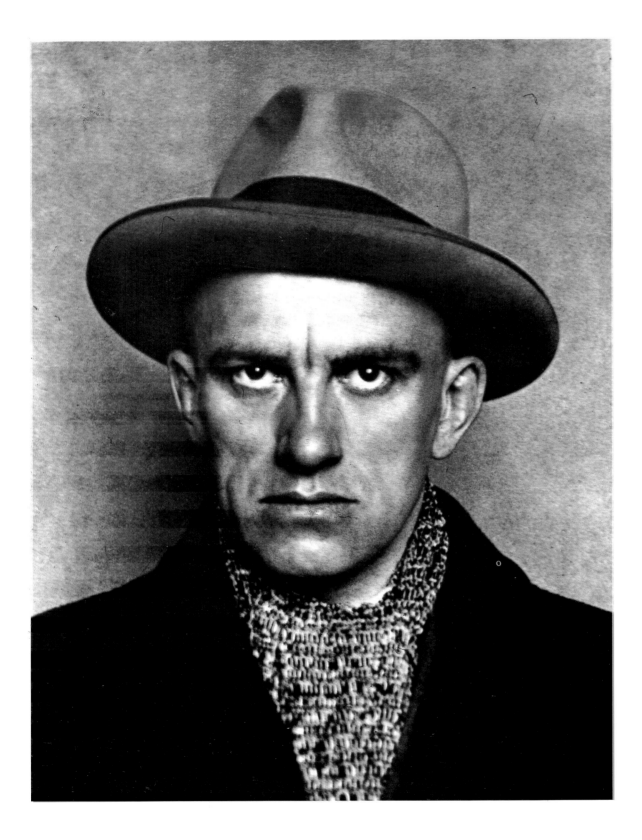

226 Rodchenko *Vladimir Mayakovsky* 1924

227 Rodchenko *Pioneer with a Horn* 1930

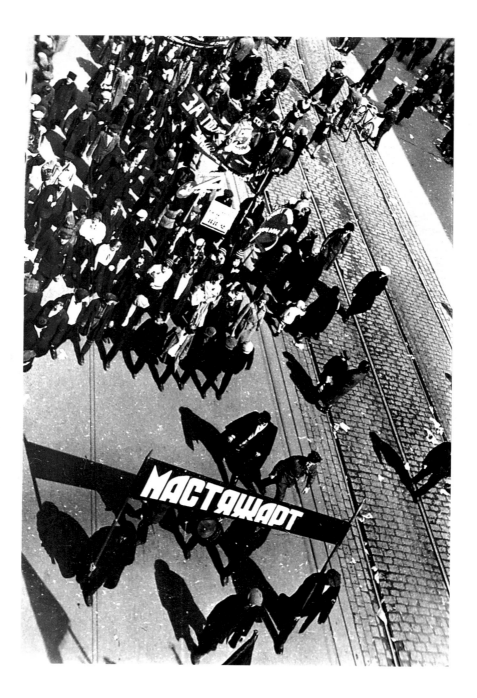

228 Rodchenko *To the Demonstration* 1932

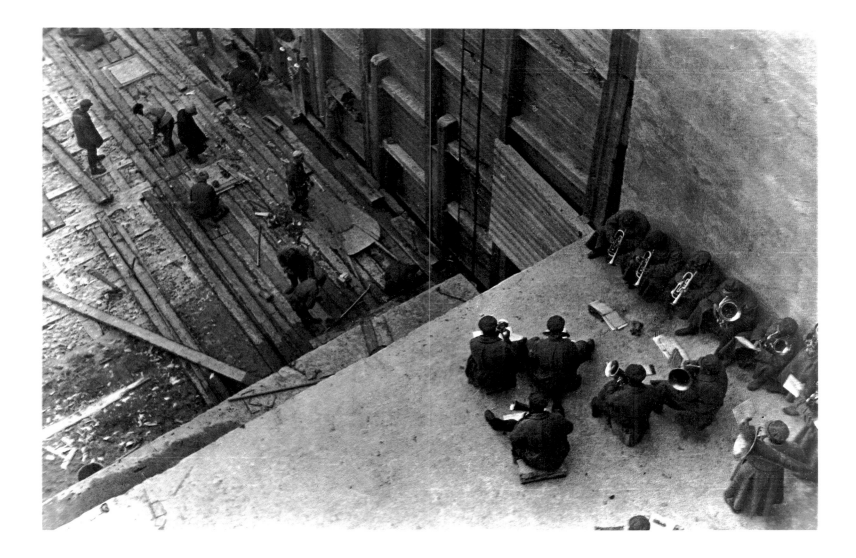

229 Rodchenko *Rehearsal, Belomorsk Canal* 1933

230 Rodchenko *Woman with Leica* 1934

231 Rodchenko *Sentry of Shukhov Tower* 1929

232 Rodchenko *Radio Listener* 1929

233 Moholy-Nagy *Boats in the Old Port of Marseilles* 1929

234 Moholy-Nagy *Marseilles* 1929

235 Moholy-Nagy *View from the Pont Transbordeur, Marseilles* 1929

236 Moholy-Nagy *Untitled* 1928

237 Moholy-Nagy *Photogram: Positive-Negative* after 1922

238 Moholy-Nagy *Negative* 1931

239 Man Ray *Woman* 1918

240 Man Ray *Man* 1918

241 Man Ray *Dust Breeding* 1920

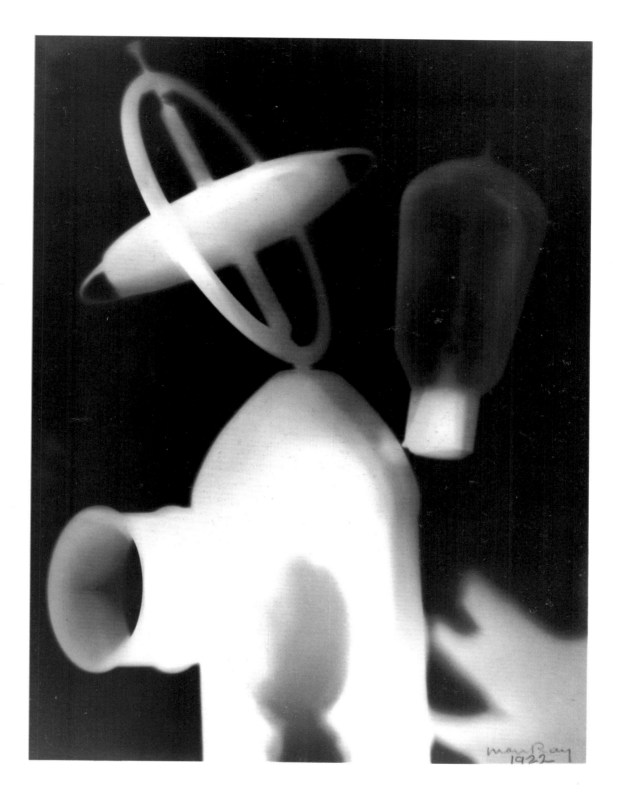

242 Man Ray *Untitled (Gyroscope)* 1922

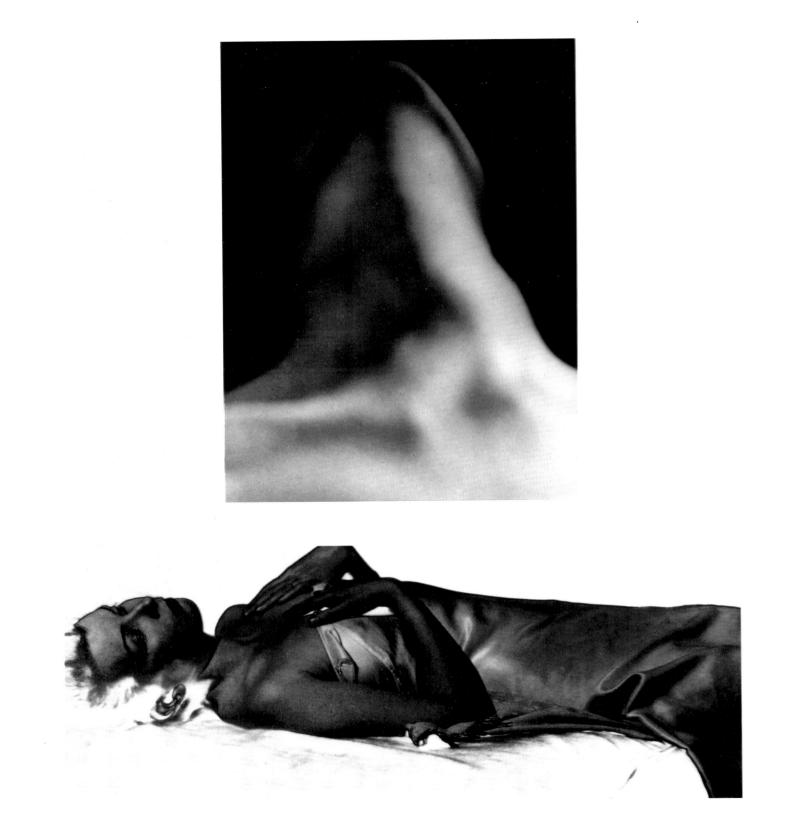

243 Man Ray *Neck* 1929

244 Man Ray *Reclining Nude on a satin Sheet* c. 1930

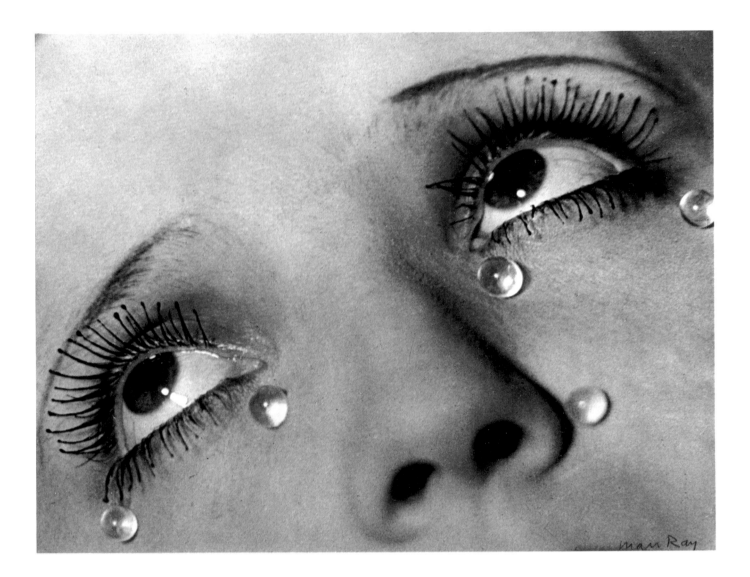

247 Man Ray *Glass Tears* c. 1930

249 Kertész *Chez Mondrian* 1926

250 Kertész *Anne-Marie Merkel* 1926

254 Kertész *Etienne Béothy, a Satiric Dancer* 1928

255 Kertész *Satiric Dancer* 1926

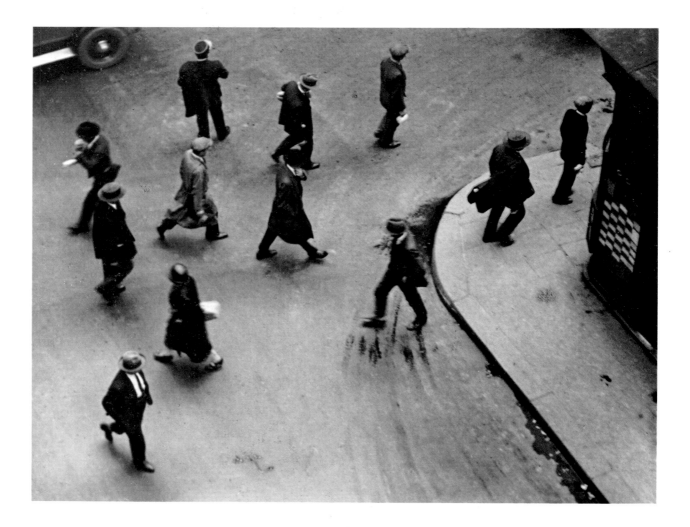

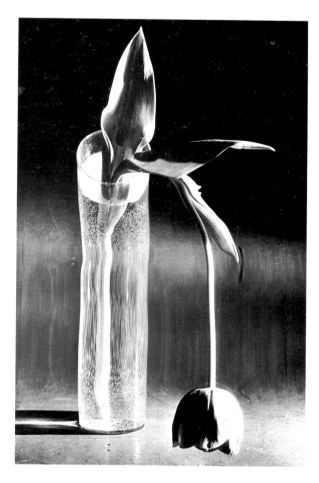

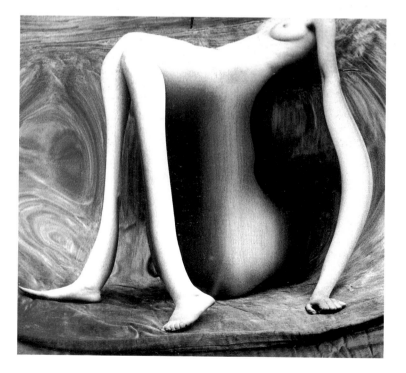

257 Kertész *Melancholic Tulip* 1939

258 Kertész *Distortion No. 141* 1933

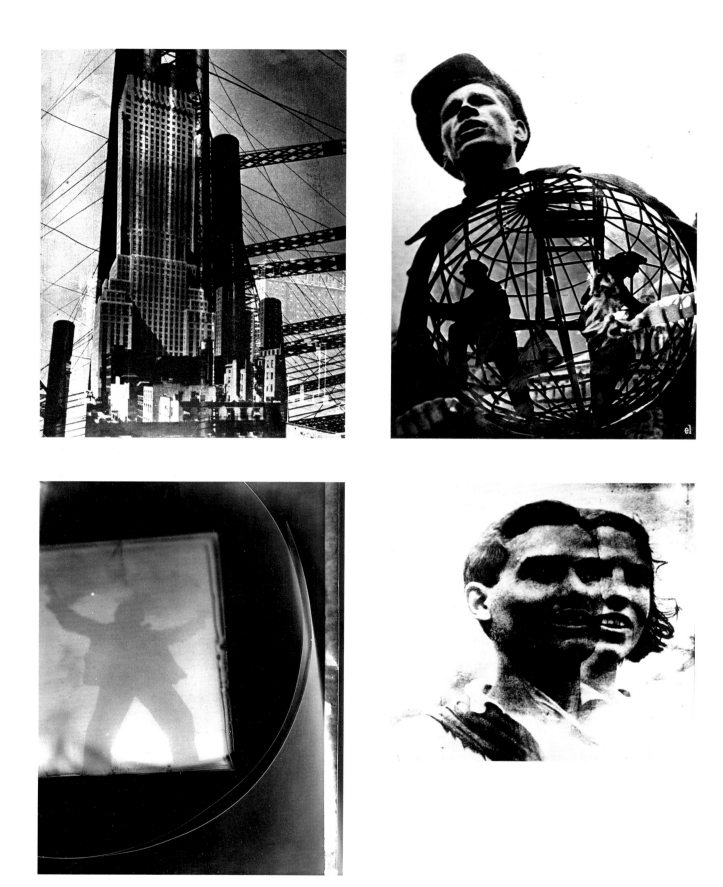

259 El Lissitzky *Photomontage: Study for Richard Neutra's 'Amerika'*
1929–30

260 El Lissitzky *Socialist Construction, Dresden 1930* 1929

261 El Lissitzky *Untitled* c. 1928

262 El Lissitzky *Photomontage: Study for a Poster* c. 1928

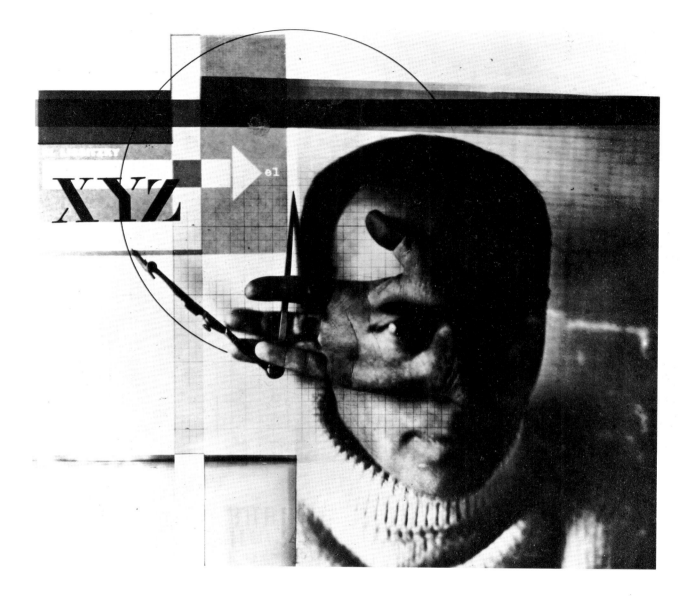

263 El Lissitzky *The Constructor* 1924

9

Ben Lifson
EUROPEAN DOCUMENTARY STYLES

The photographs in this section, taken in London, Paris, Cologne, Mexico City, Barcelona and large cities generally, between about 1920 and 1940, seem to tell us a great deal about how people behaved and how the familiar objects of everyday life looked then. And although these accounts, like all accounts of appearances given by art, are only generalisations (and sometimes poetic or idiosyncratic ones), the visual information given by them is so much more precise, detailed and immediate than generalisations about similar things in literature or visual art in this century that we grant such pictures a unique truthfulness and call them 'documents' and their style 'documentary'.

These terms can imply that photographs in this style are of a lesser order than photographs that we call art, an implication that has always vexed photographers, critics and historians. Except for the German August Sander, every photographer here—the Frenchmen Eugène Atget and Henri Cartier-Bresson, the Englishman Bill Brandt, the Transylvanian Brassaï—was trained in painting or in sculpture before turning to photography, and all were concerned with themes—the city, for example—or with issues of form that preoccupied leading visual and literary artists of their day. If here we see such details as a worker's greasy meal or the cheap furnishings of a prostitute's room presented in what strikes us first as an unartistic truthfulness, we must remember that in this same period we find theatre stubs and scraps of street trash in collage, bicycle handlebars in sculpture, passages from lurid popular melodrama in novels, and other common, utilitarian, unlovely, impolite and even indecent objects and texts taken straight out of life and inserted into works of art, apparently untransformed by any artistic means. If the details that we find in Brassaï's brothels and in Bill Brandt's upper-class drawing rooms can be considered as documentary evidence of archaeologists or private detectives, so can the pieces of oilcloth and the newspaper articles describing political rallies and crimes of passion found in Picasso's collages. Yet photographs containing apparently direct images of such objects are the only art form of the period called 'documentary'.

If the term is used widely it is often for lack of a better. This is not, however, a reason to overlook the accounts given by the pictures here. For it is upon the illusion of fact that art has built its imaginative worlds. And the skills of observation and of generalisation with which the artist constructed his illusions, and the magical skill that transforms illusion into vision, are no less difficult to acquire in photography than in painting or in literature, and the transformations no less wonderful to behold.

Thus, we can turn with gratitude and pleasure to these pictures for an abbreviated and fragmentary history of useful and decorative objects in homes and public places between the two World Wars. Much of the information here is about lower-class life, although Sander is good on the upper classes' clothes, Brandt on their crystal, silver, board games and servants' uniforms, and Atget on their parks and statues. Which is to say that these pictures—and especially Brandt's—sketch the class structure of Europe in the 1920s and 1930s as reflected by the objects of the rich and poor—and by how they are used, for these photographs also contain a history of gesture. Consider a cigar held by an aristocrat's white-gloved hand in twilight (pl. 299), a cigarette clenched between a modern urban woman's teeth (pl. 295) or one held by a woman in a bistro brushing her hair back as she accepts a kiss (pl. 284).

Within the groups of pictures representing each artist are smaller and more specialised accounts: of the fashions of the Parisian underworld in the 1930s (Brassaï); of walls, and of the volatile emotional life of large cities everywhere during the same decade (Cartier-Bresson); of French culture between the seventeenth and early twentieth centuries (Atget); and of costume and pose as signs of class, politics, occupation and psychological distress in the German people between the end of World War I and Hitler's coming to power (Sander). Still other accounts are given by various combinations of the individual photographers. Brandt, Brassaï and Sander, for example, give us a survey of rooms. In Atget's, Brassaï's and Cartier-Bresson's pictures of prostitution we can read a history of erotic style and erotic scenes, and of the mechanisms of sexual enticement.

The characters and objects that here are so full of the passions, confusions, tastes and issues of their times are also charged with the strength and surprises of art. Consider only the human figure: the flat and weightless torso of Sander's woman in white; Brandt's characters, built up out of shadow and void; and the dramatic variations upon face and figure in Brassaï's mirrors. Consider also, in Cartier-Bresson's frieze of boys at play (pl. 276), the various ways his lens has drawn the head. Moreover, each boy seems to have been photographed separately, without regard to how he was to fit into the picture, and the group of boys to have been treated independently from the crazily windowed building in the background. Scale and handling are so inconsistent throughout that this picture could have been pasted together, like a collage, from several photographs.

Like other Modernist artists of the time, these photographers responded to a rapidly changing and disorienting world. Their photographs gather and display large amounts of facts within single frames without resolving their visual, psychological or social contradictions. The resulting visual order within these frames has little to do with the orders of lists or ledgers, nor does it often follow traditional rules of composition or our world's physical laws. Rather, these photographs discover worlds with laws of their own. They create the worlds that they report upon; their generalisations are poetic responses. Cartier-Bresson's photograph of a woman standing next to a poster advertising corsets (pl. 272) could be a picture taken in an artist's studio: the painting with its model, or indeed its author. These pictures are, in general, documents of possibilities seen in appearances by the imagination.

Perhaps 'documentary' is the wrong term. The American photographer Joseph Bartscherer proposes 'expository'. This has the virtue of allowing us to consider that the distinctions between photographs we have called art and those we have called documents are distinctions between rhetorical modes within the art of photography itself. Perhaps the only true sense in which the photographs here are documents is an idealistic one: photographs in this style are documents of an ideal republic whose citizens know the degree to which knowledge, truth and beauty are one, and demand that all three be present to no less than that degree in the republic's daily accounts and common archives. In such a commonwealth a newspaper account of severe weather would have not only the wealth of observation but also the reach and the sonority found in the description of fog in the opening paragraphs of Charles Dickens's *Bleak House*. Its guide books, and the reports by its tax assessors, municipal surveyors, bureaucrats and public scribes, would have not only the plainness and the comfortable relationship to fact but the ability to generalise the calm music and the subtle accents of emotional response and ethical position of this sentence from the opening page of Charlotte Brontë's *Villette* (1853): 'The large peaceful rooms, the well-arranged furniture, the clear wide windows, the balcony outside, looking down on a fine antique street, where Sundays and holidays seemed always to abide—so quiet was its atmosphere, so clean its pavement—these things pleased me well.'

HENRI CARTIER-BRESSON

from **The Decisive Moment** (1952)

In photography there is a new kind of plasticity, product of the instantaneous lines made by movements of the subject. We work in unison with movement as though it were a presentiment of the way in which life itself unfolds. But inside movement there is one moment at which the elements in motion are in balance. Photography must seize upon this moment and hold immobile the equilibrium of it.

The photographer's eye is perpetually evaluating. A photographer can bring coincidence of line simply by moving his head a fraction of a millimetre. He can modify perspectives by a slight bending of the knees. By placing the camera closer to or farther from the subject, he draws a detail—and it can be subordinated, or he can be tyrannised by it. But he composes a picture in very nearly the same amount of time it takes to click the shutter, at the speed of reflex action.

Sometimes it happens that you stall, delay, wait for something to happen. Sometimes you have the feeling that here are all the makings of a picture—except for just one thing that seems to be missing. But what one thing? Perhaps someone suddenly walks into your range of view. You follow his progress through the viewfinder. You wait and wait, and then finally you press the button—and you depart with the feeling (though you don't know why) that you've really got something. Later, to substantiate this, you can take a print of this picture, trace on it the geometric figures which come up under analysis, and you'll observe that, if the shutter was released at the decisive moment, you have instinctively fixed a geometric pattern without which the photograph would have been both formless and lifeless.

Composition must be one of our constant preoccupations, but at the moment of shooting it can stem only from our intuition, for we are out to capture the fugitive moment, and all the interrelationships involved are on the move. In applying the Golden Rule, the only pair of compasses at the photographer's disposal is his own pair of eyes. Any geometrical analysis, any reducing of the picture to a schema, can be done only (because of its very nature) after the photograph has been taken, developed and printed—and then it can be used only for a post-mortem examination of the picture. I hope we will never see the day when photo shops sell little schema grills to clamp onto our viewfinders; and that the Golden Rule will never be found etched on our ground glass.

If you start cutting or cropping a good photograph, it means death to the geometrically correct interplay of proportions. Besides, it very rarely happens that a photograph which was feebly composed can be saved by reconstruction of its composition under the darkroom's enlarger; the integrity of vision is no longer there. There is a lot of talk about camera angles; but the only valid angles in existence are the angles of the geometry of composition and not the ones fabricated by the photographer who falls flat on his stomach or performs other antics to procure his effects.

Extract from H. Cartier-Bresson, *The Decisive Moment*, New York 1952. Copyright © 1952 by Henri Cartier-Bresson, Verve and Simon and Schuster. Reprinted by permission of Simon and Schuster, Inc.

264　Atget　*The Pond, Ville-d'Avray*　1923–25

265 Atget *Verrières—Picturesque Corner, Old Building* 1922

266　Atget　*Parc de Sceaux, May—7 a.m.*　c. 1925

267 Atget *Parc de Sceaux* 1921

268 Atget *Brothel at Versailles* c. 1921

269 Atget *La Villette, rue Asselin, prostitute taking a break* 7 March 1921

270 Atget *Avenue des Gobelins* 1925

271 Atget *Shop, avenue des Gobelins* 1925

272 Cartier-Bresson *Cordoba, Spain* 1933

273 Cartier-Bresson *Eunuch of the Imperial Court of the Last Dynasty, Peking* 1949

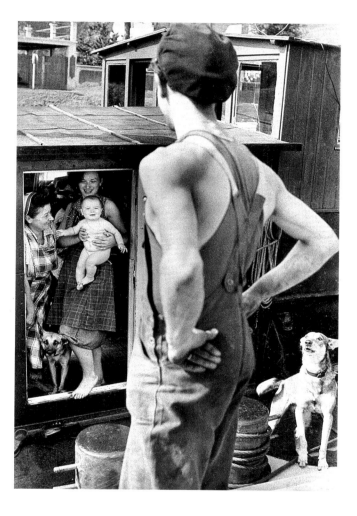

274 Cartier-Bresson *Paris, Gare St Lazare* 1932

275 Cartier-Bresson *Lock at Bougival* 1955

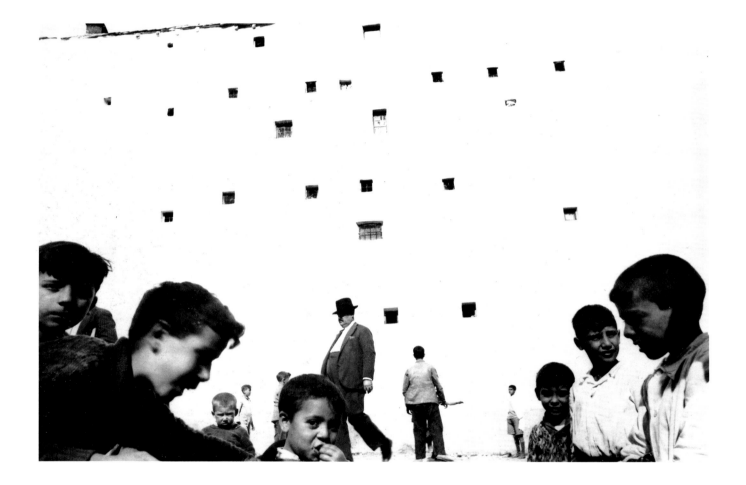

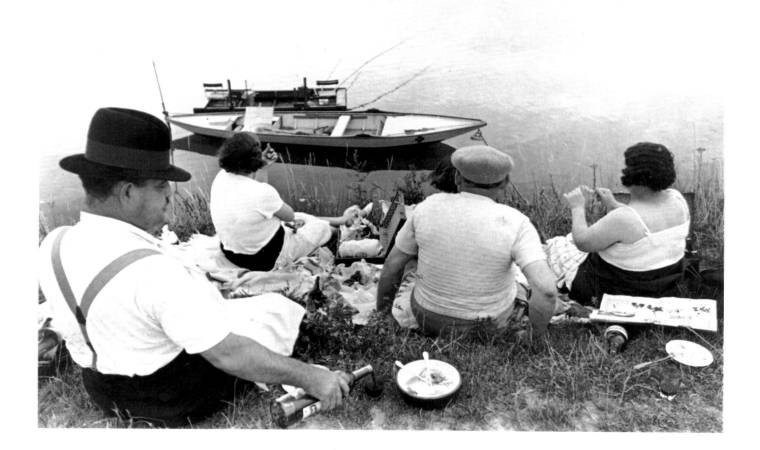

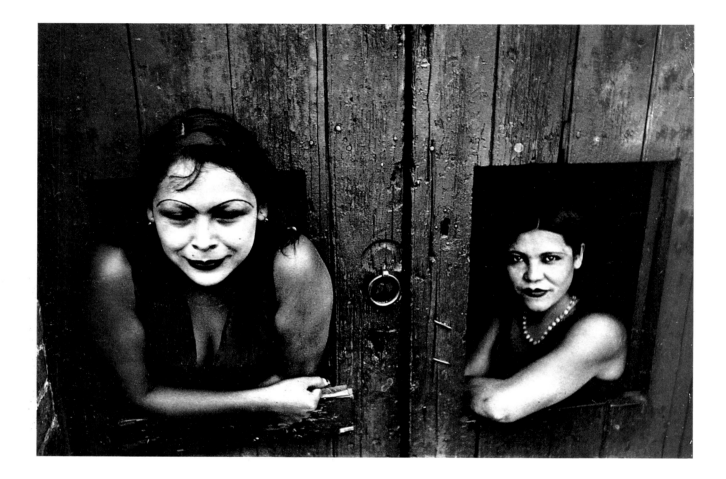

278　Cartier-Bresson　*Calle Cuauhtemoctzin, Mexico*　1934

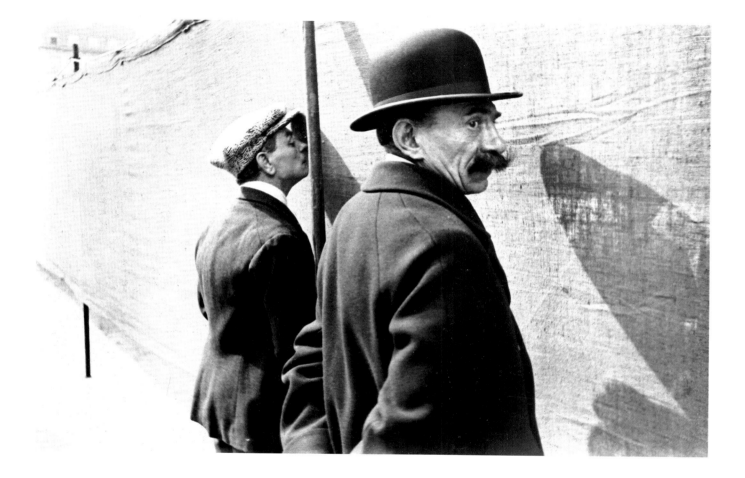

279 Cartier-Bresson *Brussels* 1932

280 Cartier-Bresson *Valencia, Spain* 1933

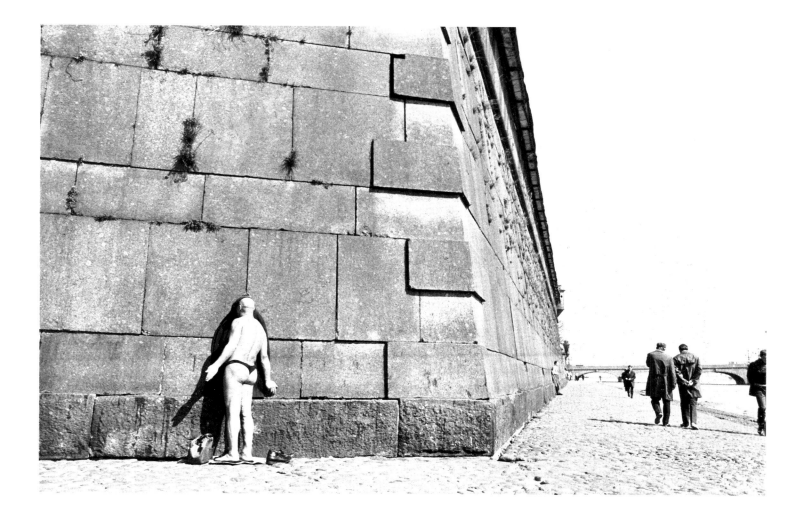

281 Cartier-Bresson *The Peter and Paul Fortress, Leningrad* 1973

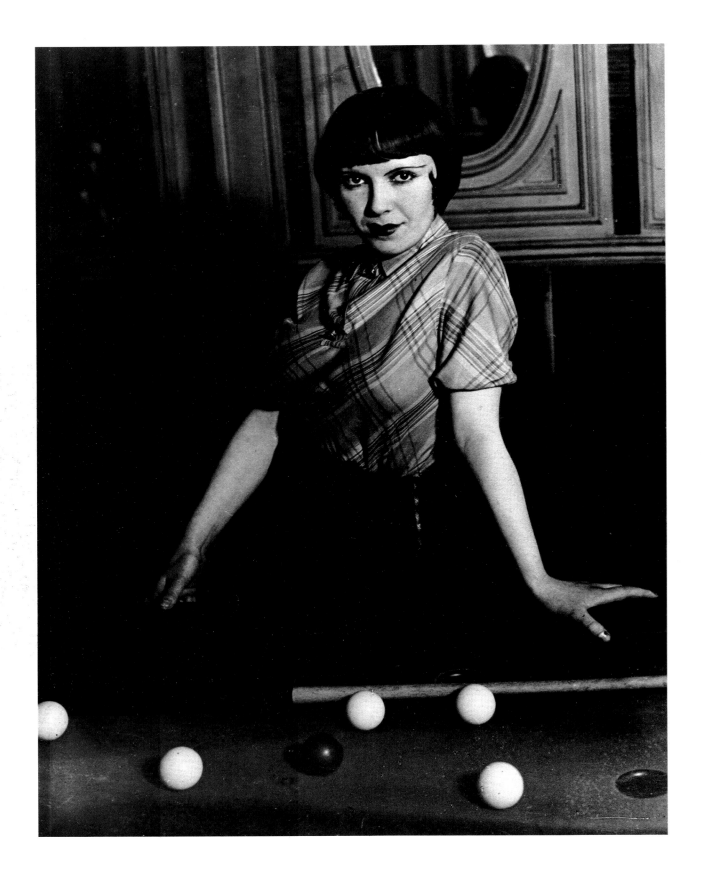

282　Brassaï　*A Prostitute playing Russian Billiards, boulevard Rochechouart, Montmartre*　1932

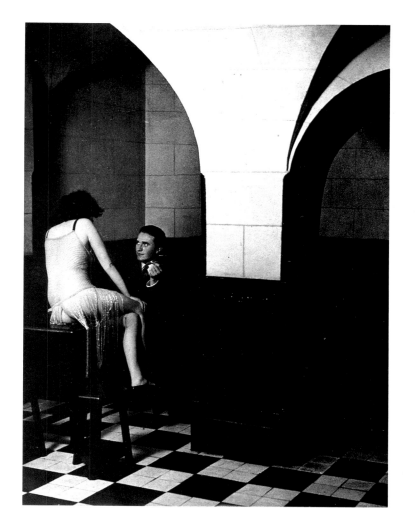

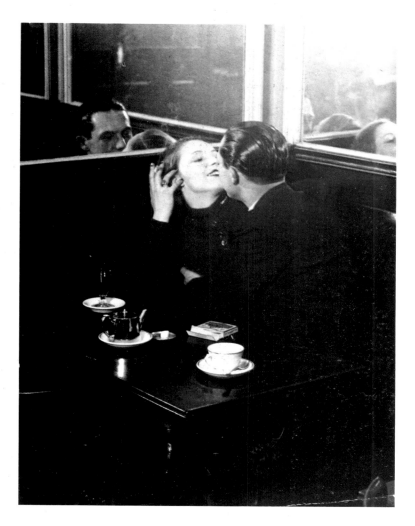

283 Brassaï *A Monastic Brothel, rue Monsieur le Prince, Quartier Latin* 1931

284 Brassaï *Rue de Lappe* 1932

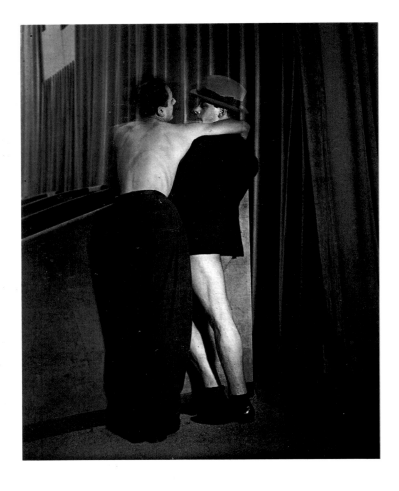

285 Brassaï *Members of Big Albert's Gang, Place d'Italie* 1932

286 Brassaï *One Suit for Two* 1932–33

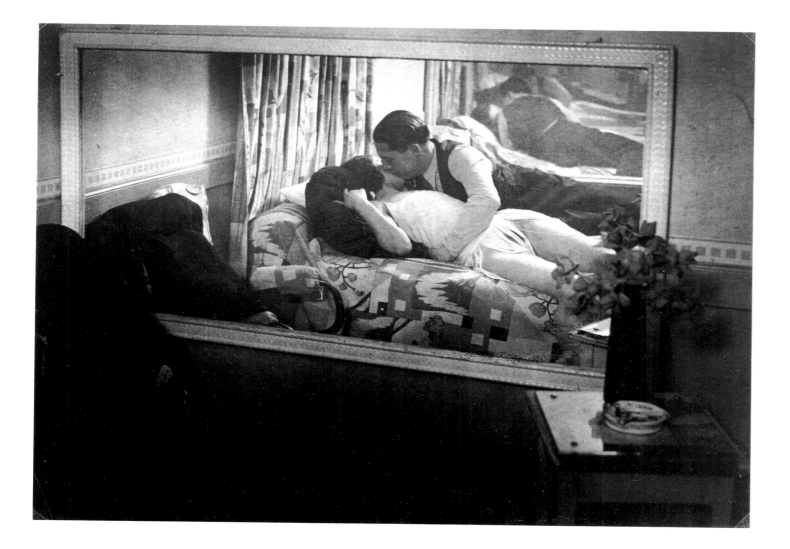

287 Brassaï *At Suzy's* 1932

288 Brandt *Northumberland Miner at his Evening Meal* 1937

289 Brandt *Parlourmaid and Under-parlourmaid ready to serve Dinner* 1932–35

290 Brandt *Tic-tac men at Ascot Races* 1935

291 Brandt *Quarrel* 1936

292 Brandt *Drawing Room in Mayfair* 1932–35

293 Brandt *Coach Party, Royal Hunt Club Day, Ascot* 1933

294 Sander *The Hod-Carrier* c. 1928

295　Sander　*The Wife of the Painter Peter Abelen*　1926

296 Sander *Gypsy* 1938

297 Sander *The Painter Gottfried Brockmann* 1924

298 Sander *Widower with Sons* 1925

299 Sander *Untitled* 1920

300　Sander　*SS Officer*　1937

301　Sander　*Persecuted Jew, Mr Leubsdorf*　1938

Anne Tucker
AMERICAN DOCUMENTARY STYLES

Each of the photographers in this section has been significantly influential on the American documentary genre. Each is intrigued with the physical world and by photography's unique ability to depict it. Their talent is to recognise content in appearances: the bleak elegance of a barren cabin, the messy horror of murder, the uninviting utility of a cheap motel room. They photographed urban life, strangers and social fabric rather than their personal lives and fantasies. Within that perimeter, all but Weegee (who was a naïve artist) were primarily committed to making art, which means they were aware of the photographs that had preceded their own and sought to make their pictures distinctive in style and vision.

Some documentary photographers create pictures that are as artless as possible to make more convincing the illusion of direct observation. For the audience to believe it is seeing the photographic subject directly, the photographer must understate his authorship. More than most photographers in the twentieth century, but like many in the nineteenth, Walker Evans chose to keep his presence discreet. From 1935 to 1938 Evans was employed by the Farm Security Administration, best known for its photographs of the dust bowl, migrant farm labourers and other symbols of the Depression and the human suffering it engendered. Evans's photographs are dryer than most made for the F.S.A. because he sought an intellectual not an emotional appeal. He perceived the camera as an 'incredible instrument of symbolic actuality' (p. 301) and he used it to make photographs that were insistently factual. In his work the actual is not transformed by heightened perspective or overtly dramatic details. His photographs are classic, understated and immaculate. His consistently frontal approach to his subjects anchored them within the picture, and in a time of chaos, imposed an enormous sense of physical stability.

Walker Evans was a Mid-Westerner, educated in New England. Weegee was the consummate New York City kid. Born Arthur Fellig, he grew up on the Lower East Side where immigrant families such as his settled before (they hoped) moving on to better neighbourhoods. He left school at fourteen to help support his family and worked many odd jobs until he became a darkroom assistant at a news agency. After twelve years developing other photographers' negatives and prints, Weegee became a freelance news photographer. Between 1935 and 1945 he worked at night with a police radio by his bedside and another radio and a portable darkroom in his car. His specialties were the worlds of crime and entertainment. He photographed the unguarded faces of victims injured by accident and by design, as well as their victimisers, policemen and lookers-on. The trade name 'Weegee' had derived from the Ouija board, because he often seemed to know beforehand where a crime scene would be. He worked best at night and could be found wherever people gathered, from Times Square to Coney Island, and from arenas to bars. Because he worked freelance for both newspapers and magazines, his photographs satisfied the enormous range required by such diverse publications. He supplied thrills to the tabloids and wit to high-society periodicals. His photographs were timely and vibrant as Evans's were quiet and timeless. In 1946 Weegee gathered both thrills and satire, together with chatty commentary, into the book *Naked City*, which made him and his photographs famous.

In the late 1960s there emerged a tradition in America that was termed 'social landscape' photography. Its chief proponents were Diane Arbus, Bruce Davidson, Lee Friedlander and Garry Winogrand, who were, in fact, among those of the third generation of photographers to base their pictures on the banality of America's urban scene. Their work had been influenced by the photographs of Robert Frank, who in turn had been responding to the work of Walker Evans. When Frank published his seminal monograph *The Americans* (1958), he was very open about his debt to Evans, but most critics did not perceive that empathy and instead attacked the subjective, burning nature of Frank's vision as contrasted with Evans's coolness. Frank was as determined to interject his responses into his photographs as Evans was to withold his. In the winter of 1955 Frank wrote to his parents: 'I am working hard not just to photograph, but to give an opinion in my photos of America. . . . America is an interesting country, but there is a lot here that I do not like and that I would never accept. I am also trying to show this in my photos.'

Frank's photographs are also the antithesis of Evans's pictures technically. Frank's images are characterised by subdued lighting, oily black tones, grainy definition and low-angle viewpoints. Like many post-war photographers, Frank worked with a 35 mm., hand-held camera that allowed him spontaneity and invention. His images are acute and visually unexpected. For instance, in *Fourth of July, Jay, New York* (pl. 327) the dominant element is a giant, patched, transparent flag; those attending the picnic are small and peripheral in comparison. The flag's commanding, if tattered, physical presence alludes to the country it signifies. Throughout *The Americans* Frank identified certain recurring images—such as the flag, politicians, automobiles and religious figures—as American icons. He invested them with symbolic power and built symbol upon symbol when sequencing *The Americans*.

Within the documentary genre, Diane Arbus concentrated on portraiture; her work is equally reminiscent of Weegee's snapshot aesthetic and nightlife milieu and Evans's classicicism. Arbus's subjects included nudists, transvestites, retarded adults and carnival performers, as well as ordinary people whom she encountered on New York City's streets, parks and beaches. Her photographs are riveting, enabling the discovery of something foreign as well as the recognition of something familiar. 'Her portraits', wrote Tom Southall, 'were not simply about faces and their expressions. They were also about bodies, clothing, furniture, wallpaper—all the details and appurtenances of an individual's identity.'[1] Beyond the uniqueness of her subject's physical person, costume, lifestyle or job are the small ubiquitous yearnings of our common humanity: the wish to be king or queen for the day, to look like Elizabeth Taylor or Marilyn Monroe or Mickey Spillane, to love our son, to celebrate a special occasion. Senior citizens want to be kings and queens; small boys want to be warriors; mothers love sons who are giants; transvestites have birthdays.

Beyond the shock of oddity, aberration or awkwardness, and beyond the bonds of recognised humanity is a subject's psychological vulnerability when confronting Arbus through her camera. Perhaps more unnerving than her choice of subjects is the coolness of her style, her physical and emotional distance from the subjects in the light of their personal disclosures. Arbus's look into others' lives is dispassionate, clear, direct and fresh. The absence of her own emotions is intentional, much as Walker Evans is absent from his pictures. Little stands between the subject and the viewer. Having gazed at Arbus, the sitter seems to be gazing at us.

Lee Friedlander and Arbus were friends and their work came into prominence simultaneously in the exhibition 'New Documents', but their styles and motives were very different. In 1960 the John Simon Guggenheim Memorial Foundation awarded Lee Friedlander a fellowship to photograph 'the changing American scene'. One might suppose from the proposal that Friedlander wanted to make sociological documents, but he was less interested in social problems than in pictorial ones. 'The

1 *Diane Arbus: Magazine Work*. ed. Doon Arbus and Marvin Israel, New York 1984, 159.

most interesting thing is the shooting,' he answered when asked what motivated him.[2] He does not mean the mechanical act, which involves skill, but the artistic decision of what and how to photograph. The possibilities are tempered both by the subject and by the inherent character of the medium as Friedlander has come to understand it.

Rather than consciously choose a subject, Friedlander will recognise that he has been increasingly attracted to a particular theme—monuments, parties, flowers, windows. Frequently there are specific pictorial problems built into photographing a subject (using a flash attachment when photographing parties, working with reflections when photographing windows). As he becomes more curious about a given topic and the concurrent picture problems, a series evolves. He is challenged by the number of good pictures that it is possible to make of a single subject, and he will work on a series for several years before culminating the project in a book or portfolio. In the process he will study and learn a great deal about both the subject and the medium. What he learns in one series will frequently carry over into a later one. *Cincinnati, Ohio* (pl. 337) and *New York City* (pl. 336) both convey the compression of space and the odd layering of objects and architecture endemic to modern cities. The former picture occurred in an early series on reflections; the latter photograph is from Friedlander's on-going fascination with how complicated a picture can be without dissolving into confusion.

Like the other photographers in this section, Joel Sternfeld is an itinerant photographer. Evans, Frank and Friedlander have all used the automobile as a metaphor for America's vast landscape; Sternfeld was one of the first to photograph it in colour. Since 1978 he has periodically criss-crossed the country photographing New England winters, sweet Southern springs and arid Western summers. For Sternfeld each region possesses distinct characteristics that are fast melting in the heat of worldwide commerce. He desires to identify and record what distinctions he still finds—maple syrup gatherers in Vermont, dogwood trees in the South and dude ranches in the West.

In the process he also finds minor news events: a burning house, beached whales, a renegade elephant and a flash flood. When photographing he frequently positions himself high and distant, so that the picture's foreground starts forty to sixty feet out from the camera. The distance allows him to incorporate more information and make more complex photographs. The most significant details are not what the viewer first notices. The beauty of the land and the sweep of the horizon catch the eye, then the viewer perceives a twist of irony or the signs of an actual or foreboding disaster. His distance also allows him to make pictures rich with incongruous juxtaposition to humorous effect.

2 Friedlander lecture, Rice University, 3 October 1977.

WALKER EVANS

from 'Photography' (1969)

The emergence, in some force, of serious, non-commercial still photography as an art is comparatively recent. It may plausibly be dated from the 1930s (not counting the work of a few previous, isolated individuals).

Modern photographers who are artists are an unusual breed. They work with the conviction, glee, pain, and daring of all artists in all time. Their belief in the power of images is limitless. The younger ones, at least, dream of making photographs like poems—reaching for tone, and the spell of evocation; for resonance and panache, rhythm and glissando, no less. They intend to print serenity or shock, intensity, or the very shape of love.

More soberly, the seasoned serious photographer knows that his work can and must contain four basic qualities—basic to the special medium of camera, lens, chemical and paper: (1) absolute fidelity to the medium itself; that is, full and frank and pure utilisation of the camera as the great, the incredible instrument of symbolic actuality that it is; (2) complete realisation of natural, uncontrived lighting; (3) rightness of in-camera view-finding, or framing (the operator's correct, and crucial definition of his picture borders); (4) general but unobtrusive technical mastery.

So much for material matters. Immaterial qualities, from the realms of the subjective, include: perception and penetration; authority and its cousin, assurance; originality of vision, or image innovation; exploration; invention. In addition, photography seems to be the most literary of the graphic arts. It will have—on occasion, and in effect—qualities of eloquence, wit, grace, and economy; style, of course; structure and coherence; paradox and play and oxymoron. If photography tends to the literary, conversely certain writers are noticeably photographic from time to time—for instance James, and Joyce, and particularly Nabokov. Here is Nabokov: '. . . Vasili Ivanovich would look at the configurations of some entirely insignificant objects—a smear on the platform, a cherry stone, a cigarette butt—and would say to himself that never, never would he remember these three little things here in that particular interrelation, this pattern, which he could now see with such deathless precision . . .'. Nabokov might be describing a photograph in a current exhibition at the Museum of Modern Art. Master writers often teach how to see; master painters sometimes teach *what* to see.

Mysterious are the ways of art history. There *is* a ground-swell, if not a wave, of arresting still photography at this time, and it may perhaps be traced to the life work of one man: Alfred Stieglitz. Stieglitz was important enough and strong enough to engender a whole field of reaction against himself, as well as a school inspired by and following him. As example of the former, Stieglitz's veritably screaming aestheticism, his personal artiness, veered many younger camera artists to the straight documentary style; to the documentary approach for itself alone, not for journalism. Stieglitz's significance may have lain in his resounding, crafty fight for recognition, as much as it lay in his *oeuvre*. Recognition for fine photography as art. We may now overlook the seeming naïveté of the Stieglitz ego; it wasn't naïve at the time, it was a brand of humourless post-Victorian bohemianism. We may enjoy the very tangible fruits of his victories: camera work placed in major art museums, in the hands of

Extract from *Quality: Its Image in the Arts*, ed. L. Kronenberger, (Atheneum) New York 1969.

discriminating private collectors, and on sale at respectable prices in established galleries. In short, Stieglitz's art was not entirely paradigmatic, but his position was.

As we are all rather tired of hearing, the photographer who knows he is an artist is a very special individual. He really is. After a certain point in his formative years, he learns to do his looking outside of art museums: his place is in the street, the village, and the ordinary countryside. For *his* eye, the raw feast: much-used shops, bedrooms, and yards, far from the halls of full-dress architecture, landscaped splendour, or the more obviously scenic nature. The deepest and purest photographers now tend to be self-taught; at least they have not as a rule been near any formal photography courses. Any kind of informal access to an established master is the best early training of all.

Whether he is an artist or not, the photographer is a joyous sensualist, for the simple reason that the eye traffics in feelings, not in thoughts. This man is in effect voyeur by nature; he is also reporter, tinkerer, and spy. What keeps him going is pure absorption, incurable childishness, and healthy defiance of Puritanism-Calvinism. The life of his guild is combined scramble and love's labour lost.

The meaning of quality in photography's best pictures lies written in the language of vision. That language is learned by chance, not system; and, in the Western world, it seems to have to be an outside chance. Our overwhelming formal education deals in words, mathematical figures, and methods of rational thought, not in images. This may be a form of conspiracy that promises artificial blindness. It certainly is that to a learning child. It is this very blindness that photography attacks, blindness that is ignorance of real seeing and is perversion of seeing. It is reality that photography reaches toward. The blind are not totally blind. Reality is not totally real.

In the arts, feeling is always meaning.—Henry James. Leaving aside the mysteries and the inequities of human talent, brains, taste, and reputations, the matter of art in photography may come down to this: it is the capture and projection of the delights of seeing; it is the defining of observation full and felt.

302 Walker Evans *Farmhouse, Westchester, New York* 1931

303 Walker Evans *Main Street, Saratoga Springs, New York* 1931

304 Walker Evans *Corrugated Tin Façade, Moundville, Alabama* 1936

305 Walker Evans *Highway Corner, Reedsville, West Virginia* 1935

306 Walker Evans *Floyd Burroughs's Bedroom, Hale County, Alabama* 1936

307 Walker Evans *Floyd and Lucille Burroughs, Hale County, Alabama* 1936

308 Walker Evans *Washroom in the Dog Run of Floyd Burroughs's home, Hale County, Alabama* 1936

309 Walker Evans *Sidewalk and Barber Shop Front, New Orleans* 1935

310 Walker Evans *Posed Portraits, New York City* 1931

311 Walker Evans *Couple at Coney Island, New York* 1928

312 Weegee *Coney Island Beach* 1940

313 Weegee *Easter Sunday, Harlem* 1940

314 Weegee *Untitled* c. 1940s

315 Weegee *The Critic* c. 1943

317 Weegee *Booked for killing a Policeman* 1939

319 Weegee *Seventeen-year-old Boy arrested for strangling a six-year-old Girl to death* 1944

321 Frank *Charleston, South Carolina* 1955

323 Frank *Metropolitan Life Insurance Building* 1955–56

324 Frank *Drive-in Movie, Detroit* 1955

325 Frank *U.S. 91, Leaving Blackfoot, Idaho* 1956

326 Frank *View from Hotel Window, Butte, Montana* 1956

327 Frank *Fourth of July, Jay, New York* 1955

328 Arbus *Untitled (6)* 1970–71

329 Arbus *A Family on their Lawn one Sunday in Westchester, New York* 1969

330 Arbus *A Child crying, New Jersey* 1967

331 Arbus *Puerto Rican Woman with a Beauty Mark, New York City* 1965

332 Friedlander *Monsey, New York* 1963

335 Friedlander *Albuquerque* 1972

337 Friedlander *Cincinnati, Ohio* 1963

338 Sternfeld *After a Flash Flood, Rancho Mirage, California* July 1979

339 Sternfeld *Buckingham, Pennsylvania* August 1978

340 Sternfeld *Manville Corporation World Headquarters, Colorado* October 1980

341 Sternfeld *Near Lake Powell, Arizona* August 1979

11

Ben Lifson
THE INNER VISION

If there is more diversity of style in this section than elsewhere in this exhibition it is because the photographers here do not share ideas about how a picture can look. They share instead a sense of the kind of experience photography can *express*. Call it psychological or mystical or philosophical, or locate it in the imagination or in dreams or in thought or in feeling, it has as much to do with insight as with seeing, and with metaphysical as well as with physical worlds. This notion came independently to three photographers around 1940.

In Prague during World War II Josef Sudek, known for his lyrical photographs of that city and its churches, began to work only in his studio, anxious lest his practice of photographing in the streets lead the Germans to think him a spy. He was already a familiar and picturesque figure in Prague; he used a large camera on a tripod in the streets and had lost an arm in World War I; he was likely to attract attention. Sudek later wrote that making pictures then of his garden as seen through the windows of his studio led him to make still lifes of ordinary objects just under the windows. 'I believe that photography loves banal objects,' he continued,

> and I love the life of objects. I am sure you know the fairy tales of Anderson: when the children go to bed, the objects come to life, toys, for example. I like to tell stories about the life of inanimate objects, to relate something mysterious. . . .[1]

Somewhat earlier in Detroit, Harry Callahan sensed that photography could express the inner and subjective life of the photographer, even of a photographer like himself, an amateur who worked as a book-keeper for General Motors, and who photographed weeds, the sides of buildings and other unpreposessing things in the objective world. In a letter of 1946 Callahan put it this way:'I have devoted every spare moment to . . . photography as a means of expressing my feelings and visual relationship to life *within me* and about me'.[2]

Also in 1946 the slightly older American Minor White, who had first wanted to be a writer in the tradition of the late-eighteenth-century English prophetic and mystical poet William Blake, depressed both by his not having photographed during his three years of military service and by the deaths he had seen in combat during the United States's invasion of the Philippines at Leyte in 1944, visited the photographer Alfred Stieglitz in New York. 'Stieglitz', White wrote a few months later,

> said something or other about photography that makes visible the invisible, and something else about true things being able to talk to each other. His talk itself was a kind of equivalent; that is, his words were not related to the sense he was making.[3]

With the word 'equivalent' White referred to Stieglitz's term for his own version of a theory which holds that, in art, pure and objective elements such as line or shape or colour can express precise constructions of abstract thought and shades of feeling. Belief in absolute relationships between forms in nature on the one hand and intellectual ideas or emotional states on the other has dogged modern thought at least since the writings of the sixteenth-century Florentine philosopher and heretic Giordano Bruno, who was burned at the stake in Rome in 1600;[4] it was put forth

1 Josef Sudek, undated letter quoted by Sonja Bullaty in *Sudek*, New York 1978, 26.

2 Harry Callahan, letter to the Museum of Modern Art, New York (30 January 1946) in the files of the Department of Photography, Museum of Modern Art, cited by John Szarkowski in *Callahan*, New York 1976; emphasis mine.

3 Minor White, *Mirrors, Messages, Manifestations*, New York 1969, 41.

4 Walter Pater, 'Coleridge', in *Appreciations, with An Essay On Style*, London 1895, 54-81 and *passim*.

most influentially in the early part of this century in relation to forms in art by the Russian abstract painter Wassily Kandinsky; it became important to Stieglitz in 1925, two years after he had begun to photograph clouds. in 1925 the word 'equivalents' first appears in Stieglitz's writing: 'I do not make "pictures".... I have a vision of life and I try to find equivalents for it sometimes in the forms of photographs.'[5] Also in that year Stieglitz's cloud pictures became increasingly abstract, and he titled them *Equivalents*.[6]

As Minor White listened to Stieglitz expound these theories that evening in 1946, their spiritual and mystical content relieved his deadness of spirit:

> If anyone had ever talked like that to me before, I certainly had not heard him. In a few minutes he broke open the lump of pure concrete that had sunk me to the bottom of Leyte Gulf.[7]

Much later, White wrote that the idea that photographs could represent more than what they described also ended a sensation of blindness and of paralysis, begun when the Army took his camera away from him in 1942:

> I stopped seeing. Consequently, impressions and experiences by the thousands piled up.... They had to be materialized before I could move on to seeing anything else. . . . Stieglitz's concept of the Equivalent opened the way to materialize these impressions and thus 'release' myself from their tight grasp.[8]

At a time, then, when photography was held to be an objective medium whose function was to describe 'public issues of the great world', three photographers in widely separated parts of the world came to a similar conclusion, summed up later by White: that photography can describe 'Things for what else they are'.

Sudek, Callahan and White had certain things in common which perhaps helped them to go against the grain: none of them had had formal training in visual art; nor did any of them at first consider photography as a livelihood; all three worked far from the world's art capitals, unhampered by conventional thought, instead, each in his own way was preoccupied with what White called in 1964 'the *metamorphosing* power of camera'.[9] Much of this was also true later of the two younger photographers included here, the Americans Robert Adams and William Eggleston, during their formative years.

Despite many dissimilarities, these five photographers share a sense of the *means* by which their visions can be expressed. And if we call their styles *visionary*, it is because these means are also those of visionary art. First, reduction—of information, of motif, of visual vocabulary and of detail. Second, exaggeration of what's left. The over-all effect is of an intensified world whose simplified detail and diminished variety seem to be due to a purification, either a purification of the world itself or a purification of our perceptions. In other words, a heightened reality, a vision.

Light, a constant element in all visionary art, is the chief transforming element of Josef Sudek's work, which is in part an inventory of the various ways that light diffused by mist, or rain, or steamed-up windows, or leafy trees, re-draws ordinary objects.

The elimination of life's randomness, a calligraphic purity of line and a simplification of the world's order are hallmarks of Harry Callahan's style. The landscapes of Minor White, with their dark and unknowable areas, their visual turbulence and their objects that we cannot name right away but whose force we feel, are created by three means: unfamiliar distances between camera and object; intensification of tonal contrast—which brings about, among other things, an exacting delineation of shapes glimpsed in stone and other non-organic material and resembling plants, and human body parts and other living things; and a lack of scale.

William Eggleston relies on exaggerated colour, scale and drawing: ordinary

5 Alfred Stieglitz, letter to J. Dudley Johnston, dated 3 April 1925, in Sarah Greenough, *Alfred Stieglitz*, Washington, D.C. 1983, 209.
6 Greenough, op. cit., 22–5.
7 White, op. cit., 41.
8 Ibid., 194.
9 Ibid., 41.

clothes, for example, often look like strangely coloured costumes; many figures seem either too large or too small for their surroundings and are extraordinarily angular, even grotesquely drawn.

Robert Adams's style depends upon an exaggerated clarity and thoroughness—a placement of the many things within the picture so that they can be seen more simply, and more for what they are, and in clearer relationship to each other, than in real life.

Nietzsche wrote, 'We have Art in order that we may not perish from Truth'.[10]

10 Cited in W. H. Auden, *The Dyer's Hand,* New York 1962, ix.

MINOR WHITE

from 'Memorable Fancies' (1952, 1957)

Today there is an attempt to make each canvas a new, original experience in the world, as far from a reminder of some experience in the world as possible. Can the camera do this? Since reporting surface facts comes naturally to photography, and since camera depends on light reflected from objects, camera is held firmly to the truth and patterns of tension at the surface or only a little way below. Yet by the alterations (or inaccurate reporting) it can report what *else* things are. Camera can even report what else things *might be* and in so doing invent much as the painter invents. And in so doing cause photographs that depend so little on the object photographed as to be, for all practical purposes, an original source of experience, much as in non-objective painting.

I have photographed three ways, or tried to—the spirit of place and person; that is, with profound respect for facts and surfaces, sought the core form, the essence. I have sought and found those places and people who photograph like undistorted mirrors of myself. I now seek, not things as they are, but what else they are; those objective patterns of tension beneath surface appearances which are also true. In fact, are the truth of which outward visible aspects are poor symbols. It is a shift from a belief in the Essence as an absolute to a belief in pattern as nearer discernible truth. And with this search try to make pictures which cause an experience of that truth in the beholder [12 June 1952].

The aesthetician in me finds pertinent exercise in the contemplation of photography as an art form. What kind of an art, pure photography, and allied matters occupy most of my aesthetic attention. When I am actually photographing, another attitude altogether comes into prominence. First of all it is a state of heightened awareness the opening stages of which I can initiate at will. (In successful periods the later stages are 'taken over' by something else.) In this condition whenever a truth is presented to me I take either one of two paths to get its symbol on film. If 'things as they are' seems the easier, or perhaps the obvious, I take that more or less objective path to something of essence. If 'things for what else they are' seems the obvious I take this subjective, highly personal, symbolic path to revelation by the evoked image. Here I am thinking of the image in the spectator's mind.

In either case, while photographing, I do not consider either my efforts or my results in terms of art or not art.

Sometimes of late, when I photograph people I do not seek for the uniqueness of the individual, nor for the amalgamation of myself and person, nor of myself mirrored in the person, but for something far more important than any of these things. When such attempts are successful, they are a clue saying that spirit worked. And there have been very very few times when I photograph people. Maybe 'it' works from the inside maybe from the outside—for me it seems to work from without. Spirit probably works from within and from without and depending on how our atoms are lined up we feel one direction to predominate [16 February 1957].

Untitled statements by Minor White from his journal 'Memorable Fancies', Collection of The Minor White Archive, Princeton University. Copyright © 1989 Trustees of Princeton University.

342 Minor White *Peeled Paint, Rochester, New York* 1959

343 Minor White *Windowsill Daydreaming* July 1958

344 Minor White *Root and Frost, Rochester, New York* February 1958

345 Minor White *Sandblaster, San Francisco* 1949

346 Minor White *Blowing Snow on Rock, Rye Beach, New Hampshire* December 1966

347 Minor White *Sun in Rock, Devil's Slide* 1947

348 Callahan *Lake Michigan* 1953

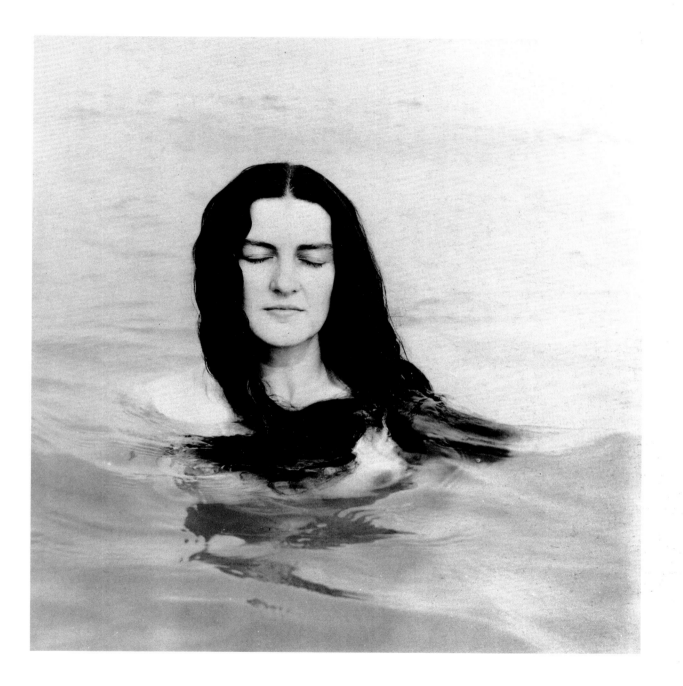

349 Callahan *Eleanor* 1949

350 Callahan *Eleanor and Barbara, Chicago* 1953

351 Callahan *Eleanor, Chicago* 1952

352 Callahan *Eleanor* 1952

353 Sudek *Chair in Janáček's House* 1972

354 Sudek *Uneasy Night* 1959

355 Sudek *Untitled* 1956

356 Sudek *Untitled* 1953

357 Sudek *My Garden with the Wash hanging* 1965

358 Sudek *Coming of Spring* 1958

359 Eggleston *Tallahatchie County, Mississippi* 1971

360 Eggleston *Black Bayou Plantation, near Glendora, Mississippi* 1971

362 Eggleston *Memphis* 1971

363 Eggleston *Huntsville, Alabama* 1971

364 Eggleston *Whitehaven, Mississippi* 1971

365 Eggleston *Sumner, Mississippi, Cassidy Bayou in Background* 1971

366 Adams *Los Angeles, Spring* 1984

367 Adams *The Garden of the Gods, El Paso County, Colorado* 1977

368 Adams *La Loma Hills, Colton, California* 1983

369 Adams *Colorado Springs, Colorado* 1968

370 Adams *Untitled* 1973

371 Adams *Fort Collins, Colorado* 1979

372 Adams *Berthoud, Colorado* 1979

Mark Haworth-Booth

British Contemporaries

The 'straight' or poetic realist tradition in Britain is no more British than, say, Bill Brandt, the master who stands behind the whole enterprise of serious and imaginative photography in Britain in the last twenty-five years. Bill Brandt himself was born in Hamburg of a British father and German mother, professionally trained in Vienna and came to artistic consciousness in Paris around 1930 before settling in London the following year. Similarly, the photographers here may all have identifiable native British characteristics, but their medium is nothing if not international.

When Raymond Moore began to teach photography for the first time, in the middle of the 1950s, he turned to the practical manuals of a Californian, Ansel Adams, and as visual source material for the non-functional photography he wanted to teach he turned to the anthologies *Subjektive Fotografie* (1952, 1955) by a German contemporary, Otto Steinert. In the 1960s he came to admire and to know the Americans Harry Callahan, Aaron Siskind and Minor White, all of whom, like himself, combined careers in teaching with free and experimental picture-making of their own. And yet, despite his internationalism, Moore's photographs are rooted in the countryside he knew intimately—notably the western margins of Britain and selected off-shore islands. His photograph *Allonby, Cumbria* (pl. 382) is characteristic. Moore's father was an architect, and buildings—not monumental ones but idiosyncratic dwelling-houses—play a large rôle in Moore's photographs. Often buildings take a particular kind of light—light off the sea giving, as here, a bleached freshness. The windows are not blank but veiled, both encouraging and denying knowledge of the residents. Is it not very British in its discretion, its lighting, and even in the building's clumsy plainness? Moore's photographs seem like fragments of autobiography or social psychology based on a pretext of topography.

Topography is at the centre of the work of John Davies. In the early 1980s his landscapes became panoramic and coherently structured—the most memorable landscape views of the Lake District, Western Scotland and Ireland since the work of Edwin Smith. However, his subsequent preoccupation with the intricacies of urban and post-industrial landscape probably owes less to native tradition than to American innovation (the New Topographics of the 1970s). His masterpiece in this genre is *Agecroft Power Station, Pendlebury, Salford, Greater Manchester* (pl. 373). In the distance is Agecroft Colliery, which fuels this electricity generating station. The slim nineteenth-century chimneys typical of L.S. Lowry's paintings have jumped to outlandish late twentieth-century size, but the game carries on regardless and—just above the left-hand goal posts—some liquid of unknown character continues to pour into the river. A white horse makes a guest appearance—as if from a whisky advertisement ('you can take a white horse anywhere')—in the lower left-hand corner, joining such rubbish as an overturned saloon car and—maybe—an abandoned stove or fridge. It is not hard to think of Philip Larkin's poetry in such a context—and quite easy, too, to think of Davies's work as a series of fully charged glimpses from an inspired train journey.

If John Davies sometimes seems like the equivalent of an eighteenth-century topographical draughtsman, constantly travelling to make views on commission, Ian

Macdonald has practised a still sharper photographic drawing in a particular locality, the North East of England. Trained as a painter, he subsequently taught in school and photographed in the school setting. Childhood is the small town everybody comes from, to paraphrase Garrison Keillor, and pictures of classrooms cut even across class. It is hard not to take interesting photographs of schools, although, on the evidence, it seems even harder to take very good ones. Whereas Raymond Moore was generally content to photograph with a 35 mm. camera and John Davies, with an intermediate format, 6 × 7 cm., Ian Macdonald is particularly associated with the 5 × 4 in. view camera (which he has used since 1974). His photographs are conceived in and for that format. This is most clearly true of his photograph of two of his pupils drawing, *Mandy Jemmerson and Paula Woods drawing Hedgerows, Secondary School, Cleveland* (pl. 385). In his photograph the schoolgirls confront the complications of the hedgerow with blank sheets of paper, sharp pencils and open minds, while, with sly and benevolent wit, the art teacher draws the whole scene from his tripod with Ruskinian subtlety and unmistakable affection.

Photography has always had the Ruskinian paradigm as a major option: accepting nature as guide, 'having no other thought but how best to penetrate her meaning; rejecting nothing, selecting nothing, and scorning nothing'.[1] However, there was always another option: the photographic vision to be found in Dickens. 'His works', wrote Walter Bagehot, 'well exemplify the telling power of minute circumstantiality . . . a detective ingenuity in microscopic detail'.[2] Martin Parr's first important series of photographs looked at the way we behave in the presence of monuments (Land's End, Stonehenge, Glastonbury Tor). His mood was amused if ironical—somewhat in the manner of that other startling choreographer of the British at play, Tony Ray-Jones (1941–72). Parr's best-known work internationally is the 1984 series *The Last Resort*, a book-length view—using 6 × 7 cm. format plus daylight flash—of holidaymaking at New Brighton on Merseyside. He stalked this resort (in much the way a Manhattan photographer might prowl Coney Island) examining how people looked enduring leisure in 1984. One of the most complicated of the pictures shows a group of three females—at a guess, a mother, daughter and grandmother—seated on a raking, pebbled beach (pl. 408). Mother's magazine is conveniently turned to a story titled 'Separate Dreams'. The young daughter looks bored, grandmother is distracted by an alsatian bounding up the beach to where a young man in jeans and sweatshirt (CHAMPION 81) has spread out a towel, just below the high-tide flotsam, on which to smoke a cigarette. Following the diagonal leads the eye to another small family group—again no male adult present—and a KWIK SAVE carrier-bag easily visible at a distance reads like a ghastly motto. Along the path and down the steps into view come other holidaymakers, leading us to where children peer over a low parapet. Closing the corner at bottom left of the picture we see the edge of a child's dinghy lettered—what, RIMA? Certainly everyone, everything, every word—the 'pictorial elements'—rhyme to a remarkable degree in this photograph, but the word RIMA suggests a final, appalled caption for the whole scene. Subsequently to this series Parr, perhaps in response to the gungho consumerism of the later 1980s, has been producing pictures taken at the point of sale.

Graham Smith and Chris Killip have exhibited together ('Another Country', 1985) and have both been closely associated with the Side Gallery, Newcastle-upon-Tyne, which has commissioned work from them and other leading photographers. Smith's work first described the streets, buildings and bridges of Newcastle, South Shields, Easington and Consett with an almost elegiac tenderness—a grand but sparsely populated city region, photographed like a place being committed to memory. During the 1980s he photographed continuously in a pub in South Bank, Middlesbrough, where he had grown up. It is impossible to improve upon Chris Killip's remark that Graham Smith is 'photography's answer to folk-singing' and

1 *The Works of John Ruskin*, ed. E. T. Cook and A. Wedderburn, London 1904, III, 624.
2 *Collected Works of Walter Bagehot*, ed. Norman St John-Stevas, London 1965, II, 84.

that—the affectionate and boisterous humour of some pictures notwithstanding—he excels at photographing (as in *Sandy and Friend*, pl. 401) 'privileged, private moments'.[3] Such photographs, in turn, invite the viewer to share Smith's own affection and respect. Killip himself has made a similar journey, first photographing his native Isle of Man in a style derived from the Paul Strand of *Tir a'Mhurain* (the 1954 series from South Uist published in 1962), and with a 5 × 4 in. camera, then moving to the North East and discovering more personal methods and imagery. His second book, and the exhibition of the same title, *In Flagrante* (1988), revealed a view of England which is the most eloquent seen in photography in Britain since Bill Brandt. Killip takes a stand with the people he photographs, outside the mainstream of the economy. Independence and endurance are key traits; individual lives are valued and celebrated in the face of political or economic expediency. Like some of his fellow-photographers, he proposes another interpretation of the present, another history.

3 Exhibition label, 'The Photographer's Eye', selected by Chris Killip, Victoria & Albert Museum, London, March–May 1988.

RAYMOND MOORE

from 'Ray Moore Talking' (1981)

Have you ever tried to, or wanted to, take pictures which summed up a society or a place?
No. I've been involved with something more personal than that. Since childhood I've been especially conscious of place . . . more conscious of place than of people. I suppose that in recent photographs I have been making some kind of a return to Wallasey ('the bedroom of Liverpool') where I grew up in the 1930s. Whole tracts of the Cumbrian coast where I work nowadays remind me of those childhood areas. They also provide me with structures and images which allow me to comment on life in general. But really I'm a loner, a reflective pessimist, and I look for signs of finality and the end of time, impending departure and desperation . . . those graffiti which come up in some of my pictures and which are the marks of people anxious to express themselves and to get things off their chests. But I'm not looking for a social point, even though I'm drawn to these often melancholic areas.

But you have, at times, worked in areas of outstanding natural beauty.
Yes, I photographed in Pembrokeshire twenty-five years ago, working with an eye for conventional beauty. But I soon exhausted myself. The places didn't seem to ring true to my complete self. I moved from the coastline to Milford Haven where there were more traces of man, and sometimes took pictures in the more run-down coastal areas. I was drawn to the edge of civilisation, and moved there more or less naturally, with no idea of understanding a place in depth. I found myself attending to the sad side of life, and find something of the same feeling in Thomas Hardy's poems. I always see what is vanishing and melancholic. Images flit across the face of things and are gone. I wish I could get rid of the feeling sometimes.

The edge of civilisation?
I can't explain this quite. If I were dropped into a slum area I don't think I'd want to photograph. I'd have to move out towards the edge. Definite statements have something of preaching about them. I prefer to tease out or to unravel what's going on. Strive for it directly and you miss it. Beauty is a by-product, which arrives without your knowing it.

When did you recognise this feeling for elusiveness in yourself, or in your art?
I was drawing and seeing in this way before I started photographing in the early '50s. I was always drawn to environments in which things shifted. When I put together still-life groups they often had connotations of disintegration and isolation. That's what I was on about—that, and the play between elements. I've also been interested in the points at which cultures meet, and would like the chance to work more in the Middle East where the Twentieth Century invades the past. When cultures clash and when man clashes with nature even the shapes become weird. I work out of season, when people make marginal encroachments. The odd figure comes into my pictures, and dogs always seem to get in somehow. The children's playground in this set, for example, loses all its magic in summer when the crowds are there. I prefer it haunted. I am also, in respect of this picture, intrigued by the way in which certain aspects of a site are changed by time or by a different light. I go back again and again to the same places, even though I make no attempt to repeat what I have previously done. Places

Interview by Ian Jeffrey, *Creative Camera* (March–April 1981), 195–6.

have far more than I can exhaust. I think that people (photographers) move around too much. Standing around in the same spot would pay off more than we realise. I am also interested in visual humour, in shapes that relate in odd ways. The world has an Alice in Wonderland quality, which in painting would look codged up. Photography's peculiar deadpan face suits the subject.

Do any pictures get better on reflection?
Not many. If I was asked I'd end up with about six. Most photographs are, to some degree or other, failures. The way in which they are failures helps one towards understanding, though. Maybe the medium can't be stretched. You can't have perfection or completion as with a painting, but this doesn't stop some degree of communication; you can have a sufficiency; you can know what the photographer means. Sometimes, though, you can be landed in a strange situation, acutely aware of conglomerations of shapes and silver surfaces, and conscious that they don't relate as well as they might.

Do you ever work with an audience in mind?
No. I think I believe, with D. H. Lawrence, that art's for my sake. If I like it I think that there's a fair chance someone else will too. I never have got over the sense of excitement at a new image coming up on the paper and unravelling film from the developing tank—I'm a bit childlike in this respect. An expectant audience would be a dangerous thing; it might well infect me.

Why photography rather than painting?
I might say that I take photographs because, in some respects at least, I couldn't do what I wanted with painting. I went to art school and ended with a diploma from the Royal College of Art. Yet I always felt the absence in myself of an instinctive ability to make exciting marks. I couldn't make the fluent statements of a good painter, couldn't get that effortless one-ness with the medium where image and attitude come together—the sort of thing which immediately excites a spectator. I was also working in an English tradition which, after 1920, favoured a dead, flat application of paint. But I had always been caught up in visual things and in questions of place and photography did suggest itself to me—as I also took photographs on the side. It was one stage away from the responsibilities involved in mark making, a more suitable way of producing images and could be a very strong ally if I could master it. Also, as with drawing, it was involved with change, with shifting light as well as with changes of approach and attitude. At that time I would start and go on with the same painting for weeks and never ended up with a painting. The severe disciplines of the camera were what I wanted, and I had to make a choice.

373 Davies *Agecroft Power Station, Pendlebury, Salford, Greater Manchester* 1983

374 Davies *Druridge Bay, no. 3, Northumberland* Midsummer's Day 1983

375 Davies *Runcorn Railway and Road Bridges, Runcorn, Cheshire* 1986

376 Davies *Mappin Art Gallery, Sheffield, Yorkshire* 1981

377 Davies *Bargoed Viaduct, Rhymney Valley, Mid Glamorgan* 1984

378 Davies *Site of Groesfaen Colliery, Deri, Rhymney Valley, Mid Glamorgan* 1984

379 Moore *Alderney* 1965

380 Moore *Kintyre* 1985

381 Moore *Eire* 1976

382 Moore *Allonby* 1982

383 Moore *Raes Knowes* 1980

384 Moore *Dumfriesshire* 1985

385 Macdonald *Mandy Jemmerson and Paula Woods drawing Hedgerows, Secondary School, Cleveland* 1983

386 Macdonald *Equinox Flood Tide, Greatham Creek, Teesmouth* 1974

387 Macdonald *Mathematics Detention, Secondary School, Cleveland* 1983

388 Macdonald *Tipped Slag, Redcar, No. 1 Blastfurnace, Teesmouth, Cleveland (night)* c. 1985

 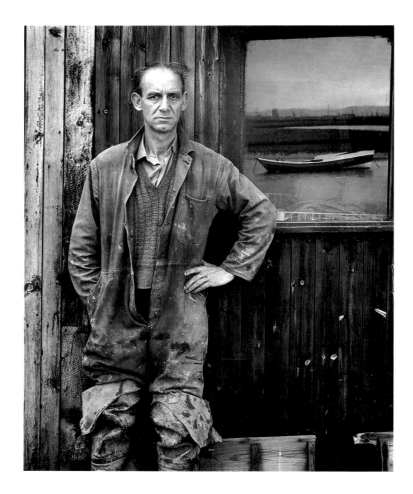

389 Macdonald *South Gare, Teesmouth, June* 1980

390 Macdonald *Ken Robinson, Greatham Creek, Teesmouth* 1973

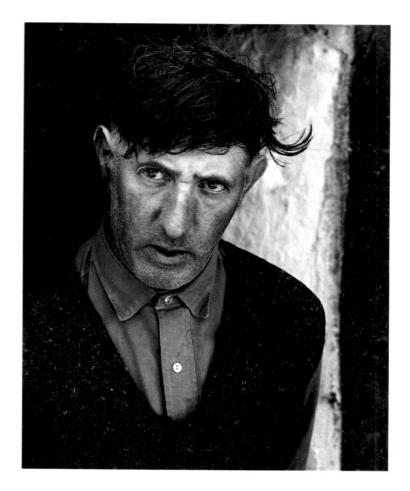

391 Killip *Portrait* [n.d.]

392 Killip *Mr John Moore, Ballalonna, Isle of Man* 1969–73

393 Killip *Concert, Sunderland* 1984

394 Killip *Baked Beans* [n.d.]

395 Killip *Youth on Wall, Jarrow* 1976

396 Killip *Swans, Cass-ny-Hawin, Santon, Isle of Man* 1969

397 Graham Smith *I thought I saw Liz Taylor and Bob Mitchum in the back room of the Commercial, South Bank* 1984

398 Graham Smith *South Bank* 1982

399 Graham Smith *The Zetland, Middlesbrough* 1983

400 Graham Smith *Back Room of the Commercial, Friday Night, South Bank* 1983

401 Graham Smith *Sandy and Friend, South Bank* 1983

402 Graham Smith *Easington, Co. Durham* 1976

403　Parr　*Passing Naturalists, Pagham Harbour*　1975

404　Parr　*Glastonbury Tor*　1976

405 Parr *Tupperware Party* 1985

406 Parr *New Brighton* 1984

407 Parr *Videoshop* 1985

408 Parr *New Brighton* 1984

13

David Mellor

SCENES OF CONFLICT

Before the mid-1930s wars had, of course, been reported photographically, but a definite change occurred abruptly in 1936 with the onset of the Spanish Civil War. A visceral instantaneity, a closeness to combat itself, utilising the new generation of miniature, 35 mm. cameras, became established as a new mode for representing war. Robert Capa is the paradigm of this new combat photographer: an existentially engaged hero; the reporter as man of action, who places him- or her-self into the extreme situations of life and death. This was a rôle that would be emulated by successive photographers: Dmitri Baltermants, W. Eugene Smith, Don McCullin and Susan Meiselas.

The texts of Ernest Hemingway (with whom he became friends in Spain) offered a model of laconic martial stoicism which Capa used to narrate his autobiography *Slightly Out of Focus* (1947), in which he described his D-Day experiences in terms of an existential gamble with 'his stake—his life'—a test which he partly failed through an attack of 'the shakes' under withering fire, which led him to retreat and then to cope with his lacerating sense of guilt for not having stayed on 'Easy Red' beach to take photographs. Throughout the episode the act of photography is seen to be inseparable from the military action, caught up in its chaos rather than being objective and apart. Here was a sketch for the rôle of a participant-observer who had to be wholly involved with the event, risking his life in combat, if his pictures were to have any value.

Proximity to danger was the key device: upon it rested the worth of the photograph, summed up in Capa's dictum: 'If your pictures aren't good enough, you aren't close enough.' Thus, Capa's photographs from 'Easy Red' beach are marked with the scarifying authenticity of violent action—blurs of bodies thrown into a hostile world against the elements of sea and land. The prints hover on illegibility, distressed by another destructive act: the negative emulsions melted during the drying of the films, visibly distending the sprocket holes on one print, forming indexical signs of an existential universe of accident.

Capa aspired to the cinema, taking his name from the Hollywood director Frank Capra and hoping also that his autobiography would be adapted into a film. But the imagination, in the mid-1930s, was stocked with another kind of cinema, that of the Soviet Union. An inescapable influence of the time—one that configures his *Soldier at the Moment of Death, Spanish Civil War* (pl. 410)—were films such as *We From Kronstadt* (1936), which laid down a lexicon of compositions and postures for imagining war according to some new genre of heroic struggle where the body strained towards political sacrifice and transcendence. The recently established tradition of writing history with film was extended into still photography in the Soviet Union from 1941–45, during the Great Patriotic War. The cinematic flows and movements of figures, the dissolution of contours into flat, powerful patches of energy, become the distinguishing formal feature of the work of Dmitri Baltermants and Georgi Zelma. In Baltermants's *Attack* (pl. 419), as in Capa's salvaged D-Day pictures, the record of war is a set of rapid gestures lacking all tonal transitions. Baltermants's infantrymen are black silhouettes, their coats and knees producing vectors of speed, force and urgency, recognisable within a tradition of Soviet poster design from the 1920s.

390

This vectoral *élan*, while present in Capa's lyrical snatches of instants of war, is elaborated into an epic by the Soviet photographers. The category of epic is signified by their arching, spanning visions across vistas of open landscape, roads or blitzed towns, often produced by joining up two or three frames—a recourse to the spaces of late-nineteenth-century panorama-paintings of Russian history, or those popular diorama formats which depicted Civil War events, producing, altogether, an encircling sweep of space and narrative. The sky above these racing Soviet heroes is a place of apocalyptic clouds, big, black, grey and smoky: allegories of the storm of war over the motherland of Russia. In the later photographs of the Battle of Berlin, with pillars of smoke over the Reichstag, the sky is again an allegory, this time signifying the apocalypse of the Nazi order.

The drive towards some monumental, epic account of the war was shared by one of the American photographers in the Pacific, W. Eugene Smith. Within his ostensibly secular representations of war the vestiges of the sacred persisted as visual schemas. Just as Baltermants's *Kerch, Crimea (Grief)* (pl. 422), depended for its strongly affective charge upon the iconography of grieving women at some new Golgotha, so Smith re-used the pathos of the Roman Catholic iconography of his childhood to shape a place for weary and wounded marines, placing them in a continuum of representations of martyrdom. Benediction fell upon the head-wound stretcher case in *Okinawa, April 19, 1945* (fig. 15), when he, in Smith's own words, 'brought his hands together in the folded position of prayer, his lips began to move, he stopped writhing'.[1] Smith's monumental formalising presented the wounded soldier in that position, like a tombstone effigy, a *memento mori*. A savage quietism, a contemplation of the passage of the dead amid a present purgatory, informs Smith's combat Depositions and Pietàs, as much as his later photograph of a wake in a Spanish village in 1951. Smith had wished to photograph Spain after he had seen Capa's reportages of the Civil War in *Life* in 1938–39. But instead of Capa's mobile glances from the era of hope and voluntaristic struggle, by 1951 Smith's Spain was the world of Franco's consolidation, of Cold War pieties, of a stasis incarnated in those oppressive figures of armed power and brutal order, the three Guardia Civil (pl. 413).

If Capa and Baltermants had the substantial promise of the defeat of the Axis tyrannies as a spur to their work, no such assurance of any future triumph can be found in Don McCullin's photographs. In him is further intensification of Roman Catholic darkness and morbidity, and another mobilisation of the resonances of Entombment and Deposition iconography, but—crucially—shorn of their redemptive dimension. The fall of the sparrow at the close of McCullin's *The Destruction Business* (1971) passes unnoticed by a now absent God. McCullin marks the point where an open nihilism structures war photography. For while an epic, tempestuous sky passed over Russia, in McCullin the horizon has vanished and our attention is lowered to an earth that has been pulverised, a polluted mess of 'dust and dirt'.[2] Abjection and dejection are his great themes; whether troops in Hué in 1968 or a teenager in Liverpool in 1964, his figures are gaunt, dark eyed, downcast; they appear to have risen from the grave. Part of an English neo-gothic tradition like Bill Brandt, McCullin confronts the undead of a black, sunless planet. Beset by anxieties, these dead in war might, he feared, 'sit up and touch me and drag me down'.[3]

If McCullin wove together the wars of the Third World and the degradation of the West in twilight tones and monochrome butchery, Susan Meiselas drew up a Central American insurrection in polychrome and a spectacularly anti-heroic mode. Her book *Nicaragua* (1981) shows a communalist imagery, presenting that unified topic of the citizen-soldier, the people-in-arms, improvisatory, agile, set against inflexible, repressive professional soldiery (of which Smith's Guardia Civil were prototypes). Meiselas's strategy of representation uses the figures of carnival; here

Fig. 15 W. Eugene Smith, *Okinawa, April 19, 1945*. Center for Creative Photography, University of Arizona.

1 Eugene Smith, *Let Truth be the Prejudice*, New York 1985, 101
2 Don McCullin, *The Destruction Business*, London 1971, 14
3 Ibid., 18.

masks are worn by shy, awkward and posing insurrectionists: delicately painted Indian dance masks, *yanqui* pop-culture Spiderman masks, baseball caps and 'beanie' hats with NEW ORLEANS printed on them. A fragmented war, a *bricoleur*'s war; perhaps, even, a Postmodern war of disjunctions between different kinds of representations. Horror recovers its poignancy through grotesque sights; the shocking vicissitudes of the fallen body—quick-limed, carbonised in fire, eaten by wild animals—a catalogue of abject human disposability and transformation into waste.

Meiselas's war was still fundamentally a narrative of violent contention, a visual document of the popular memory, despite all her devices of carnival, shock and hallucinatory colour. But it constructed tropes of dissimulation, occlusion, hiding and masking. In Paul Graham's photographs of Northern Ireland from the mid-1980s, published as *Troubled Land* (1987), armed conflict has virtually disappeared, except for some tell-tale sign. Graham's photographs are a departure from certain into the deep background, lost or hidden. Yet in each photograph there exist minimal signs of sectarian conflict, military surveillance, terror and counter-terror; all shrunk, miniaturised into a conventional landscape or cityscape. An army helicopter, apparently the size of a dragonfly, moves out behind an overgrown country hedge in summer; painted kerbstones under more stormy skies declare the insignia of Unionism. Time, space and incident seem emptied out, flattened and waning. These are omens, generally banal ones, often indistinguishable from the social tissue, signalling local affiliations, badges of identity. Occasionally, as in *Graffiti, Ballysillan Estate, Belfast* (pl. 433) there comes a warning: in flaring orange under rainy blue-grey clouds—BEWARE. The landscape is a trap, but Graham has created a myth that discloses the landscape as an insurgent place of 'low intensity operations', a photographically surveyed zone where 'we can no longer distinguish war from peace'.[4]

4 Paul Virilio and Sylvère Lotringer, *Pure War*, New York 1983, 6.

ROBERT CAPA

from *Slightly Out of Focus* (1947)

I would say that the war correspondent gets more drinks, more girls, better pay, and greater freedom than the soldier, but that at this stage of the game, having the freedom to choose his spot and being allowed to be a coward and not be executed for it is his torture. The war correspondent has his stake—his life—in his own hands, and he can put it on this horse or that horse, or he can put it back in his pocket at the very last minute.

I am a gambler. I decided to go in with Company E in the first wave.

Once I decided to go in with the first assault troops I began to convince myself that the invasion would be a push over and that all this talk about an 'impregnable west wall' was just German propaganda. . . .

My beautiful France looked sordid and uninviting, and a German machine gun, spitting bullets around the barge, fully spoiled my return. The men from my barge waded in the water. Waist-deep, with rifles ready to shoot, with the invasion obstacles and the smoking beach in the background—this was good enough for the photographer. I paused for a moment on the gangplank to take my first real picture of the invasion. The boatswain who was in an understandable hurry to get the hell out of there, mistook my picture-taking attitude for explicable hesitation, and helped me make up my mind with a well-aimed kick in the rear. The water was cold, and the beach still more than a hundred yards away. The bullets tore holes in the water around me, and I made for the nearest steel obstacle. A soldier got there at the same time, and for a few minutes we shared its cover. He took the waterproofing off his rifle and began to shoot without much aiming at the smoke-hidden beach. The sound of his rifle gave him enough courage to move forward and he left the obstacle to me. It was a foot larger now, and I felt safe enough to take pictures of the other guys hiding just like I was.

It was still very early and very grey for good pictures, but the grey water and the grey sky made the little men, dodging under the surrealistic designs of Hitler's anti-invasion brain trust, very effective.

I finished my pictures, and the sea was cold in my trousers. Reluctantly, I tried to move away from my steel pole, but the bullets chased me back every time. Fifty yards ahead of me, one of our half-burnt amphibious tanks stuck out of the water and offered me my next cover. I sized up the situation. There was little future for the elegant raincoat heavy on my arm. I dropped it and made for the tank. Between floating bodies I reached it, paused for a few more pictures, and gathered my guts for the last jump to the beach.

Now the Germans played on all their instruments, and I could not find any hole between the shells and bullets that blocked the last twenty-five yards to the beach. I just stayed behind my tank, repeating a little sentence from my Spanish Civil War days, '*Es una cosa muy seria. Es una cosa muy seria.*' This is a very serious business. . . . The next shell fell even closer. I didn't dare to take my eyes off the finder of my Contax and frantically shot frame after frame. Half a minute later, my camera jammed—my roll was finished. I reached in my bag for a new roll, and my wet, shaking hands ruined the roll before I could insert it in my camera.

I paused for a moment . . . and then I had it bad.

Extract from Robert Capa, *Slightly Out of Focus*, (Henry Holt and Co.) New York 1947.

The empty camera trembled in my hands. It was a new kind of fear shaking my body from toe to hair, and twisting my face. I unhooked my shovel and tried to dig a hole. The shovel hit stone under the sand and I hurled it away. The men around me lay motionless. Only the dead on the water line rolled with the waves. An LCI braved the fire and medics with red crosses painted on their helmets poured from it. I did not think and I didn't decide it. I just stood up and ran toward the boat. I stepped into the sea between two bodies and the water reached to my neck. The rip tide hit my body and every wave slapped my face under my helmet. I held my cameras high above my head, and suddenly I knew that I was running away. I tried to turn but couldn't face the beach, and told myself, 'I am just going to dry my hands on that boat . . .' .

Our boat was listing and we slowly pulled away from the beach to try and reach the mother ship before we sank. I went down to the engine room, dried my hands, and put fresh films in both cameras. I got up on deck again in time to take one last picture of the smoke-covered beach. Then I took some shots of the crew giving transfusions on the open deck. An invasion barge came alongside and took us off the sinking boat. The transfer of the badly wounded on the heavy seas was a difficult business. I took no more pictures. . . .

I woke up in a bunk. My naked body was covered with a rough blanket. On my neck, a piece of paper read: 'Exhaustion case. No dog tags.' My camera bag was on the table, and I remembered who I was.

In the second bunk was another naked young man, his eyes staring at the ceiling. The tag around his neck said only: 'Exhaustion case.' He said: 'I am a coward.' He was the only survivor from the ten amphibious tanks that had preceded the first waves of infantry. All these tanks had sunk in the heavy seas. He said he should have stayed back on the beach. I told him that I should have stayed on the beach myself.

The engines were humming; our boat was on its way back to England. During the night the man from the tank and I both beat our breasts, each insisting that the other was blameless, that the only coward was himself.

In the morning we docked at Weymouth. A score of hungry newspapermen who had not been allowed to go along on the invasion were waiting for us on the pier to get the first personal experience stories of the men who had reached the beachhead and returned. I learned that the only other war correspondent photographer assigned to the 'Omaha' beach had returned two hours earlier and had never left his boat, never touched the beach. He was now on his way back to London with his terrific scoop.

I was treated as a hero. I was offered a plane to take me to London to give a broadcast of my experience. But I still remembered the night enough, and refused. I put my films in the press bag, changed my clothes, and returned to the beachhead a few hours later on the first available boat.

Seven days later, I learned that the pictures I had taken on 'Easy Red' were the best of the invasion. But the excited darkroom assistant while drying the negatives, had turned on too much heat and the emulsions had melted and run down before the eyes of the London office. Out of one hundred and six pictures in all, only eight were salvaged. The captions under the heat-blurred pictures read that Capa's hands were badly shaking.

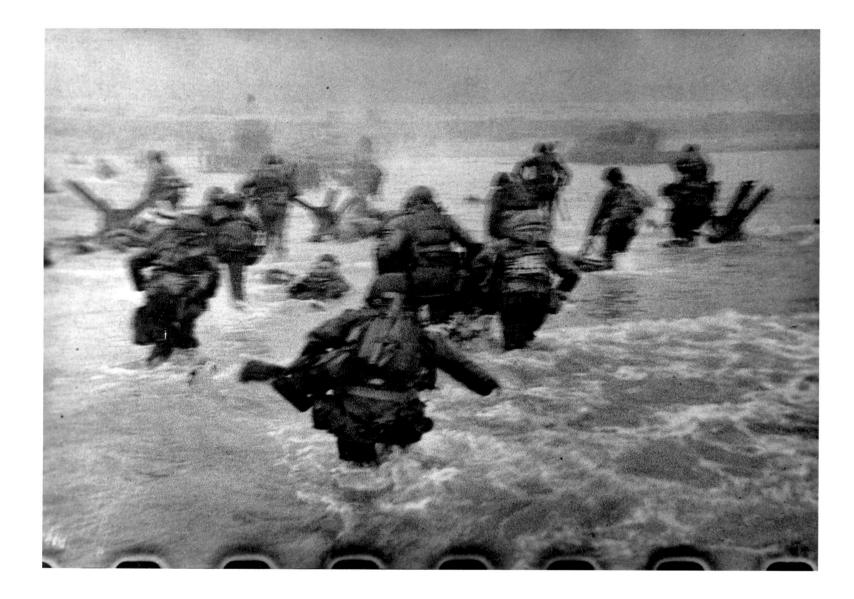

409 Capa *D-Day, Omaha Beach, near Colleville-sur-Mer, Normandy Coast, June 6, 1944*

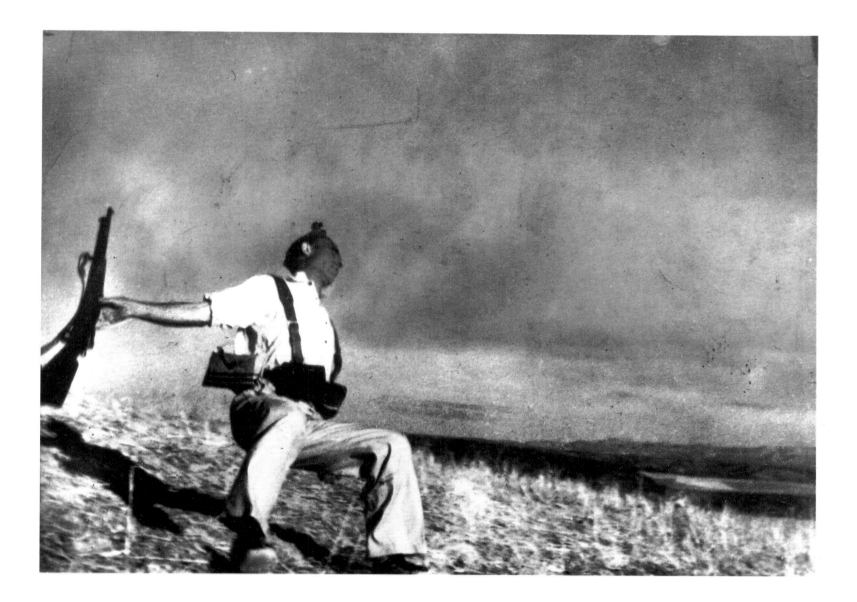

410 Capa *Soldier at the Moment of Death, Spanish Civil War* 1936

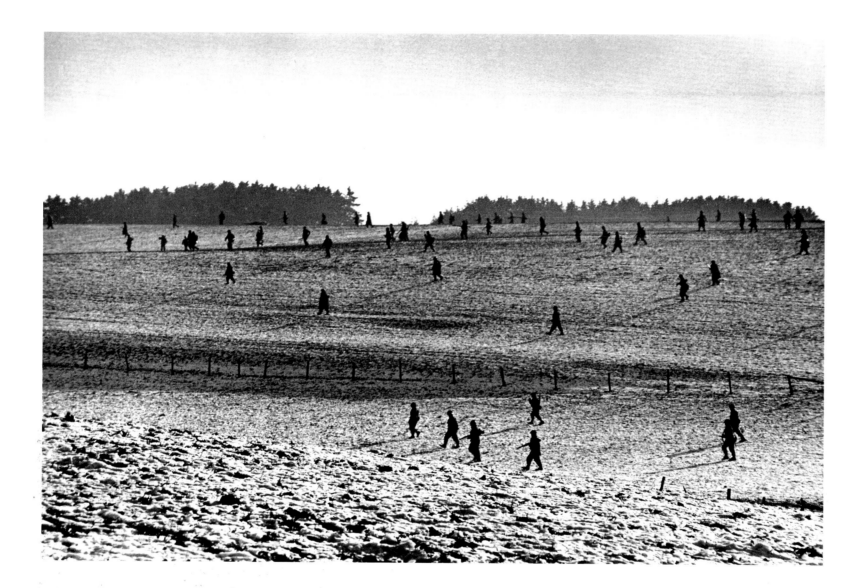

411 Capa *South of Bastogne, Belgium* 23–26 December 1944

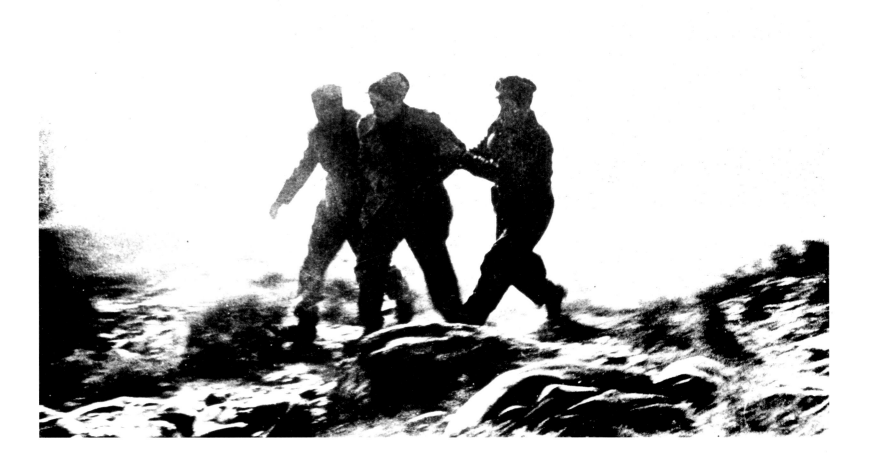

412 Capa *Spain* 1936

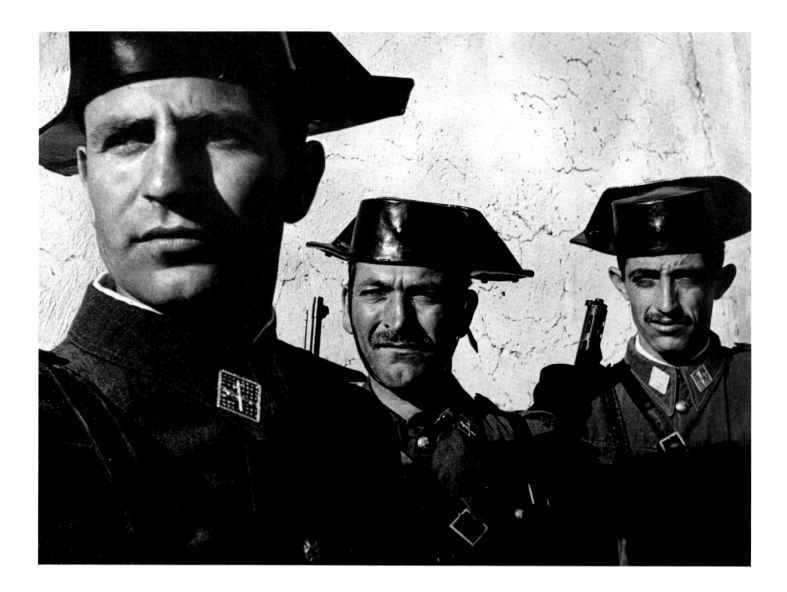

413 W. Eugene Smith *Untitled* 1950

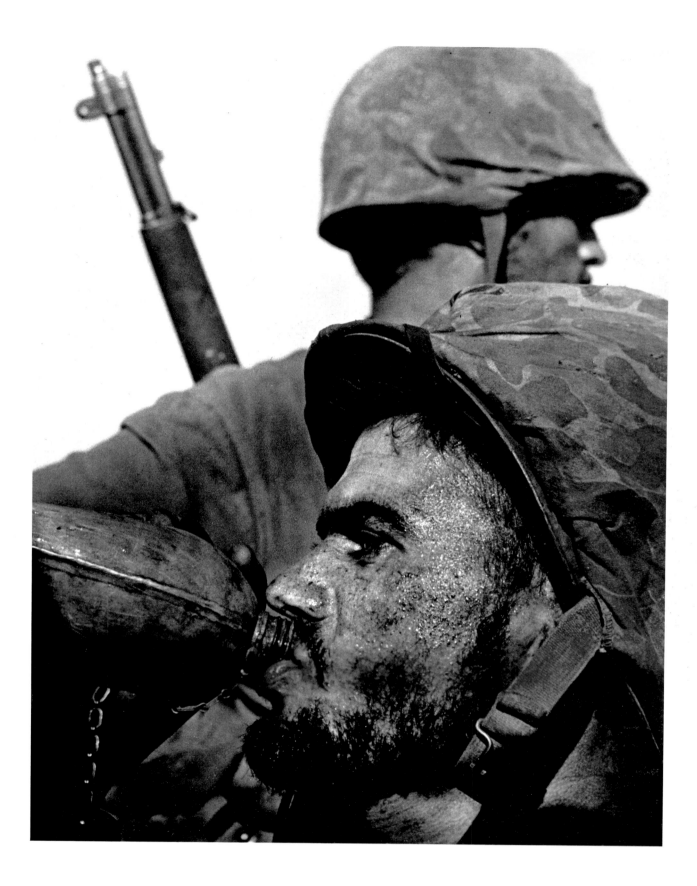

414 W. Eugene Smith *Soldier with Canteen, Saipan* 1944

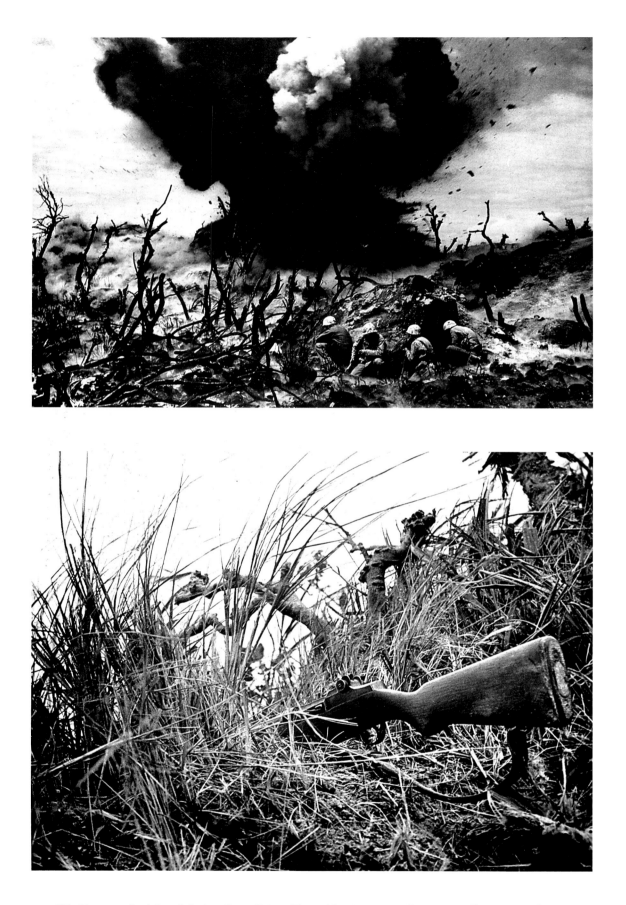

415 W. Eugene Smith *Marine Demolition Team blasting out a Cave on Hill 382, Iwo Jima* 1945

416 W. Eugene Smith *Okinawa* April 1945

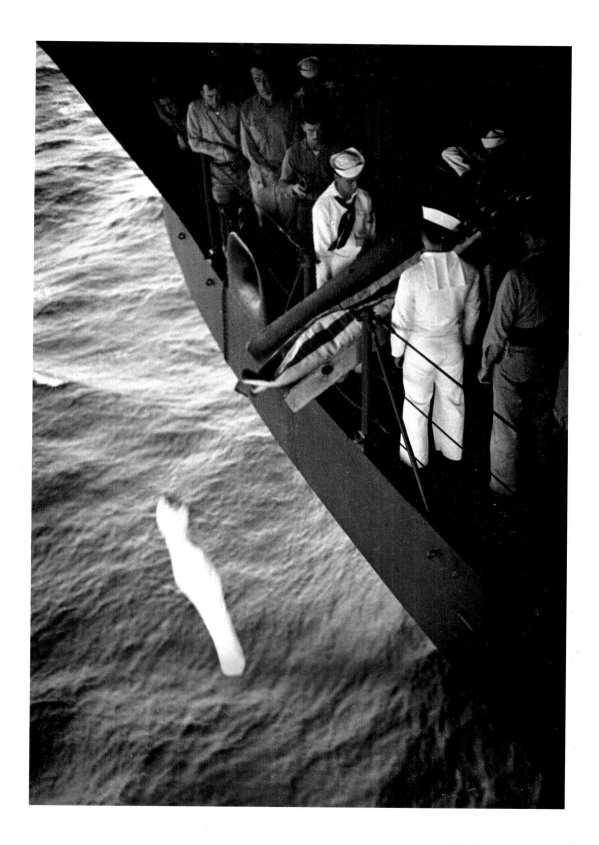

417 W. Eugene Smith *Burial at Sea* c. 1943

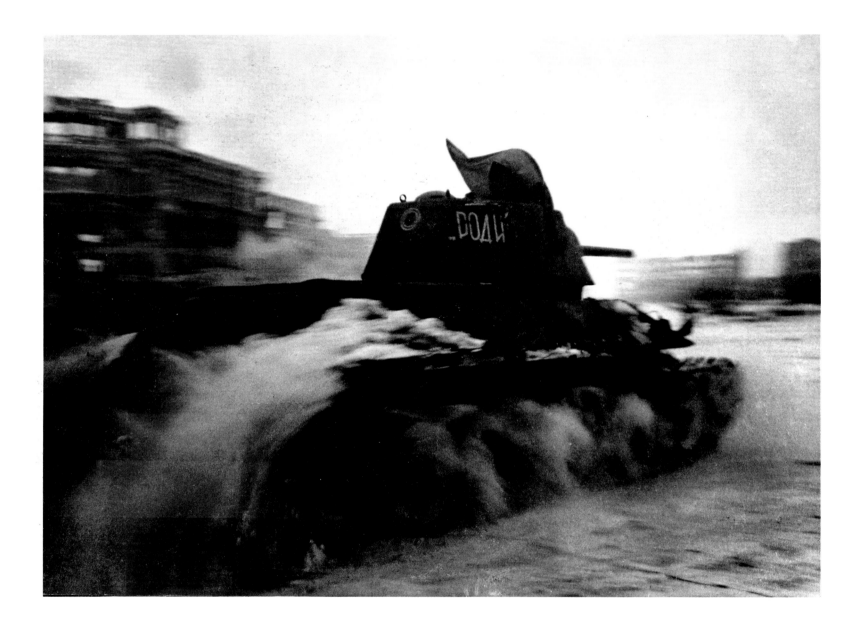

418 Zelma *A Tank called 'Motherland'* c. 1942

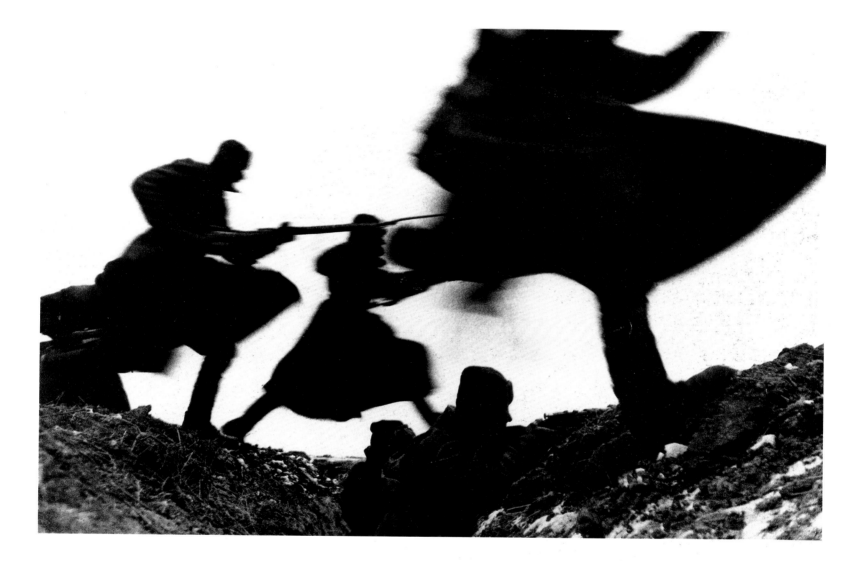

419 Baltermants *Attack* 1941

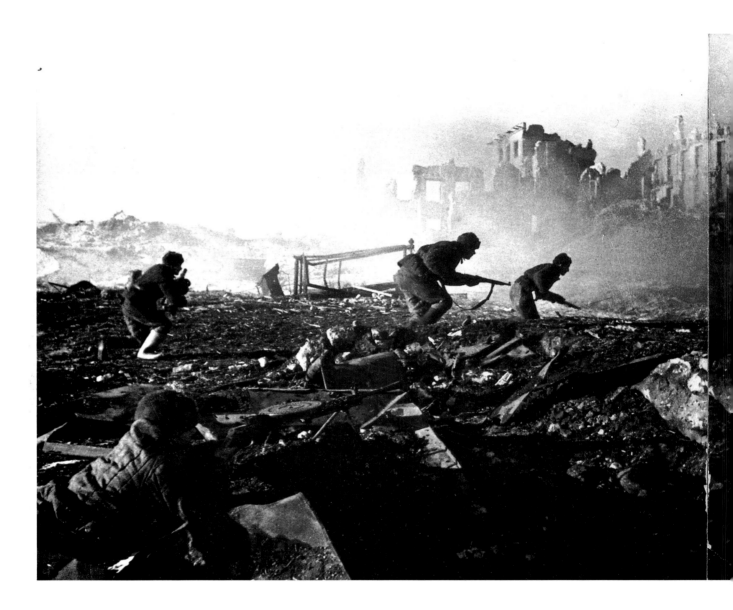

420 Zelma *The Assault of the 13th Guard, Stalingrad* 1942

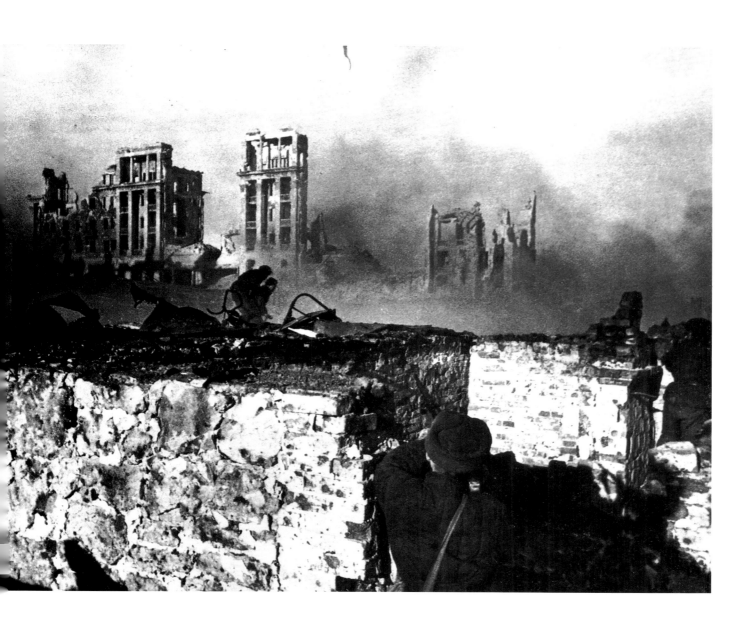

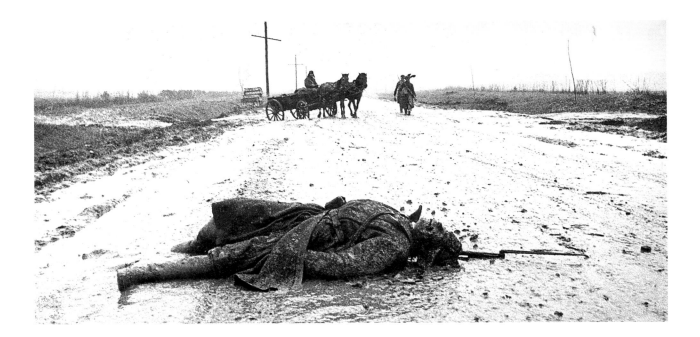

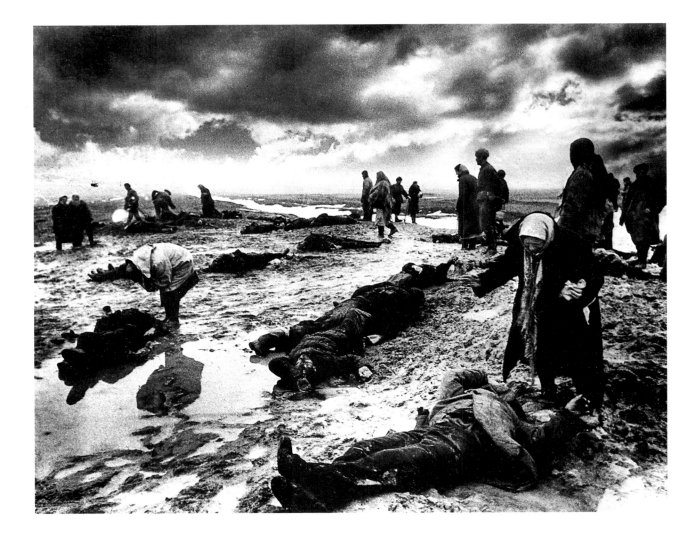

421 Baltermants *Outskirts of Moscow* 1941

422 Baltermants *Kerch, Crimea (Grief)* 1942

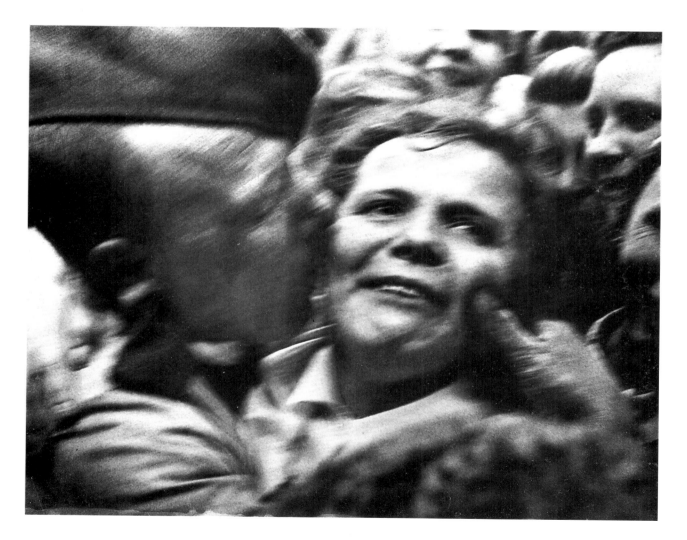

423 Morozov *The Victorious Troops signing their Names in the Lobby of the Reichstag* May 1945

424 Petrusov *Homecoming* 1945

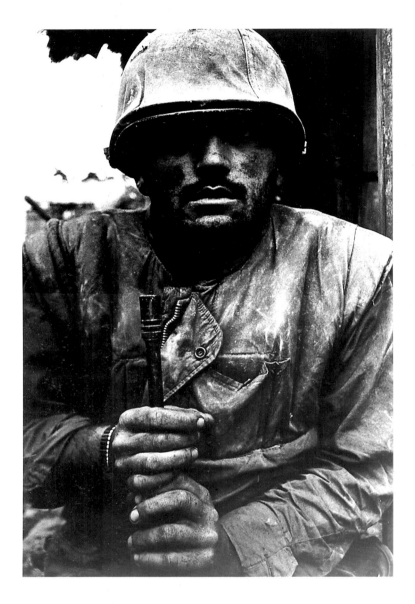

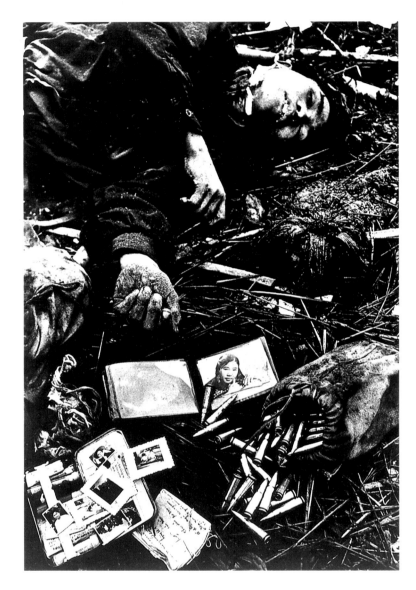

425 McCullin *Shell-shocked Soldier awaiting Transportation away from the Front Line, Hué* 1968

426 McCullin *Fallen North Vietnamese Soldier with his personal Effects scattered by body-plundering Soldiers* 1968

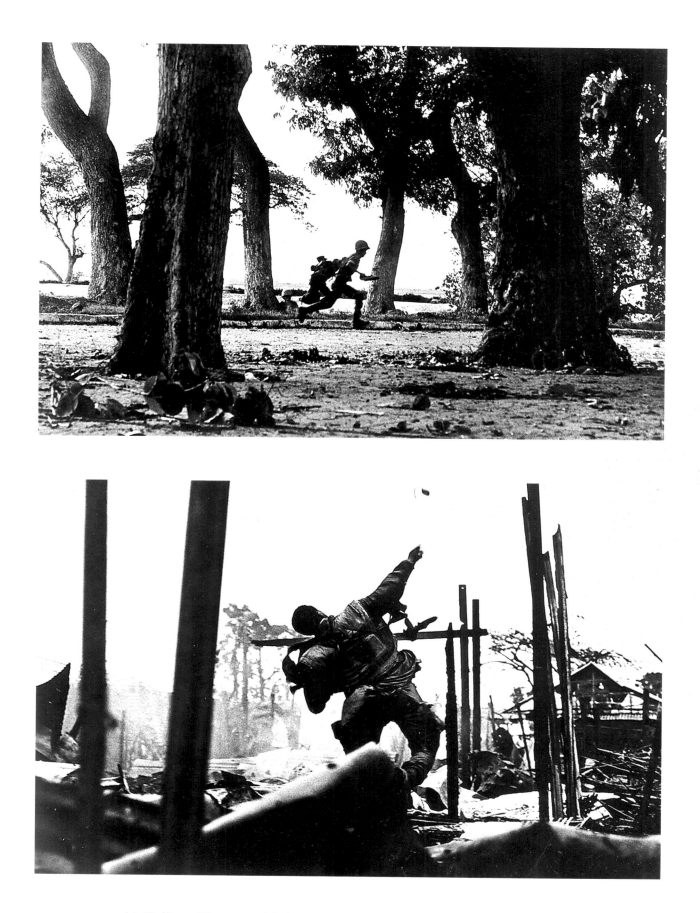

427　McCullin　*Vietnamese Marines running across a dangerous Road in Cambodia*　1970

428　McCullin　*Man throwing Grenade, Hué*　1968

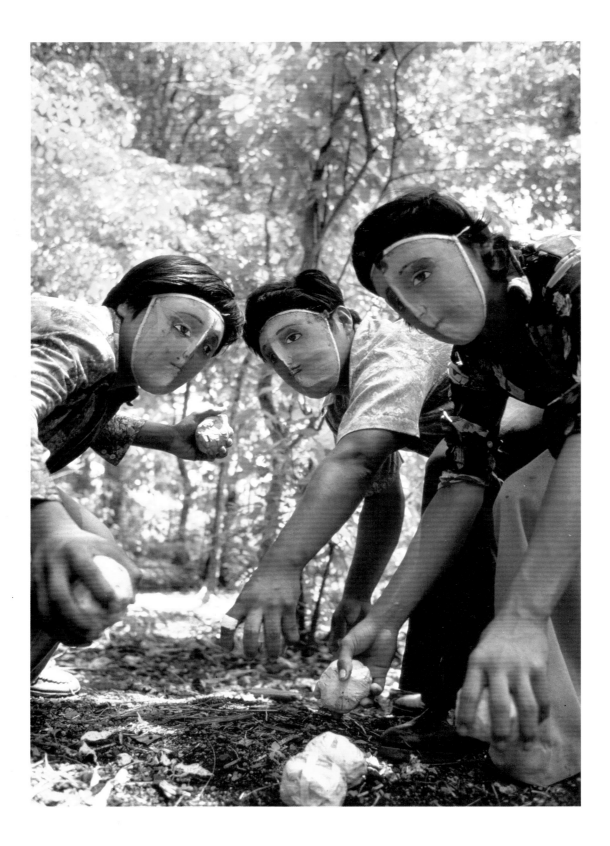

429 Meiselas *Youths Practice throwing Contact Bombs in Forest surrounding Monimbo* 1978

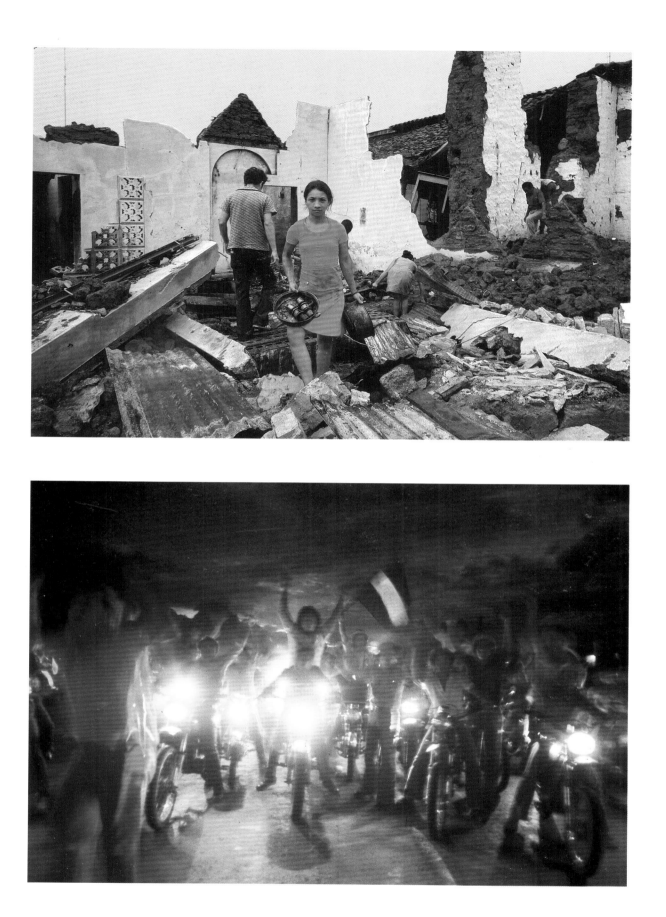

430 Meiselas *Returning Home, Masaya* September 1978

431 Meiselas *Motorcycle Brigade, Monimbo, Nicaragua* 5 July 1978

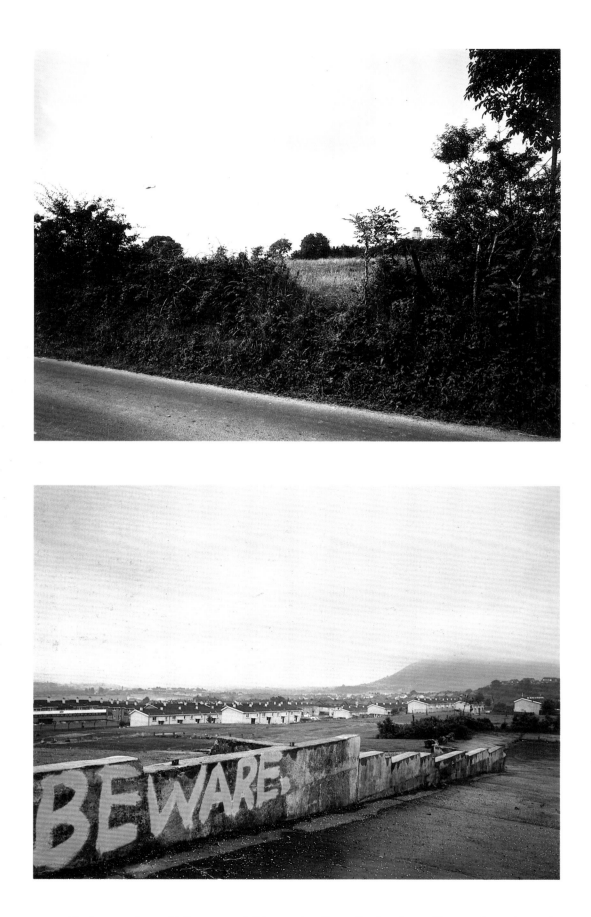

432 Graham *Army Helicopter and Observation Post, Border Area, County Armagh* 1986

433 Graham *Graffiti, Ballysillan Estate, Belfast* 1986

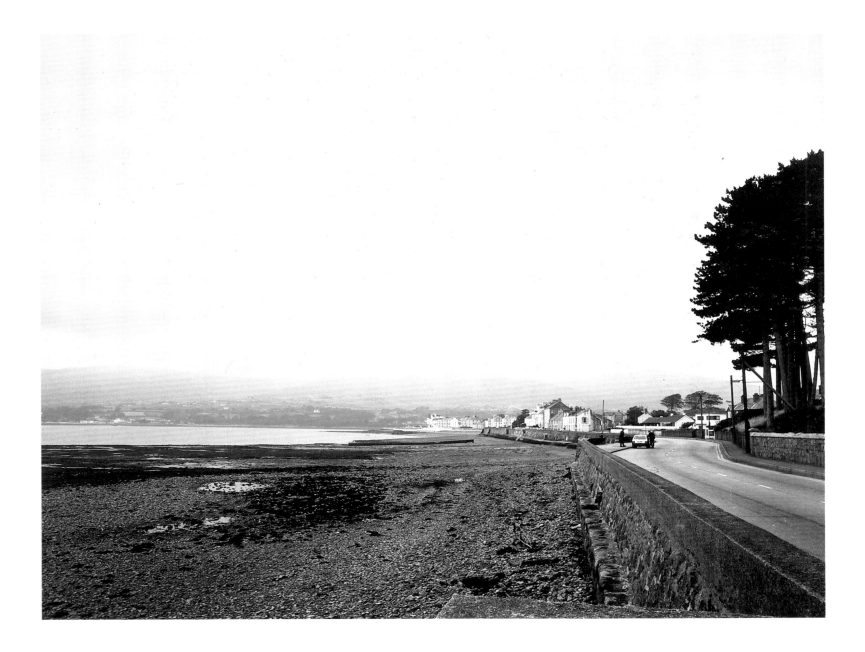

434 Graham *Army Stop and Search, Warrenpoint* 1986

14

David Mellor

FIGURES OF STYLE

Photographing those individuals, costumes and commodities that were, in effect, being sanctioned as fashionable was a discourse invented and put into circulation in the 1910s and '20s. The primary vehicle for this was a recently established group of New York magazines, *Vogue, Harper's Bazaar* and *Vanity Fair*, and in the following decades a variety of professional skills and shifting strategies for representing what was fashionable were developed through what amounted to rhetorical figures of style in photography.

The career of Baron Adolf de Meyer, who was drawn into the corporate structures of this new genre in 1914, stands at its foundation: his *Man with a Cane* (pl. 435) anticipates and epitomises an entire tradition of modish portraiture. The anonymous dandy is presented as a motif of urbane bodily and costumed perfection; his swallow-tailed coat swings out for the spectator's inspection; he is an ornament, a figurine in one of the newly popular pageants and displays organised by the fashionable aristocrats of de Meyer's circle, such as Comte Etienne de Beaumont. Facing the empty chair, he appears in frozen dialogue with an invisible lady, one whose shawl has fallen over the seat and onto the floor. This persona of formal correctness is the very one in which, twenty years later, Martin Munkácsi will photograph Fred Astaire, animating it with vivid movement and relaxing its dress codes. Fashionable photography will oscillate between these two fundamental poles of statuesque, isolated poise and open informality.

De Meyer's courtier-like articulation of a world of leisure revives the tradition of aristocratic portraits which itself was surviving in pastiche form at the hands of Anglo-American Edwardian painters such as John Singer Sargent. De Meyer's illumination is consistently *contre jour*, producing not so much a silhouette, as an auratic body, mysterious and soft edged, constituted by the softened tones of luxurious surfaces of clothing, of tulle and silk. These signs of conspicuous consumption depend upon the repeated presence of superfluity: an excess of light, a materialisation of costly goods and ultra-refined atmosphere.

De Meyer stands as the historical mediator between the universes and functions of Sargent, Whistler and Boldini on the one hand and of Huene, Horst and Beaton—the specialist technicians of style in the new era marked by the turn of the 1920s—on the other. He had arrived at *Vogue* at the crisis moment—the onset of the Great War, followed by the Soviet Revolution—to engineer a simulation, a re-invention for the camera in the age of the money economy, of those disappearing rites of a high 'aristocratic' life-style. This was to be his especial fiction, one upon which, with all its tensions, a photographer such as Helmut Newton would continue to elaborate.

The recruitment of the ex-sports and reportage photographer, Munkácsi by *Harper's Bazaar*, in 1933, replaced de Meyer and the connotations of his style, both literally and metaphorically. As in contemporary developments in war photography, the body, according to Munkácsi, became vectorised, thrown out of repose and fixity, relocating the avant-garde issue of dynamism at the heart of this branch of commercial photography. One of the preferred subjects of central and East European New Vision, particularly at the Bauhaus, had been the 'eccentric', acrobatic body in motion. Munkácsi's *Someone at Breakfast* (fig. 16) establishes the

Fig. 16 Martin Munkácsi, *Someone at Breakfast*, c.1933. Gilman Paper Company Collection.

1 Carmel Snow with Mary Louisa Aswell, *The World of Carmel Snow*, New York 1962, 88.
2 Cf. Elizabeth Wilson, *Adorned in Dreams*, London 1985, 43, 92.
3 Thorstein Veblen, *Theory of the Leisure Class* [1925], London 1957, 157.
4 Ibid., 15.

point at which this cult of representing a dynamised body in off-axis and anti-gravity photographic accounts becomes a public novelty and spectacle. While his female colleague sits motionless, a male entertainer dances on the wall, the world is rotated and posture and position are questioned. Munkácsi proceeded to map such New Vision codes onto society fashion mannequins rather than onto marginals such as acrobats. *Harper's Bazaar* editor, Carmel Snow, described that moment in the autumn of 1933: 'It seemed that what Munkácsi wanted was for the model to run toward him. Such a "pose" had never been attempted before for fashion. . . . The resulting picture . . . a typical American girl in action.'[1] Thus, the cultural mythology of the athletic, healthy, all-American girl naturalised the *neue Sachlichkeit* mode in the photograph *Lucille Brokaw* (pl. 439).

Munkácsi's manipulation of Modernism's fascination with the activated, angular body moving in space was made complicit with changes in the fashion industry, such as the invasion of formal wear by sports clothes in the 1930s.[2] Similarly, the fashion work of Irving Penn was unthinkable outside the network of meanings encircling the 'New Look' in Parisian dress design towards the end of the 1940s. An austere formalism, a neo-Romantic return to the past, a melancholy sense of closure—these elements characterise his photographs as he emerges as a portraitist and fashion photographer. Penn belongs to this tragic, even pessimistic moment in the Western visual imagination: all the fine promises of Modernist utopias and politics have collapsed. Apart from his highly contrasted oppositions of black and white, his bleached-out graphic designs of 1950, such as *Black and White Vogue Cover* (pl. 441), Penn represents a grave, subdued vision. In this photograph northern light matches the disconsolate bareness of interior isolation, according to the prevalent cultural mood of the time. A purgative purism defines Penn's 1948 revolution in portraiture, a paring down to the irreducible object, with minimal props signifying meagreness in absent spaces.

In these photographs light is rendered into powdery atoms: even, entropic, eclipsed and sourceless. It resembles dust and goes to produce an elegiac register of covers and shrouds. Behind the *Rochas Mermaid Dress* (pl. 443) a bank of grey felt or paper falls, stained grey on grey, like an imaginary Abstract Expressionist canvas, a field of amorphous, long-worn-out spillages, while a swath of tulle splays and becomes lost against the tonalities of the background, the final refuge of the ineffable and auratic, as if de Meyer were being renegotiated for the Age of Anxiety.

In the face of used-up Western history, archaism and exoticism, Penn looked beyond the instabilities of fashionable change and rôles. He invented rank, ennobling the coalman in a *petit métier* portrait (pl. 445) in which signs of labour (his unravelling protective sack, the sooty, soiled shirt) were displaced into signs to be savoured in terms of surface and tonalities. His connoiseurship of 'relatively stable costumes'[3] is there at the origin of his photography in Peru in 1948: it has since been extended by Penn to the Third World, to New Guinea and, as in *Two Guedras* (pl. 442), to Morocco.

Penn's primordial decontextualisation, the photographing of isolated charismatics (or grotesques) in puristic surroundings, flourished in the work of David Bailey. Yet instead of severing his sitters from time and history, Bailey's portrait and fashion photography is irremediably fed back into a historical moment—London in the 1960s. While Penn's figures lie in some immaculate region beyond the frame, Bailey's break into the spectator's space, leaning in, energetic, the epitome of the fashionable 'personality'; the media hero (or villain) is literally foregrounded. In *Michael Caine* (pl. 446) and *Kray Brothers* (pl. 447) the sitters meet our gaze and aggrandise us; as in the case of Munkácsi, Bailey has given his subjects an identity as 'centre[s] of unfolding, impulsive activity'.[4] The premium has returned to some discourse of the dynamic body—a provocative body in *Sharon Tate and Roman*

Polanski (pl. 448). If the erotics of the 'sharp' business suit are the supports for the *Michael Caine* and *Kray Brothers* portraits, then a narrative around hair sustains the Polanski/Tate picture. Here a circuit of hair, a wreath (part curvilinear device of the contemporary revival of Art Nouveau, part displaced sign of their carnality) frames the two lovers.

Incorporating the (sexually) transgressive within the cordon of figures of style has been the domain of Helmut Newton's photography since the late 1960s. His dislocating, incremental intrusion of the bizarre, during that period was the beginning of narratives constructed around female masquerades and fetishism. In contrast to Munkácsi's athleticist *Lucille Brokaw* (pl. 439), Newton's running model (pl. 450) is caught up in a dissociated, perverse version of *Alice in Wonderland*. Newton has created for the spectator scenes of fascination. Body parts, enlarged, become scenes of adorned sadness and anxiety, pitting an anti-gracefulness and unease against received icons of *chic*. A cropped, close-up eye (pl. 449) floods with silted mascara, the debris of 'beauty'; likewise a foot and an ankle (pl. 451) are a morbid, wrinkled stump.

In the midst of 'femininity', in Newton's masquerade, the phallic is rediscovered as both imperious and, at times, transformed into a masculinised woman. Newton's scenario for one 1980 fashion feature which dissimulated gender ran: 'The men are women dressed up as men. But the illusion must be as perfect as possible, to try to confuse the reader. This man/woman ambiguity has always fascinated me.'[5] Five years before this session, Newton had recreated the ambience of Brassaï's transvestite *Secret Paris of the Thirties*.[6] His nostalgia for the Paris represented by Brassaï matches his nostalgia for a lost object, an eroticised lost past of *alta Europa*, an old Europe, a Europe of Grand Hotels, Chancelleries and aristocratic order, in many ways the privileged Europe of de Meyer, before the deluge.

5 Helmut Newton, *World Without Men*, New York 1984, 128.
6 *Vogue* (Paris), (September 1975), 146.

HELMUT NEWTON
from *World Without Men* (1984)

Ever since I saw *La Dolce Vita* I have been very interested in the phenomenon of the paparazzi, a totally new breed of press photographers. This is why I am now in Rome. It is only in Rome that one can find them. (*Later, of course the idea of paparazzi photography spread all over the world.*) I have asked *Linea Italiana,* for which I am working, to arrange a contact with some of these people, as I want to hire half a dozen of them to pose with my model; and I want the real thing. So an appointment has been set up for me to meet the head man at the Caffé Greco, which is their headquarters.

At 5 pm I'm at the bar, drinking a cup of coffee with him. In front of him, next to his coffee cup is a packet of cigarettes. He says to me:

'See the man at the other end of the bar? He is a high functionary in the Intelligence Service. He's embroiled in a big political scandal at the moment; I've been trying to get a picture of him and I just got it.'

The cigarette pack contained a tiny camera and he had been shooting all the time while we were having our coffee. I was very impressed. He explained to me that the paparazzi always work in twos. They will wait outside a restaurant where they know that a certain celebrity is dining, then, when the man comes out, one of the photographers will create a scene—he might provoke him, push him a bit—the victim will get angry, protect his dinner companion, generally a glamorous woman. The paparazzo will jump out of the way, leaving the field clear for his partner to shoot the pictures fast with a flash. Very ingenious and effective.

Most of these young men with cameras are completely untrained in photography. They are country lads who come to Rome, the head man gives them cameras, explains the basic rudiments (at night working with a flash the exposure never changes, in daytime a fill-in flash is always used, technically simple and perfectly adequate for what certain newspapers and magazines require). What is highly developed is a network of information on who dines with whom at what place, often couples who would not wish to be seen together in public. . . .

The head man introduces me to the guys who will pose for me, a price for the three-day shoot is agreed, and we start work. I explain that I want them to treat my model as if she were a celebrity, to give no quarter and work exactly in the way they normally would. I tell them I will shoot very fast and get the scenes as they create them.

After the second day one of the guys comes to me and tells me that two of his colleagues have loaded their cameras with film, have taken shots of the model and me, have found out how much I am getting for my photographs, and have put together a nice little exposé which he has sold in advance to one of the tabloids. It takes all the persuasion of an Italian friend of mine and a whopping big tip to get the rolls of film back. At the end of the third day my model is completely exhausted and hysterical from the constant pummelling, running and goading she has undergone.

Extract from Helmut Newton, *World Without Men*, (Moreau, Xavier, Inc.) New York 1984.

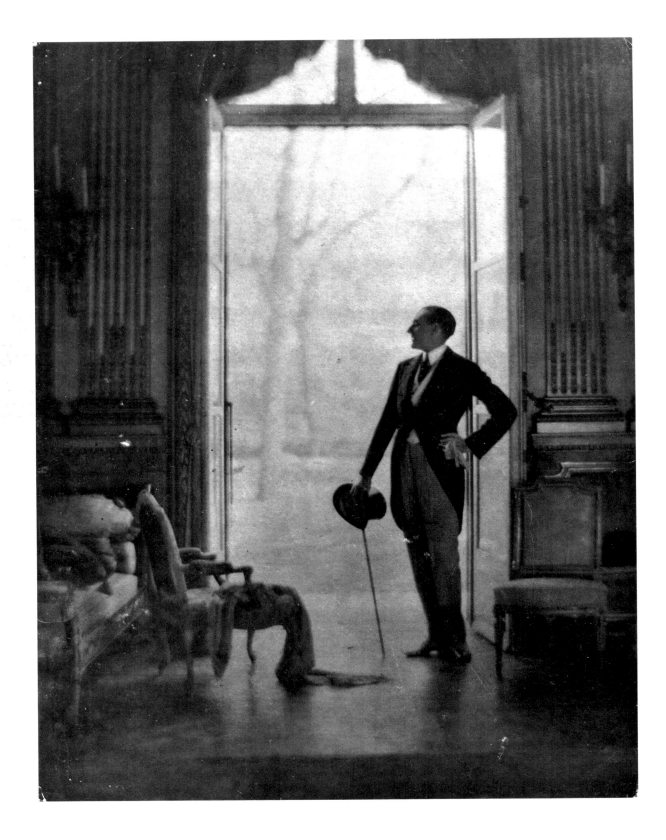

435 De Meyer *Man with a Cane* c. 1919

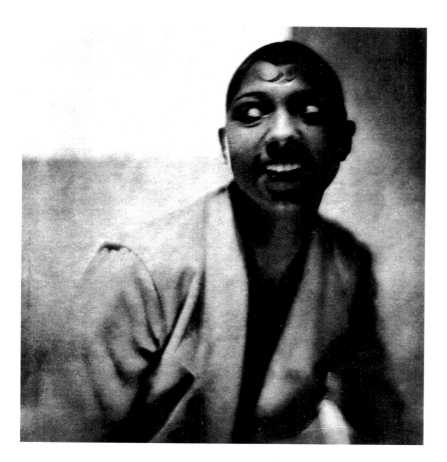 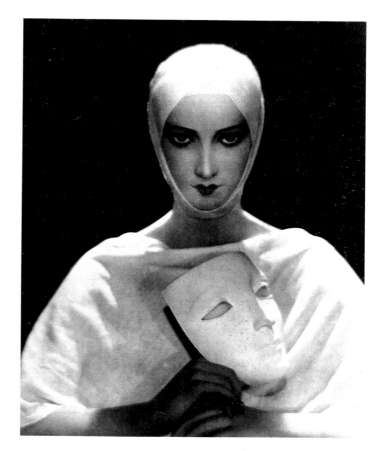

436 De Meyer *Josephine Baker* 1925

437 De Meyer *Advertisement for Elizabeth Arden* 1926

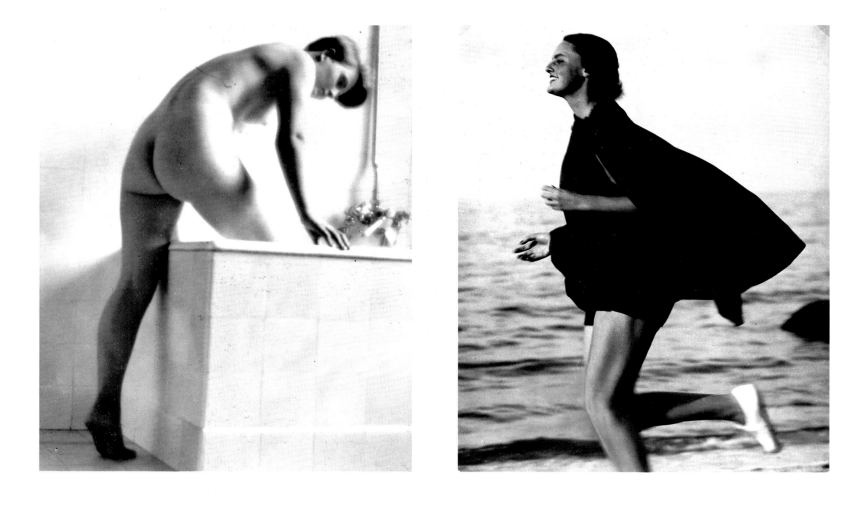

438 Munkácsi *Washing, Berlin* c. 1929

439 Munkácsi *Lucille Brokaw* 1933

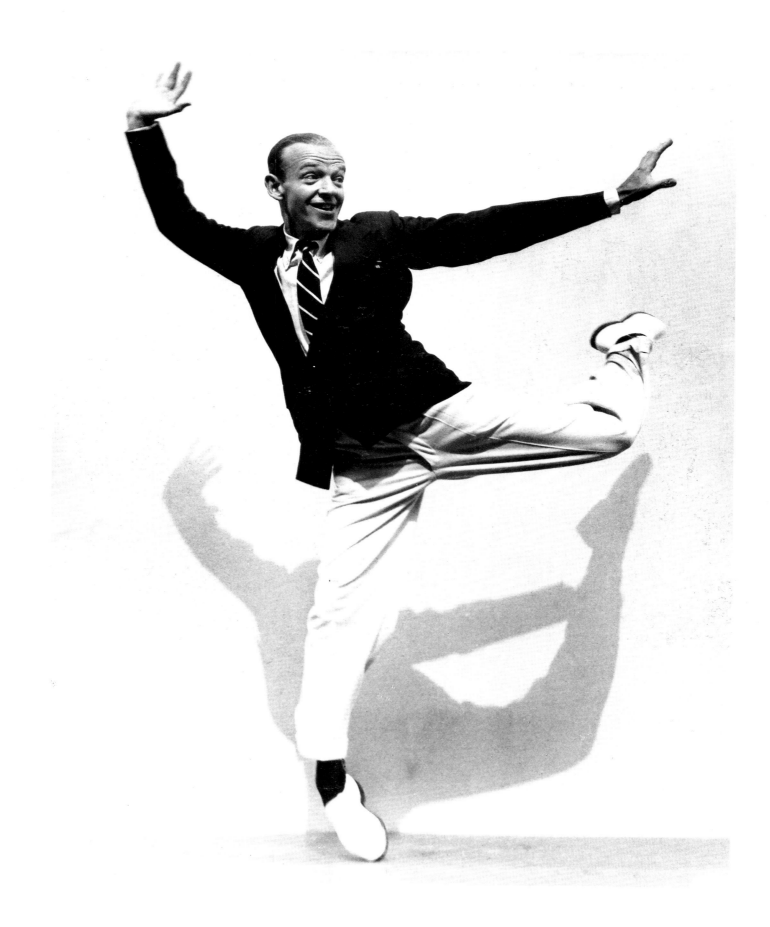

440 Munkácsi *Fred Astaire* 1936

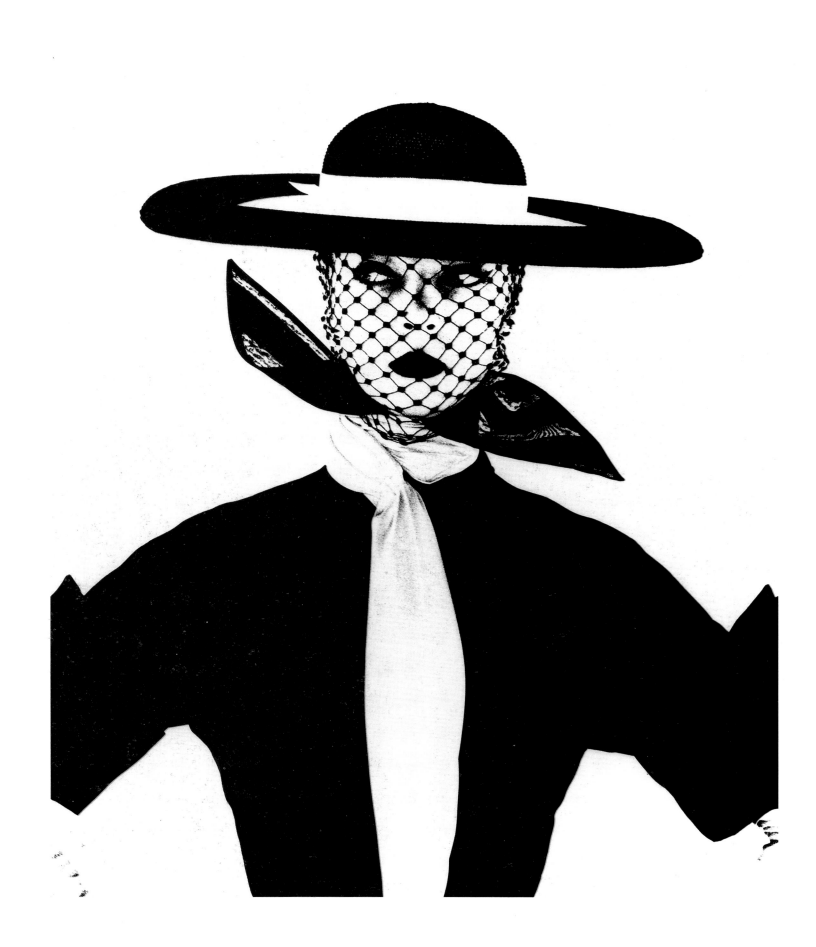

441 Penn *Black and White Vogue Cover* 1950

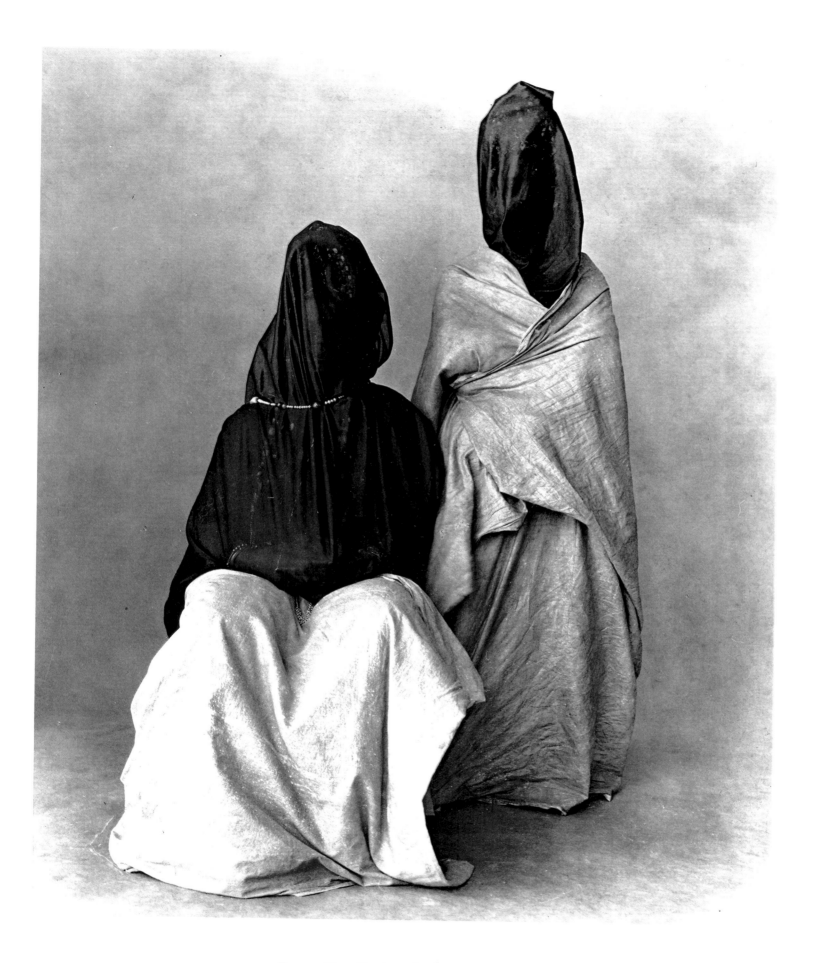

442 Penn *Two Guedras, Goulimine, Morocco* 1971

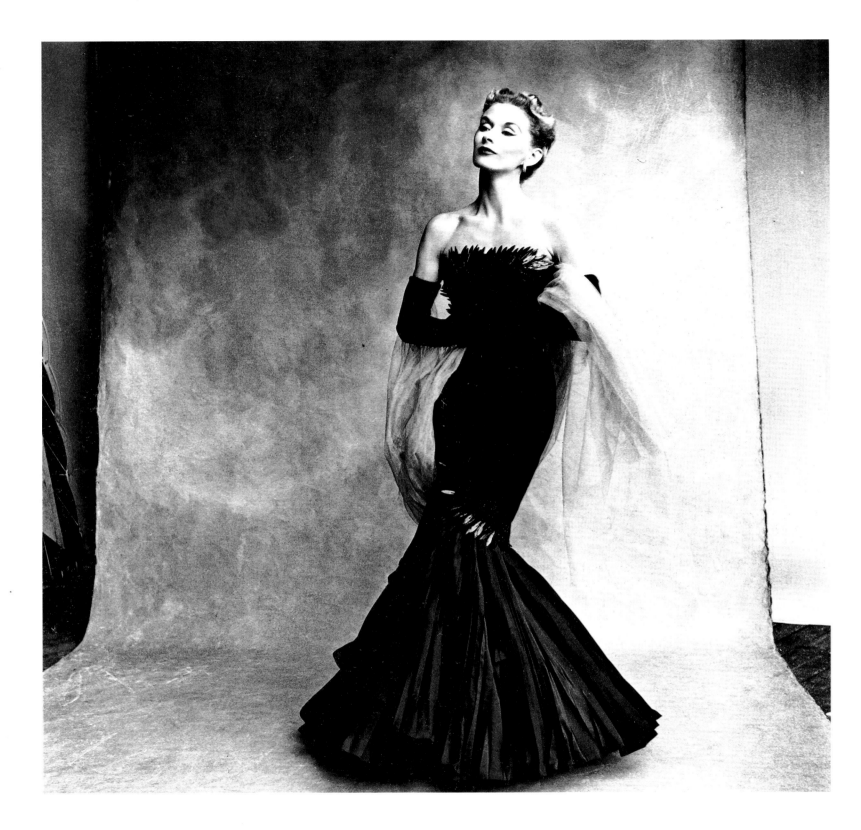

443 Penn *Rochas Mermaid Dress* 1950

444 Penn *Cecil Beaton* 1950

445 Penn *Coal Man* 1950

446 Bailey *Michael Caine* 21 May 1965

447 Bailey *Kray Brothers* 20 April 1965

448 Bailey *Sharon Tate and Roman Polanski* 1969

449 Newton *Bordighera Detail* 1983

450 Newton *Untitled* c. 1965

451 Newton *Shoe* 1983

15

Chris Titterington
CONSTRUCTION AND APPROPRIATION

The invention of photography may be seen as part of an effort, begun in the later eighteenth century, to remove the traces of an intervening, mediating consciousness from artistic production. This impulse gave rise to a number of phenomena: in painting, to naturalism and to the elevation of the sketch; in literature, to the cults of the primitive and the child, and in them both, to the emphasis on immediate creation and response.

This idea also underpins the major artistic movements of this century. In 'straight' photography, in Expressionist and Cubist primitivism, in the child art of Klee and Picasso and in the emphasis upon the unconscious in Surrealism and Abstract Expressionism, the rational mind is circumvented or in some measure anaesthetised. All of these approaches are manifestations of a cult of immediacy that spans the art of the last two hundred years and that we now call Romantic Modernism. As such they are responses to the perennial problem of achieving spontaneous and unself-conscious creativity and should be seen as part of a larger solution to that problem.

In its re-emphasis of the constructive, intervening consciousness, the work presented in this section of the exhibition is part of a broad effort to shake off solutions inherited from the eighteenth century and to attempt answers of our own in the light of new knowledge in physics and psychology. This effort has enabled a re-examination of the problem that in some ways makes it appear chimerical. That photography should have emerged as a major vehicle of the avant garde in Pop art and more recently in Postmodernism surely owes much to the presence of dominant expressionist movements that underline the traditional metaphysic of Romantic Modernism. For the artists shown here, however, the stress on immediacy implicit in such work is little more than self-delusion, and their adoption of photography has thus to do with decisions reached by a rejection of painting as too heavily redolent of expressionist irrationalism. In this scheme of thought photography is preferred for its mechanical surface—one that does not draw attention to itself as a physical object. In so doing it breaks with the morality of Modernism that taught that a work of art should not deceive but take its place in the world of things as an object in its own right. The clearest sense of this is given by the artist David Salle, who speaks of his preference for an inert surface: the work has to be 'dead; that is from life but not part of it, in order to show how [it] can be said to have anything to do with life in the first place'.[1] Photography is thus preferred less for what it is than for what it is not.

There are a number of possible motives for the rejection of the Romantic Modern principle of immediacy and for the substitution of the obvious display of mediation in the use of staged imagery. On the level of material realism the idea of unmediated experience is plainly ill-founded. We have long known that our minds supply much of what common sense would consider to be properties external to and independent of ourselves—colour and sound for instance—but we now know not only that these 'secondary qualities' are dependent upon the subject, but also that the very substance of materiality—the particulate nature of matter—is determined by the presence of an observing intelligence. This is not without irony, for the impulse towards construction is of course another manifestation of our desire to ground ourselves through an appeal to external nature. Our conception of natural, appropriate

1 D. Salle, 'The Paintings are Dead', *Cover* 1 (May 1979).

behaviour is dependent upon there being such a nature to which we may look for vindication. Clearly, the observer-interactive world we now recognise makes this impossible as we are faced with the knowledge that there is no strictly 'external' nature to which we may look.

The broader justification for constructed imagery in the work of Burgin, Boltanski, Webb and Sherman may be sought in this direction. In *Untitled no. 145* (pl. 457), for instance, Sherman photographs herself in a scene that is wholly constructed in the studio and that is clearly the product of her own ordering imagination. We are not made aware of the 'story', and the characters she has played in other works since 1978—from B-movie starlet to fairytale monster—have similarly never been fully identified. This situation, however, is not quite so simple. The expressive artist has been historically imagined as an individual free to create from an autonomous inner resource that has little to do with the compulsions and obligations of the surrounding culture. Modern linguistic-based psychology shows, however, that we are products of the linguistic structures within which we exist, and thus the 'imagination' Sherman brings into play in the building of her characters and sets is capable only of repeating cinematic clichés.

Though the realist argument is thus responsible for much of the move towards constructive modes of operation there is a more basic impulse at work here. It is that of the rejection of the essentially nostalgic cast of mind of Romantic Modernism. The attempt to circumvent the mediating higher consciousness is motivated by a sense that things had been better before the rise of intelligence, without the encumbrance of which (so the story goes) we were able to create greatly and spontaneously. It should thus be seen as an attempt to redeem the Fall and return us to a golden age of prelapsarian self-integration in which we act in the world as participants rather than self-conscious observers. This has been the enabling myth of Romantic Modernism for two centuries or more. Its demise marks the beginning of an attitude that accepts the fact and responsibility of our intelligence. It sees humanity not as a freak of nature, perpetually Adam-like and cast out from a paradise of intuition and spontaneity, but as the supreme product of evolution—a self-reflexive organ by which the world contemplates and completes itself. We are thus more fundamentally 'of' nature than Romantic Modernism can have imagined.

This situation is received with mixed feelings. For some, the acceptance of mediated, constructed experience is part of a hopeful new realism which, although opposed to the metaphysical tradition of Romantic Modernism, continues its utopian aims. In *Park Edge* (pl. 455), Victor Burgin examines patterns of constructed behaviour in an attempt to deflect that behaviour onto more humane trajectories. Here he tries to suggest, for example, that the very method of picturing the world in classical European painting—the Euclidian model—maintains the fiction of our autonomous individuality contained within a silhouette-like boundary. His accompanying text panel refers to the psychological condition of persecutory paranoia that maintains rigid boundaries of the self like a city walled against intrusion. Like the Surrealists who saw madness as potentially liberating, Burgin concludes, 'Sanity maintains the objective world, locus of the other, in a relation of "outside" to the subject's "inside". Psychosis knows better the extent to which others inhabit us.' Part of his concern here is thus to open the closed world of the self to that 'other', while affirming the value of constructed sexual polarity.

Others, like Sherman, are more ambivalent. Her ambivalence is visible in the sense that, although she makes us aware of the transmission of sexual stereotypes by showing the self as a shifting field, she perhaps also suggests the inevitability and absolute delimitation of that field—an area in which we are effectively imprisoned. But if in this sense we are imprisoned, in another we are 'locked out' from unself-conscious experience and there is surely an element of sadness in Sherman that

corresponds to the eighteenth-century melancholy that gave rise to Romantic Modernism and that may be seen in Watteau's *fêtes galantes*. For if she shows the rôles that we may, indeed that we *must* adopt, she also appears in some measure to wish to *be* her characters and is saddened, like Watteau, by the knowledge that these are only rôles and that the life of natural spontaneity and vigour does not lie in the past, but is a cinematic fiction that never was at all. As it is conceived of today, photography is the perfect medium in which to speak of this 'loss'. Christian Boltanski, for instance, exploits the sense of remoteness in the installation shown here (pl. 454). Although the photograph was invented as a result of the nineteenth-century desire for immediacy, it appears to many today to distance reality—to have a poignancy that emphasises the absence in our population of the child victims that Boltanski commemorates.

If the Postmodern awareness of our constructed and constructive nature diminishes the Romantic Modern problem of disunity with external nature, it seemingly does little to alleviate the difficulty of a self-consciousness that inhibits creation. This has some bearing on the tendency to appropriate or 'steal' images from pre-existing sources. Although appropriation is often thought of as motivated (in Warhol, for instance) by a need to reflect the 'condition' of modern life—in that we are increasingly surrounded by (and rely on) images for information about the world—in some quarters it amounts to a pessimistic acknowledgement of the mediated nature of experience. If we cannot circumvent this state, so the argument goes, then the desire for an originality that expresses fresh insight must in fact be futile, and the point should be emphasised by the employment of the mediate world of images as the 'raw' data of experience from which art may be made.

Yet, as Thomas Lawson argues,[2] the rejection of immediacy seems to create a valuable aesthetic distance that gives room and time for a critical discourse to open which is not at all informed with melancholy. In Romantic Modern thought this gap was seen as a lamentable, but inevitable product of consciousness. But for the artists presented here the paradoxical quality of absence inherent in photography is seen as an aid to the attainment of a critical distance from which seamlessly persuasive 'reality' may be seen coolly for what it is—an artifact that is not a natural inevitability, but one that may be remade.

2 Thomas Lawson, 'Last Exit: Painting', *Art Forum* (October 1981).

Victor Burgin

from 'Photographic Practice and Theory' (1974)

. . . than at any time does a simple *reproduction of reality* tell us anything about reality. A photograph of the Krupp works or GEC yields almost nothing about these institutions. Reality proper has slipped into the functional. The reification of human relationships, the factory, let's say, no longer reveals these relationships. Therefore something has actually to be *constructed*, something artificial, something set up.

These remarks by Brecht were quoted nearly fifty years ago by Walter Benjamin in his article 'A Short History of Photography'. In the intervening years considerable attention has been paid to the mechanics of signification, work of great relevance to those concerned to construct meanings from appearances. However, and leaving aside film, the influence of such theory within art has so far been confined to a very few of those manifestations which have attracted the journalistic tag 'conceptual'. One thing conceptual art has done, apart from underlining the central importance of theory, is to make the photograph an important tool of practice. The consequence of such moves has been to further render the categorical distinction between art and photography ill-founded and irrelevant. The only gulf dividing the arts today separates the majority still laden with the aesthetic luggage of Romanticism and Romantic Formalism (Modernism) from the rest.

Benjamin accurately described the debate over the respective merits of painting and photography as 'devious and confused . . . the symptom of a historical transformation the universal impact of which was not realised by either of the rivals'. In the nineteenth century the arts of painting and sculpture entered a crisis from which they did not recover. Increasingly estranged from their social context by the processes of democratisation, they suffered added displacement with the invention of photography and the harnessing of this invention to the means of mass production. In 'The Work of Art in the Age of Mechanical Reproduction' Benjamin describes the functional dislocation of works of art which occurred when their mechanical reproduction severed them from their cult value as autonomous objects. He finds that photography also suffered in the encounter, particularly from

> this fetishistic, fundamentally anti-technical notion of *Art* with which theorists of photography have tussled for almost a century without, of course, achieving the slightest result. For they sought nothing beyond acquiring credentials for the photographer from the judgement-seat which he had already overturned.

The fetishistic and anti-technical notion of art is no less prevalent now than it was at the time Benjamin named it. Its correlate is an equally fetishistic and anti-technical notion of the production of meaning. It seems to be extensively believed by photographers that meanings are to be found in the world much in the way that rabbits are found on downs, and that all that is required is the talent to spot them and the skill to shoot them. A certain *je ne sais quoi*, which may be recognised but never predicted, may produce art out of the exercise. But those moments of truth for which the photographic opportunist waits, finger on the button, are as great a mystification as the notion of autonomous creativity.

Extract from *Thinking Photography*, ed. V. Burgin, (Macmillan Ltd) London 1982.

452 Beuys *No. 1. from the 'Greta Garbo Cycle'* 1964–69

453 Beuys *No. 8. from the 'Greta Garbo Cycle'* 1964–69

454a Boltanski *Monuments (Les Enfants de Dijon)* 1985

454b Boltanski detail from *Monuments (Les Enfants de Dijon)*

455 Burgin *Park Edge* refabricated 1988

456 Burgin *Office at Night, no. 1* 1986

457　Sherman　*Untitled no. 145*　1985

458 Sherman *Untitled no. 168* 1987

459　Webb　*Day for Night*　1988

460 Webb *Sargasso* 1985

461 Warhol *Early Electric Chair* 1963

462 Warhol *Elvis* 1963

Glossary

Albumen Print (1850–c. 1900)
On thin paper coated with an eggwhite-and-salt solution and sensitised with silver nitrate, the albumen print was often toned with gold chloride to give a purplish-brown colour and glazed for a high finish. *Wet collodion* was the negative process used most commonly, printed from a glass plate coated by hand with a viscous solution of collodion and potassium salts, then immersed in a bath of silver nitrate. Together, the collodion negative and the albumen print offered high definition and clarity.

Autochrome Transparency (1904–1930s)
The first commercially available colour process, the autochrome was developed by the Lumière brothers. Starch grains dyed red, green and blue-violet were stuck to a glass plate (black carbon powder being added to fill the spaces between them), laminated, coated with a panchromatic silver bromide solution and exposed in the camera. After development the image produced was a positive colour transparency on glass, which was viewed by projection or in a hand viewer.

Autotype Carbon Print
See Carbon Print

Blanquart-Evrard Salted-Paper Print
(1853–c. 1880)
Modifying the *calotype* and *salted-paper* (q.v.) processes of Talbot, Blanquart-Evrard devised a printing paper that was more sensivite to light and more permanent. The paper was soaked in a solution of gelatine and potassium bromide and iodide, then dried and stored, and sensitised before exposure with a solution of silver nitrate with nitric acid. It produced a cool image colour deepening to purplish-black in shadow areas and was used with many negative processes, especially the *waxed-paper negative* (q.v.).

Bromoil Print
Publicised in 1907 by C. Wellbourne Piper and E. J. Wall, the bromoil was a gelatine-silver bromide print treated with potassium bichromate to bleach the dark silver image and to allow the gelatine to selectively harden in order to absorb greasy oil pigments applied by hand, according to the amount of silver (shadows and mid-tones) originally in the print.

Calotype Negative
See Salted-Paper Print.

Carbon Print (1864–1930s)
First introduced by Alphonse Poitevin (1855), the carbon print as patented by Sir Joseph W. Swan was produced by a pigmented gelatine tissue (composed of gelatine, bichromate and, initially, carbon black) being exposed under a negative. After exposure, which hardened the gelatine according to the amount of light passed through the negative, the tissue was attached to a second sheet of paper with a clear gelatine coating. Its backing paper was then soaked off and the unhardened soluble gelatine washed away, leaving a coloured gelatine image in slight relief.

Cibachrome Print
In 1963 the Ilford Company (which took over the Lumière factories in France) developed a product for making prints from colour transparencies. The paper contained three silver-halide emulsion layers, each sensitised to one primary colour and also holding a full density of its complementary colour. The process is sometimes described as 'silver dye bleach' or 'dye destruction process' because, during exposure and development, some of the dyes are destroyed by chemical bleaching, leaving only those dye colours that make up the final image.

Colour Coupler Print
Also known as the 'Type C' or 'chromogenic development' print, this process was introduced in the 1950s for prints from colour negatives. The paper contains three layers, sensitised to primary colours and protected from other colours of light by internal filters. During development both silver and dye images are formed, the silver image being removed by acid to leave cyan, magenta and yellow dyes to form the image on a white paper support.

Cyanotype Print
Invented by Sir John Herschel in 1842, the cyanotype was a low-cost permanent print made by exposing a negative against paper prepared by soaking it in a solution of ammonio-citrate of iron and potassium ferricyanide, drying it in the dark and exposing by contact printing in daylight. After washing in water, a print on paper revealed an image of insoluble Prussian blue on a light ground.

Daguerreotype (1839–c. 1860)
The silvered surface of a copper plate was made light-sensitive with iodine or bromine vapour, and after exposure developed in mercury vapour, then fixed with sodium thiosulphate to produce the daguerreotype's finely detailed image. The plate was mounted behind glass to protect its extremely delicate surface because, as a direct positive process, each one was unique. At its introduction, the daguerreotype required exposure times of ten to twenty minutes.

Dye Transfer Print
Originally introduced by the Jos Pé Company in 1925, dye transfer is also referred to as a 'dye imbibition' or 'wash-off relief' process. It is produced by the registration and imprinting of three gelatine relief images from separation negatives, dyed in three primary colours, onto a prepared gelatine paper to create a full colour image. Because these dyes are less susceptible to fading than most other colour materials, it is considered to be relatively permanent.

Gelatine-Silver Print
When gelatine-silver papers became available in the 1880s, they were the first products sensitive enough to be exposed by artifical light and could therefore be used to make enlargements. The gelatine-silver bromide paper, which is similar to that used today for black-and-white printing, was coated with a gelatine emulsion of silver bromide and silver iodide. Gelatine-silver chloride papers, because they were less sensitive to light, were generally used for contact printing.

Gum-Bichromate Print
First introduced by John Pouncy in the 1850s, the gum-bichromate process was revived by Robert Demachy and Alfred Maskell in the 1890s. It was similar in concept to a *carbon print* (q.v.), employing gum arabic instead of gelatine as the support, and was often used in combination with other processes, especially platinum. The image was produced by exposing a negative against paper painted with a solution of gum arabic, potassium bichromate and the artist's choice of pigment which hardened in direct proportion to

the light transmitted through the negative. The unexposed emulsion was then washed away, and the tonal values of the remaining pigmented image could be further manipulated with a brush while still wet.

Palladium Print
See Platinum Print.

Photogram
A photographic print made without a camera, the idea of the photogram is essentially the same as Talbot's 'photogenic drawing'. The image is produced by placing objects (either opaque or translucent) upon light-sensitive paper which registers their shadows during exposure. It is also known as the 'Schadograph' or 'Rayograph' after Christian Schad and Man Ray who practised the technique in the 1920s.

Photogravure
Invented by Karl Klíč in 1879, the photogravure was prepared by covering a copper plate with grains of resin dust which fused to the metal surface when heated. It was covered with a sheet of bichromated gelatine tissue, which was then contact printed under a positive transparency and etched in an acid bath. The gelatine, which was hardened by light, served to protect the highlights from being etched, while the shadow areas where the gelatine had been washed away were etched more deeply, and could transfer more ink to the paper.

Photo-Silkscreen
Also known as 'serigraphy' or 'screen printing', the photo-silkscreen employs a fine mesh of fabric (originally silk) onto which is stuck a high-contrast film negative developed to form a stencil. Ink is then pushed through the unblocked areas with a rubber blade, so printing the image.

Platinum Print (1873–c. 1930)
Platinum was the process overwhelmingly chosen by photographers in the 1880s and '90s for its permanence and its delicacy of tone. Patented by William Willis Jr, it combined platinum and iron salts to make up a light-sensitive solution applied to a sheet of fine paper. After exposure by contact printing (usually from gelatine dry-plate negatives), the print was developed in a bath of potassium oxalate, leaving a pure platinum image. Similar results could be achieved with salts of palladium instead of platinum. The Platinotype Company, founded by Willis, made the paper commercially available from 1879. In 1913 Willis introduced Satista paper, which combined the properties of platinum and silver in one print.

Salted-Paper Print (1839–c. 1855)
The first process of photographic printing on paper, the salted-paper print was sensitised by soaking it in a solution of common salt and then brushing it evenly with a solution of silver nitrate, which would darken visibly on exposure to light. Talbot produced his 'photogenic drawings' by this technique as early as 1834, but the details were not made public until 1839. In 1841 Talbot discovered that paper sensitised with potassium iodide and then with silver nitrate formed on exposure an invisible 'latent' image which could be developed in gallo-nitrate of silver to produce a negative—he named it the *calotype* from the Greek 'kalos' for beautiful (as the 'Talbotype' it was first publicly promoted by Sir David Brewster in 1841). This marked the invention of the negative-positive process, as contact prints could then be made from calotypes (oiled or waxed to increase transparency) on similarly sensitised papers. The *waxed-paper negative* was a variant of the calotype process, invented in 1851 by Gustave Le Gray, in which the paper was waxed before sensitising to give greater definition, transparency and detail. It reduced exposure times from up to half an hour in bright sunlight (for the first photogenic drawing papers) to approximately five minutes, and could be prepared and sensitised ten to fourteen days before exposure.

Satista Print
See Platinum Print.

Waxed-Paper Negative
See Salted-Paper Print.

ARTISTS' BIOGRAPHIES AND WORKS IN THE EXHIBITION

Artists are listed in alphabetical order. Works in the exhibition are listed under the relevant artist. Height precedes width in the dimensions given. Loans with limited venues are indicated after the name of the lender as follows: ★London only; ★★Houston only; †London and Houston only; ††London and Canberra only; †††Houston and Canberra only.

Robert Adams
(American b. 1937)

Educated in California (Ph.D. in English, University of Southern California, 1965), Adams began working as a freelance photographer and writer in 1967. His photographs were published in *White Churches of the Plains* (1970), *The Architecture and Art of Early Hispanic Colorado* (1974), *The New West* (1974), *Denver: A Photographic Survey of the Metropolitan Area* (1977), and *Prairie* (1978). He produced a book of criticism, *Beauty in Photography: Essays in Defence of Traditional Values*, in 1981. *Our Lives and Our Children* (1983) was followed by three more monographs: *Summer Nights* (1985), *Los Angeles Spring* (1986), and *Robert Adams: Photographs 1965-1985* (1988).

366 **Los Angeles, Spring** 1984
Gelatine-silver print, made 1986:
45.7 × 38.1 cm. 18 × 15 in.
John Froats

367 **The Garden of the Gods, El Paso County, Colorado** 1977
Gelatine-silver print made 1980:
17.8 × 22.3 cm. 7 × 8¾ in.
Private collection

368 **La Loma Hills, Colton, California** 1983
Gelatine-silver print made 1986:
22.8 × 18.6 cm. 9 × 11¼ in.
Private collection

369 **Colorado Springs, Colorado** 1968
Gelatine-silver print made 1974:
15.2 × 15.2 cm. 6 × 6 in.
Diane Keaton

370 **Untitled** [from the series 'Denver'] 1973
Gelatine-silver print made 1977: 15.2 × 19 cm.
6 × 7½ in.
Private collection

371 **Fort Collins, Colorado** 1979
Gelatine-silver print made 1985:
12.7 × 12.7 cm. 5 × 5 in.
Private collection

372 **Berthoud, Colorado** 1979
Gelatine-silver print made 1985:
12.7 × 12.7 cm. 5 × 5 in.
Private collection

Diane Arbus
(American 1923-71)

Arbus received her education in New York (Ethical Culture and Fieldston schools) and developed her serious interest in photography as a student of Lisette Model (1955-57). Her photographs were first published in *Harper's Bazaar* in 1961 ('Portraits of Eccentrics'), and she worked as a freelance photographer for *Esquire*, *Glamour*, *Show*, *The New York Times Magazine*. She taught photography courses at Parsons School of Design, Rhode Island School of Design, and at Cooper Union, New York. *A Box of Ten Photographs* (a limited portfolio) was produced in 1970, and in 1970-71 she gave a master class in New York City. In 1972, a monograph *Diane Arbus*, was published posthumously in New York, and in 1984 *Diane Arbus: Magazine Work* (ed. Doon Arbus and Marvin Israel) appeared.

Patricia Bosworth, *Diane Arbus: A Biography*, New York 1984.

328 **Untitled (6)** 1970-71
Gelatine-silver print: 36.9 × 36.2 cm.
14½ × 14¼ in.
Private Collection

329 **A Family on their Lawn one Sunday in Westchester, New York** 1969
Gelatine-silver print: 41.2 × 39.2 cm.
16 × 15¼ in.
Collection, The Museum of Modern Art, New York, Anonymous loan

330 **A Child crying, New Jersey** 1967
Gelatine-silver print: 40.7 × 39.7 cm.
16 × 15⅝ in.
Collection, The Museum of Modern Art, New York, Lily Auchincloss Fund, 321.72

331 **Puerto Rican Woman with a Beauty Mark, New York City** 1965
Gelatine-silver print: 36.4 × 37.2 cm.
14⅜ × 14⅝ in.
The J. Paul Getty Museum, 84.XM.796.1

Jean-Eugène-Auguste Atget
(French 1857-1927)

Atget worked as a sailor, actor and painter before taking up photography around 1890 in Paris. Self-taught, he was encouraged by Braque and Utrillo, who occasionally painted from his photographs. He received a commission in 1921 to document the brothels of Paris and also photographed buildings and areas of Paris in danger of demolition. He sold his pictures to painters, museums and libraries, and the Commission des Monuments Historiques. He was taken up in Paris in 1925 by the American photographer Berenice Abbott, who published a portfolio of his photographs, *Untitled*, in New York in 1956. The first monograph of his work, *Atget, Photographe de Paris* (preface by Pierre MacOrlan) was published in Paris in 1930. *The World of Atget* by Berenice Abbott, was published in New York in 1964 (repr. 1975, 1979).

The Work of Atget (Vol. I: *Old France*; Vol. II: *The Art of Paris*; Vol. III: *The Ancien Régime*; Vol. IV: *Modern Times*), New York 1981-85 (essays by John Szarkowski and Maria Morris Hambourg); James Borcoman, *Eugène Atget 1857-1927*, Ottawa 1984.

264 **The Pond, Ville-d'Avray** (*Ville d'Avray, Etang*) 1923-25
Albumen print on arrowroot paper:
17.3 × 22.5 cm. 6¹³⁄₁₆ × 8⅞ in.
Gilman Paper Company Collection, 485.80

265 **Verrières—Picturesque Corner, Old Building** (*Verrières-coin pittoresque, Vieux Logis*) 1922
Albumen silver print: 17.7 × 21.5 cm. 7 × 8⁷⁄₁₆ in.
Collection, The Museum of Modern Art, New York, Abbott-Levy Collection, Partial gift of Shirley C. Burden, sc88.80

266 **Parc de Sceaux, May—7 a.m.** (*Parc de Sceaux, mai – 7h matin*) c. 1925
Albumen silver print: 20.6 × 16.4 cm. 8⅛ × 6½ in.
Collection, The Museum of Modern Art, New York, Abbott-Levy Collection, Partial gift of Shirley C. Burden, 1.69.2686

267 **Parc de Sceaux** 1921
Albumen print: 17.7 × 21.5 cm. 7 × 8⁷⁄₁₆ in.
Collection, The Museum of Modern Art, New York, Abbott-Levy Collection, Partial gift of Shirley C. Burden, 1.60.2687

268 **Brothel at Versailles** (*Versailles: maison close*) c. 1921
Albumen print: 18 × 21.3 cm. 7¹⁄₁₆ × 8⅜ in.
Roger Thérond

269 **La Villette, rue Asselin, prostitute taking a break** (*La Villette, rue Asselin, fille publique faisant le quart devant sa porte, 19e arr.*) 7 March 1921
Albumen print: 21.7 × 18 cm. 8⁹⁄₁₆ × 7¹⁄₁₆ in.
Roger Thérond

270 **Avenue des Gobelins** 1925
Albumen print: 23 × 17.9 cm. 9¹⁄₁₆ × 7¹⁄₁₆ in.

Collection, The Museum of Modern Art, New York, Abbott-Levy Collection, Partial gift of Shirley C. Burden, 1.69.1545

271 Shop, avenue des Gobelins (*Magasin, avenue des Gobelins*) 1925
Albumen print: 21.1 × 16.7 cm. 8¼ × 6⁹⁄₁₆ in.
Collection, The Museum of Modern Art, New York, Abbott-Levy Collection, Partial gift of Shirley C. Burden, 1.69.1544

Charles Hippolyte Aubry
(French 1811-77)

Aubry's first career was as a designer of patterns for carpet, wallpaper and fabric manufacturers. In the early 1860s he began to photograph arrangements of flowers and leaves, offering them for sale to the public. In 1864 he presented to the Prince Imperial a large album of the flower studies, *Etude de Feuilles*, now in the Bibliothèque Nationale, Paris.

Anne McCauley, 'Photographs for Industry: The Career of Charles Aubry', *J. Paul Getty Museum Journal* 14 (1986), 157-72.

84 A Study of Leaves 1864
Albumen print: 48.6 × 38.4 cm. 19⅛ × 15⅛ in.
Philadelphia Museum of Art, Funds from the American Museum of Photography, 71-4-124

David Bailey
(British b. 1938)

Bailey became interested in photography during his service with the RAF in Malaya (1957-58). He became photographic assistant to John French in 1959, and his photographs were first published in that year in the *Daily Express*. He received a contract from *Vogue* magazine in 1960 and photographed the model Jean Shrimpton in the streets of New York in 1962. *Box of Pin-ups*, portraits of 'swinging London', was published in 1965, followed by *Goodbye Baby and Amen* in 1969. He moved into directing films and advertisements in the late 1960s with *Beaton by Bailey* (1971) for television and the film *Andy Warhol* (1973).

David Bailey: Black and White Memories, text by Martin Harrison, London and Melbourne 1983.

446 Michael Caine 21 May 1965
Gelatine-silver print made 1988, from 'Box of Pin Ups':
91.4 × 91.4 cm. 36 × 36 in.
Lent by the artist

447 Kray Brothers 20 April 1965
Gelatine-silver print made 1988, from 'Box of Pin Ups':
91.4 × 91.4 cm. 36 × 36 in.
Lent by the artist

448 Sharon Tate and Roman Polanski 1969
Gelatine-silver print made 1988, from 'Goodbye Baby and Amen':
91.4 × 91.4 cm. 36 × 36 in.
Lent by the artist

Edouard-Denis Baldus
(French 1815-82)

Trained as a painter, Baldus was accepted into the Paris Salon in 1842, 1847 and 1850-51, and by 1849 had mastered the technique of photography. He was a founding member of the Société Héliographique (1851) and the Société Française de Photographie (1857). In 1851 he received the first of the 'missions héliographiques' assigned by the Commission des Monuments Historiques to document the architectural monuments of France. Further works included photographs of monuments in Paris (1852), *Chemin de fer du Nord* (1855), an album recording the route of the railway, a record of the exterior of the new wing of the Louvre in Paris (1857-58), *Chemin de fer de Paris à Lyon et à la Méditerannée* and other views of Paris (1860).

Philippe Néagu and Françoise Heilbrun, 'Baldus: Paysages, Architecture', *Photographies* 1 (spring 1983), 56-7.

70 The Enghien Watermill c. 1855
Salted-paper print: 26 × 39.5 cm. 10¼ × 15⁹⁄₁₆ in.
International Museum of Photography at George Eastman House, 74:051:06

77 Pavillon Richelieu [The Louvre] c. 1860
Albumen print: 44.6 × 34.3 cm. 17⁹⁄₁₆ × 13½ in.
Michael G. Wilson Collection, 86.2481

Dmitri Baltermants
(Russian b. 1912)

Working first in the printing shop of *Izvestia*, Baltermants studied mathematics at Moscow University from 1928. In 1936 he bought a 35 mm. camera and began to photograph for publication. He learned photography from Musinov, an *Izvestia* reporter, and left his teaching job in 1939 for work as a photojournalist. He documented the Great Patriotic War of the USSR against Nazi Germany for *Izvestia* and the Red Army newspaper *Na Razgromvraga*.

419 Attack 1941
Gelatine-silver print: 29.2 × 43.9 cm.
11½ × 17¼ in.
International Center of Photography, New York, Permanent Collection, Gift of the photographer

421 Outskirts of Moscow 1941
Gelatine-silver print: 29.2 × 59.8 cm.
11½ × 23½ in.
International Center of Photography, New York, Permanent Collection, Gift of the photographer, 379.86

422 Kerch, Crimea (Grief) 1942
Gelatine-silver print: 28.6 × 36.4 cm.
11¼ × 14⅜ in.
International Center of Photography, New York, Permanent Collection, Gift of the photographer, 380.86

Felice A. Beato
(British c. 1830-1906)

Beato met James Robertson in Malta in 1850 and they began the partnership of Robertson, Beato and Company by photographing in Malta, Egypt, Constantinople and Athens. In 1855 they made over sixty photographs of the fall of Sebastopol, exhibited in London in February 1856. Beato and Robertson photographed together in Palestine in 1857 and documented the aftermath of the Indian Mutiny of 1857-58. Beato photographed alone at the Siege of Lucknow (1857). He was the first known Western photographer in China, recording the destruction of the Imperial Summer Palace near Peking and the capture of Tientsin. From 1862 to 1877 he photographed the people and landscapes of Japan for albums such as *Photographic Views of Japan* (Yokohama 1868). His improvement of the albumen process (reducing exposure time) was recognised by the *British Journal of Photography* (19 March 1886).

Antonio Azzano, ed., *Verso Oriente: Fotografie di Antonio e Felice Beato*, Florence 1986; Isabel Crombie, 'China 1860: A Photographic Album by Felice Beato', *History of Photography* XI, 1 (January 1987), 25-37.

123 Tycoons' Halting Place on the Tocaido Hasa 1868
Albumen print, from *Photographic Views of Japan*: 23.5 × 29.1 cm. 9¼ × 11⁷⁄₁₆ in.
Michael G. Wilson Collection, 84.1410

124 Giving Prayer to Buddha c. 1865
Albumen print: 22.5 × 29.1 cm. 8⅞ × 11⁷⁄₁₆ in.
Michael G. Wilson Collection, 84.1401

125 Samurai with raised Sword c. 1860
Albumen print: 26.4 × 21.7 cm. 10⅜ × 8⁹⁄₁₆ in.
Michael G. Wilson Collection, 87.3320

Joseph Beuys
(German 1921–86)

After his initial education at Rindern, near Kleve (1930–39), and one year of medical study (1940), Beuys served as a pilot in the Luftwaffe during World War II. From 1947 to 1951 he studied art at the Staatliche Kunstakademie in Düsseldorf. He worked as an independent artist in Düsseldorf and Kleve from 1951 and had his first exhibition in 1952 at the Kunstmuseum, Wuppertal, West Germany. In 1961, he was appointed Professor of Sculpture at the Staatliche Kunstakademie, Düsseldorf, and taught there until 1972. A retrospective exhibition of his work was shown at the Guggenheim Museum, New York, in 1979.

Caroline Tisdall, *Joseph Beuys*, London 1979.

452 No. 1 from the 'Greta Garbo Cycle' 1964–69
Oil (Braunkreuz) on paper:
39.5 × 27 cm. 15½ × 10⅝ in.
Private collection, courtesy, Anthony d'Offay Gallery, London★

453 No. 8 from the 'Greta Garbo Cycle' 1964–69
Oil (Braunkreuz) on paper:
29.5 × 21 cm. 11⅝ × 8¼ in.
Private collection, courtesy Anthony d'Offay Gallery, London★

Louis-Auguste Bisson
(French 1814-76)
Auguste-Rosalie Bisson
(French 1826-1900)

The elder Bisson brother was an architect and the younger worked with their father as an heraldic painter. In 1840 the family established the photographic firm of Bisson Père et Fils, and they were founding members of the Société Française de Photographie. Their daguerreotype portraits (1848-49) of all 900 members of the National Assembly were later published as lithographs. In the early 1850s they changed to glass negatives and albumen prints. Their *Choix d'Ornaments Arabes de l'Alhambra* was published in Paris in 1853. In that year they began their publication (completed in 1862) of *Reproductions photographiques des plus beaux types d'architecture et de sculpture*. In 1860 Auguste-Rosalie photographed the Alps at Chamonix and in 1861 climbed Mont Blanc to photograph the summit. Other publications included *Monographie de Notre Dame de Paris* (c. 1853-57); *L'Oeuvre de Rembrandt reproduit par la Photographie* (1854-58); and *Le Mont Blanc et Ses Glaciers* (1860). The brothers were made official photographers to Emperor Napoleon III in 1860.

78 Portal of St Ursinus at Bourges 1863
Albumen print: 43 × 35.3 cm. 16$\frac{15}{16}$ × 13$\frac{7}{8}$ in.
The Art Institute of Chicago, Mary and Leigh B. Block Purchase Fund, 1980.213†††

Christian Boltanski
(French b. 1944)

During the 1960s, Boltanski made large-scale paintings. He took up photography in 1968 and produced a film, *La Vie impossible de Christian Boltansky*. In 1970 he began to use his own photographs, and others', in conceptual presentations. His first book, *Reconstitutions des Gestes*, appeared in 1971. The books *10 Portraits photographiques* and *Album photographique* were produced in 1972. *Inventaire* was published in West Germany in 1973, *Quelques Interprétations* in 1974 and other books followed: *20 Règles et Technique* (1975), *Les Morts pour Rire* (1975), and *Modellbilder*, with others, (1976). A retrospective exhibition was shown in 1981 at the Musée d'Art Moderne, Paris, and a touring exhibition of his work, 'Images fabriquées', was opened at the Centre George Pompidou in 1983.

Musée Nationale d'Art Moderne, *Boltansky*, Paris 1984.

454 Monuments (Les Enfants de Dijon) 1985
Installation, gelatine-silver prints ranging from 28 × 24 cm. to 40 × 50 cm. (11 × 9$\frac{7}{16}$ in. to 15$\frac{3}{4}$ × 19$\frac{11}{16}$ in.)
Collection Anne and William S. Hokin, Chicago

Samuel Bourne
(British 1834-1912)

Bourne left a banking career in late 1862 to travel to India to photograph the landscape and architecture. In 1864 he formed a photographic partnership with Charles Shepherd in Simla. They later opened a second branch in Calcutta and became the primary suppliers of Indian views. In 1865 and 1866 Bourne travelled to the Himalayas and sent back a series of articles for the *British Journal of Photography* describing his expeditions: 'Narrative of a photographic trip to Kashmir and adjacent districts' (5 October 1866–8 February 1867); 'A Photographic Journey through the Higher Himalayas' (6 November 1869–1 April 1870).

Pauline F. Heathcote, 'Samuel Bourne of Nottingham', *History of Photography* VI, 2 (April 1982), 99-112; Arthur Ollman, *Samuel Bourne: Images of India*, *Untitled* 33, Carmel 1983.

133 Group of Todas c. 1868
Albumen print: 23.5 × 28.4 cm. 9$\frac{1}{4}$ × 11$\frac{3}{16}$ in.
Private collection

134 Lepcha Man 1868
Albumen print: 28.4 × 23.5 cm. 11$\frac{1}{8}$ × 9$\frac{1}{4}$ in.
Robert Hershkowitz

Bill Brandt
(British 1904–83)

Born in Hamburg, Brandt spent his childhood in Germany and Switzerland and studied under the Czech artist K. E. Ort. In Paris in 1928 he photographed Ezra Pound who introduced him to Man Ray. He worked as Man Ray's assistant during 1929 and as a freelance photographer for *Paris Magazine* in 1930. He came to London in 1931, having decided to follow a career in photojournalism. Throughout the 1940s he worked on assignment for *Lilliput* and *Picture Post*, and his photographs also appeared in *Harper's Bazaar*, *News Chronicle* and *Verve*. His work was exhibited at the Museum of Modern Art, New York, in 1948 with that of Lisette Model, Harry Callahan and Ted Croner. His first book, *The English at Home* (1936) was followed by *A Night in London* and a series of photographs documenting London during World War II for the British Home Office. *Camera in London* was published in 1948 and *Literary Britain* in 1951. Later books include *Perspective of Nudes* (1961) and *Shadow of Light* (1966).

Mark Haworth-Booth ed., *Literary Britain: Photographed by Bill Brandt*, London 1984; Mark Haworth-Booth and David Mellor, *Bill Brandt: Behind the Camera*, Millerton, N.Y. 1985.

288 Northumberland Miner at his Evening Meal 1937
Gelatine-silver print: 21.6 × 18.8 cm. 8$\frac{1}{2}$ × 7$\frac{3}{8}$ in.
Pritzker Collection, courtesy Edwynn Houk Gallery, Chicago

289 Parlourmaid and Under-parlourmaid ready to serve Dinner 1932-35
Gelatine-silver print made 1930s:
22.5 × 19 cm. 8$\frac{7}{8}$ × 7$\frac{1}{2}$ in.
Pritzker Collection, courtesy Edwynn Houk Gallery, Chicago

290 Tic-tac men at Ascot Races 1935
Gelatine-silver print made 1930s:
19.7 × 16.5 cm. 7$\frac{3}{4}$ × 6$\frac{1}{2}$ in.
Edwynn Houk Gallery, Chicago

291 Quarrel 1936
Gelatine-silver print: 24.8 × 19.4 cm. 9$\frac{3}{4}$ × 7$\frac{5}{8}$ in.
Pritzker Collection, courtesy Edwynn Houk Gallery, Chicago

292 Drawing Room in Mayfair 1932-35
Gelatine-silver print made 1930s:
22.9 × 19.7 cm. 9 × 7$\frac{3}{4}$ in.
Edwynn Houk Gallery, Chicago

293 Coach Party, Royal Hunt Club Day, Ascot 1933
Gelatine-silver print made 1930s:
19.1 × 17.2 cm. 7$\frac{1}{2}$ × 6$\frac{3}{4}$ in.
Edwynn Houk Gallery, Chicago

Brassaï (Gyula Halàsz)
(French 1899–1984)

Born in Hungary and educated there and in Germany, Brassaï came to Paris as a journalist in 1924. He was encouraged by his fellow-expatriate André Kertèsz to take up photography and in 1933 he produced his first book of photographs, *Paris de Nuit*. He worked for the magazines *Minotaure* (1933–36) and *Harper's Bazaar* (1936–65). In 1949 he produced *Brassaï, Camera in Paris*. His book, *Conversations avec Picasso* (1964), was followed by an account of a writer, *Henry Miller–Grandeur Nature* (1975).

A portfolio, *Transmutations*, was published in Vaucluse, France in 1966. In 1973 *Portfolio Brassaï* was published in New York, with an introduction by A. D. Coleman. Brassaï made a film, *Tant qu'il y aura des bêtes* in 1955.

Brassaï, *Paris de Nuit*, Paris and London 1933; Brassaï, *The Secret Paris of the 30's*, New York 1976.

282 A Prostitute playing Russian Billiards, boulevard Rochechouart, Montmartre 1932
Gelatine-silver print: 23.1 × 19.7 cm. 9$\frac{1}{16}$ × 7$\frac{3}{4}$ in.
Pritzker Collection, courtesy Edwynn Houk Gallery, Chicago

283 A Monastic Brothel, rue Monsieur le Prince, Quartier Latin 1931
Gelatine-silver print: 23.8 × 17.8 cm. 9$\frac{3}{8}$ × 7 in.
Pritzker Collection, courtesy Edwynn Houk Gallery, Chicago

284 Rue de Lappe 1932
Gelatine-silver print made 1930s:
19.4 × 14 cm. 7$\frac{5}{8}$ × 5$\frac{1}{2}$ in.
Edwynn Houk Gallery, Chicago

285 Members of Big Albert's Gang, Place d'Italie 1932
Gelatine-silver print: 22.3 × 18.1 cm. 8$\frac{3}{4}$ × 7$\frac{1}{8}$ in.
Pritzker Collection, courtesy Edwynn Houk Gallery, Chicago

286 One Suit for Two (*Un Costume pour deux*) 1932-33
Gelatine-silver print made 1970s: 40 × 30 cm.
15$\frac{3}{4}$ × 11$\frac{3}{4}$ in.
Photographie Brassaï © Gilberte Brassaï

287 At Suzy's 1932
Gelatine-silver print: 17.8 × 24.8 cm. 7 × 9¾ in.
Edwynn Houk Gallery, Chicago

Adolphe Braun
(French 1812–77)

Working as a textile designer for a cloth manufacturer in Alsace, Braun began photographing flowers as a basis for his designs in the early 1850s, beginning with *Fleurs Photographiées* (1851) which comprised six folio volumes. In 1854 he presented albums of flower prints to the British Academy, and the following year the English edition *Flowers from Nature* was published at Dornach. Also published in 1854 was *Alsace Photographié*, three volumes containing 100 plates. In 1866 he purchased a franchise from Joseph Wilson Swan, inventor of the carbon process; later he added the Woodburytype process to his workshop. From 1860 on he engaged also in studio portraiture and was named as official photographer to the court of Napoleon III.

Naomi Rosenblum, 'Adolphe Braun: A 19th Century Career in Photography', *History of Photography* III, 4 (October 1979), 357–72; P. Tyl, 'Adolphe Braun–Photographe mulhousien 1812–77' (University of Strasbourg, Mémoire de Maîtrise, 1982).

82 Still life with Game 1865
Carbon print: 75.1 × 54 cm. 29⁹⁄₁₆ × 21¼ in.
The J. Paul Getty Museum, 84.XP.458.31

Victor Burgin
(British b. 1941)

Educated at the Royal College of Art, London (1965) and Yale University (1967), Burgin taught at Trent Polytechnic until 1973. His work was featured in the exhibition 'Information' at the Museum of Modern Art, New York in 1970. In 1973 he published *Work and Commentary* and began a teaching position in the School of Communication, Polytechnic of Central London. From 1976 to 1980 he was a member of the Photography and Publications Committees of the Arts Council of Great Britain. *Two Essays on Art, Photography, and Semiotics* was published in 1976. He edited and wrote critical essays for *Thinking Photography: Essays in the Theory of Photographic Representation* (1981). Two books were published in 1986: *Victor Burgin: Between* in Oxford and *The End of Art Theory: Criticism and Modernity* in New York.

Tony Godfrey, 'Sex, Text, Politics', *Block*, 6, 1982.

455 Park Edge refabricated 1988
Photographic image in Formica, handcut
182.8 × 182.8 cm. 72 × 72 in.
Courtesy of the artist

456 Office at Night, no. 1 1986
Mixed media: 182.8 × 243.8 cm. 72 × 96 in.
Collection M.J.S., Paris

Harry Callahan
(American b. 1912)

Callahan studied engineering at Michigan State College, 1931–33, and worked as a photographic technician in 1944. From 1946 he taught at the Chicago Institute of Design until 1961 when he moved to the Rhode Island School of Design to head the Photography Department. Monographs of his work incude: *The Multiple Image: Photographs by Harry Callahan* (1961), *Photographs, Harry Callahan* (1964), *Harry Callahan* (1967), *Callahan* (1976), *Harry Callahan: Color* (1980), and *Harry Callahan: New Color* (1988).

Callahan, ed. John Szarkowski, New York 1976.

348 Lake Michigan 1953
Gelatine-silver print made late 1970s:
20.3 × 25.4 cm. 8 × 10 in.
Hallmark Photographic Collection, Hallmark Cards, Inc., Kansas City, Missouri, USA

349 Eleanor 1949
Gelatine-silver print made 1950s:
17.2 × 16.5 cm. 6¾ × 6½ in.
Hallmark Photographic Collection, Hallmark Cards, Inc., Kansas City, Missouri, USA

350 Eleanor and Barbara, Chicago 1953
Gelatine-silver print made 1950s:
20 × 25.1 cm. 7⅞ × 8⅞ in.
Hallmark Photographic Collection, Hallmark Cards, Inc., Kansas City, Missouri, USA

351 Eleanor, Chicago 1952
Gelatine-silver print made 1988:
20.3 × 25.4 cm. 8 × 10 in.
Courtesy Pace/MacGill Gallery, New York

352 Eleanor 1952
Gelatine-silver print made 1970s:
20.3 × 25.4 cm. 8 × 10 in.
Hallmark Photographic Collection, Hallmark Cards, Inc., Kansas City, Missouri, USA

Julia Margaret Cameron
(British 1815–79)

Born in Calcutta and briefly educated in France, Cameron settled in England when her husband retired from the Supreme Council of India. She translated Bürger's *Leonora* (1847), and joined the Arundel Society (1859). She took up photography in 1863 and was soon presenting her friends Lord Overstone and Sir John Herschel with albums of photographs. In 1866 she began to exhibit her photographs in Colnaghi's gallery. In 1874–75 she published in two parts *Illustrations to Alfred Tennyson's Idylls of the King and Other Poems*.

Colin Ford, *The Cameron Collection*, Wokingham and New York 1975; Mike Weaver, *Julia Margaret Cameron 1815–1879*, London and Boston 1984.

52 The Angel at the Tomb 1870
Albumen print: 34.75 × 26.35 cm. 13¹¹⁄₁₆ × 10⅞ in. (arched)
International Museum of Photography at George Eastman House, 81:1124:09

53 A Light Study [Child's Head] c. 1866
Albumen print: 34 × 28.1 cm. 13⅜ × 11¹⁄₁₆ in. (arched)
International Museum of Photography at George Eastman House, 81:1121:39

54 Untitled c. 1867–69
Albumen print: 35.1 × 28 cm. 14 × 11 in.
Erich Sommer

55 Christabel [May Prinsep] c. 1867
Albumen print: 33.8 × 27.7 cm. 13⅜ × 10¹⁵⁄₁₆ in.
The Board of Trustees of the Victoria and Albert Museum, London, 946-1913

56 The Whisper of the Muse [G. F. Watts] April 1865
Albumen print, from Overstone Album:
26.1 × 21.5 cm. 10¼ × 8⁷⁄₁₆ in.
The J. Paul Getty Museum, 84.XZ.186.96/97

57 May Day 1875
Albumen print: 33.8 × 28.5 cm. 13⁵⁄₁₆ × 11¼ in.
The Board of Trustees of the Victoria and Albert Museum, London, 933-1913

58 Prayer and Praise 1865
Albumen print, from Overstone Album:
28.1 × 22.7 cm. 11¹⁄₁₆ × 8¹⁵⁄₁₆ in.
The J. Paul Getty Museum, 84.XZ.186.91/92

59 The Double Star April 1864
Albumen print, from Overstone Album:
25.4 × 20 cm. 10 × 7⅞ in.
The J. Paul Getty Museum, 84.XZ.186.75

60 Pomona [Alice Liddell] September–October 1872
Albumen print: 36.8 × 28.5 cm. 14½ × 11¼ in.
Erich Sommer

61 Child's Head [Kate Keown] 1866
Albumen print: 29.2 cm. 11½ in. (max. diameter)
Erich Sommer

62 Sir J. F. W. Herschel April 1967
Albumen print: 33.9 × 27.6 cm. 13⅜ × 10¹⁵⁄₁₆ in.
Rubel Collection, courtesy Thackrey and Robertson, San Francisco

63 Thomas Carlyle 1867
Albumen print: 30 × 24.2 cm. 11¹³⁄₁₆ × 9½ in.
The J. Paul Getty Museum, 84.XM.443.17

Robert Capa (André Friedmann)
(American 1913–54)

A student of sociology and journalism in Berlin, Capa took up photography in 1930 and worked as a darkroom assistant for Dephot picture agency. He moved to Paris in 1933, became friends with Cartier-Bresson and 'Chim' (David Seymour) and worked for *Vu* magazine until the late 1930s. He photographed the events of the Spanish Civil War, under the name Robert Capa, from 1936 to 1939. His first book, *Death in the Making*, appeared in 1937. He documented the Japanese invasion of China in 1938 and worked as a correspondent for *Life* and *Collier's* magazine photographing the war in the European theatre from 1942 to 1945. In 1947 he co-founded Magnum photographic agency and produced his autobiography *Slightly Out of Focus. Images of War* (1964) was published after his death.

Richard Whelan, *Robert Capa*, New York 1985.

409 D-Day, Omaha Beach, near Colleville-sur-Mer, Normandy Coast, June 6, 1944
Gelatine-silver print: 25.2 × 35.6 cm. 9⅞ × 14 in.
International Center of Photography, New York, Permanent Collection, Gift of the Estate of Robert Capa, 173.84

410 Soldier at the Moment of Death, Spanish Civil War 1936
Gelatine-silver print: 24.5 × 34.2 cm.
$9\frac{5}{8}$ × $13\frac{7}{16}$ in.
International Center of Photography, New York, Permanent Collection, Gift of Cornell and Edith Capa

411 South of Bastogne, Belgium 23–26 December 1944
Gelatine-silver print: 25.8 × 35.5 cm.
$10\frac{1}{16}$ × 14 in.
International Center of Photography, New York, Permanent Collection, Gift of Cornell and Edith Capa

412 Spain 1936
Gelatine-silver print: 20.1 × 25.3 cm. $7\frac{7}{8}$ × $9\frac{15}{16}$ in.
International Center of Photography, New York, Permanent Collection, Gift of Cornell and Edith Capa, 578.87

Henri Cartier-Bresson
(French b. 1908)

Cartier-Bresson studied painting with André Lhôte in Paris, then painting and literature at Cambridge University in 1928 and developed a serious interest in photography in 1931. His work was first exhibited at the Julien Levy Gallery, New York, and first published in *Vu* magazine in 1932. He assisted Jean Renoir on the films *La Vie est à nous* (1936) and *La Règle du jeu* (1939). His own documentary film on the hospitals of Republican Spain was produced with Herbert Kline in 1937. In 1945 he made a film on the liberation of the concentration camps with Richard Banks called *Le Retour*. His work was exhibited at the Museum of Modern Art, New York, in 1946, and in 1947 he became a co-founder of Magnum photographic agency. His book *Images à la sauvette* was published in 1952 in Paris (*The Decisive Moment*, New York) and in 1955 he produced *The Europeans*.

Henri Cartier-Bresson: Photographer (foreword by Yves Bonnefoy), Boston, Mass. 1979; Peter Galassi, *Henri Cartier-Bresson: The Early Work*, New York 1987.

272 Cordoba, Spain 1933
Gelatine-silver print: 24.1 × 16.5 cm. $9\frac{1}{2}$ × $6\frac{1}{2}$ in.
Pritzker Collection, courtesy Edwynn Houk Gallery, Chicago

273 Eunuch of the Imperial Court of the Last Dynasty, Peking (*Pékin, derniers jours du Koumingtang, Eunuque de la dernière imperatrice, 1949*) 1949
Gelatine-silver print made 1985 by Pierre Gassmann: 41.5 × 31.5 cm. $16\frac{3}{8}$ × $12\frac{3}{8}$ in.
The Menil Collection, Houston, FO 85-15.315 MF

274 Paris, Gare St Lazare 1932
Gelatine-silver print made 1985 by Pierre Gassmann: 41.5 × 31.5 cm. $16\frac{3}{8}$ × $12\frac{3}{8}$ in.
The Menil Collection, Houston, FO 85-15.007 MF

275 Lock at Bougival (*La Seine, écluse de Bougival*) 1955
Gelatine-silver print made 1985 by Pierre Gassmann: 41.5 × 31.5 cm. $16\frac{3}{8}$ × $12\frac{3}{8}$ in.
The Menil Collection, Houston, FO 85-15.003 MF

276 Madrid, Spain 1933
Gelatine-silver print, made before 1947:
16.2 × 24.1 cm. $6\frac{3}{8}$ × $9\frac{1}{2}$ in.
National Gallery of Canada, Ottawa

277 On the Banks of the Marne 1938
Gelatine-silver print: 23.5 × 35.1 cm. $9\frac{1}{4}$ × 14 in.
Private collection

278 Calle Cuauhtemoctzin, Mexico 1934
Gelatine-silver print: 25.3 × 36.4 cm.
$9\frac{15}{16}$ × $14\frac{5}{16}$ in.
Private collection

279 Brussels 1932
Gelatine-silver print: 19.4 × 29.2 cm.
$7\frac{5}{8}$ × $11\frac{1}{2}$ in.
The J. Paul Getty Museum, 84.XM.1008.2

280 Valencia, Spain 1933
Gelatine-silver print: 23.2 × 29.5 cm.
$9\frac{1}{8}$ × $11\frac{5}{8}$ in.
The J. Paul Getty Museum, 84.XM.1008.1

281 The Peter and Paul Fortress, Leningrad
(*Leningrad, Forteresse Pierre et Paul*) 1973
Gelatine-silver print, made 1985 by Pierre Gassmann: 31.5 × 41.5 cm. $12\frac{3}{8}$ × $16\frac{3}{8}$ in.
The Menil Collection, Houston, FO 85-15.194 MF

Claude-Joseph-Desiré Charnay
(French 1828–1915)

Educated at the Lycée Charlemagne in Paris, Charnay emigrated to America in 1850 and worked as a schoolteacher in New Orleans. He returned to France with the ambition of becoming an explorer and obtained the support of the French Ministry of Public Instruction for an expedition to the Yucatan, which he began in 1857. Between 1858 and 1860 he photographed the ruined cities of Mitla, Palenque, Chichen-Itza and Uxmal, and then returned to Paris where a large portfolio of his photographs, *Cités et ruines américaines, Mitla, Palenque, Izamal, Chichen-Itza, Uxmal*, was published in 1862–63. A shortened edition of the book was published as *Le Mexique et ses monuments anciens* in 1864. In the following years he joined expeditions to Madagascar, Brazil, Chile, Argentina, Java and Australia, but is best known for his work on an extended expedition in Mexico (1880–82) in which he excavated, photographed, took casts and collected artifacts at the Yucatan ruins. An account of the project, *Les anciennes villes du Nouveau monde* (1885), was illustrated with wood-engravings after his photographs. In 1888 he was made an officer of the Legion of Honour.

Keith F. Davis, *Desiré Charnay: Expeditionary Photographer*, Albuquerque 1981.

138 Facade, Governor's Palace, Uxmal 1860
Albumen print: 33.6 × 41.1 cm. $13\frac{1}{4}$ × $16\frac{1}{4}$ in.
The J. Paul Getty Museum, 84.XP.960.28

140 Tree of Santa-Maria del Tule, Mexico
c. 1858
Albumen print: 42.1 × 34.2 cm. $16\frac{9}{16}$ × $13\frac{1}{2}$ in.
Private collection

Alexandre-Jean-Pierre Clausel
(French 1802–84)

Clausel was a painter who produced landscape daguerreotypes in and around Troyes, France, in the 1850s. An album, 'Troyes photographié', was commented upon at the Exposition Universelle of 1855 (*La Lumière*, 6 October 1855).

21 Untitled [probably near Troyes]
c. 1855
Daguerreotype: 17 × 21.3 cm. $\frac{11}{16}$ × $8\frac{3}{8}$ in.
International Museum of Photography at George Eastman House, 76:0168:35

Alvin Langdon Coburn
(British 1882–1966)

American-born, Coburn was introduced to serious photography in 1898 by a cousin, F. Holland Day. In 1902 and 1903 he attended Arthur Wesley Dow's Summer School of Art in Ipswich, Massachusetts. He studied photogravure at the London County Council School of Photo-Engraving in 1906. He published books of his own photogravures, *London* (1909), *New York* (1910) and *Men of Mark* (1913). In 1915 he organised the exhibition 'Old Masters of Photography' (all British) for the Albright Gallery, Buffalo. In 1917, his vortographs and paintings were exhibited at the Goupil Gallery in London. In 1919 he became a Freemason and began to give up photography for comparative religion.

Alvin Langdon Coburn: Photographer–An Autobiography, London 1968, repr. New York 1978; Mike Weaver, *Alvin Langdon Coburn: Symbolist Photographer*, New York 1986.

170 St Paul's from Ludgate Circus 1905
Photogravure: 38.7 × 28.6 cm. $15\frac{1}{4}$ × $11\frac{1}{4}$ in.
Private collection

171 The Coal Cart 1911–12
Platinum print: 39.8 × 30.6 cm. $15\frac{11}{16}$ × $12\frac{1}{16}$ in.
International Museum of Photography at George Eastman House, 61:144:217

172 Singer Building, New York 1909–10
Gum platinum print: 42 × 22.2 cm. $16\frac{1}{2}$ × $8\frac{3}{4}$ in.
International Museum of Photography at George Eastman House, 67:144:217

173 Trinity Church 1912
Platinum print: 42 × 32.8 cm. $16\frac{7}{8}$ × $12\frac{7}{8}$ in.
International Museum of Photography at George Eastman House, 67:144:307

Louis-Jacques-Mandé Daguerre
(French 1787–1851)

Working first as a scene painter and stage designer for the Paris Opera, Daguerre was an assistant to Pierre Prévost in panorama painting from 1807 to 1815. His own dioramas (enormous transparent paintings exhibited under various lighting effects) were shown in Paris in 1822 and the following year in London. In 1829, he went into partnership with Nicéphore Niépce, the inventor of photography in France, and together they began their photographic experiments. In January 1839 Daguerre's success in fixing the image on the silvered plate was announced by François Arago to the Académie des Sciences, Paris, although the details of the process were not

made public until August. His *Histoire et description des procédés du Daguerreotype et du Diorama* was published in 1839.

Helmut and Alison Gernsheim, *L. J. M. Daguerre: The History of the Diorama and the Daguerreotype*, New York 1968.

17 Notre Dame from the Pont des Tournelles 1838–39
Daguerreotype attributed to Daguerre:
16.4 × 22.1 cm. $6\frac{7}{16}$ × $8\frac{11}{16}$ in.
Gernsheim Collection, Harry Ransom Humanities Research Center, University of Texas at Austin

John Davies
(British b. 1949)

Davies studied photography at Trent Polytechnic, Nottingham, graduating in 1974. For the next four years he received Arts Council Awards to photograph in Ireland. He has worked as a freelance photographer since 1978. In 1981 a touring exhibition, 'Landscapes' (of Cumbria), was sponsored by Side Gallery, Newcastle-upon-Tyne. In 1983 his photographs were commissioned by Side for a group exhibition, 'For Druridge', and an individual exhibition, 'Durham Coalfield'. In 1985 his photographs of Rhymney Valley were shown at Ffotogallery, Cardiff. His first book, *Mist Mountain Water Wind*, appeared in 1986, and *A Green and Pleasant Land* in 1987.

John Davies, *A Green and Pleasant Land*, Manchester 1987.

373 Agecroft Power Station, Pendlebury, Salford, Greater Manchester 1983
Gelatine-silver print, selenium toned:
57.15 × 39.37 cm. $22\frac{1}{2}$ × $15\frac{1}{2}$ in.

Beyond the cooling towers is Agecroft Colliery, which provides fuel for this coal-fired electricity generating station.
 The recreation grounds are owned by the C.E.G.B. for their workers.

John Davies★

374 Druridge Bay, no. 3, Northumberland
Midsummer's Day, 1983
Gelatine-silver print, selenium toned:
57.15 × 39.37 cm. $22\frac{1}{2}$ × $15\frac{1}{2}$ in.

Druridge Bay covers a relatively unpolluted seven-mile strand along the Northumberland coastline. A stretch of land, facing the Bay, has been purchased by the Central Electricity Generating Board. They propose to build Sizewell-type nuclear reactors on the site to utilise the strong coastal currents of the Bay.

John Davies★

375 Runcorn Railway and Road Bridges, Runcorn, Cheshire 1986
Gelatine-silver print, selenium toned:
57.15 × 39.37 cm. $22\frac{1}{2}$ × $15\frac{1}{2}$ in.

The railway bridge was built over the Mersey Estuary in the 1860s to transport Lancashire coal into Cheshire and return with Cheshire salt. It is now on the main rail link between Liverpool and London.

The road bridge, having the largest steel arch in Europe when it was built in 1956–61, replaced an earlier transporter bridge.

John Davies★

376 Mappin Art Gallery, Sheffield, Yorkshire 1981
Gelatine-silver print, selenium toned:
57.15 × 39.37 cm. $22\frac{1}{2}$ × $15\frac{1}{2}$ in.

Situated in Weston Park, the art gallery was bequeathed to the City in 1887. A gift from the Mappin family – whose wealth had been established through the mass production techniques of silver plating cutlery. The gallery and museum are overlooked by Sheffield University and the Royal Hallamshire Hospital tower blocks.

John Davies★

377 Bargoed Viaduct, Rhymney Valley, Mid Glamorgan 1984
Gelatine-silver print, selenium toned:
57.15 × 39.37 cm. $22\frac{1}{2}$ × $15\frac{1}{2}$ in.

The railway viaduct was first opened in the 1850s to transport iron and then coal to Cardiff docks; it is now used entirely for passenger services. Beyond, in Aberbargoed, the mountain of waste from three demolished collieries was planted with 'evergreen' trees in 1974. The stone viaduct and re-landscaped waste heap remain, monuments to the enormous wealth once generated by the valley.

John Davies★

378 Site of Groesfaen Colliery, Deri, Rhymney Valley, Mid Glamorgan 1984
Gelatine-silver print, selenium toned:
57.15 × 39.37 cm. $22\frac{1}{2}$ × $15\frac{1}{2}$ in.

Having been sunk at the beginning of 1900 the colliery was closed in 1968. A reclamation scheme began in 1975 to remove the workings and to re-landscape the huge waste heaps.
 Transatlantic airliners use the nearby Brecon Beacons as an air-traffic turning point.

John Davies★

William Eggleston
(American b. 1939)

Educated in Tennessee and at the University of Mississippi, Eggleston has worked as a freelance photographer in Memphis and Washington, D.C., since 1962. His portfolio, *14 Pictures*, was produced in Washington, D.C., in 1974. In 1976 the Museum of Modern Art, New York, initiated a travelling exhibition of his work and a publication, *William Eggleston's Guide*. His book *Election Eve*, with an introduction by Lloyd Fonvielle, was published in New York in 1977. During 1978–79 he worked as Researcher in Colour Video at the Massachusetts Institute of Technology. A second portfolio, *Troubled Waters*, was published in New York in 1978. *Graceland and the South* was exhibited at the Art Institute of Chicago in 1984, and in 1985 his *Recent Color Photos* were shown at the gallery of the Friends of Photography, Carmel, California.

William Eggleston's Guide, intro. John Szarkowski, Cambridge, Mass. 1976.

359 Tallahatchie County, Mississippi 1971
Dye transfer print: 50.8 × 61 cm. 20 × 24 in.
Lent by the artist

360 Black Bayou Plantation, near Glendora, Mississippi 1971
Dye transfer print: 50.8 × 61 cm. 20 × 24 in.
Lent by the artist

361 Near Greenwood, Mississippi 1971
Dye transfer print: 50.8 × 61 cm. 20 × 24 in.
Lent by the artist

362 Memphis 1971
Dye transfer print: 61 × 50.8 cm. 24 × 20 in.
Lent by the artist

363 Huntsville, Alabama 1971
Dye transfer print: 61 × 50.8 cm. 24 × 20 in.
Lent by the artist

364 Whitehaven, Mississippi 1971
Dye transfer print: 50.8 × 61 cm. 20 × 24 in.
Lent by the artist

365 Sumner, Mississippi, Cassidy Bayou in Background 1971
Dye transfer print: 50.8 × 61 cm. 20 × 24 in.
Lent by the artist

Peter Henry Emerson
(British 1856–1936)
Thomas Frederick Goodall
(British 1857–1944)

Born in Cuba, Emerson spent his childhood in the U.S. and then moved to England where he received a scientific education at Clare College, Cambridge, graduating with a medical degree. In 1885 he first photographed the Norfolk Broads and became friends with a Naturalist painter, T. F. Goodall, who shared with him the authorship of two-thirds of the photographs in *Life and Landscape on the Norfolk Broads* (1886) and collaborated with him on *Idyls of the Norfolk Broads* (1887). In 1886 Emerson was elected to the council of the Royal Photographic Society, and in 1889 he published *Naturalistic Photography for Students of the Art*. *Wild Life on a Tidal Water* appeared in 1890. *On English Lagoons* (1893) and *Marsh Leaves* (1895) were his last two photographic books. After his retrospective exhibition at the Royal Photographic Society in 1900, he devoted his time to purely literary pursuits.

Nancy Newhall, *P. H. Emerson: The Fight for Photography as a Fine Art*, Millerton, N.Y. 1975; Neil McWilliam and Veronica Sekules, eds, *Life and Landscape: P. H. Emerson*, Norwich 1986.

149 In Marsh Land c. 1885
Platinum print from a negative by Emerson alone:
27.6 × 22.9 cm. $10\frac{7}{8}$ × 9 in.
International Museum of Photography at George Eastman House, 82:2532:13

150 Rowing Home the Schoof-stuff 1886
Platinum print: 12.7 × 28.1 cm. 5 × $11\frac{1}{16}$ in.
Leonard J. Halpern

151 Coming Home from the Marshes 1886
Platinum print: 20 × 29 cm. $7\frac{7}{8}$ × $11\frac{7}{16}$ in.
Leonard J. Halpern

152 Poling the Marsh Hay 1886
Platinum print: 23.5 × 29.5 cm. $9\frac{1}{4}$ × $11\frac{5}{8}$ in.
Leonard J. Halpern

153 Snipe Shooting 1886
Platinum print: 19.2 × 18.9 cm. $7\frac{9}{16}$ × $11\frac{3}{8}$ in.
Leonard J. Halpern

154 **A Rushy Shore** 1886
Platinum print from a negative by Emerson alone:
17.8 × 26.3 cm. 7 × 10⅜ in.
Leonard J. Halpern

155 **The Snow Garden** 1895
Photogravure from a negative by Emerson alone:
12.7 × 20 cm. 5 × 7¹³⁄₁₆ in.
The Metropolitan Museum of Art, New York, Gift
of Robert Hershkowitz in memory of Samuel J.
Wagstaff, Jr, 1988.⁺

156 **The Fetters of Winter** 1895
Photogravure from a negative by Emerson alone:
11.2 × 18.9 cm. 4⅜ × 7⁷⁄₁₆ in.
The Metropolitan Museum of Art, New York, Gift
of Robert Hershkowitz in memory of Samuel J.
Wagstaff, Jr, 1988.⁺

Frederick H. Evans
(British 1853–1943)

Formerly a bookseller and collector, Evans took
up photography in the early 1880s and, in 1887,
received the Photographic Society's Medal of
Honour for his photomicrographs. Some of his
first photographs of cathedrals were shown at the
Society's annual exhibition of 1890. In 1896, he
photographed Kelmscott Manor, home of
William Morris. He was elected to the Linked
Ring in 1900 and a large one-man exhibition of
his platinum photographs was held at the Royal
Photographic Society. He was commissioned by
Country Life magazine in 1905 to photograph the
French *châteaux*. In 1908–9 he made a series of
landscapes for a memorial edition of the poems
of George Meredith. His photographs were used
in the 1914 edition of *The Curves of Life* by
Theodore Andrea Cook, with whom Evans also
collaborated on *Twenty-Five Great Houses of
France* [1916]. Around 1911 he compiled albums
of his 'harmonograph' drawings, made by
pendulum oscillations. In 1911 he produced a
series of photographs of the interior of
Westminster Abbey in London.

Beaumont Newhall, *Frederick H. Evans: Photographer
of the majesty, light and space of the medieval cathedrals of
England and France*, Millerton, N.Y. 1973; Anne
Hammond, 'F. H. Evans: The Spiritual Harmonies of
Architecture', in Mike Weaver, ed., *British Photo-
graphy in the Nineteenth Century*, New York and
Cambridge 1989.

157 **Kelmscott Manor: Through a Window in the
Tapestry Room, Kelmscott Manor** 1896
Platinum print: 18.9 × 12.9 cm. 7⁷⁄₁₆ × 5ⁱ⁄₁₆ in.
Royal Photographic Society, Bath, 8022

158 **Kelmscott Manor: Attics** 1896
Platinum print: 15.2 × 20 cm. 6 × 7⅞ in.
Collection, The Museum of Modern Art, New
York, Purchase, 455.66

159 **Untitled** [Château] c. 1906–9
Platinum print: 19.4 × 16.2 cm. 7⅝ × 6⅜ in.
International Museum of Photography at George
Eastman House, 66:030:18

160 **'A Sea of Steps', Wells Cathedral: Stairs to the
Chapter House and Bridge to Vicar's
Close** 1903
Platinum print: 23.7 × 18.9 cm.
9⅝ × 7⁷⁄₁₆ in.
Royal Photographic Society, Bath, 5012

161 **In Redland Woods, Surrey** 1894
Platinum print: 29.9 × 23.2 cm. 11¾ × 9¼ in.
International Museum of Photography at George
Eastman House, 81:1198:10

162 **Westminster Abbey, South Nave Aisle** c. 1911
Platinum print: 24.1 × 18.4 cm. 9½ × 7¼ in.
International Museum of Photography at George
Eastman House 81:1198:57

Walker Evans
(American 1903–75)

Raised in Illinois and educated in Massachusetts,
Evans studied informally at the Sorbonne, Paris,
during 1926. He took up photography seriously
in 1928. In 1930 his photographs were published
as illustrations in Hart Crane's *The Bridge*, and in
1932 he had his first exhibition at the Julien Levy
Gallery, New York. From 1935 to 1938 he was a
photographer for the Farm Security Adminis-
tration. His first book, *American Photographs*,
appeared in 1938 and *Let Us Now Praise Famous
Men*, a collaboration with James Agee, in 1941.
He worked for *Time* as a writer (1943–45) and
for *Fortune* as a writer and photographer
(1945–65). From 1965 to 1971 he was Professor
of Graphic Design at Yale University. His book
Message from the Interior was published in 1966
and *First and Last* appeared in 1978. Several
portfolios of his photographs were produced: *14
Photographs* (1971), *Selected Photographs* (1974)
and *Selected Images, 1929–71* (1977).

*Walker Evans: Photographs for the Farm Security
Administration 1935–1938*, New York 1973; *Walker
Evans at Work*, London 1982, repr. 1985.

302 **Farmhouse, Westchester, New York** 1931
Gelatine-silver print: 17.4 × 21.8 cm. 6⅞ × 8⁹⁄₁₆ in.
The J. Paul Getty Museum, 84.XM.956.441

303 **Main Street, Saratoga Springs, New
York** 1931
Gelatine-silver print: 17.1 × 14.7 cm. 6¾ × 5¾ in.
Collection, The Museum of Modern Art, New
York, Anonymous Fund, 404.38.8

304 **Corrugated Tin Facade, Moundville,
Alabama** 1936
Gelatine-silver print: 16.5 × 22.8 cm. 6½ × 9 in.
Collection, The Museum of Modern Art, New
York, David H. McAlpin fund, 58.71

305 **Highway Corner, Reedsville, West
Virginia** 1935
Gelatine-silver print: 25.4 × 20.6 cm. 10 × 8⅛ in.
The J. Paul Getty Museum, 84.XM.129.5

306 **Floyd Burroughs's Bedroom, Hale County,
Alabama** 1936
Gelatine-silver print: 17.8 × 22.2 cm. 7 × 8¾ in.
The J. Paul Getty Museum, 84.XM.956.3504

307 **Floyd and Lucille Burroughs, Hale County,
Alabama** 1936
Gelatine-silver print made after 1936:
19.1 × 21.5 cm. 7½ × 8⁷⁄₁₆ in.
The J. Paul Getty Museum, 84.XM.956.336

308 **Washroom in the Dog Run of Floyd
Burroughs's Home, Hale County,
Alabama** 1936
Gelatine-silver print: 23.5 × 16.7 cm. 9¼ × 6½ in.
The J. Paul Getty Museum, 84.XM.956.335

309 **Sidewalk and Barber Shop Front, New
Orleans** 1935
Gelatine-silver print: 15.4 × 10.9 cm.
6¹⁄₁₆ × 4⁹⁄₃₂ in.
The J. Paul Getty Museum, 84.XM.956.476

310 **Posed Portraits, New York City** 1931
Gelatine-silver print: 20.3 × 14 cm. 8 × 5½ in.
The J. Paul Getty Museum, 84.XM.956.503

311 **Couple at Coney Island, New York** 1928
Gelatine-silver print: 18.6 × 15.5 cm.
7⁵⁄₁₆ × 6¹⁄₁₆ in.
The J. Paul Getty Museum, 84.XM.956.464

Jean-Gabriel Eynard-Lullin
(Swiss 1775–1863)

Eynard pursued a banking career in Italy for the
first part of his life. He belonged to several
learned societies for the arts and literature
between 1817 and 1863, and was active in
international politics. In 1839 he began to
produce daguerreotypes in Switzerland, France
and Greece which received high praise from
Paymal Lerebours in his *Traité de photographie*
(1843). He produced daguerreotypes in stereo in
1852.

Le Chevalier Jean-Gabriel Eynard, Athens 1963; *J.-G.
Eynard*, Geneva 1963.

18 **Panorama of Geneva** c. 1850
Daguerreotypes: left: 11 × 14.7 cm. 4⅜ × 5¾ in.;
right: 11 × 14.7 cm. 4⁵⁄₁₆ × 5¹³⁄₁₆ in.
The J. Paul Getty Museum, 84.XT.255.24 and
84.XT.255.25

Roger Fenton
(British 1819–69)

Fenton received his education in law at
University College, London, and studied paint-
ing in the early 1840s with the history painter
Charles Lucy. He joined the Calotype Club
(later the Photographic Club) around 1847. In
1851 Fenton visited Paris and became acquainted
with Gustave Le Gray, photographer and co-
founder of the Société Héliographique. By 1852
he had begun to make photographs by both the
waxed-paper and collodion-negative processes.
In 1853 he helped to found the Photographic
Society of London (later called the Royal
Photographic Society), and his work was
represented in the Society's annual exhibition
until 1861. From 1854 to 1858 he worked as
photographer to the British Museum, and in
1855 he photographed the area of Balaclava in
the aftermath of the Crimean War. His
photographs were also exhibited at the Manches-
ter Art Treasures exhibition in 1857.

John Hannavy, *Roger Fenton of Crimble Hall*, Boston,
Mass. and London 1975; Valerie Lloyd, *Roger Fenton:
Photographer of the 1850s*, London 1988

97 **External Walls of the Kremlin,
Moscow** September 1852
Salted-paper print: 18.3 × 21.5 cm. 7⁷⁄₁₆ × 8⁷⁄₁₆ in.
Collection Centre Canadien d'Architecture/
Canadian Centre for Architecture, Montreal,
PH79.0328

98 **The Harbour of Balaklava, the Cattle Pier** 1855
Albumen print: 29.2 × 36.5 cm. 11½ × 14⅜ in.
The J. Paul Getty Museum, 84.xo.376.3

99 **The Valley of the Shadow of Death** 1855
Salted-paper print: 28.4 × 35.9 cm.
11³⁄₁₆ × 14⅛ in.
Gernsheim Collection, Harry Ransom Humanities
Research Center, University of Texas at Austin

100 **Cloud Study** 1859
Salted-paper print: 25 × 43.6 cm.
9⅞ × 17³⁄₁₆ in.
Rubel Collection, courtesy Thackrey and
Robertson, San Francisco★

101 **The Long Walk, Windsor** 1860
Albumen print: 17.3 × 29.2 cm. 6¹³⁄₁₆ × 11½ in.
Lent by Her Majesty The Queen‡

102 **Pont y Garth near Capel Curig** 1858
Albumen print: 34.3 × 43.4 cm. 13½ × 17⅛ in.
The J. Paul Getty Museum, 85.xm.169.9

103 **View in the Slopes, Windsor** 1860
Albumen print: 34 × 43 cm. 13⅜ × 16¹⁵⁄₁₆ in.
Lent by Her Majesty The Queen⁵

104 **Harewood House from across the Lake** 1860
Albumen print: 28.6 × 23.2 cm. 11¼ × 9⅛ in.
(oval)
Royal Photographic Society, Bath, 3260

105 **The Keeper's Rest, Ribbleside** 1858
Albumen print: 36 × 42.2 cm. 14³⁄₁₆ × 16⅝ in.
The Board of Trustees of the Victoria and Albert
Museum, London, 355-1935

106 **Vista, Furness Abbey** 1860
Albumen print: 28.1 × 26.2 cm. 11¹⁄₁₆ × 10⁵⁄₁₆ in.
Royal Photographic Society, Bath, 3026★

107 **Lichfield Cathedral: Portal of the South Transept** 1858
Albumen print: 34.7 × 42.6 cm. 13⅝ × 16¾ in.
Collection Centre Canadien d'Architecture/
Canadian Centre for Architecture, Montreal,
PH1982.0787

108 **Untitled** [Nubian study] 1858
Salted-paper print: 35.6 × 27.2 cm.
14 × 10¹¹⁄₁₆ in.
Private collection

109 **Odalisque** 1858
Salted-paper print: 28.5 × 39 cm.
11³⁄₁₆ × 15⅜ in.
Rubel Collection, courtesy Thackrey and
Robertson, San Francisco

110 **Still life with Statue** 1860
Albumen print: 35.2 × 43.7 cm. 13⅞ × 17³⁄₁₆ in.
(arched)
Royal Photographic Society, Bath, 3102

111 **Still life** 1860
Albumen print: 35.3 × 43.1 cm. 13¹⁵⁄₁₆ × 16¹⁵⁄₁₆ in.
Royal Photographic Society, Bath, 3098

John H. Fitzgibbon
(American c. 1816–82)

Born in London, Fitzgibbon arrived in New
York City as a child. He was employed first as a
saddler and worked as a hotel-keeper and
daguerreotypist from 1841 to 1846. He opened a
gallery in St. Louis, Missouri, in 1846. In 1853 he
bought the R. H. Vance collection of daguer-
reotype views of California. After his retirement
in 1866 he became editor and publisher of the *St.
Louis Practical Photographer*, first published in
1877. He was president of the Photographer's
Association of America in 1882.

26 **Kno-Shr, Kansas Chief** 1853
Daguerreotype, hand coloured:
17.9 × 14.8 cm. 7¹⁄₁₆ × 5⅞ in.
Gillman Paper Company Collection, PH81.770★

Robert Frank
(American b. 1924)

Educated in Zurich, Frank was apprenticed to
photographers in Basle and Zurich from 1940 to
1942, then worked as a freelance still photo-
grapher until 1944. In 1947 he moved to New
York where he worked under Alexey Brodo-
vitch for *Harper's Bazaar*, *Fortune*, *Life* and *Look*
magazines. In 1948 the Museum of Modern Art,
New York, exhibited his photographs. His book
Les Américains was published in Paris in 1958
(*The Americans*, New York 1959, repr. 1972). In
1962 he again exhibited at MOMA, this time
with Harry Callahan. From 1956 he turned his
attention to making films: *Pull My Daisy* (1959);
The Sin of Jesus (1961); *O.K. End Here* (1963); *Me
and My Brother* (1968); *Conversation in Vermont*
(1969); *Life Raft–Earth* (1969); *About Me: A
Musical* (1971); *Cocksucker Blues* (1972); *Keep
Busy* (with Rudy Wurlitzer) (1975); and *Life
Dances On* (1980).

Stuart Alexander, *Robert Frank: A Bibliography,
Filmography, and Exhibition Chronology 1946–1985*,
Tucson 1986; Anne Tucker, ed., *Robert Frank: New
York to Nova Scotia*, Houston 1987.

320 **Beaufort, South Carolina** 1955
Gelatine-silver print: 31.6 × 47.5 cm.
12⁷⁄₁₆ × 18¹¹⁄₁₆ in.
Philadelphia Museum of Art, Funds given by
Dorothy Norman, 69.195.54

321 **Charleston, South Carolina** 1955
Gelatine-silver print: 50.2 × 60.6 cm.
20 × 23⅞ in.
Richard Pare

322 **Canal Street, New Orleans** 1955
Gelatine-silver print: 32.1 × 48 cm. 12⅝ × 18⅞ in.
Philadelphia Museum of Art, Funds given by
Dorothy Norman, 69.195.50

323 **Metropolitan Life Insurance Building** 1955–56
Gelatine-silver print: 33 × 22.5 cm. 13 × 8⅞ in.
Collection of Joseph E. Seagram and Sons, Inc.

324 **Drive-in Movie, Detroit** 1955
Gelatine-silver print made 1973:
32.3 × 47.8 cm. 12¾ × 18¾ in.
Courtesy Canadian Museum of Contemporary
Photography, Ottawa, EX.78.311

325 **U.S. 91, Leaving Blackfoot, Idaho** 1956
Gelatine-silver print: 20.5 × 30.3 cm.
8¹⁄₁₆ × 11¹⁵⁄₁₆ in.
Courtesy Canadian Museum of Contemporary
Photography, Ottawa, EX.78.309

326 **View from Hotel Window, Butte, Montana** 1956
Gelatine-silver print: 29.2 × 44.5 cm.
11½ × 17½ in.
Jean Pigozzi

327 **Fourth of July, Jay, New York** 1955
Gelatine-silver print: 47.1 × 31.1 cm.
18¾ × 12¼ in.
Philadelphia Museum of Art, Funds given by
Dorothy Norman, 69.195.33

Lee Friedlander
(American b. 1934)

A student of photography under Edward
Kaminski at Art Center School, Los Angeles
(1953–55), Friedlander began as a freelance
photographer for *Esquire*, *McCall's*, *Collier's*, *Art
in America* and other magazines in 1955. In 1963
his work was exhibited at George Eastman
House, Rochester, New York. *Work from the
Same House* (a collaborative book with Jim Dine)
was published in London and New York in 1969,
along with a portfolio, *Photographs by Lee
Friedlander and Etchings by Jim Dine* (London).
His book *Self-Portrait* appeared in 1970. His
photographs were exhibited in 1974 at the
Museum of Modern Art, New York, and again
in 1975. *15 Photographs by Lee Friedlander*, a
portfolio introduced by Walker Evans, was
published in 1973, and another portfolio,
Photographs of Flowers, in 1975. The book *The
American Monument* was produced in 1976, *Lee
Friedlander: Photographs* in 1978, the portfolio
Flowers and Trees in 1981, *Factory Valleys* in 1982
and *Portraits* in 1985.

332 **Monsey, New York** 1963
Gelatine-silver print, made late 1960s:
38.8 × 57.2 cm. 15¼ × 22½ in.
The Museum of Fine Arts, Houston, promised gift

333 **New York City** 1974
Gelatine-silver print, made 1983:
39.4 × 57.8 cm. 15½ × 22¾ in.
The Museum of Fine Arts, Houston, promised gift

334 **Kansas City** 1965
Gelatine-silver print, made 1983:
38.8 × 57.8 cm. 15¼ × 22¾ in.
The Museum of Fine Arts, Houston, promised gift

335 **Albuquerque** 1972
Gelatine-silver print, made 1983:
38.8 × 57.8 cm. 15¼ × 22¾ in.
The Museum of Fine Arts, Houston, promised gift

336 **New York City** 1980
Gelatine-silver print: 57.8 × 38.8 cm.
22¾ × 15¼ in.

337 **Cincinnati, Ohio** 1963
Gelatine-silver print, made 1983:
58.1 × 39.4 cm. 22⅞ × 15½ in.
The Museum of Fine Arts, Houston, promised gift

Francis Frith
(British 1822–98)

Working first as a grocer in Liverpool
(1845–56), Frith took up photography around
1850. He was a founding member of the
Liverpool Photographic Society (1853). Bet-
ween 1856 and 1860 he made three expeditions
to the Middle East, bringing back photographs
which were published in a wide range of sizes.
The voyages produced nine publications in all,
including *Egypt and Palestine Photographed and
Described by Francis Frith* (1858–60) and *Egypt,
Sinai and Jerusalem* (published by W. Mackenzie,
1860), which featured the largest photographs
then published in book form. In 1859 the firm of

F. Frith and Company was established in Reigate, Surrey, publishing not only Frith's work but that of other photographers, such as Roger Fenton, whose negatives the company purchased in 1862.

Bill Jay, *Victorian Cameraman*, Newton Abbot 1973; Julia van Haaften, *Egypt and the Holy Land in Historic Photographs: 77 Views by Francis Frith*, New York 1980.

129 Fallen Colossus, Ramasseum, Thebes 1858
Albumen print: 38.7 × 48 cm. 15¼ × 18⅞ in.
The J. Paul Getty Museum, 84.XO.434.4

130 Pyramids from the Southwest, Giza 1858
Albumen print: 38 × 48.8 cm. 15 × 19¼ in.
The J. Paul Getty Museum, 84.XO.434.12

Alexander Gardner
(American 1821–82)

Born in Scotland, Gardner worked as reporter and editor for the *Glasgow Sentinel* before travelling to America in 1856 to work for Mathew Brady. In 1866 he published *Gardner's Photographic Sketch Book of the War* with some photographs by himself and his son. He was appointed official photographer for the Union Pacific Railroad and photographed the landscape along its route and the Great Plains Indians of the region. He made numerous portraits of President Abraham Lincoln and documented the execution of Lincoln's assassination conspirators and Lincoln's funeral procession.

Robert Sobieszek, 'Alexander Gardner's Photographs Along the 35th Parallel', *Image* (June 1971).

64 Abraham Lincoln and his Son Thomas (Tad) 1865
Albumen print: 43.3 × 33.2 cm. 17⅟₁₆ × 13⟋₁₆ in.
The J. Paul Getty Museum, 85.XM.285.1

65 Abraham Lincoln 10 April 1865
Albumen print: 45 × 38.6 cm. 17¹¹⁄₁₆ × 14⅜ in.
National Portrait Gallery, Smithsonian Institution, Washington, D.C., NPG.M.81.1

66 Lincoln reading his Second Inaugural Address 1865
Albumen print: 18 × 23.4 cm. 7⅟₁₆ × 9³⁄₁₆ in.
Private collection

67 Railroad Commissioners at the State Line, Kansas 1867
Albumen print: 32.9 × 47.4 cm. 13 × 18¹¹⁄₁₆ in.
The J. Paul Getty Museum, 84.XM.1027.25

Gilbert
(French active 1850s)

A painter-photographer by the name of Gilbert was working from 13 rue Saint-Marc in Paris in 1856.

20 Landscape with Waterfall 1843–45
Daguerreotype: 14.3 × 10.8 cm. 5⅝ × 4¼ in.
Musée d'Orsay, Paris

Paul Graham
(British b. 1956)

Originally a student of microbiology at Bristol University, Graham began his career as an independent photographer after graduation in 1978. His first book of colour photographs, *A1: The Great North Road*, was published in 1983, followed by *Beyond Caring* (1986) and *Troubled Land* (1987).

432 Army Helicopter and Observation Post, Border Area, County Armagh 1986
Colour coupler print made 1987:
76.2 × 101.6 cm. 30 × 40 in.
Courtesy of the artist

433 Graffiti, Ballysillan Estate, Belfast 1986
Colour coupler print made 1987:
76.2 × 101.6 cm. 30 × 40 in.
Courtesy of the artist

434 Army Stop and Search, Warrenpoint 1986
Colour coupler print made 1987:
76.2 × 101.6 cm. 30 × 40 in.
Courtesy of the artist

Baron Jean-Baptiste-Louis Gros
(French 1793–1870)

In 1823 Baron Gros was French *attaché* in Lisbon, and his diplomatic career later took him to Egypt (1828), Mexico (1831) and Bogotá (1838). He made his first daguerreotypes in 1839, and in 1840 photographed Buenos Aires. In 1847 he published the details of his photographic technique, *Recueil de mémoires et de procédés nouveaux concernant la photographie*. He photographed at the Acropolis in Athens (1850) and in London (1851) and produced twenty-five daguerreotypes of the Fête des Aigles, Champs-de-Mars in 1852. He was a founder member of the Société Française de Photographie in 1854.

23 Athens, the Acropolis May 1850
Daguerreotype: 15.3 × 20.3 cm. 6 × 8 in.
Private collection

24 Monument of Lysicrates, Athens 1850
Daguerreotype: 10.8 × 17.2 cm. 4¼ × 6¾ in.
International Museum of Photography at George Eastman House, 69:0265:123

David Octavius Hill
(British 1802–70)
Robert Adamson
(British 1821–48)

Hill began his career in the 1820s as a painter and illustrator, publishing, at the age of nineteen, a series of landscapes, *Sketches of Scenery in Perthshire* (1821), by the new process of lithography. In 1830 he was a founder member, and also served as secretary, of the Royal Scottish Academy. He illustrated the works of Scottish poets, producing in 1840 engravings for the two-volume *Land of Burns*. Robert Adamson learned photography from his brother, Dr John Adamson, one of the first Scottish calotypists. In 1843 Hill was introduced to Adamson by Sir David Brewster, friend of Talbot, and they began a four-year collaboration photographing ministers and prominent members of the Free Church of Scotland. The calotype portraits were preparatory to Hill's large history painting commemorating the ministers' rebellion against the established Church. Their work was rediscovered around 1890 by James Craig Annan, whose photogravure copies of their calotypes were published in *Camera Work* (1905).

Colin Ford, ed., *An Early Victorian Album: The Photographic Masterpieces (1843–47) of David Octavius Hill and Robert Adamson*, New York 1976; Sara Stevenson, *David Octavius Hill and Robert Adamson: Catalogue of their Calotypes*, Edinburgh 1981.

35 Disruption Group: Rev. Dr John Bruce, Rev. John Sym, Rev. Dr David Walsh c. 1843
Salted-paper print: 14.1 × 18.7 cm. 5⁹⁄₁₆ × 7⅜ in.
Rubel Collection, courtesy Thackrey and Robertson, San Francisco

36 Masons working on a carved Griffin for the Scott Monument c. 1844
Salted-paper print: 14.6 × 19.9 cm. 5¾ × 7¹³⁄₁₆ in.
Rubel Collection, courtesy Thackrey and Robertson, San Francisco

37 Sergeant of the 42nd Gordon Highlanders reading the Orders of the Day April 1846
Salted-paper print: 14.5 × 19.2 cm. 5¾ × 7⅝ in.
Rubel Collection, courtesy Thackrey and Robertson, San Francisco

38 Gordon Highlanders at Edinburgh Castle 1845–46
Salted-paper print: 13.7 × 18.6 cm. 5¹³⁄₃₂ × 7⁵⁄₁₆ in.
Edinburgh City Libraries, 4662

39 Glynn, an Actress and Reader c. 1845
Salted-paper print: 19.6 × 15.2 cm. 7¾ × 6 in.
Rubel Collection, courtesy Thackrey and Robertson, San Francisco

40 Mrs Elizabeth Johnstone, Newhaven c. 1846
Salted-paper print: 20.1 × 14.6 cm. 7¹⁵⁄₁₆ × 5¹³⁄₁₆ in.
Rubel Collection, courtesy Thackrey and Robertson, San Francisco

41 The Reverend Thomas Henshaw Jones 1843
Salted-paper print, from calotype negative:
21 × 15.2 cm. 8¼ × 6 in.
Scottish National Portrait Gallery

42 George Meikle Kemp
[Architect of the Scott Monument] c. 1843
Salted-paper print, from calotype negative:
21 × 14.5 cm. 8⁵⁄₁₆ × 5¾ in.
Rubel Collection, courtesy Thackrey and Robertson, San Francisco

43 Hugh Miller 1843–47
Salted-paper print, from calotype negative:
15.4 × 11.5 cm. 6⅟₁₆ × 4½ in.
Private collection

William Henry Jackson
(American 1843–1942)

In 1858 Jackson worked for C. C. Schoonmaker's portrait studio in Troy, N.Y, retouching and colouring photographs. After serving as a Union soldier in the Civil War, he went west in 1866 and opened a photographic studio in Omaha, Nebraska, with his brother the following year. From 1870 to 1878 he was official photographer for the U.S. Geological Survey. His documentation of Rocky Mountain landscapes (*View of the Yellowstone*, 1871) was instrumental in establishing Yellowstone as the first national park. In 1879 he opened the Jackson

Photographic Company in Denver, Colorado. In 1894–95, *Harper's Weekly* sent him on a photographic world tour on assignment for the World Transportation Commission. His autobiography *Time Exposure* was published in 1940.

Beaumont Newhall and Diana E. Edkins, *William H. Jackson*, New York and Fort Worth 1974.

144 Cañon of the Rio Las Animas, Colorado
after 1880
Albumen print: 42.2 × 53.9 cm. 16⅝ × 21³⁄₁₆ in.
Private collection

145 Grand Canyon of the Colorado 1883
Albumen print: 53.3 × 43.2 cm. 21 × 17¹⁄₁₆ in.
The J. Paul Getty Museum, 85.XM.11.34

146 Old Faithful 1870
Albumen print: 51.4 × 42.5 cm. 20³⁄₁₆ × 16¾ in.
The J. Paul Getty Museum, 85.XM.5.38

André Kertész
(American 1894–1985)

Born and educated in Hungary, Kertész emigrated to France in 1925 and to the U.S. in 1936. He began photographing in 1912, working freelance in Paris (1925–35) for publications such as *Berliner Illustrierte*, *Uhu*, *Le Nazionale de Fiorenza*, *Vu*, *Sourire* and *The Times* (London). In 1934 the book *Paris Vu par André Kertész* was published, with text by Pierre MacOrlan. He worked as a freelance magazine photographer in New York (1937–49) for *Harper's Bazaar*, *Vogue*, *Town and Country*, *Collier's*, *Look* and other magazines, and worked as contract photographer for Condé Nast Publications from 1949 to 1962. After 1962 he became a freelance photographer again. His photographs were exhibited by the Museum of Modern Art, New York, in 1964, when *André Kertész, Photographer* (with text by John Szarkowski) appeared. Other books include *On Reading* (1971), *André Kertész: Sixty Years of Photography* (1972), *Distortions* (1976) and *From My Window* (1981).

André Kertész: Of Paris and New York, London and New York 1985; *André Kertész: Diary of Light, 1912–1985*, New York 1987.

248 Mondrian's Studio 1926
Gelatine-silver print: 11 × 6.5 cm. 4⁵⁄₁₆ × 2⁹⁄₁₆ in.
Thomas Walther Collection, New York

249 Chez Mondrian 1926
Gelatine-silver print: 11 × 8 cm. 4⁵⁄₁₆ × 3⅛ in.
Thomas Walther Collection, New York

250 Anne-Marie Merkel 1926
Gelatine-silver print: 21.5 × 13 cm. 8½ × 5⅛ in.
Thomas Walther Collection, New York

251 Fork 1928
Gelatine-silver print: 7 × 9.2 cm. 2¾ × 3⅝ in.
Thomas Walther Collection, New York

252 Mondrian's Glasses and Pipe, Paris 1926
Gelatine-silver print: 8 × 9.5 cm. 3⅛ × 3¾ in.
Thomas Walther Collection, New York

253 At Zadkine's Studio 1926
Gelatine-silver print: 10.5 × 6.7 cm. 4⅛ × 2⅝ in.
Thomas Walther Collection, New York

254 Etienne Béothy, a Satiric Dancer 1928
Gelatine-silver print: 9.1 × 8 cm. 3⁹⁄₁₆ × 3⅛ in.
Thomas Walther Collection, New York

255 Satiric Dancer 1926
Gelatine-silver print: 96 × 79 cm. 37⅝ × 31¹⁄₁₆ in.
Private collection

256 Untitled (People on the street) [n.d.]
Gelatine-silver print: 16.2 × 20.6 cm. 6⅜ × 8⅛ in.
(sight)
Jedermann Collection, N.A.†

257 Melancholic Tulip 1939
Gelatine-silver print: 86.36 × 54.61 cm.
34 × 21½ in.
The Detroit Institute of Arts, Founders Society Purchase, Acquisitions Fund, F1983.69

258 Distortion No. 141 1933
Gelatine-silver print: 24.5 × 26 cm. 9¾ × 10¼ in.
Richard L. Sandor

William Edward Kilburn
(British active 1846–62)

Kilburn operated daguerreotype studios in London, producing portrait and stereoscopic daguerreotypes and in 1853 registered a combination stereoscope and daguerreotype case. In 1846–52 he was commissioned to make daguerreotype portraits of the Royal Family. His photographs were shown at the Great Exhibition of 1851.

19 The Great Chartist Meeting on Kennington Common 10 April 1848
Daguerreotype: 10.1 × 14.2 cm. 4 × 5⅝ in.
Lent by Her Majesty The Queen★

Chris Killip
(British b. 1946)

Born and raised on the Isle of Man, Killip worked as a photographic assistant in London, 1963–69, and as a freelance photographer from 1969. His first individual exhibition, 'Photos of North East England', was held in 1977 at the Side Gallery, Newcastle-upon-Tyne, of which he was director in 1978. In 1980 the book *Isle of Man: A Book about the Manx* was published. An exhibition of photographs entitled 'Seacoal' was shown at the Side Gallery in 1984, and his work was represented in a major exhibition, 'Another Country', at the Serpentine Gallery, London, in 1985. The book *In Flagrante* (with essays by John Berger and Silvia Grant) was published in 1988.

Mark Haworth-Booth, 'Chris Killip: Scenes from Another Country', *Aperture* 103 (summer 1986), 16–33.

391 Portrait [n.d.]
Gelatine-silver print: 60.96 × 50.8 cm.
24 × 20 in.
Chris Killip★

392 Mr John Moore, Ballalonna, Isle of Man 1969–73
Gelatine-silver print: 19 × 15 cm.
7½ × 5⅞ in.
The Board of Trustees of the Victoria and Albert Museum, London, PH. 689-1980 X959A★

393 Concert, Sunderland 1984
Gelatine-silver print: 50.8 × 60.96 cm.
20 × 24 in.
Chris Killip★

394 Baked Beans [n.d.]
Gelatine-silver print: 50.8 × 60.96 cm.
20 × 24 in.
Chris Killip★

395 Youth on Wall, Jarrow 1976
Gelatine-silver print: 50.8 × 60.96 cm.
20 × 24 in.
Chris Killip★

396 Swans, Cass-ny-Hawin, Santon, Isle of Man 1969
Gelatine-silver print: 29.21 × 25.4 cm.
11½ × 10 in.
Chris Killip★

Heinrich Kühn
(Austrian 1866–1944)

Born in Dresden, Kühn studied botany and medicine in Leipzig, Berlin and Freiburg and experimented with microphotography at the University of Innsbruck, Austria (1887–88). He took up photography seriously in 1891, working as a portraitist. In 1894 he joined the Wiener Kamera Klub where he met Hugo Henneberg and Hans Watzek with whom he founded *Das Kleeblatt* (the Trifolium) in 1896. Introduced to the gum bichromate process by Henneberg the previous year, he began producing multiple-gum prints in 1897. He experimented with the Lumière autochrome plates in 1907. His photographs were featured in an issue of *Camera Work* (1911), and in 1912 in Innsbruck he founded a school for art photography. He was a design researcher for photo-optical companies from 1923 to 1935 and he worked as a photographer for magazines such as *Das Deutsche Lichtbild*, 1923–30.

Heinrich Kühn (1866–1944) Photographien, Frankfurter Kunstverein, Frankfurt 1981; *Heinrich Kühn*, essays by Elizabeth Pollock, Odette M. Appel-Heyne and Ronald J. Hill, Cologne 1981.

174 Untitled c. 1909–12
Gum-bichromate: 21.1 × 29.3 cm. 8½ × 11⅝ in.
Marjorie and Leonard Vernon

175 Flowers in a Bowl c. 1909–12
Autochrome transparency: 17.8 × 23.8 cm.
7 × 9⅜ in.
Gilman Paper Company Collection, PH79.597

176 Lotte and Edeltrude c. 1908
Autochrome transparency in original case:
18.1 × 24.2 cm. 7⅛ × 9½ in.
Gilman Paper Company Collection, PH79.522

177 Lotte and Edeltrude c. 1908
Autochrome transparency in original case:
18.1 × 24.2 cm. 7⅛ × 9½ in.
Gilman Paper Company Collection, PH79.520

Gustave Le Gray
(French 1820–82)

In 1845 Le Gray studied painting with Delaroche and exhibited his pictures at the Paris Salon in 1848–49 and 1853. He became seriously

interested in photography in 1847, and in 1848 opened his first studio in the Boulevard des Italiens. Le Gray was the first to suggest the use of collodion in photography (1850), and his invention of the waxed-paper process was publicised in *Traité pratique de photographie sur papier et sur verre* (1850). In 1851 he became a founder member of the Société Héliographique and was appointed by the fourth Commission des Monuments Historiques to photograph in Touraine and Aquitaine. He operated his portrait studio at the Barrière de Clichy in Paris from 1851–59, but concentrated his energy on architectural views and landscapes. He experimented with combination printing, producing seascapes with clouded skies from two negatives. He was co-founder of the Société Française de Photographie in 1854 and began to give lessons in photography—among his students were Nègre, Le Secq and Du Camp. In 1858 he was appointed photographer to the Emperor. In 1859 he left Paris for Palermo and finally Egypt.

Eugenia Parry Janis, *The Photography of Gustave Le Gray*, Chicago 1988.

85 **Breakwater at Sète** c. 1855
Albumen print: 31.8 × 41.5 cm. 12½ × 16 5/16 in.
The Board of Trustees of the Victoria and Albert Museum, London, 86.097

86 **The Great Wave, Sète** 1856–59
Albumen print: 34.6 × 42 cm. 13 5/8 × 16½ in.
Private collection

87 **An Effect of the Sun, Normandy** 1856–59
Albumen print: 32.5 × 41.5 cm. 12 13/16 × 16 5/16 in.
The Board of Trustees of the Victoria and Albert Museum, London, 67.998

88 **The Imperial Yacht, 'La Reine Hortense', Le Havre** 1856
Albumen print: 32.5 × 40.3 cm. 12 13/16 × 15 7/8 in.
The Board of Trustees of the Victoria and Albert Museum, London, 327-1935

89 **The Sun at its Zenith, Normandy** c. 1860
Albumen print: 32.5 × 41.5 cm. 12 13/16 × 16 5/16 in.
The Board of Trustees of the Victoria and Albert Museum, London, 67.999

90 **Arrival of the Body of Admiral Bruat and Flagship 'Montebello' at Toulon**
2–3 December 1855
Albumen print: 22.1 × 30.5 cm.
8 11/16 × 12 in.
Courtesy Robert Koch Gallery, San Francisco†

91 **Tree Study in the Forest of Fontainbleau** 1856
Albumen print: 31.75 × 41.35 cm. 12½ × 16 9/32 in.
The Metropolitan Museum of Art, New York, Purchase, Joyce and Robert Menschel, The Howard Gilman Foundation, Harrison D. Horblitt, Harriette and Noel Levine, and Paul F. Walter Gifts and David Hunter McAlpin Fund, and Gift of Mr and Mrs Harry H. Lunn, Jr, 1987★

92 **Beech Tree in the Forest of Fontainbleau**
before 1858
Albumen print: 31.9 × 39.5 cm. 12 9/16 × 15 9/16 in.
Private collection

93 **Cavalry Maneouvres, Camp de Châlons** 1857
Albumen print: 27.3 × 34.5 cm. 10¾ × 13 9/16 in.
Private collection

94 **Cavalry Manoeuvres, Camp de Châlons** 1857
Albumen print
25.8 × 33.5 cm. 10⅛ × 13 3/16 in.
Private collection

95 **Pavillon Molien, Louvre, Paris** c. 1857–59
Albumen print: 32.1 × 41.6 cm.
12 5/8 × 16 3/8 in.
Private collection

96 **Karnak: Pillars of the Great Hall** c. 1859
Albumen print: 35.9 × 47 cm.
14⅛ × 18½ in.
Private collection

Jean-Louis Henri Le Secq (des Tournelles)
(French 1818–82)

Le Secq studied art with Delaroche in 1840, and his paintings were exhibited at the Paris Salon from 1842 to 1880. In 1848–49 he took instruction in photography from Le Gray, and from 1850 to 1853 he photographed the architectural monuments of Amiens and Paris. A founder of the Société Héliographique in 1851, he was appointed by the Historic Monuments Commission to photograph in Champagne, Lorraine and Alsace. In 1852 and 1853 he produced large calotype views of Rheims, Strasbourg, Amiens and Chartres cathedrals before their restoration. His architectural views were exhibited at the Exposition Universelle of 1855. Apart from making a series of still lifes (c. 1856), he later gave up photography but published photolithographic prints of some of his early negatives.

Janet E. Buerger, 'Le Secq's "Monuments" and the Chartres Cathedral Portfolio', *Image*, XXIII (June 1980), 1–5; Eugenia Parry Janis and Josiane Sartre, *Henri Le Secq: Photographe de 1850 à 1860*, Paris 1986.

73 **Forest Stream** c. 1850–55
Salted-paper print: 52.3 × 39.2 cm.
20 9/16 × 15 7/16 in.
Bibliothèque des Arts Décoratifs, Paris

81 **Water Jug, engraved Glass and Pears on a plate** c. 1862
Cyanotype print: 25.7 × 34.6 cm. 10⅛ × 13 5/8 in.
Bibliothèque des Arts Décoratifs, Paris

El Lissitzky (Eliezer Markowich)
(Russian 1890–1941)

Born in Russia, Lissitzky was educated in Germany, then returned to Moscow where he received his qualification as an architect in 1917. In 1919 he was invited by Chagall to teach at the Art Labour Co-operative, Vitebsk, where he met Malevich and Tatlin. He then began the first of his 'Proun' constructions (Project for the Affirmation of the New in Art), combining geometric abstraction and perspectival illusion. In 1921 he participated in the first exhibition of the Constructivist group in Moscow. He moved to Berlin in 1922 where he became acquainted with Van Doesburg, Schwitters and Herbert Bayer and began to work with photography. In 1926 he made photocollages and experimented with the 'sandwich' technique of printing. He designed the cover of *Foto-Auge* in 1929, and his work appeared in the 'Film und Foto' exhibition in Stuttgart that year. He was co-founder and editor (with Rodchenko and others) of *USSR in Construction* magazine, 1932–38.

David Elliot, *El Lissitzky 1890–1941*, Oxford 1977; Sophie Lissitzky-Küppers, *El Lissitzky: Life, Letters, Texts*, London 1980.

259 **Photomontage: Study for Richard Neutra's 'Amerika'** 1929–30
Gelatine-silver print: 25.5 × 19 cm. 10 1/16 × 7½ in.
Robert Shapazian, Fresno, California

260 **Socialist Construction, Dresden 1930** 1929
Gelatine-silver print: 27.2 × 21 cm. 10¾ × 8¼ in.
Robert Shapazian, Fresno, California

261 **Untitled** c. 1928
Gelatine-silver photogram: 23.5 × 17.7 cm.
9¼ × 7 in.
Robert Shapazian, Fresno, California

262 **Photomontage: Study for a Poster** [for the Russian Exhibition, Zurich 1929] c. 1928
Gelatine-silver print: 22.5 × 24 cm. 8 7/8 × 9 7/16 in.
Robert Shapazian, Fresno, California

263 **The Constructor** 1924
Gelatine-silver print: 7.6 × 8.6 cm. 3 × 3 3/8 in.
Thomas Walther Collection, New York

Don McCullin
(British b. 1935)

Educated in London, he studied painting at the Hammersmith School of Arts and Crafts (1948–50). He was a photographic assistant in aerial reconnaissance with the Royal Air Force in Egypt, East Africa and Cyprus, 1953–55. He bought his first camera, a Rolleicord, in 1958. From 1961 to 1964 he worked as a freelance photojournalist for *The Observer* newspaper (London). In 1964 he began work as Staff Photographer for *The Sunday Times* (London) in the Congo (1967), Vietnam (1968), Cambodia (1970), Biafra (1968, 1970), India, Pakistan, Northern Ireland, etc. A major exhibition of his work was held in 1971 at the Kodak Gallery, London, and a selection of photographs was published as *The Destruction Business*. In 1980, the book *Don McCullin: Hearts of Darkness* was published in London, and *Perspectives* appeared in 1987.

Mark Haworth-Booth, 'Don McCullin', *Creative Camera* (March/April 1981).

425 **Shell-shocked Soldier awaiting Transportation away from the Front Line, Hué** 1968
Gelatine-silver print: 31.2 × 20.5 cm.
12 5/16 × 9⅛ in.
The Board of Trustees of the Victoria and Albert Museum, London, PH.1280.1980

426 **Fallen North Vietnamese Soldier with his personal Effects scattered by body-plundering Soldiers** 1968
Gelatine-silver print: 25.7 × 38.9 cm.
10⅛ × 15 5/16 in.
The Board of Trustees of the Victoria and Albert Museum, London, PH.1281.1980

427 **Vietnamese Marines running across a dangerous Road in Cambodia** 1970
Gelatine-silver print: 20.6 × 31.5 cm.
8⅝ × 12⅜ in.
The Board of Trustees of the Victoria and Albert Museum, London, PH.1290-1980

428 Man throwing Grenade, Hué 1968
Gelatine-silver print: 25.6 × 39 cm.
$10\frac{1}{16}$ × $15\frac{3}{8}$ in.
The Board of Trustees of the Victoria and Albert
Museum, London, PH.1267-1980

Ian Macdonald
(British b. 1946)

Macdonald studied photography at Sheffield
School of Art (1971–74) and Birmingham
Polytechnic (1974–75). He worked in the
chemical/steel industry and as a part-time
photographic technician, and then as an art
teacher in a comprehensive school. In 1976 he
had two exhibitions: 'Greatham Creek' at the
Impressions Gallery, York, and 'Faces along the
Road' at Middlesbrough Art Gallery. In 1980
his exhibition 'Quoits' was shown at the Side
Gallery, Newcastle-upon-Tyne. *Blast Furnace*, a
series of photographs of the Teeside iron and
steel industry, was exhibited at the Side Gallery
in 1986. He produced a book with Len Tabner,
Smith's Dock Shipbuilders, in 1987.

**385 Mandy Jemmerson and Paula Woods drawing
Hedgerows, Secondary School, Cleveland**
1983
Gelatine-silver print: 26.7 × 32.7 cm.
$10\frac{1}{2}$ × $12\frac{7}{8}$ in.
Ian Macdonald★

**386 Equinox Flood Tide, Greatham Creek,
Teesmouth** 1974
Gelatine-silver print: 26.7 × 32.7 cm.
$10\frac{1}{2}$ × $12\frac{7}{8}$ in.
Ian Macdonald★

**387 Mathematics Detention, Secondary School,
Cleveland** 1983
Gelatine-silver print: 26.7 × 32.7 cm.
$10\frac{1}{2}$ × $12\frac{7}{8}$ in.
Ian Macdonald★

**388 Tipped Slag, Redcar, No.1 Blastfurnace,
Teesmouth, Cleveland (night)** c. 1985
Gelatine-silver print: 26.7 × 32.7 cm.
$10\frac{1}{2}$ × $12\frac{7}{8}$ in.
Ian Macdonald★

389 South Gare, Teesmouth, June 1980
Gelatine-silver print: 32.7 × 32.7 cm.
$12\frac{7}{8}$ × $10\frac{1}{2}$ in.
Ian Macdonald★

**390 Ken Robinson, Greatham Creek,
Teesmouth** 1973
Gelatine-silver print: 32.7 × 26.7 cm.
$12\frac{7}{8}$ × $10\frac{1}{2}$ in.
Ian Macdonald★

Robert MacPherson
(British 1811–72)

MacPherson studied medicine in Edinburgh
(1831–35) and in 1840 moved to Rome, where
he took up landscape painting. He learned
photography from a doctor friend who visited
him in 1851, and began a twenty-year career
photographing views of Rome and adjacent
areas. He patented a method of lithography on
stone and metal in 1853. In 1855 he demonstrated
his technique of photolithography to the Société
Française de Photographie, and to the Scottish

Photography Association in 1856. The Architec-
tural Photography Association, London, exhi-
bited some 400 of his photographs in 1862, and in
1863 a *Guide Book to the Sculptures in the Vatican*
was published with more than 300 of his prints.

Ray McKenzie, 'The Cradle and Grave of Empires:
Robert MacPherson and the Photography of Nine-
teenth Century Rome', *The Photographic Collector*, IV,
2 (autumn 1983), 215–32; Marjorie Musterburg, 'A
Biographical Sketch of Robert MacPherson', *The Art
Bulletin* LXVIII, 1 (March 1986) 142–53.

**137 The Arco dei Pantani at the Entrance of the
Forum of Augustus, with the Temple of Mars
Ultor, Rome** before 1863
Albumen print: 40 × 28.7 cm. $15\frac{3}{4}$ × $11\frac{5}{16}$ in.
Collection Centre Canadien d'Architecture/
Canadian Centre for Architecture, Montreal,
PH1979.0205

139 Grotto at Tivoli c. 1860
Albumen print: 62.8 × 47 cm. $24\frac{5}{8}$ × $18\frac{5}{8}$ in.
Collection of Peter Coffeen

Man Ray (Emmanuel Rudnitsky)
(American 1890–1976)

Born in Philadelphia, Man Ray studied art at the
National Academy of Design in New York
(1908/12) and took up photography in 1915.
From 1921 to 1940 he was a freelance
photographer, film-maker and painter in Paris.
In 1922 he published in Paris a portfolio of
Rayographs, *Les Champs Délicieux: Album de
Photographies*. His book *Man Ray* appeared in
1924 and *Revolving Doors 1916–17* in 1926. In
1931 he produced a portfolio of ten photographs,
Electricité. *Man Ray Photographies, 1920–1934,
Paris* (with texts by André Breton, Paul Eluard
and Tristan Tzara) was published in 1934, and his
manifesto, *La Photographie n'est pas l'Art*
(foreword by André Breton), appeared in 1937.
He moved to the U.S. during the war and taught
photography at Art Center School in Los
Angeles, 1942–50. His autobiography, *Self
Portrait*, was published in London in 1963, and a
portfolio, *Man Ray: 12 Photographs 1921–28*,
appeared the same year in New York. Three
other portfolios followed: *Les Invendables* (1969),
Mr. and Mrs. Woodman (1970) and *Man Ray:
Femmes 1930–35* (1981). In 1981 a retrospective
exhibition of his work was held at the Centre
Pompidou, Paris. His films include *The Return to
Reason* (1923), *Emak Bakia* (1926), *L'Etoile de Mer*
(1928) and *The Mystery of the Château of Dice*
(1929).

Man Ray: Photographs 1920–1934, New York 1975;
Janus, ed., *Man Ray. The Photographic Image*, London
1977, repr. 1980.

239 Woman (*Femme*) 1918
Gelatine-silver print: 23.9 × 17.9 cm. $9\frac{3}{8}$ × $7\frac{1}{16}$ in.
Thomas Walther Collection, New York

240 Man (*Homme*) 1918
Gelatine-silver print: 48.3 × 35.6 cm. 19 × 14 in.
(sight)
Jedermann Collection, N.A.★

241 Dust Breeding (*Elevage de Poussière*) 1920
Gelatine-silver print made 1964: 21 × 40.5 cm.
$8\frac{1}{4}$ × 16 in.
Permanent collection High Museum of Art,
purchase with funds from Georgia-Pacific
Corporation, 1984.223

242 Untitled (Gyroscope) 1922
Gelatine-silver Rayograph: 23.8 × 17.8 cm.
$9\frac{3}{8}$ × 7 in. (sight)
Collection Timothy Baum, New York

243 Neck (*Le Cou*) 1929
Gelatine-silver print: 28.9 × 21.6 cm.
$11\frac{3}{8}$ × $8\frac{1}{2}$ in.
Jedermann Collection, N.A.[+]

244 Reclining Nude on a satin Sheet c. 1930
Gelatine-silver print: 14.6 × 37.2 cm.
$5\frac{3}{4}$ × $14\frac{5}{8}$ in.
Thomas Walther Collection, New York

245 Portrait of a tearful Woman 1936
Gelatine-silver print, retouched and hand-coloured:
22.9 × 15.3 cm. 9 × 6 in.
The Emily and Jerry Spiegel Collection, New York

246 Le Violon d'Ingres 1924
Gelatine-silver print: 29.6 × 23 cm. $11\frac{5}{8}$ × 9 in.
The J. Paul Getty Museum, 84.XM.626.10[‡‡‡]
Mr and Mrs Melvin Jacobs★

247 Glass Tears (*Larmes*) c. 1930
Gelatine-silver print: 22.5 × 28.6 cm.
$8\frac{7}{8}$ × $11\frac{1}{4}$ in.
Jedermann Collection, N.A.[±]

Charles Marville
(French 1816–c. 1879)

A painter-engraver and lithographic artist in
Paris, Marville began to photograph in 1851.
Many of his calotype negatives were published in
the albums of Blanquart-Evrard, beginning with
Album Photographique de l'Artiste et de l'Amateur
(1851). In 1852 he travelled to Algeria and in
1852–53 made photographic expeditions in
central France and Germany. In 1856 he
recorded the baptism of the Prince Imperial in
Notre Dame, Paris. In 1858 he photographed
parks such as the Bois de Boulogne and old Paris
for the French government. He took up
collodion in 1860 and in 1861–62 photographed
drawings by Italian masters in Milan and Turin.
By 1862 he was named as photographer to the
Imperial Museum of the Louvre, to the Ville de
Paris and to King Victor Emmanuel of Italy.

Charles Marville: Photographs of Paris 1852–1879, essays
by Maria M. Hambourg and Marie de Thézy, New
York and Paris 1981.

**68 Vue du Pont de la Réforme ou Pont Louis
Philippe, Paris** 18 February 1853
Blanquart-Evrard salted-paper print:
25.4 × 34.7 cm. 10 × $13\frac{5}{8}$ in.
Collection Harrison D. Horblitt[±]

**74 Young Man reclining beneath a Horse-
chestnut Tree** 1853
Blanquart-Evrard salted-paper print:
21 × 18 cm. $8\frac{1}{4}$ × $7\frac{1}{16}$ in.
Private collection

John Jabez Edwin Mayall
(American 1810–1901)

In Philadelphia, Mayall lectured on chemistry

461

and operated a daguerreotype studio with Marcus A. Root, 1842–46. He then moved to London, where he briefly managed Claudet's studio until 1847 when he opened his American Daguerreotype Institution in London. In 1845 he produced a ten-plate sequence illustrating the Lord's Prayer, and his series of large-format daguerreotypes was shown at the Great Exhibition in 1851. He patented the 'ivorytype' (a method of photographic printing on artificial ivory) in 1855. In 1860 his studio published a carte-de-visite album of the Royal Family which helped to popularise the trade in England. He later opened a studio in Brighton, Sussex, and engaged in cabinet portrait photography. In the 1860s he was among the first to take portraits by electric light.

L. L. Reynolds and A. T. Gill, 'The Mayall Story', *History of Photography* IX (April–June 1985), 89–107.

22 The Crystal Palace, Hyde Park 1850
Daguerreotype: 30.4 × 24.7 cm.
12 × 9$\frac{11}{16}$ in.
The J. Paul Getty Museum, 84.XT.955.1

Susan Meiselas
(American b. 1948)

Meiselas was educated at Sarah Lawrence College (B.A. 1970) and Harvard Graduate School of Education (M.Ed. 1971). While at Harvard she worked as assistant film editor to Frederick Wiseman. In 1973–74 she served as Artist-in-Residence for schools throughout South Carolina and Mississippi and worked as a consultant to the Polaroid Foundation in 1974. In 1975 and 1976 she taught photography at the New School of Social Research, New York. Since 1975 she has worked as a freelance photographer for *New York Times*, *Harper's*, *Time*, *Life*, *Geo* and other magazines. The book *Nicaragua* was published in New York in 1981, and she co-edited *El Salvador: The Work of Thirty Photographers* (1983).

G. Emerson, 'Susan Meiselas—At War', *Esquire* (December, 1984).

429 Youths Practise throwing Contact Bombs in Forest surrounding Monimbo 1978
Cibachrome print made 1988: 50.8 × 40.7 cm.
20 × 16 in.
Lent by the artist, courtesy Magnum

430 Returning Home, Masaya September 1978
Cibachrome print made 1988: 40.7 × 50.8 cm.
16 × 20 in.
Lent by the artist, courtesy Magnum

431 Motorcycle Brigade, Monimbo, Nicaragua
5 July 1978
Cibachrome print made 1988: 40.7 × 50.8 cm.
16 × 20 in.
Lent by the artist, courtesy Magnum

Baron Adolf (Gayne) de Meyer
(American 1868–1946)

Raised in Paris, de Meyer exhibited photographs

in Paris and London in 1894 and at a salon of the Linked Ring, London, in 1898. He was voted a member of the Linked Ring in 1895 and became known for his society portraits of Edwardian London and still-life studies. His work was featured in *Camera Work* in 1908 and 1912 and exhibited at '291' in 1909. In 1911 he made a series of photographs of Nijinsky, when Diaghilev's Ballets Russes appeared in London, and published them as *Sur le Prélude à l'Après-Midi d'un Faune* (1914). He began work for Condé Nast (*Vogue* magazine) in 1914, and worked for *Harper's Bazaar* (1923–34).

Robert Brandau, *de Meyer*, New York 1976.

435 Man with a Cane c. 1919
Gelatine-silver print: 48.6 × 36.1 cm.
19$\frac{1}{8}$ × 14$\frac{3}{16}$ in.
International Museum of Photography at George Eastman House, Louise Dahl-Wolfe Collection, 70:189:15★★

436 Josephine Baker 1925
Gelatine-silver print: 39.1 × 42.3 cm.
15$\frac{3}{8}$ × 16$\frac{5}{8}$ in.
The J. Paul Getty Museum, 84.XP.452.5

437 Advertisement for Elizabeth Arden 1926
Gelatine-silver print made 1935:
35.4 × 27.8 cm. 13$\frac{15}{16}$ × 10$\frac{15}{16}$ in.
Thomas Walther Collection, New York

László Moholy-Nagy
(American 1895–1946)

Born and educated in Hungary, Moholy-Nagy studied law at the University of Budapest (1913–14, 1918–19) and was an independent painter and writer in Vienna and Berlin, 1919–23. He produced experimental photograms in Berlin in 1922 and headed the Foundation Course at the Bauhaus in Weimar (1923–25) and Dessau (1925–28). From 1928 to 1931 he worked as a theatre designer in Berlin and maintained a commercial design office, 1928–34. The book *Malerei, Fotografie, Film* was published in 1925 and *The New Vision* in 1930. He worked as a designer in Amsterdam and London in the mid-1930s. In 1937 he became founder-director of the New Bauhaus School in Chicago, and then the School of Design in Chicago (from 1944, the Institute of Design), making photography an integral part of the curriculum. *Vision in Motion* was published in 1947. His films include *Berliner Stilleben* (1929), *Marseilles Vieux Port* (1929) and *Lichtspiel Schwarz-Weiss-Grau* (1930).

Andreas Haus, *Moholy-Nagy: Photographs and Photograms*, New York and London 1980; Joseph Harris Caton, *The Utopian Vision of Moholy-Nagy*, Ann Arbor and Epping 1984.

233 Boats in the Old Port of Marseilles 1929
Gelatine-silver print: 50.4 × 40 cm. 19$\frac{7}{8}$ × 15$\frac{3}{4}$ in.
International Museum of Photography at George Eastman House, 81:2163:43

234 Marseilles 1929
Gelatine-silver print: 37.5 × 27.3 cm.
14$\frac{3}{4}$ × 10$\frac{3}{4}$ in.
Yasuo Hattori

235 View from the Pont Transbordeur, Marseilles 1929
Gelatine-silver print: 40 × 36 cm. 15$\frac{3}{4}$ × 14$\frac{3}{16}$ in.
International Museum of Photography at George Eastman House, 81:2163:28

236 Untitled (View from the Berlin Radio Tower in winter) 1928
Gelatine-silver print: 24.5 × 18.9 cm. 9$\frac{5}{8}$ × 7$\frac{7}{16}$ in.
G. E. Kidder Smith

237 Photogram: Positive-Negative after 1922
Gelatine-silver print:
Positive: 38.4 × 28.5 cm. 15$\frac{1}{8}$ × 11$\frac{1}{4}$ in.
Negative: 38.6 × 29.6 cm. 15$\frac{3}{16}$ × 11$\frac{5}{8}$ in.
International Museum of Photography at George Eastman House, 81:2163:25/23

238 Negative 1931
Gelatine-silver print: 35.6 × 28 cm.
14 × 11 in.
Yasuo Hattori

Raymond Moore
(British 1920–87)

After serving in the Royal Air Force during the war, Moore studied at the Royal College of Art, London, from 1947 to 1950 and began a career as freelance photographer in 1955. From 1956 to 1974, he was lecturer in creative photography at Watford College of Art, Hertfordshire. In 1967 an exhibition, 'Modfor 1: Raymond Moore', was held at the Royal Watercolour Society Gallery, London, and toured the U.K. and Europe. Another touring exhibition was organised in 1968 by the Welsh Arts Council Gallery, Cardiff. In 1970 he studied with Minor White at Massachusetts Institute of Technology, and his work was shown at George Eastman House, Rochester, N.Y. Retrospective exhibitions of his work were held at the Art Institute of Chicago in 1971 and at the Hayward Gallery, London, in 1981.

Ian Jeffrey, 'Raymond Moore', *The London Magazine* (April–May 1985).

379 Alderney 1965
Gelatine-silver print: 19.8 × 30.2 cm.
7$\frac{3}{4}$ × 11$\frac{7}{8}$ in.
Mary Cooper

380 Kintyre 1985
Gelatine-silver print: 19.7 × 29.5 cm.
7$\frac{3}{4}$ × 11$\frac{5}{8}$ in.
Mary Cooper

381 Eire 1976
Gelatine-silver print: 21 × 29.9 cm.
8$\frac{1}{4}$ × 11$\frac{3}{4}$ in.
Mary Cooper

382 Allonby 1982
Gelatine-silver print: 23.8 × 35.4 cm.
9$\frac{3}{8}$ × 13$\frac{7}{8}$ in.
Mary Cooper

383 Raes Knowes 1980
Gelatine-silver print: 24.1 × 35.4 cm.
9$\frac{1}{2}$ × 14 in.
Mary Cooper

384 Dumfriesshire 1985
Gelatine-silver print: 19 × 28.5 cm.
$7\frac{1}{2}$ × $11\frac{1}{4}$ in.
Mary Cooper

Anatoli Morozov
(Russian active 1940s)

423 The Victorious Troops signing their Names in the Lobby of the Reichstag May 1945
Gelatine-silver print: 27.4 × 39.8 cm.
$10\frac{13}{16}$ × $15\frac{5}{8}$ in.
International Center of Photography, New York, Permanent Collection, Gift of the photographer, 384.86

Martin Munkácsi (Martin Marmorstein)
(American 1896–1963)

Educated in Hungary, Munkácsi worked in Budapest as a writer-reporter for *Az Est*, *Pesti Napló* and *Színházi Elet* publications from 1914 to 1921. He was a photographer for *Az Est* newspaper and *Theatre Life* weekly review, 1921–27. From 1927 to 1930 he worked as contract photographer for Ullstein Verlag publishers, contributing to *Berliner Illustrierte Zeitung*, *Die Dame*, *Koralle*, and *Uhu* magazines. He photographed in the early 1930s for *The Studio*, *Harper's Bazaar*, *Das Deutsche Lichtbild*, *Photographie* and *Modern Photography* in Berlin and New York. In 1934 he emigrated to the U.S. and worked as fashion photographer (1934–40) for *Harper's Bazaar*, *Town and Country*, *Pictorial Review* and *Life*. During these years he began a new style of outdoor, 'action' fashion photography. He photographed for *Ladies' Home Journal* until 1946, and after that worked as freelance photographer, film cameraman and lighting designer for television. His autobiography, *Fool's Apprentice*, was published in 1945, and the book *Munkácsi: Nudes* in 1951.

Spontaneity and Style, Munkácsi: A Retrospective, International Center of Photography, New York 1978; Nancy White and John Esten, eds, *Style in Motion: Munkácsi Photographs*, New York 1979.

438 Washing, Berlin c. 1929
Gelatine-silver print: 33.6 × 26.7 cm.
$13\frac{1}{4}$ × $10\frac{1}{2}$ in.
Lent from the collection of Liza Cowan, courtesy of Photofind Gallery, New York City

439 Lucille Brokaw 1933
Gelatine-silver print: 33 × 25.4 cm. 13 × 10 in.
Lent from the collection of Liza Cowan and Sharon Mumby, courtesy of Photofind Gallery, New York City

440 Fred Astaire 1936
Gelatine-silver print: 33.7 × 26.8 cm.
$13\frac{1}{4}$ × $10\frac{1}{2}$ in.
Takouhy and Don Wise

John Murray
(British 1809–98)

Murray received his degree in medicine in 1832 and entered the medical service of the Army of the East India Company. In 1849 he became Medical Officer in charge of the Medical School at Agra and began photographing shortly thereafter. The London publisher, J. Hogarth, exhibited thirty-five of Murray's architectural and landscape views from waxed-paper negatives in 1857 and the following year published them as *Photographic Views of Agra and Its Vicinity*. A second publication, *Picturesque Views in the North Western Provinces of India*, was produced by Hogarth in 1859.

131 Untitled (Panorama of Agra) 1859
Albumen print: 36.9 × 28.3 cm. $14\frac{1}{2}$ × $50\frac{1}{2}$ in.
George T. Butler

132 Untitled (The Taj Mahal) c. 1856
Calotype negative, selectively painted:
39.3 × 46.5 cm. $15\frac{1}{2}$ × $18\frac{3}{8}$ in.
Rubel Collection, courtesy Thackrey and Robertson, San Francisco

Nadar (Gaspard Félix Tournachon)
(French 1820–1910)

Nadar studied medicine in Lyons and worked at a great number of odd jobs before settling on a career as writer and illustrator in the 1840s. In 1848 he began work with *Le Charivari*, founded the *Revue Comique* and produced caricatures for *Journal pour Rire*. His 'Panthéon Nadar', begun in 1853, was a project to create lithographic caricatures of the thousand most famous faces of his time. In the following year he opened a photographic portrait studio which became a gathering place for artists and intellectuals and which in 1874 was the location of the first Impressionist Exhibition. In the mid-1850s he worked briefly with his brother, Adrien Tournachon. One of the first to photograph with artificial light, in 1860 he opened the 'salon of electric photography'. He initiated the practice of the photo-interview when, in 1886, his son photographed him interviewing the scientist Chevreul on his 100th birthday, and the event was published in the *Journal Illustré*.

Nigel Gosling, *Nadar*, New York 1976; Ullrich Keller, 'Nadar as Portraitist', *Gazette des Beaux-Arts*, ser. 6, CVII (April 1986), 133–78.

44 Pierre Petroz 1855–65
Salted-paper print: 23.6 × 17.6 cm. $9\frac{5}{16}$ × $6\frac{15}{16}$ in.
The J. Paul Getty Museum, 84.XM.436.344

45 Jean-François Millet 1855–65
Salted-paper print: 24.5 × 17.9 cm. $9\frac{5}{8}$ × $7\frac{1}{16}$ in.
Private collection

46 Théophile Gautier 1855–65
Salted-paper print: 28.4 × 21.1 cm. $11\frac{3}{16}$ × $8\frac{5}{16}$ in.
Private collection

47 Gustave Doré 1855–65
Salted-paper print: 24.7 × 17.2 cm. $9\frac{3}{4}$ × $6\frac{3}{4}$ in.
Private collection

48 Mère Eulalia Jamet 1860
Salted-paper print: 21.8 × 16.7 cm. $8\frac{5}{8}$ × $6\frac{9}{16}$ in.
The J. Paul Getty Museum, 84.XM.436.497

49 Gioacchino Rossini 1855–65
Salted-paper print: 24.5 × 17.9 cm. $9\frac{5}{8}$ × 7 in.
Private collection

50 The Mime, Debureau, expressive Figure 1854–55
Albumenised salted-paper print: 28 × 18.7 cm.
11 × $7\frac{3}{8}$ in.
Musée d'Orsay, Paris†

51 The Son of Auguste Lefranc c. 1855–65
Salted-paper print: 18.3 × 13.7 cm. $7\frac{3}{16}$ × $5\frac{3}{8}$ in.
The J. Paul Getty Museum, 84.XM.436.18

Charles Nègre
(French 1820–80)

A student of painting, Nègre studied with Delaroche (1839) and later with Ingres. In 1844 he began making daguerreotypes of his paintings, and in 1847, when Blanquart-Evrard's modification of Talbot's process became available, he changed to the paper process. Within weeks of Le Gray's announcement of the waxed-paper process (1851), Nègre and Le Secq were putting it into practice. In 1851 he began to photograph in earnest, and his first exhibition was held that year at the Société Héliographique. In 1852 he produced 200 negatives for a proposed part work, *Le Midi de la France*, which failed financially after one issue and was unfinished. In 1854 he reported his experiments with heliogravure on steel, and in 1856 an example of his method of heliographic engraving called 'gravure paniconographique' was published in *La Lumière*.

James Borcoman, *Charles Nègre, 1820–1880*, Ottawa 1976; Françoise Heilbrun, *Charles Nègre, photographe, 1820–1880*, Paris 1980.

75 Chartres Cathedral: Part of the Porch of the North Transept c. 1851
Salted-paper print: 15.7 × 11.4 cm. $6\frac{3}{16}$ × $4\frac{1}{2}$ in.
Private collection

76 Montmajour: The Abbey's Postern 1852
Salted-paper print: 29.4 × 22.4 cm. $11\frac{9}{16}$ × $8\frac{13}{16}$ in.
Private collection

Helmut Newton
(Australian b. 1920)

Born and educated in Berlin (1928–35), Newton was apprenticed to a fashion and theatre photographer, Yva (1936–40). He emigrated to Australia and served in the Australian Army during World War II and then worked as a freelance photographer in Sydney. Since 1958 he has contributed to *Jardin des Modes*, *Elle*, *Queen*, *Playboy*, *Nova*, *Marie Claire* and most recently *Stern* and French and American *Vogue*. His work was first exhibited in 1975 at Nikon Gallery, Paris, and Canon Photo Gallery, Amsterdam. His first book, *White Women/Femmes secrètes*, appeared in 1976. He produced the book *Sleepless Nights/Nuits blanches* in 1978 and *Helmut Newton: Special Collection: 24 Photo Lithos* in 1979. An exhibition '31 Nudes/Personalities', was shown at the Olympus Gallery, London, in 1983. Two more books followed: *World Without Men* (1983) and *Helmut Newton: Portraits* (1987).

449 Bordighera Detail 1983
Gelatine-silver print made 1988 by Bernard Binesti:
35.1 × 43.2 cm. 14 × 17 in.
Courtesy of the artist

450 Untitled c. 1965
Gelatine-silver print: 43.2 × 35.1 cm.
17 × 14 in.
Courtesy of the artist

451 Shoe 1983
Gelatine-silver print made 1988 by Tom Consilvio:
43.2 × 35.1 cm. 17 × 14 in.
Courtesy of the artist

Timothy H. O'Sullivan
(American 1840–82)

In 1860 O'Sullivan was employed at the studio of Mathew Brady in Washington, D.C. He left in 1862 to work for Alexander Gardner, who published many of his photographs of Civil War battlefields in *Gardner's Photographic Sketch Book of the War* (1866). In 1867–69 he joined Clarence King in his expedition along the 40th parallel, as official photographer for the U.S. Geological Survey. He photographed with the Darien Survey to Panama in 1870. In 1871–75 he worked on the Wheeler expeditions to California, Nevada and Arizona. He documented the culture and landscape of the South-west Indians in 1874, and in 1880 he was named chief photographer for the Department of the Treasury.

Joel Snyder, *American Frontiers: The Photographs of Timothy O'Sullivan, 1867–1874*, Millerton, N.Y. 1981.

141 The Ancient Ruins of the Cañon de Chelle, New Mexico 1873
Albumen print: 27.2 × 20.3 cm. 10¹¹⁄₁₆ × 8 in.
Private collection

142 Inscription Rock, New Mexico [recording the Spanish Conquest] 1873
Albumen print: 20.5 × 27.6 cm. 8¹⁄₁₆ × 10⁷⁄₈ in.
Private collection

143 Desert Sand Hills near Sink of Carson, Nevada 1867
Albumen print: 22.3 × 29.1 cm. 8³⁄₁₆ × 11⁷⁄₁₆ in.
The J. Paul Getty Museum, 84.XM.484.42

Martin Parr
(British b. 1952)

Parr studied photography at Manchester Polytechnic from 1970 to 1973, during which time an exhibition of his photographs, 'Butlins by the Sea', was shown at the Impressions Gallery, York (1972). In 1973–74, he worked as a photojournalist for Manchester Council for Community Relations. Since 1974 he has been a freelance photographer. After moving to Ireland in 1980 he produced the books *Bad Weather* (1982) and *A Fair Day: Photographs from the West of Ireland* (1984). *Calderdale Photographs* was published in 1984 to accompany an exhibition at Piece Hall Art Gallery, Yorkshire. His work was exhibited at the Serpentine Gallery and Photographers' Gallery, London, in 1986, and the book *The Last Resort: Photographs of New*

Brighton also appeared in that year. In 1987 he moved to Bristol and began a series of photographs of suburban England. His work was exhibited in 1987 at the National Centre of Photography in Paris.

David Lee, 'Photography', *Arts Review* (August 1986), 440.

403 Passing Naturalists, Pagham Harbour 1975
Gelatine-silver print: 40.64 × 30.48 cm.
16 × 12 in.
Collection of the photographer★

404 Glastonbury Tor 1976
Gelatine-silver print: 40.64 × 30.48 cm.
16 × 12 in.
Collection of the photographer★

405 Tupperware Party 1985
Colour coupler print: 60.96 × 50.8 cm.
24 × 20 in.
Collection of the photographer★

406 New Brighton 1984
Colour coupler print: 60.96 × 50.8 cm.
24 × 20 in.
Collection of the photographer★

407 Videoshop 1985
Colour coupler print: 60.96 × 50.8 cm.
24 × 20 in.
Collection of the photographer★

408 New Brighton ('Separate Dreams') 1984
Colour coupler print: 60.96 × 50.8 cm.
24 × 20 in.
Collection of the photographer★

Irving Penn
(American b. 1917)

From 1934 to 1938 Penn studied with Alexey Brodovitch at the Philadelphia Museum School of Industrial Art. In 1940–41 he was employed in the art and advertising department of Saks Fifth Avenue. After a year spent as a painter in Mexico he took a job with *Vogue* in New York (1943), first designing covers for the magazine and later producing photographic illustrations. In 1953 he opened his own studio. His book, *Moments Preserved: 8 Essays in Photographs and Words*, was published in 1960, and the following year the Museum of Modern Art, New York, initiated a touring exhibition of his photographs. *Worlds in a Small Room* appeared in 1974, *Flowers* in 1980 (repr. 1987), and *Irving Penn* in 1984, when MOMA opened a retrospective exhibition of his work in New York. *Penn: A Photographic Essay* appeared in 1986.

John Szarkowski, *Irving Penn*, New York 1984.

441 Black and White Vogue Cover 1950
Platinum-palladium print made 1968:
41.9 × 35 cm. 16½ × 13¾ in.
Courtesy of *Vogue*

442 Two Guedras, Goulimine, Morocco 1971
Platinum and platinum-palladium print made January 1977: 53.3 × 43.2 cm. 21 × 17 in.
The FORBES Magazine Collection, New York

443 Rochas Mermaid Dress 1950
Platinum-palladium print made 1979:
49.9 × 50.2 cm. 19⅝ × 19¾ in.
The FORBES Magazine Collection, New York

444 Cecil Beaton 1950
Platinum-palladium print made 1980:
38.1 × 37.2 cm. 15 × 14⅝ in.
Courtesy of *Vogue*

445 Coal Man 1950
Platinum-palladium print made 1975:
49 × 34.1 cm. 19⁵⁄₁₆ × 13⁷⁄₁₆ in.
Courtesy of *Vogue*

Georgii Petrusov
(Russian 1903–71)

Petrusov worked as an accountant at the Industrial Bank of Rostov from 1920 to 1924 and took up photography in those years as an amateur. In 1924 he became a photographer–reporter in Moscow, working for the journal *Metalist* (1924–25) and later for *Robochii-Khimik*. From 1926 to 1928 he worked as a documentary photographer for *Pravda*, and from 1930–41 he photographed for the publication *USSR in Construction*, which included a series by him on the first farming co-operative. He served as war correspondent (1941–45) for the Soviet Information Bureau and *Izvestia*. From 1957 to 1971 he worked with the press agency Novosti/APN which published *Soviet Life*, a journal for the American market.

424 Homecoming 1945
Gelatine-silver print: 46.9 × 59.9 cm.
18½ × 23½ in.
International Center of Photography, New York, Permanent Collection, Gift of the photographer, 378.86

Henri-Victor Régnault
(French 1810–78)

Born in Germany, Régnault moved to Paris in his youth, entering the Ecole Polytechnique in 1830. In 1840 he became professor there and was elected to the Académie des Sciences. The following year he became professor of physics at the Collège de France. He studied photography with Blanquart-Evrard in 1847. A founder-member of the Société Héliographique (1851), he discovered the use of pyrogallic acid as a developing agent. He wrote chemistry text books, *First Elements of Chemistry* appearing in 1850. His photographs were published by Blanquart-Evrard in *Etudes et paysages* (1853–54), and he also produced portraits. He was a founder-member of the Société Française de Photographie (1854) and an honorary member of the Photographic Society of London (1855). From 1854 to 1871 he was director of the Sèvres porcelain factory. In the twentieth century his negatives were printed by Claudine Sudre (early 1970s) and Pierre Gassman (1979).

André Jammes, 'Victor Régnault, Calotypist', in Van Deren Coke, ed., *One Hundred Years of Photographic History: Essays in Honor of Beaumont Newhall*, Albuquerque 1975.

71 Sèvres, the Seine at Meudon c. 1853
Carbon print by Poitevin: 31 × 42.8 cm.
$12\frac{1}{4}$ × $16\frac{13}{16}$ in.
Private collection

72 The Manufactory at Sèvres, East Entrance
c. 1852
Salted-paper print: 43.9 × 34.8 cm.
$17\frac{1}{4}$ × $13\frac{11}{16}$ in.
Private collection

Louis-Rémy Robert
(French 1811–82)

Coming from a family of painters and artisans employed at Sèvres porcelain factory, Robert was appointed director of painting on glass in 1832. He was introduced to photography around 1848 by the factory's administrator Henri-Victor Régnault. Some of his photographs of Versailles made in 1853 were published by Blanquart-Evrard in *Souvenirs de Versailles*. In the years following he also photographed at Sèvres, in the park of Saint-Cloud and in Normandy. He became a member of the Société Française de Photographie in 1855. From 1858 to 1872 he taught photographic chemistry at the Ecole des Ponts et Chaussées. On Régnault's retirement in 1871 he was appointed administrator of the Sèvres factory, a position he held until 1879.

79 Versailles, Fountain of the Pyramid of Girardon 1853
Blanquart-Evrard salted-paper print:
30 × 24.7 cm. $11\frac{13}{16}$ × $9\frac{11}{16}$ in.
Private collection

83 Still life with Statuette and Vases 1855
Carbon print made 1870: 32.3 × 26.1 cm.
$12\frac{3}{4}$ × $10\frac{5}{16}$ in.
The J. Paul Getty Museum, 84.XP.218.10

Henry Peach Robinson
(British 1830–1901)

After five years' apprenticeship to a printer and bookseller at the age of fourteen, Robinson studied drawing and painting. He learned daguerreotypy in 1851, also experimenting with photogenic drawing and calotype, and later with the collodion process. From 1853 to 1856 he was employed in bookselling and publishing. In 1854 he began photographic studies under Dr H. W. Diamond in London and opened his own photographic studio in 1857. In 1858 he exhibited the photograph *Fading Away*, constructed from five negatives by combination printing, at the Crystal Palace. In 1862 he was elected a member of the Council of the Photographic Society of London and served on the jury of the International Exhibition. The book *Pictorial Effect in Photography* was published in 1869 and *The Art and Practice of Silver Printing* (jointly with Abney), in 1881. In 1888 he retired from commercial work and published *Letters on Landscape Photography*. He was an active member of the Linked Ring from 1893 to 1900.

Margaret F. Harker, *Henry Peach Robinson: Master of Photographic Art*, Oxford and New York 1988.

147 Bringing Home the May 1862
Albumen print: 19.3 × 49.8 cm. $7\frac{5}{8}$ × $19\frac{9}{16}$ in.
Gernsheim Collection, Harry Ransom Humanities Research Center, University of Texas at Austin

148 The Lady of Shalott 1860–61
Albumen print: 31 × 52.1 cm. $12\frac{3}{16}$ × $20\frac{1}{2}$ in.
(arched)
Gernsheim Collection, Harry Ransom Humanities Research Center, University of Texas at Austin

Alexandr Mikhailovich Rodchenko
(Russian 1891–1956)

Rodchenko studied graphic arts at Kazan School of Arts (1907–14) and the Stroganov Institute in Moscow (1914–15), then worked as assistant to Tatlin at the 1916 Futurist exhibition. In 1918 he became founder-member of the Museum of Artistic Culture and by 1920 was an active member of the Institut Khudozhestvennoy Kultury. During his years of teaching at the Moscow School of Applied Art, Vkhutemas (1920–30) he became friends with El Lissitzky. From 1923 he used found images to construct photomontages and began to employ his own photographs the next year. Throughout the 1920s he designed the covers of many publications, including the books of the poet Mayakovsky (1925–29) and the Russian Constructivist *Kino-Fot* magazine (1922). In 1926 he began working as a photojournalist for the publications *Lef, Novyj Lef, Ogonok, Radio-slushatel, Prozhektor, Krasnoye Studenchestvo, Dayosh, Za Rubzhom, Smena, Borba Klassov* and *Vechernaya Moskva*. In 1922 he collaborated with the film-maker Dziga Vertov, and he later directed a documentary film, *The Chemicalization of the Forest*. He stopped using photography in 1942 and returned to painting, producing abstract expressionist work in the 1940s.

David Elliot, *Alexander Rodchenko*, London and New York 1979; German Karginov, *Rodchenko*, London 1979.

224 Pioneer 1930
Gelatine-silver print: 56.8 × 48.4 cm.
$22\frac{3}{8}$ × $19\frac{1}{8}$ in.
The J. Paul Getty Museum, 84.XM.258.43

225 The Critic Osip Brik 1924
Gelatine-silver print: 28.5 × 20.9 cm.
$11\frac{1}{4}$ × $8\frac{3}{16}$ in.
The J. Paul Getty Museum, 84.XM.258.30

226 Vladimir Mayakovsky 1924
Gelatine-silver print made 1940s:
40.3 × 29.6 cm. $15\frac{7}{8}$ × $11\frac{11}{16}$ in.
The J. Paul Getty Museum, 84.XM.258.27

227 Pioneer with a Horn 1930
Gelatine-silver still, cut out: 19.1 × 15.3 cm.
$7\frac{1}{2}$ × 6 in.
Thomas Walther Collection, New York

228 To the Demonstration 1932
Gelatine-silver print: 18.1 × 12 cm. $7\frac{1}{8}$ × $4\frac{3}{4}$ in.
The J. Paul Getty Museum, 84.XM.258.1

229 Rehearsal, Belomorsk Canal 1933
Gelatine-silver print: 29.8 × 43.8 cm.
$11\frac{3}{4}$ × $17\frac{1}{4}$ in.
Collection, The Museum of Modern Art, New York, Purchase, 48.70

230 Woman with Leica 1934
Gelatine-silver print: 30 × 20.4 cm. $11\frac{13}{16}$ × $8\frac{1}{16}$ in.
Thomas Walther Collection, New York

231 Sentry of Shukhov Tower 1929
Gelatine-silver print made 1940s:
23.9 × 15.6 cm. $9\frac{3}{8}$ × $6\frac{1}{8}$ in.
The J. Paul Getty Museum, 85.XM.155.1

232 Radio Listener 1929
Gelatine-silver print made posthumously:
29.9 × 40.1 cm. $11\frac{3}{4}$ × $15\frac{13}{16}$ in.
The J. Paul Getty Museum, 85.XM.258.57

August Sander
(German 1876–1964)

Apprenticed in 1889 to an iron-miner, Sander first took up photography in 1892. After his military service (1896–98), around 1902, he opened a photographic studio jointly with Franz Stukenberg, whom he bought out in 1904. His first one-man exhibition was held in 1906 at the Landhaus Pavillon, Linz. In 1910 he opened a studio in Cologne and began his lifetime photographic project, 'Man in the Twentieth Century', photographs of people from all walks of life. The first publication of a group of these images was *Antlitz der Zeit* (*Face of Our Time*) in 1929. In 1931 he delivered a series of radio lectures on photography. Five books in the 'German Land, German People' series were published between 1933 and 1934, when he also began photographing landscapes and studies from nature.

Gunther Sander, ed., *August Sander: Citizens of the Twentieth Century*, Cambridge, Mass. and London 1986.

294 The Hod-Carrier (*Handlanger*) c. 1928
Gelatine-silver print: 22 × 14.8 cm. $8\frac{5}{8}$ × $5\frac{13}{16}$ in.
Private collection

295 The Wife of the Painter Peter Abelen (*Frau eines Malers. Verheiratet mit Peter Abelen*) 1926
Gelatine-silver print: 23 × 16.3 cm. $9\frac{1}{16}$ × $6\frac{7}{16}$ in.
The J. Paul Getty Museum, 84.XM.498.9

296 Gypsy (*Zigeuner*) 1938
Gelatine-silver print made 1950s:
27.5 × 21.1 cm. $10\frac{13}{16}$ × $8\frac{5}{16}$ in.
The J. Paul Getty Museum, 84.XM.498.6

297 The Painter Gottfried Brockmann (*Der Maler Gottfried Brockmann*) 1924
Gelatine-silver print: 21.4 × 15.6 cm. $8\frac{3}{8}$ × $6\frac{1}{8}$ in.
The J. Paul Getty Museum, 84.XM.126.411

298 Widower with Sons (*Witwer mit seinen Söhnen*) 1925
Gelatine-silver print: 26.7 × 18.7 cm.
$10\frac{1}{2}$ × $7\frac{3}{8}$ in.
The J. Paul Getty Museum, 84.XM.126.242

299 Untitled 1920
Gelatine-silver print: 28.9 × 22.6 cm.
$11\frac{3}{8}$ × $8\frac{7}{8}$ in.
The J. Paul Getty Museum, 84.XM.126.244

300 SS Officer (*Schutzstaffel*) 1937
Gelatine-silver print: 28.5 × 20.1 cm.
$11\frac{1}{4}$ × $7\frac{7}{8}$ in.
The J. Paul Getty Museum, 84.XM.126.258

301 Persecuted Jew, Mr Leubsdorf (*Verfolgter Jude, Herr Leubsdorf*) 1938
Gelatine-silver print: 28.8 × 20.3 cm. $11\frac{3}{8}$ × 8 in.
The J. Paul Getty Museum, 84.XM.126.236

Cindy Sherman
(American b. 1954)

Educated at New York State University College, Buffalo, she produced a series of black-and-white photographs (1978–79) called *Untitled Film Stills* which investigated the pictorial conventions of film. Her first individual exhibition was held in Buffalo, New York, in 1979. The next year she began to show her work (1980–85) at Metro Pictures gallery in New York. In 1982 her photographs were shown at the Stedelijk Museum, Amsterdam and in 1985 at Westfälischer Kunstverein, Munster, West Germany. The book *Cindy Sherman* was published in 1984, with an introduction by Peter Schjeldahl.

Cindy Sherman, essays by Peter Schjeldahl and Lisa Phillips, Whitney Museum of American Art, New York 1987.

457 Untitled, no.145 1985
Colour coupler print: 177.8 × 119.4 cm.
70 × 47 in.
Cindy Sherman, courtesy Metro Pictures, New York

458 Untitled, no.168 1987
Colour coupler print: 210.9 × 152.4 cm.
55 × 60 in.
Collection Metro Pictures, New York

Camille de Silvy
(French active 1858–69)

Abandoning a diplomatic career, Silvy took up photography in 1858 and joined the Société Française de Photographie in Paris. His first photographic subjects were the Eure-et-Loire, the banks of the Huisne and the King and Queen of Sardinia. From 1859 to 1869 he operated a studio in London, in Porchester Terrace near Hyde Park, where he specialised in society portraits and cartes-de-visite. He wrote for the *Photographic Journal* (London) and his letters appeared in the *Revue des Deux Mondes* and the *Revue Photographique*. He produced photographic portraits of the Royal Family in 1860, and in 1861 he voiced his concern that all ancient manuscripts should be reproduced by photography. In 1865 he photographed the vaults of the Chapel of Dreux. He sold his business in 1869 and retired to his family château in France, returning to England years later as consul in Exeter.

69 River Scene, France 1858
Albumen print from two collodion glass plate negatives: 25.7 × 35.6 cm. 10⅛ × 14 in.
Private collection

Graham Smith
(British b. 1947)

After attending Middlesbrough College of Art (1968–71) and receiving an M.A. in photography from the Royal College of Art, London

(1973), Smith published a series of his photographs, *Skinningrove* (1973). From 1973 to 1980 he was a member of the film and photography co-operative Amber Associates, Newcastle-upon-Tyne. *The Quayside* was published in 1974 by the Side Gallery, Newcastle-upon-Tyne, which also exhibited *Consett—A Steel Town* in 1980. Further exhibitions were held in 1984 at the South Bank, London, and the Side Gallery, and his work was represented in a major exhibition, 'Another Country', at the Serpentine Gallery, London, in 1985.

397 I thought I saw Liz Taylor and Bob Mitchum in the back room of the Commercial, South Bank 1984
Gelatine-silver print: 50.8 × 40.64 cm.
20 × 16 in.
Graham Smith★

398 South Bank 1982
Gelatine-silver print: 50.8 × 40.64 cm.
20 × 16 in.
Graham Smith★

399 The Zetland, Middlesbrough 1983
Gelatine-silver print: 50.8 × 40.64 cm.
20 × 16 in.
Graham Smith★

400 Back Room of the Commercial, Friday Night, South Bank 1983
Gelatine-silver print: 50.8 × 40.64 cm.
20 × 16 in.
Graham Smith★

401 Sandy and Friend, South Bank 1983
Gelatine-silver print: 50.8 × 40.64 cm.
20 × 16 in.
Graham Smith★

402 Easington, Co. Durham 1976
Gelatine-silver print: 50.8 × 40.64 cm.
20 × 16 in.
Graham Smith★

W. Eugene Smith
(American 1918–78)

Already a press photographer at the age of seventeen, Smith went on to study photography on a scholarship at Notre Dame University, Indiana (1936–37). In 1937–38 he worked as Staff Photographer for *Newsweek* magazine. After two years as freelance photographer with the Black Star agency, he joined *Life* magazine (1939–41). From 1942–45 he was a war correspondent covering the Pacific, first for Ziff-Davis Publishing (*Popular Photography*) and then for *Life*. After recovering from a serious war injury, he returned to photojournalism with *Life*, producing a number of photo-essays, 1947–54. He was a member of Magnum photographic agency (1955–59), afterwards working as freelance independent photographer and producing a series of photographs in Japan, *Minamata* (1975).

William S. Johnson ed., *W. Eugene Smith: Master of the Photographic Essay*, Millerton, N.Y. 1981; Ben Maddow, *Let Truth Be the Predjudice: W. Eugene Smith His Life and Photographs*, Millerton, N.Y. 1985.

413 Untitled (Three soldiers with the Spanish Guardia Civil) 1950
Gelatine-silver print: 38.1 × 49.3 cm.
15 × 19⅜ in.
Center for Creative Photography, University of Arizona, Tucson, 82:113:105

414 Soldier with Canteen, Saipan 1944
Gelatine-silver print: 34 × 26.3 cm. 13⅜ × 10⅜ in.
Center for Creative Photography, University of Arizona, Tucson, 92:102:438

415 Marine Demolition Team blasting out a Cave on Hill 382, Iwo Jima 1945
Gelatine-silver print: 25.7 × 33.1 cm.
10⅛ × 13 in.
Center for Creative Photography, University of Arizona, Tucson, 82:102:558

416 Okinawa April 1945
Gelatine-silver print: 26.6 × 33.9 cm.
10½ × 13⅜ in.
Center for Creative Photography, University of Arizona, Tucson, 82:102:200

417 Untitled [Burial at Sea] [from Ziff-Davis essay 'Marshall Islands Campaign' published January–March 1944] c. 1943
Gelatine-silver print made 1988:
32.5 × 22.5 cm. 12⅞ × 8⅞ in.
Center for Creative Photography, University of Arizona, Tucson

Charles Soulier
(French, before 1840–after 1876)

Between 1854 and 1859 Soulier worked in photographic partnership with A. Clouzard, with whom he created panoramas of Paris (1854–57) and exhibited views of the Louvre (1856). The partnership ended in 1859, and Soulier accompanied Napoleon III on his campaign in Austria. From 1860 to 1864 he collaborated with Claude-Marie Ferrier, and they produced a series of stereoscopic views of Paris on glass. In 1865 he made topographic views of Paris, Savoy and Italy. In 1867 he joined the Société Française de Photographie and was made Photographer to the Emperor. He documented the Paris Commune and Communards in 1871.

80 The Pont-Neuf, Paris 1865
Albumen print: 30.7 × 39.5 cm. 12⅛ × 15⅝ in.
(oval)
The J. Paul Getty Museum, 84.XP.373.6

Albert Sands Southworth
(American 1811–94)
Josiah Johnson Hawes
(American 1808–1901)

Receiving his education at Phillips Academy, Andover, Massachusetts (1833–35), Southworth was working as a pharmacist when he learned daguerreotypy in 1840 from François Gouraud, American agent for Daguerre. A carpenter's apprentice, Hawes joined Southworth and J. Pennell as a partner in their Boston studio in 1841. After Pennell left in 1844 the firm took the name 'Southworth and Hawes'. Before the partnership dissolved in 1862, it produced thousands of daguerreotype portraits of the

American cultural élite, including Daniel Webster, Ralph Waldo Emerson, Longfellow, Jenny Lind and Harriet Beecher Stowe. The firm also photographed the city of Boston and Niagara Falls.

Robert A. Sobieszek and Odette M. Appel, *The Spirit of Fact: The Daguerreotypes of Southworth and Hawes 1843–1862*, Boston, Mass. 1976.

27 **Operation under Ether** c. 1852
Daguerreotype attributed to Southworth and Hawes: 15.3 × 20.4 cm. 6 × 8 in.
Massachusetts General Hospital, Boston, Pl.1979

28 **Classroom in Emerson School for Girls** 1850s
Daguerreotype: 21.6 × 16.5 cm. 8½ × 6½ in.
The Metropolitan Museum of Art, New York, Gift of I. N. Phelps Stokes and the Hawes Family, 1937. 37.14.22[†]

29 **Women in the Southworth and Hawes Studio** c. 1854
Daguerreotype: 16.5 × 21.6 cm. 6½ × 8½ in.
The Metropolitan Museum of Art, New York, Gift of I. N. Phelps Stokes and the Hawes Family, 1937. 37.14.56[†]

30 **Untitled** c. 1852
Daguerreotype: 8 × 10.2 cm. 3⅛ × 4 in.
Private collection

31 **Self-portrait** c. 1848
Daguerreotype by Southworth alone, hand-coloured: 14 × 10.5 cm. 5½ × 4⅛ in.
Gilman Paper Company Collection, PH80.658

32 **Lola Montez** 1851
Daguerreotype: 21.6 × 16.5 cm. 8½ × 6½ in.
The Metropolitan Museum of Art, New York, Gift of I. N. Phelps Stokes and the Hawes Family, 1937. 37.14.41[†]

33 **Daniel Webster** c. 1851
Daguerreotype: 16.5 × 11.5 cm. 6½ × 4½ in.
Richard L. Sandor

34 **Unidentified Girl with Gilbert Stuart Portrait of George Washington** 1850s
Daguerreotype: 21.6 × 16.5 cm. 8½ × 6½ in.
The Metropolitan Museum of Art, New York, Gift of I. N. Phelps Stokes and the Hawes Family, 1937[†]

Edward Steichen
(American 1879–1973)

Born in Luxembourg, Steichen was raised in Hancock, Michigan, and studied painting in Milwaukee, Wisconsin, in the late 1890s. He learned photography in 1895 and first met Stieglitz in New York before leaving for Europe in 1900. He was elected to the Linked Ring in 1901 and co-founded the Photo-Secession on his return to New York in 1902. Returning to Paris in 1905, he began organising exhibitions of avant-garde artists such as Picasso, Matisse, Brancusi, Cézanne and Rodin for Stieglitz's '291' gallery. After World War I, during which he established a department of aerial photography for the U.S. Army, he opened a commercial studio in New York (1923–30), becoming chief photographer for Condé Nast (*Vogue* and *Vanity Fair*) in 1923. His photographs of World War II at sea were shown in two exhibitions, 'Road to Victory' (1942) and 'Power in the Pacific' (1945), at the Museum of Modern Art, New York. As

director of the photography department at MOMA (1947–62), he organised some fifty exhibitions, including 'The Family of Man' in 1955. His autobiography, *A Life in Photography*, was published in 1963.

Dennis Longwell, *Steichen: The Master Prints, 1895–1914: The Symbolist Period*, New York and London 1978; *A Centennial Tribute*, Rochester, N.Y. 1979.

163 **Rodin, 'Le Penseur', Paris** 1902
Photogravure: 32.1 × 25.7 cm. 12⅝ × 10⅛ in.
Mary Steichen Calderone, M.D.

164 **J. P. Morgan** 1904
Bromoil print: 40 × 30.5 cm. 15¾ × 12 in.
Private collection

165 **After the Grand Prix, Paris** 1907
Carbon print with selectively applied yellow toning made 1911: 27.2 × 29.5 cm. 10^{11}/_{16} × 11⅝ in.
The Metropolitan Museum of Art, New York, Alfred Stieglitz Collection[†]

166 **Balzac, the Open Sky, 11 p.m.** 1908
Carbon print made 1909: 48.7 × 38.5 cm. 19⅛ × 15⅛ in.
The Metropolitan Museum of Art, New York, Alfred Stieglitz Collection[†]

167 **Nocturne: Orangerie Staircase, Versailles** 1907
Gum-bichromate print: 30.5 × 40.6 cm. 12 × 16 in.
Albright-Knox Art Gallery, Buffalo, New York, General Purchase Funds, 1911

168 **Trees, Long Island** 1905
Carbon print on base of silver paint: 36.5 × 34.5 cm. 14⅜ × 13⁹/₁₆ in.
Museum of Fine Arts, Houston, museum purchase with funds provided by The Long Endowment for American Art and the Sarah Campbell Blaffer Foundation, 86.1

169 **The Big White Cloud, Lake George** 1903
Carbon print: 39.3 × 48.3 cm. 15½ × 19 in.
The Metropolitan Museum of Art, New York, Alfred Stieglitz Collection[†]

Alfred Stieglitz
(American 1864–1946)

Born in Hoboken, New Jersey, Stieglitz studied at the Technische Hochschule, Berlin, with H. W. Vogel, the photochemist. In 1897 he published twelve photogravures, *Picturesque Bits of New York*, and began to edit the journal of the Camera Club of New York, *Camera Notes*. With experience of his own photoengraving company he edited *Camera Work* (1903–17). He organised a score of exhibitions at home and abroad, which culminated in the International Exhibition of Pictorial Photography, Buffalo, New York, of 1910. He ran his own small galleries: '291' (1905–17), The Intimate Gallery (1925–29) and 'An American Place' (1929–46), which supported the work of Paul Strand among photographers, and painters like John Marin, Marsden Hartley, Arthur Dove and Georgia O'Keeffe, whom he married in 1924.

William Innes Homer, *Alfred Stieglitz and the American Avant-Garde*, Boston, Mass. 1977; Sarah Greenough, *Alfred Stieglitz: Photographs and Writings*, Washington, D.C. 1983.

197 **The Terminal** 1893
Photogravure: 25.6 × 33.53 cm. 10¹/₁₆ × 13³/₁₆ in.
The National Gallery of Art, Washington, D.C., Alfred Stieglitz Collection

198 **The Hand of Man** 1902
Photogravure: 24.2 × 31.8 cm. 9½ × 12½ in.
Private collection

199 **The Steerage** 1907
Photogravure published 1915:
32.1 × 27.5 cm. 12⅝ × 10^{13}/_{16} in.
Museum of Fine Arts, Houston, the Target Collection of American Photography, 76.254

200 **Out of the Window, '291', New York** 1915
Platinum print: 24.6 × 19.5 cm. 9^{11}/_{16} × 7^{11}/_{16} in.
Collection, The Museum of Modern Art, New York, Gift of Charles Sheeler, 631.41

201 **From the Back Window, '291', New York** 1915
Platinum print: 24.2 × 19.4 cm. 9½ × 7⅝ in.
The Art Institute of Chicago

202 **From the Back Window, '291', New York** 1915
Platinum print: 24.4 × 19.4 cm. 9⅝ × 7⅝ in.
National Gallery of Art, Washington, D.C., Alfred Stieglitz Collection, 1949.3.372[†]

203 **Georgia O'Keeffe: A Portrait** 1918
Palladium print: 24 × 19.2 cm. 9⅜ × 7½ in.
National Gallery of Art, Washington, D.C., Alfred Stieglitz Collection, 1980.70.88[†]

204 **Georgia O'Keeffe: A Portrait—Neck** 1921
Palladium print: 24.4 × 19.4 cm. 9⅝ × 7⅝ in.
National Gallery of Art, Washington, D.C., Alfred Stieglitz Collection, 1980.70.159[†]

205 **Hands with Thimble** [Georgia O'Keeffe] 1920
Palladium print: 24.1 × 19.5 cm. 9½ × 7⅝ in.
Collection, The Museum of Modern Art, New York, Alfred Stieglitz Collection

206 **Music: A Sequence of Ten Cloud Photographs, No. VIII** 1922
Gelatine silver-print: 24 × 19 cm. 9⅜ × 7½ in.
National Gallery of Art, Washington, D.C., Alfred Stieglitz Collection 1949, D-836[†]

207 **Equivalent** 1924–26
Gelatine-silver print: 9.2 × 11.6 cm. 3⅝ × 4⁹/₁₆ in.
Private collection

208 **House with Grape Leaves** 1934
Gelatine-silver print: 24.3 × 19.5 cm. 9⁹/₁₆ × 7^{11}/_{16} in.
National Gallery of Art, Washington, D.C., Alfred Stieglitz Collection, D-778[†]

209 **Grapes and Vine** 1933
Gelatine-silver print: 18.9 × 23.7 cm. 7⁷/₁₆ × 9^{15}/_{16} in.
The Cleveland Museum of Art, Gift of Cary Ross, Knoxville, Tennessee, 35.97

210 **From the Shelton, looking west** 1935–36
Gelatine-silver print: 24.5 × 19.2 cm. 9⅝ × 7⁹/₁₆ in.
The Art Institute of Chicago

211 **From the Shelton, looking west** 1933–35
Gelatine-silver-chloride print: 24.2 × 19.2 cm. 9½ × 7⁹/₁₆ in.
The Art Institute of Chicago

Joel Sternfeld
(American b. 1944)

After earning a B.A. degree from Dartmouth College (1965), Sternfeld began work in 1966 as a freelance photographer. He has worked exclusively in colour since 1968. He taught photography at Stockton State College, New

Jersey (1971–84), at Yale University (1984–85) and, from 1985, at Sarah Lawrence College, New York. His photographs were first exhibited in 1976 at the Pennsylvania Academy of Fine Arts, and at the Museum of Modern Art, New York, in 1984.

Museum of Fine Arts, Houston, *American Prospects: Photographs by Joel Sternfeld*, essays by Andy Grundberg and Anne W. Tucker, Houston 1987.

338 After a Flash Flood, Rancho Mirage, California July 1979
Colour coupler print: 40.7 × 50.8 cm.
16 × 20 in.
Private collection

339 Buckingham, Pennsylvania August 1978
Colour coupler print: 40.7 × 50.8 cm.
16 × 20 in.
Private collection

340 Manville Corporation World Headquarters, Colorado October 1980
Colour coupler print: 40.7 × 50.8 cm.
16 × 20 in.
Private collection

341 Near Lake Powell, Arizona August 1979
Colour coupler print: 40.7 × 50.8 cm.
16 × 20 in.
Private collection

William J. Stillman
(American 1828–1901)

Educated at Union College, Schenectady, N.Y. (1848), Stillman first went to England in 1850, where he studied the paintings of J. M. W. Turner and met John Ruskin. In 1855 and 1856 he was co-founder of and writer for America's first art journal, *The Crayon*, based on Ruskin's theories, and in 1860 he made a trip with Ruskin through the Alps. Stillman was consul to Rome from 1862 and began to take photographs around 1865 during his time as consul to Crete. In 1868 he travelled to Athens, and the photographs he took there were later published as *The Acropolis of Athens: Illustrated picturesquely and architecturally in photography* (London 1870). Another version, *Twenty-three Photographic Views of Athens*, was published in 1872. In the early 1870s he contributed articles on photography to the *Nation*, and in 1874 he wrote *The Amateur's Photographic Guide-Book, Being a Complete Résumé of the Most Useful Dry & Wet Collodion Processes*.

Elizabeth Lindquist-Cock, 'Stillman, Ruskin & Rossetti: the Struggle Between Nature and Art', *History of Photography* III (January 1979), 1–14; Anne Ehrenkranz, ed., *Poetic Localities: Photographs of the Adirondacks, Crete, Athens, Italy, and Cambridge by William J. Stillman*, New York 1988.

135 Western Portico of the Parthenon, from above 1870
Autotype carbon print: 18.8 × 23.2 cm.
7⅜ × 9³⁄₁₆ in.
Private collection

136 Western Portico of the Parthenon 1870
Autotype carbon print: 24.2 × 18.8 cm.
9½ × 7⅜ in.
Private collection

Paul Strand
(American 1890–1976)

Born in New York, he attended the Ethical Culture High School, where he began photography with Lewis Hine. Published in *Camera Work* (1916–17), he remained under the influence of the Stieglitz circle until 1932 by which time he had become committed to socialism, first clearly manifested in his film *Redes* (*The Wave*) (1934), made in Mexico for the Secretariat of Education. He was president of Frontier Films (1937–42), a socialist film collective which produced, most notably, *Native Land* (1942). He returned to still photography with a portfolio of photographs made earlier, *Photographs of Mexico* (1940), and *Time in New England* (1950). McCarthyism caused his self-exile in France, where he published *La France de Profil* (1952). Other books followed: *Un Paese* (1955), *Tir a'Mhurain* (1962), *Living Egypt* (1969) and *Ghana: An African Portrait* (1975). In the late 1960s he reappeared on the American scene and had a retrospective at the Philadelphia Museum of Art in 1971.

Paul Strand: A Retrospective Monograph (one- and two-volume edns) Millerton, N.Y. 1971; Naomi Rosenblum, 'Paul Strand: the Early Years, 1910–1932' (University Microfilms) Ann Arbor, Mich. 1978.

183 Wall Street, New York 1915
Platinum print: 25.3 × 32.1 cm. 9¹⁵⁄₁₆ × 12⅝ in.
Philadelphia Museum of Art, The Paul Strand Retrospective Collection: 1915–1975, Gift of the Estate of Paul Strand†

184 People, Streets of New York, 83rd and West End Avenue 1915
Platinum print: 25.4 × 33 cm. 10 × 13 in.
Museum of Fine Arts, Boston, Gift of the Paul Strand Foundation★★

185 Shadows, Twin Lakes, Connecticut 1916
Satista print: 33 × 24.8 cm. 13 × 9¾ in.
Thomas Walther Collection, New York†

186 Abstraction, Bowls, Twin Lakes, Connecticut 1916
Platinum print: 33.5 × 25 cm. 13³⁄₁₆ × 9⅞ in.
The Metropolitan Museum of Art, New York, Alfred Stieglitz Collection†

187 Wire Wheel, New York 1918
Platinum print: 32.1 × 25.2 cm. 12⁹⁄₁₆ × 9¹³⁄₁₆ in.
The Metropolitan Museum of Art, New York, Alfred Stieglitz Collection†

188 Man, Five Points Square, New York 1916
Satista print: 25.1 × 25.8 cm. 9⅞ × 10⅛ in. (sight)
Jedermann Collection, N.A.★★

189 Rebecca, New York c. 1922
Platinum print: 24.6 × 19.2 cm. 9¹¹⁄₁₆ × 7⁹⁄₁₆ in.
Thomas Walther Collection, New York

190 Church on the Hill, Vermont 1946
Gelatine-silver print: 24.5 × 20 cm. 9¹¹⁄₁₆ × 7⅞ in.
Collection, The Museum of Modern Art, New York, Gift of the photographer, 247.57

191 Bell Rope, Massachusetts 1945
Gelatine-silver print: 24.4 × 19.2 cm.
9⁹⁄₁₆ × 7⁹⁄₁₆ in.
Museum of Fine Arts, Houston, Museum Purchase, 80.59

192 Susan Thompson, Cape Split, Maine 1945
Gelatine-silver print: 21.7 × 17 cm. 8½ × 6¾ in.

Collection, The Museum of Modern Art, New York, Mrs John D. Rockefeller Fund, 194.76

193 The Family, Luzzara, Italy 1953
Gelatine-silver print: 11.7 × 16 cm. 4⅝ × 6⅝ in.
The J. Paul Getty Museum, 84.XM.894.2

194 Young Boy, Gondeville, Charente, France 1951
Gelatine-silver print: 11.8 × 14.6 cm. 4⅝ × 5¾ in.
The J. Paul Getty Museum, 86.XM.683.86

195 Tailor's Apprentice, Luzzara, Italy 1953
Gelatine-silver print: 15.2 × 12.4 cm. 6 × 4⅞ in.
The J. Paul Getty Museum, 86.XM.685.1

196 Couple at Rucar, Rumania 1967
Gelatine-silver print: 21.3 × 16.5 cm. 8⅜ × 6½ in.
Philadelphia Museum of Art, The Retrospective Collection: 1915–1975, Gift of the Estate of Paul Strand, 1980-21-488

Josef Sudek
(Czechoslovakian 1896–1976)

Born and educated in Kolin, Bohemia, Sudek was apprenticed to a book-binder (1911–13) and began to photograph in 1913. He served in the Czech army during World War I and afterwards studied photography at the State School of Graphic Arts, Prague (1922–24). He was a founder-member of the Czech Photographic Society in 1924. From 1928 to 1936 he worked as a commercial and portrait photographer and as co-editor of *Panorama* and *Zijene* magazines. In 1928 his first portfolio of fifteen photographs, *Svaty Vit* (*Saint Vitus*) was published, and he was named as official photographer of the city of Prague. The book *Praha-Ceskoslovensko* (*Prague-Czechoslovakia*) appeared in 1929. His photographs were first exhibited in Prague in 1933. 'Sudek in the Arts', an exhibition by a group of painters and graphic artists, paid homage to Prague's revered photographer in 1960. In 1964 *Sudek: 96 Photographs* appeared. His international reputation was enhanced by the opening of an exhibition in New York (Bullaty/Lomeo Studio) on his seventy-fifth birthday, 1971, and in 1976 *Josef Sudek: Portfolio*, of thirteen photographs, was published with an introduction by Petr Tausk.

Sudek, text by Anna Farova, Prague 1976; Sonja Bullaty, *Josef Sudek*, New York 1986.

353 Chair in Janáček's House 1972
Gelatine-silver print: 11.4 × 15.3 cm.
6¹⁄₁₆ × 4⁹⁄₁₆ in.
The J. Paul Getty Museum, 84.XM.149.37

354 Uneasy Night [from the series 'Remembrances'] 1959
Gelatine-silver print: 24 × 18 cm. 9⁷⁄₁₆ × 7¹⁄₁₆ in.
Collection: Sonja Bullaty and Angelo Lomeo

355 Untitled [from the cycle 'Memories of an Evening Walk'] 1956
Gelatine-silver print: 23.1 × 17 cm. 9¹⁄₈ × 6¾ in.
The J. Paul Getty Museum, 84.XM.149.28

356 Untitled [from the series 'Remembrances'] 1953
Gelatine-silver print: 18 × 24 cm. 7¹⁄₁₆ × 9⁷⁄₁₆ in.
Collection: Sonja Bullaty and Angelo Lomeo

357 My Garden with the Wash hanging 1965
Gelatine-silver print: 17.8 × 23.7 cm. 7 × 9⅜ in.
The J. Paul Getty Museum, 84.XM.149.1

358 Coming of Spring 1958
Gelatine-silver print: 22.7 × 27.2 cm.
$8\frac{15}{16}$ × $10\frac{11}{16}$ in.
Private collection

William Henry Fox Talbot
(British 1800–77)

Born in Melbury, Dorset, Talbot went to Harrow School and Trinity College, Cambridge, from which he graduated twelfth in mathematics in 1821. His family having been long in debt, he did not move into Lacock Abbey until 1827. In 1830 he published *Legendary Tales in Verse and Prose*. In 1831 he was elected to the Royal Society and in 1832 elected to Parliament as a Liberal. He began his photographic experiments in 1834 and made his first negative in 1835. The late 1830s saw him researching classical and biblical subjects, with *Hermes* published in 1838 and *The Antiquity of the Book of Genesis* in 1839. The announcement of Daguerre's process in 1839 provoked him to pursue photography again, and in 1841 he announced his calotype process. In 1843 he patented his invention and set up a photographic printing works in Reading. 1844–46 saw the issue of *The Pencil of Nature* in parts, and in 1847 he published *English Etymologies*. In the 1850s he was working on photoglyphic engraving. Studies in Assyriology occupied much of his later life, but he also continued work on scientific subjects.

H. J. P. Arnold, *William Henry Fox Talbot*, London 1977; Gail Buckland, *Fox Talbot and the Invention of Photography*, Boston and London 1980.

1 Leaf of a Plant c. 1839
Plate VII from *The Pencil of Nature*
Salted-paper print, photogenic drawing:
22.5 × 18.6 cm. $8\frac{7}{8}$ × $7\frac{5}{16}$ in.
The National Museum of Photography, Film, Television (National Museum of Science and Industry), Bradford

2 Lace c. 1845
Salted-paper print, photogenic drawing:
23.1 × 18.8 cm. $9\frac{1}{8}$ × $7\frac{3}{8}$ in.
Hans P. Kraus, Jr, New York

3 Articles of China 1844
Salted-paper print, from calotype negative:
13.6 × 18.1 cm. $5\frac{3}{8}$ × $7\frac{1}{8}$ in.
Hans P. Kraus Jr, New York

4 Honeysuckle 1 June 1840
Salted-paper print, from calotype negative:
15.2 × 20 cm. 6 × $7\frac{7}{8}$ in.
The National Museum of Photography, Film, Television (National Museum of Science and Industry), Bradford

5 A Bush of Hydrangea in flower mid-1840s
Salted-paper print, from calotype negative:
15.5 × 19.4 cm. $6\frac{1}{8}$ × $7\frac{5}{8}$ in.
Hans P. Kraus, Jr, New York

6 Beech Trees, Lacock Abbey c. 1844
Salted-paper print, from calotype negative:
15.9 × 19.3 cm. $6\frac{1}{4}$ × $7\frac{5}{8}$ in.
The National Museum of Photography, Film, Television (National Museum of Science and Industry), Bradford

7 Trees and Reflections [The Lake, Lacock Abbey] 1843
Salted-paper print, from calotype negative:
20.3 × 24.8 cm. 8 × $9\frac{3}{4}$ in.
Robert Hershkowitz

8 The Haystack 1844
Plate X from *The Pencil of Nature*
Salted-paper print, from calotype negative, varnished: 17.9 × 22.7 cm. 7 × $8\frac{15}{16}$ in.
Jacques Rauber, Erlenbach

9 Broom and Spade c. 1842
Salted-paper print, from calotype negative:
17.4 × 21.2 cm. $6\frac{7}{8}$ × $8\frac{5}{16}$ in.
The National Museum of Photography, Film, Television (National Museum of Science and Industry), Bradford

10 The Open Door 1 March 1843
Plate VI, from *The Pencil of Nature*
Salted-paper print, from calotype negative:
14.4 × 19.4 cm. $5\frac{11}{16}$ × $7\frac{5}{8}$ in.
The National Museum of Photography, Film, Television (National Museum of Science and Industry), Bradford

11 The Ladder 1844
Plate XIV from *The Pencil of Nature*
Salted-paper print, from calotype negative:
17.1 × 18.3 cm. $6\frac{3}{4}$ × $7\frac{1}{4}$ in.
Rubel Collection, courtesy Thackrey and Robertson, San Francisco

12 Man with a Crutch c. 1844
Salted-paper print, from calotype negative:
16 × 19.2 cm. $6\frac{5}{16}$ × $7\frac{9}{16}$ in.
The National Museum of Photography, Film, Television (National Museum of Science and Industry), Bradford

13 The Chess Players c. 1845
Salted-paper print, from calotype negative:
19.5 × 14.5 cm. $7\frac{3}{4}$ × $5\frac{3}{4}$ in.
Rubel Collection, courtesy Thackrey and Robertson, San Francisco

14 Trafalgar Square: Nelson's Column under construction 1843
Salted-paper print, from calotype negative:
17 × 21.1 cm. $6\frac{3}{4}$ × $8\frac{3}{8}$ in.
Rubel Collection, courtesy Thackrey and Robertson, San Francisco

15 Ships in the Harbour at Rouen 16 May 1843
Salted-paper print, from calotype negative:
16.3 × 17.8 cm. $6\frac{1}{2}$ × $7\frac{1}{16}$ in.
Rubel Collection, courtesy Thackrey and Robertson, San Francisco

16 Street Scene, Paris 1843
Salted-paper print, from calotype negative:
18.8 × 23.2 cm. $6\frac{5}{8}$ × $6\frac{13}{16}$ in.
Rubel Collection, courtesy Thackrey and Robertson, San Francisco

John Thomson
(British 1837–1921)

Born in Scotland, Thomson studied chemistry at Edinburgh University in the late 1850s and began photography in the early 1860s. He made photographs in Ceylon in 1862 and in Cambodia a few years later, and between 1864 and 1866 he travelled and photographed also in Malaysia, Singapore and Bangkok. He was made a fellow of the Royal Geographical Society in 1866. His book of photographs *Antiquities of Cambodia* was published in 1867, followed by another trip in 1867–68 to South-East Asia and in 1869 to Hong Kong. In 1870 he travelled to Macao and up the

coast of China, a trip that resulted in the publication of *Illustrations of China and Its People* (1873–74) in four volumes, reproduced by the collotype process. He translated Tissandier's history, *Les Merveilles de la Photographie*, into English in 1876. In 1877–78 he produced with Adolphe Smith *Street Life in London* in parts, a series of photographs of the working classes. His last photographic expedition was to Cyprus (1878–79), and in the 1880s he operated a London portrait studio with Royal patronage.

Stephen White, *John Thomson: Life and Photographs*, London 1985.

126 Prince Kung c. 1871–72
Albumen print: 23.9 × 18 cm. $9\frac{7}{16}$ × $7\frac{1}{8}$ in.
Collection Stephen White, Los Angeles

127 The Altar of Heaven c. 1870–71
Carbon print: 23.5 × 29.8 cm. $9\frac{1}{4}$ × $11\frac{3}{4}$ in.
Collection Stephen White, Los Angeles

128 A Pagoda Island in the Mouth of the Min River c. 1870–71
Carbon print: 22.1 × 28.8 cm. $8\frac{3}{4}$ × $11\frac{3}{8}$ in.
Collection Stephen White, Los Angeles

Andy Warhol
(American 1928–87)

Educated in fine arts at Carnegie Institute of Technology, Pittsburgh (1945–49), Warhol worked for two years as an illustrator for *Glamour* magazine and then as a commercial artist in New York (1950–57). His paintings were first exhibited in 1952 at New York's Hugo Gallery. From 1957 he worked as an independent artist, taking his imagery from the icons of popular culture photographically reproduced in the media. He made his first silkscreen paintings (produced by photo-silkscreen) in 1962. He edited *Inter/View* magazine during the 1960s and 1970s. During his career, he directed or supervised over fifty films, beginning with *Sleep* (1963) and including *Empire* (1964), *The Velvet Underground* and *Chelsea Girls* (1966), and *Lonesome Cowboys* (1967).

John Coplans, ed., *Andy Warhol*, New York 1971; *Andy Warhol: America*, New York 1985.

461 Early Electric Chair 1963
Acrylic and silkscreen ink on canvas:
51 × 76 cm. 20 × 30 in.
The Menil Collection, Houston, 79-13DJ★★
Collection: Australian National Gallery, Canberra†††

462 Elvis 1963
Screenprint, metallic paint on canvas:
208 × 91 cm. $81\frac{13}{16}$ × $35\frac{13}{16}$ in.
Collection: Australian National Gallery, Canberra†††

Carleton Eugene Watkins
(American 1829–1916)

Watkins left his birthplace of Oneonta, N.Y., for California around 1850. He learned the daguerreotype and wet-collodion processes in 1854 from the photographer Robert H. Vance in San Francisco. He managed Vance's gallery until

setting up his own establishment which he operatd 5.til 1906. He made his first visit to Yosemite in 1861, and in 1863 he published himself an album, *Yosemite Valley: Photographic Views of the Falls and Valley*. He travelled as photographer with the U.S. Geological Survey of California in 1866, again to Yosemite. In 1867 he produced the book *Yosemite*. He photographed the Mt Shasta and Mt Lassen areas for the U.S. Geological Survey in 1870. In 1873 his work was exhibited at the Vienna International Exposition, beside that of O'Sullivan and Muybridge. He photographed the Comstock Lode and Virginia City, Nevada, in 1876 and documented the route of the Southern Pacific Railway to Tucson, Arizona.

James Alinder, ed., *Carleton E. Watkins: Photographs of the Columbia River and Oregon*, Carmel 1979; Peter E. Palmquist, *Carleton E. Watkins, Photographer of the American West*, Albuquerque 1983.

112 Panorama of Yosemite Valley from Sentinel Dome 1866
(a) *The Domes*
Albumen print, left panel of the panorama: 39.4 × 52.3 cm. 15½ × 20½ in.
The J. Paul Getty Museum, 84.XP.220.31/32
(b) *The Lyall Group and Nevada Fall*
Albumen print, centre panel of the panorama: 39.8 × 52.3 cm. 15¾ × 20½ in.
The J. Paul Getty Museum, 84.XP.220.29
(c) *The Merced Group*
Albumen print, right panel of the panorama: 39.4 × 52.3 cm. 15⅝ × 20½ in.
The J. Paul Getty Museum, 84.XP.220.30

113 Untitled [River cascade] c. 1872
Albumen print: 39 × 51.5 cm. 15⅝ × 20¼ in.
Private collection

114 Yosemite Valley from the 'Best General View' c.1886
Albumen print: 41.2 × 52.1 cm. 16¼ × 20½ in.
Museum of Fine Arts, Houston, museum purchase with funds provided by Mr and Mrs Robert L. Clarke, 80.50

115 Multnomah Falls Cascade, Columbia River 1880
Albumen print: 51.5 × 38.1 cm. 20¼ × 15 in.
Harriette and Noel Levine

116 Cathedral Spires, Yosemite 1861
Albumen print: 52.1 × 35.6 cm. 20½ × 14 in.
Private collection

117 Casa Grande, Arizona 1880
Albumen print: 39 × 53.5 cm. 15⅜ × 21 1/16 in.
Carleton Watkins Collection, Department of Special Collections, University Research Library, University of California, Los Angeles

118 Sugar Loaf Islands, Farallons c. 1868–69
Albumen print, from *Photographs of the Pacific Coast*, published 1872: 40 × 52.4 cm. 15¾ × 20⅝ in.
Gilman Paper Company Collection, PH79.550

119 A Storm on Lake Tahoe c. 1880–85
Albumen print: 39.4 × 54.3 cm. 15½ × 21⅜ in.
Private collection

120 Buckeye Tree, California c. 1870
Albumen print: 39.1 × 51.9 cm. 15⅜ × 20⅜ in.
Collection Centre Canadien d'Architecture/ Canadian Centre for Architecture, Montreal, PH1977.0076

121 The Wreck of the Viscata 1868
Albumen print made 1880: 40 × 52.2 cm.
15¾ × 20 9/16 in.
Amon Carter Museum, Fort Worth, Texas, 80.33★★

122 Cape Horn near Celilo, Oregon 1867
Albumen print made 1868: 56.2 × 71.6 cm
22⅛ × 28 3/16 in.
Private collection, courtesy of William E. Schaeffer

Boyd Webb
(New Zealander b. 1947)

Webb studied first at the Ilam School of Art (1968–71) and then at the Royal College of Art in London from 1972 to 1975. His large colour photographs were first exhibited in 1976 at the Robert Self Gallery, London, followed by exhibitions in Britain, Europe, New Zealand, U.S.A. and Australia.

Ian Walker, 'Boyd Webb', *Creative Camera* 23 (December 1984); *Boyd Webb*, London 1987.

459 Day for Night 1988
Cibachrome print: 158 × 123 cm.
62¼ × 48½ in.
Private collection, courtesy Anthony d'Offay Gallery, London

460 Sargasso 1985
Cibachrome print: 155 × 122 cm.
59 13/16 × 48 in.
Private collection, courtesy Anthony d'Offay Gallery, London†††

Weegee (Arthur Fellig)
(American 1899–1968)

Born in Poland as Usher Fellig, Weegee emigrated to New York in 1910. He worked as assistant to a commercial photographer and for three years as a passport photographer. In 1924 he joined Acme Newspictures (now U.P.I.), working first as a darkroom technician and later as a news photographer, until 1935. He then became a freelance photographer, following the night-shift police beat, for the *Herald Tribune*, *World Telegram*, *Daily News*, *Post*, *Journal-American* and *Sun* newspapers. He worked for the tabloid *P.M.* from 1940 to 1945 and occasionally for *Vogue*, *Life*, *Look* and *Fortune*. His photographs were exhibited in a one-man show at the Photo League of New York in 1944. His first book, *Naked City*, came out in 1945, followed by *Weegee's People* (1946). He produced *Naked Hollywood* in 1953, and his autobiography, *Weegee by Weegee* in 1961. A major retrospective of his work, 'Weegee the Famous', was held in 1977 at the International Center of Photography in New York. He made three films: *Weegee's New York* (1948), *The Cocktail Party* (c. 1950) and *The Idiot Box* (c. 1965).

Louis Stettner, ed., *Weegee*, New York 1977; *Weegee's New York: 335 photographs 1935–1960*, intro. by John Coplans, New York and Munich 1982.

312 Coney Island Beach 1940
Gelatine-silver print: 28 × 36 cm. 11 × 14¼ in.
Collection of Peter Coffeen

313 Easter Sunday, Harlem 1940
Gelatine-silver print: 35.6 × 43.2 cm. 14 × 17 in.
Private collection

314 Untitled (Crowd in a theatre) c. 1940s
Gelatine-silver print: 28 × 35.6 cm.
11 × 14 in.
Private collection

315 The Critic [Mrs Cavanaugh and Friend] c. 1943
Gelatine-silver print: 28 × 35.6 cm. 11 × 14 in.
Jean Pigozzi

316 Murder in Hell's Kitchen 1940
Gelatine-silver print: 34.3 × 26.7 cm.
13½ × 10½ in.
Joe Kelly

317 Booked for killing a Policeman 1939
Gelatine-silver print: 24 × 25 cm. 9 7/16 × 9⅞ in.
Thomas Walther Collection, New York

318 Their First Murder 1944
Gelatine-silver print: 26.6 × 33.5 cm.
10½ × 13 3/16 in.
Thomas Walther Collection, New York

319 Seventeen-year-old Boy arrested for strangling a six-year-old Girl to death 1944
Gelatine-silver print: 24 × 19.4 cm. 9 7/16 × 7⅝ in.
Thomas Walther Collection, New York

Edward Weston
(American 1886–1958)

Born in Highland Park, Illinois, Weston went to photography school and, after working as a printer in California, opened a commercial studio in Glendale, California, in 1911. After ten years of salon exhibitions he went to Mexico in March 1922, before visiting Stieglitz in New York in November. Returning to Mexico for long periods until 1926, the mural painters, particularly Jean Charlot, advanced his art education. From 1927 he was making his series of shells, vegetables, rocks and nudes. In 1932 he joined Ansel Adams and others in the formation of the f64 group and published *The Art of Edward Weston*. In 1937–38 he received a Guggenheim Fellowship to photograph in the West and North-west. Books followed: *California and the West* (1940), illustrations to *Leaves of Grass* (1942), *My Camera on Point Lobos* (1950) and, posthumously, *The Daybooks of Edward Weston* in two volumes (1961, 1966).

Ben Maddow, *Edward Weston: Seventy Photographs*, Millerton, N.Y. 1973.

212 Armco Steel, Ohio 1922
Platinum print: 23.2 × 17.5 cm. 9⅛ × 6⅞ in.
Thomas Walther Collection, New York

213 Attic 1921
Platinum print: 19 × 24 cm. 7½ × 9 7/16 in.
Thomas Walther Collection, New York

214 Untitled [Pool Abstraction] 1919
Platinum print: 24.4 × 19.2 cm. 9½ × 7½ in.
Marjorie and Leonard Vernon

215 Cloud, Mexico 1926
Platinum print: 15 × 24.1 cm. 5⅞ × 9 7/16 in.
The J. Paul Getty Museum, 84.XM.229.24

216 Tina Modotti 1924
Platinum print: 24.4 × 19.1 cm. 9⅝ × 8½ in.

Museum of Fine Arts, Houston, the Target
Collection of American Photography, 78.61

217 **Of Neil** 1925
Platinum print: 22.9 × 15.2 cm. 9 × 6 in. (sight)
Exchange National Bank of Chicago

218 **Legs** 1927
Gelatine-silver print: 22.1 × 16.6 cm.
$8\frac{11}{16} × 6\frac{1}{2}$ in.
The J. Paul Getty Museum, 87.XM.61.3

219 **Hand on Breast** c. 1923
Gelatine-silver print: 24.3 × 13 cm. $9\frac{9}{16} × 5\frac{1}{8}$ in.
Thomas Walther Collection, New York

220 **Pepper No. 30** 1930
Gelatine-silver print: 24.1 × 19 cm.
$9\frac{1}{2} × 7\frac{1}{2}$ in.
Private collection

221 **Dunes, Oceano** (*The Black Dune*) 1936
Gelatine-silver print made 1937: 19 × 24.1 cm.
$7\frac{1}{2} × 9\frac{1}{2}$ in.
Margaret Weston and Russ Anderson

222 **Tide Pool, Point Lobos** 1940
Gelatine-silver print: 24.3 × 19.2 cm.
$9\frac{9}{16} × 7\frac{9}{16}$ in.
Collection, The Museum of Modern Art, New
York, Gift of David H. McAlpin, 410.56

223 **Point Lobos** 1946
Gelatine-silver print made 1948:
24.1 × 19.3 cm. $9\frac{9}{16} × 7\frac{9}{16}$ in.
Collection, The Museum of Modern Art, New
York, Gift of David H. McAlpin, 409.56

Clarence H. White
(American 1871–1925)

In 1890 White became book-keeper for a
grocery firm in Newark, Ohio. On his
honeymoon trip in 1893 he visited the World's
Columbian Exposition in Chicago, and first
took up photography. He helped to organise the
Newark Camera Club in 1898, and in 1899
Stieglitz exhibited White's photographs at the
New York Camera Club. He was elected to the
Linked Ring in 1900, and in 1902 was a founder-
member of the Photo-Secession. In 1906 he
moved to New York and established a studio
there, and in 1907 he began to lecture on
photography at Columbia University Teachers'
College. Stieglitz devoted an issue of *Camera
Work* to White's photographs in 1908. In 1910 he
co-founded (with Fred Holland Day, Gertrude
Käsebier and Max Weber) a summer school of
photography in Georgetown Island, Maine. He
taught at Brooklyn Institute of Arts and Sciences
from 1908 to 1921. In 1914 he opened the
Clarence White School of Photography in New
York, attracting students such as Margaret
Bourke-White, Ralph Steiner, Dorothea Lange,
Laura Gilpin and Paul Outerbridge, Jr.

William Innes Homer, *Symbolism of Light: The
Photographs of Clarence H. White*, Wilmington,
Delaware 1977; Peter C. Bunnell, *Clarence H. White:
The Reverence for Beauty*, Athens, Ohio 1986.

178 **The Fountain** 1906
Platinum print made 1907: 24 × 19.3 cm.
$9\frac{1}{2} × 7\frac{5}{8}$ in.
Royal Photographic Society, Bath, 6043

179 **The Orchard** 1902
Platinum print made 1907: 24 × 19.3 cm.
Gilman Paper Company Collection, PH77.241

180 **The Faun** 1907
Platinum print: 24.1 × 18.7 cm. $9\frac{1}{2} × 7\frac{3}{8}$ in.
Royal Photographic Society, Bath, 6042

181 **The Mirror** 1912
Platinum print: 24.4 × 18.1 cm. $9\frac{1}{2} × 7$ in.
Royal Photographic Society, Bath, 5884

182 **Still life** 1907
Platinum print: 22.2 × 19.3 cm. $8\frac{3}{4} × 7\frac{9}{16}$ in.
Royal Photographic Society, Bath, 6067

Minor White
(American 1908–76)

Educated at the University of Minnesota,
Minneapolis (1928–33), White moved to Port-
land, Oregon, where he worked as a hotel clerk
until 1938 and was active in the Oregon Camera
Club. During his tour of duty with the U.S.
Army (1942–45) he was converted to Roman
Catholicism, further broadening his spiritual
interests to include Zen, Gestalt theory and the
teachings of Gurdjieff. From 1946 to 1953 he
taught photography under Ansel Adams at the
California School of Fine Arts (now San
Francisco Art Institute). An exhibition, 'Song
Without Words', was toured by the San
Francisco Museum of Art in 1948. In 1951 he
published his first portfolio of photographs,
Sequence 6, and in 1952 co-founded (with
Beaumont and Nancy Newhall, Ansel Adams
and others) the magazine *Aperture*. From 1953 to
1957 he was an assistant curator at George
Eastman House, Rochester, New York, editing
Image magazine (1956–57) and teaching at
Rochester Institute of Technology (1956–59).
From 1965 to 1975 he taught at Massachusetts
Institute of Technology. *Mirrors, Messages,
Manifestations* was published in 1969 and the
Philadelphia Museum of Art held a retrospective
exhibition of his work in 1970. *Be-Ing Without
Clothes* appeared in 1970, followed by *Octave of
Prayer* in 1972. *Invitational Portfolio 1* was
produced in 1973 and *Jupiter Portfolio* in 1975.

Peter C. Bunnell, ed., *Minor White: The Eye That
Shapes*, The Art Museum, Princeton 1989.

342 **Peeled Paint, Rochester, New York** 1959
Gelatine-silver print: 24.2 × 19.2 cm.
$9\frac{1}{2} × 7\frac{9}{16}$ in.
Private collection

343 **Windowsill Daydreaming** July 1958
Gelatine-silver print: 24.2 × 18 cm. $9\frac{1}{2} × 7\frac{1}{16}$ in.
Private collection

344 **Root and Frost, Rochester, New York**
February 1958
Gelatine-silver print made c. 1970:
22.9 × 28.2 cm. 9 × $11\frac{1}{8}$ in.
The Art Museum, Princeton University, The
Minor White Archive, © 1982 Trustees of
Princeton University, MWA 58-49

345 **Sandblaster, San Francisco** 1949
Gelatine-silver print: 18.9 × 22.3 cm. $7\frac{7}{16} × 8\frac{3}{4}$ in.
Private collection

346 **Blowing Snow on Rock, Rye Beach, New
Hampshire** December 1966
Gelatine-silver print made c. 1970:
20.2 × 29.7 cm. $7\frac{15}{16} × 11\frac{11}{16}$ in.
The Art Museum, Princeton University, The
Minor White Archive, © 1982 Trustees of
Princeton University, MWA 66-233

347 **Sun in Rock, Devil's Slide** 1947
Gelatine-silver print made c. 1948:
9.3 × 12 cm. $3\frac{11}{16} × 4\frac{3}{16}$ in.
The Art Museum, Princeton University, The
Minor White Archive, © 1982 Trustees of
Princeton University, MWA 74-168

Georgi Zelma
(Russian b. 1906)

In 1921–22 Zelma studied photography at the
Photo Club School in Moscow and film camera
work at the Proletkino Film Studio (1922–23).
From 1923 to 1924 he was an apprentice
photographer at the Roussfoto Agency and his
photographs were published in *Pravda Vostoka*.
He worked as a photojournalist for Roussfoto in
Moscow and Tashkent until 1947, and for
Soyuzfoto Agency until 1936. In the early 1930s
he photographed freelance for *SSSR na Stroike*,
Kraznaya Svezda, *Izvestia* and other publi-
cations, specialising in the problems of Central
Asia. As a reporter for *Izvestia* he covered the
Great Patriotic War, especially in Odessa. In
1942 he photographed the Battle of Stalingrad.
After the war, he worked as a photographer for
Ogonyok, and since 1962 he has worked for the
Novosti Agency in Moscow.

418 **A Tank called 'Motherland'** c. 1942
Gelatine-silver print: 43.4 × 58.5 cm.
$17\frac{1}{8} × 23$ in.
International Center of Photography, New York,
Permanent Collection, Gift of the photographer,
382.86

420 **The Assault of the 13th Guard, Stalingrad**
1942
Gelatine-silver print: 28.3 × 74.9 cm.
$11\frac{3}{16} × 29\frac{1}{2}$ in.
International Center of Photography, New York,
Permanent Collection, Gift of the photographer,
383.86

Unknown Photographer

25 **Indian Women grinding Paints** [n.d.]
Daguerreotype: 9.5 × 14.7 cm. $3\frac{3}{4} × 5\frac{3}{4}$ in.
Gilman Paper Company Collection, PH81.770★

SELECT BIBLIOGRAPHY

Ades, Dawn, *Photomontage*, rev. edn, London 1986.

Alinovi, F. and C. Marra, *La Fotografia. Illusione o rivelazione?*, Bologna 1981.

Arts Council of Great Britain, *Three Perspectives on Photography*, London 1979.

Auer, Michèle and Michel, *Encyclopédie internationale des photographes de 1839 à nos jours*, Geneva 1985.

Becchetti, Piero, *Fotografi E Fotografia in Italia 1839–1880*, Rome 1978.

Bellone, Roger and Luc Fellot, *Histoire mondiale de la photographie en couleurs*, Paris 1981.

Bertonati, Emilio, *Das Experimentelle Photo in Deutschland 1918–1940*, Munich 1978.

Billeter, Erika, *Fotografie Lateinamerika*, Zurich 1981.

Boni, Albert, ed., *Photographic Literature: an International Bibliographic Guide*, New York 1962.

Boni, Albert, ed., *Photographic Literature 1960–1970*, New York 1972.

Brettell, Richard R., et al, *Paper and Light: the Calotype in France and Great Britain, 1839–1970*, Boston, Mass. 1984.

Buerger, Janet E., *The Era of the French Calotype*, New York, 1982.

Bunnell, Peter C., *A Photographic Vision: Pictorial Photography 1889–1923*, Salt Lake City, 1980.

Burgin, Victor, ed., *Thinking Photography*, London 1982.

Centre Georges Pompidou, *La Photographie Polonaise 1900–1980*, Paris 1980.

Chudakov, G., *Pioneers of Soviet Russian Photography, 1917–1924*, London 1983.

Coke, Van Deren, *The Painter and the Photographer: From Delacroix to Warhol*, Albuquerque 1964, repr. 1972.

Complete History of Japanese Photography series, 12 vols, Tokyo 1986.

Dimond, Frances and Roger Taylor, *Crown and Camera*, Harmondsworth 1987.

Eder, Josef Maria, *History of Photography*, trans. E. Epstean, New York 1945, repr. 1972, 1978.

Eskildsen, U. and J.-C. Horak, eds, *Film und Foto der zwanziger Jahre*, Stuttgart 1979.

The Family of Man, New York 1955, repr. 1967, 1985.

Fontanella, Lee, *Historia de la Fotografia en España*, Madrid 1981.

Gernsheim, Helmut, *Incunabula of British Photographic Literature 1839–1875*, London and Berkeley 1984.

Gernsheim, Helmut, *The History of Photography*, London 1969.

Gernsheim, Helmut, *The Origins of Photography*, London 1982.

Green, Jonathan, ed., *Camera Work: A Critical Anthology*, Millerton, N.Y. 1973.

Grundberg, Andy and Kathleen McCarthy Gauss, *Photography and Art: Interactions Since 1946*, New York 1987.

Hall-Duncan, Nancy, *The History of Fashion Photography*, New York 1977.

Harker, Margaret, *The Linked Ring: The Secession Movement in Photography in Britain, 1892–1910*, London 1979.

Haworth-Booth, Mark, ed., *The Golden Age of British Photography: 1839–1900*, Millerton, N.Y. 1984.

Heiting, Manfred, ed., *50 Years/Modern Color Photography*, Frankfurt 1986.

Hochreiter, Otto O. and T. Starl, *Geschichte der Fotografie in Österreich*, Bad Ischl 1983.

Homer, William Innes, *Alfred Stieglitz and the Photo-Secession*, Boston, Mass. 1983.

Hoy, Anne H., *Fabrications: Staged, Altered, and Appropriated Photographs*, New York 1987.

International Center of Photography, *Encyclopedia of Photography*, New York 1984.

Jammes, André and Eugenia Parry Janis, *The Art of French Calotype*, Princeton, N.J. 1983.

Japan Photographers Association, *A Century of Japanese Photography*, New York 1980.

Jeffrey, Ian, *Photography: A Concise History*, London, New York and Toronto 1981.

Josef-Haubrich-Kunsthalle, Köln, *Farbe im Photo: Die Geschichte der Farbephotographie von 1861 bis 1981*, Cologne 1981.

Jussim, Estelle and Elizabeth Lindquist-Cock, *Landscape as Photography*, New Haven and London 1985.

Kahmen, Volker, *Photography as Art*, London 1974.

Köhler, Michael and Gisela Barche, *Das Aktfoto: Ansichten von Körper im fotografischen Zeitalter*, Munich 1985, repr. Schaffhausen 1987.

Koschatzky, Walter, *Die Kunst der Photographie*, Vienna 1984.

Krauss, Rolf H., et al, *Kunst mit Photographie*, Berlin 1983.

Krauss, Rosalind, Jane Livingston, Dawn Ades, *L'Amour fou. Photography and Surrealism*, New York 1985.

Lécuyer, Raymond, *Histoire de la Photographie*, Paris 1945.

Lemagny, Jean-Claude and André Rouillé, eds, *A History of Photography*, Cambridge and New York 1987.

Lemagny, Jean-Claude, Alain Sayag and Agnés de Gouvion St. Cyr, *Art or Nature: Twentieth-Century French Photography*, London 1988 (as *Twentieth-Century French Photography*, New York 1988).

Lyons, Nathan, ed., *Photographers on Photography: A Critical Anthology*, Englewood Cliffs, N.J. 1956.

Macmillan Biographical Encyclopedia of Photographic Artists & Innovators, New York and London 1983.

Marbot, Bernard, *After Daguerre: Masterworks of French Photography 1848–1900*, New York 1980.

Mellor, David, ed., *Germany, the New Photography 1927–33*, London 1978.

Ministerio de Cultura, *Idas y Caos: Aspetos de las vanguardias fotográficas en España*, Madrid 1984.

Modern Art Bibliographical Series, vol 2, *Photography*, Oxford and Santa Barbara 1982.

Morosov, S. A., *Sovetskaia khudozhestvennaia fotografiia (1917–1957)*, Moscow 1958.

Morosov, S. A., *Tvorcheskaia fotografiia*, Moscow 1985.

Morozov, Sergei, et al, *Soviet Photography: An Age of Realism*, London 1984.

Mrázková, Daniela and Vladimir Remeš, *The Russian War 1941–1945*, London 1978.

Néagu, Philippe, *La Mission héliographique. Photographies de 1851*, Paris 1980.

Néagu, Philippe and Jean-Jacques Poulet-Allamagny, *Anthologie d'un patrimoine photographique (1847–1926)*, [Paris] 1980.

Newhall, Beaumont, *The Daguerreotype in America*, New York 1976.

Newhall, Beaumont, *The History of Photography: from 1839 to the Present*, New York 1964, repr. London 1972, New York 1982.

Newhall, Beaumont, *Latent Image: The Discovery of Photography*, Albuquerque 1983.

Pare, Richard, *Photography and Architecture*, New York 1982.

Peters, Ursula, *Stilgeschichte der Fotografie in Deutschland 1839–1900*, Cologne 1979.

Robinson, Cervin and Joel Herschman, *Architecture Transformed: A History of the Photography of Buildings from 1839 to the Present*, London 1987.

Roh, Franz and Jan Tschichold, *Foto-Auge/Oeil et Photo/Photo-Eye*, Tubingen 1929, repr. New York 1978.

Rosenblum, Barbara, *Photographers at Work*, New York 1978

Rosenblum, Naomi, *A World History of Photography*, New York 1984.

Rudisill, Richard, *Mirror Image: The Influence of the Daguerreotype on American Society*, Albuquerque 1971.

Seiberling, Grace and Carolyn Bloore, *Amateurs, Photography and the Mid-Victorian Imagination*, Chicago and London 1986.

Scharf, Aaron, *Art and Photography*, Harmondsworth 1968, rev. edn. 1974.

Sennett, Robert S., *Photography and Photographers to 1900: An Annotated Bibliography*, New York and London 1985.

Staatsuitgeverij, *Fotografie in Nederland*, 's-Gravenhage 1978.

Szilagyi, G., *Tény-Kép. A magyar fotografia törtenete 1840–1981*, Budapest 1981.

Tausk, Petr, *Photography in the 20th Century*, London 1980.

Tausk, P., *Přehled vývoje československé fotografie ad roku 1918 až po naše dny*, Prague 1986.

Une Invention du XIXe Siècle: La Photographie (Collections de la Société française de photographie), Paris 1976.

Walker Art Center, *The Frozen Image: Scandanavian Photography*, Minneapolis 1982.

Walsh, George, et al, eds, *Contemporary Photographers*, London and New York 1982, rev. edn 1988.

Weaver, Mike, ed., *British Photography in the Nineteenth Century*, New York and Cambridge 1989.

Weaver, Mike, *The Photographic Art: Pictorial Traditions in Britain and America*, London and New York 1985.

Xanthakis, Alkis X., *History of Greek Photography 1839–1960*, Athens 1988.